A+ ADAPTIVE EXAMS

TestTaker's Guide Series

A+ ADAPTIVE EXAMS

TestTaker's Guide Series

Christopher A. Crayton

CHARLES RIVER MEDIA, INC.
Hingham, Massachusetts

Acquisitions Editor: Brian Sawyer
Production: Publishers' Design & Production Services
Cover Design: The Printed Image

CHARLES RIVER MEDIA, INC.
20 Downer Avenue, Suite 3
Hingham, Massachusetts 02043
781-740-0400
781-740-8816 (FAX)
info@charlesriver.com
www.charlesriver.com

This book is printed on acid-free paper.

Christopher Crayton. *A+ Adaptive Exams*.
ISBN: 1-58450-065-4

All brand names and product names mentioned in this book are trademarks or service marks of their respective companies. Any omission or misuse (of any kind) of service marks or trademarks should not be regarded as intent to infringe on the property of others. The publisher recognizes and respects all marks used by companies, manufacturers, and developers as a means to distinguish their products.

Library of Congress Cataloging-in-Publication Data

Crayton, Christopher.
 A+ adaptive exams / Christopher Crayton.
 p. cm.
 ISBN 1-58450-065-4 (paperback with CD-ROM : alk. paper)
 1. Electronic data processing personnel—Certification. 2. Computer technicians—Certification. 3. Microcomputers—Maintenance and repair—Examinations—Study guides. I. Title.
 QA76.3 .C78 2002
 004.16—dc21

 2001008720

Printed in the United States of America
02 7 6 5 4 3 2 First Edition

CHARLES RIVER MEDIA titles are available for site license or bulk purchase by institutions, user groups, corporations, etc. For additional information, please contact the Special Sales Department at 781-740-0400.

Dedicated to all my students and all certification exam test takers who have the courage to change their lives by achieving certification success!

To Amanda, Rachael, and Randy Hutchinson, Theodore, Nancy and Ken Crayton—thank you for your love, guidance, and support.

CONTENTS

ACKNOWLEDGMENTS

First and foremost, I would like to thank Brian Sawyer, acquisitions editor at Charles River Media, for making this project possible. It has been an honor to work with Brian, whose goal was identical to mine—that is, to provide the most useful A+ certification test preparation book ever written. Brian's mentorship, professionalism, and attention to detail have helped to make this the obvious A+ study reference of choice.

Thank you to co-worker and software developer Mark Porter for the design and creation of the excellent software testing package on the CD-ROM that accompanies this book. Its design, ease of use, and accuracy displays the many talents of a great developer.

Thank you to co-worker, IT Manager, and technical illustrator Mr. Bear for the design and contribution of the technical illustrations included in this book. Their clarity, detail, and accuracy truly demonstrate the technical skills of their creator.

Special thanks go to Steve Bleile, IT director at Sarasota Protocol, for his patience and guidance throughout the creation of this book. Without Steve's advice and direction, I would never have been able to write this book.

For their encouragement and support, I would also like to acknowledge the best technical group of people I have ever had the privilege of working with: Carlven Hall, Chris Gair, Brian King, Micah Huston, William Burch, Patricia Blakney, Dom Bruyere, and Shane Lewis.

Finally, I thank my former fellow teachers at Keiser College, Alex Butakow and David Guthrie. Together we successfully mentored thousands of hopeful students in the process of achieving their certification goals. They were my true inspiration.

PREFACE

Welcome to a resource that will prepare you to take and pass the newly designed Computing Technology Industry Association's (CompTIA's) A+ certification computerized adaptive tests (CATs). In the next several pages you will learn the importance of A+ certification and how it can affect your career goals. You will learn why you should use this particular book to prepare for the current A+ CATs and future certification exams. You will gain insight into the process of scheduling an exam and what to expect when you get to the test site.

If you are interested in gainful employment in the technology industry, you should be certified. The majority of businesses today require applicants to provide proof of certification. If you are applying for a position as a PC technician, network administrator, systems engineer, software engineer, or programmer, A+ certification is normally a minimum requirement. If you are already employed and wish to enhance your technical job opportunities, as well as your income, A+ certification is for you. Many businesses today require their entire IT staff to be A+ certified.

This book was written as a no-nonsense guide to prepare you to pass the A+ CATs. It is not intended as a replacement for hands-on training, nor will it prepare you to be an expert PC technician. It is not designed to fill your head with unneeded information before you enter the test site (this type of preparation is usually accompanied by failure). The book isolates particular topics that are most likely going to be addressed on the exams. The author's main objective is to teach the reader to focus on these specific topics and prepare for the exams by studying questions relevant to these topics.

INTRODUCTION

IN THIS CHAPTER

- The New A+ Certification Computerized Adaptive Tests
- Registering for the A+ Tests
- Test Site Requirements and a Little Advice
- How Computerized Adaptive Testing Works
- The Test Design
- Your State of Mind
- Useful Tools, Tips, and Study Techniques
- Book Structure and Sample Review Questions
- Chapter Summary

THE NEW A+ CERTIFICATION COMPUTERIZED ADAPTIVE TESTS

There are two tests you must pass to become A+ certified: the A+ Hardware Service Technician CAT 220-221 and the A+ Operating System Technologies CAT 220-222. The current tests are in adaptive format, which is addressed in detail in this chapter. The new adaptive tests are offered in English, Japanese, French, Spanish, and German.

The A+ Hardware Service Technician test focuses on computer hardware, including motherboards, processors, peripherals, memory, cables and connectors, electronics, and basic networking. The A+ Operating System Technologies test focuses primarily on the most popular operating

systems in use, including DOS, Windows 9X, Windows NT, and Windows 2000. It also includes test questions focusing on memory utilization, printing, hard drive partitioning, and basic networking. At the time this book was published, there were no Linux questions on this test. CompTIA has a separate certification called Linux+.

REGISTERING FOR THE A+ TESTS

This book has you and your certification status in mind. You (the examinee) must reduce the stress levels involved with preparation and scheduling for the tests in order to focus your energy on your goal: getting A+ certified for life. *A+ Adaptive Exams* is your best resource.

In the United States and Canada, there are two companies to register with to take the A+ certification tests (as well as other certification tests): VUE and Prometric. You can register online or call either company. To register with VUE, visit www.vue.com or call 1-952-995-8800. To register with Prometric, visit www.2test.com or call 1-800-776-4276.

ON THE CD

You are required to register at least 12 hours before you take the test. If you decide to cancel after registering, you must call 12 hours before your scheduled test time to cancel or you will forfeit your money. Your best bet is to pick a target date for taking the tests, give yourself at least 30 days to study this book, and answer all questions correctly on the included testing preparation CD-ROM. Register at least three days ahead of the date and time you wish to sit for the exams. Ask the registration person for the nearest test center location.

Currently, the cost of each test is $132 U.S. You do not get your money back if you fail. You can take each test separately or take them together. If you pass one, you will get credit for that test only. You must pass both tests to become A+ certified. In other words, if you pass one and fail the other, you must reregister for the one you failed and pass it to complete the certification objectives. If you pass both tests, you are instantly A+ certified. A welcome kit will be sent to you within four to six weeks, depending on shipping and other factors.

Information you need to have ready before you register:

- Your name, company name, and your mailing address.
- The exam name and number you wish to take; in this case, A+ Core Hardware Service Technician exam 220-221 and/or A+ Operating Systems Technologies exam 220-222.

- Your method of payment. For quick registration and getting the testing date and time slot that fits your schedule, pay with a valid credit card. Other forms of payment must be received by the registration center before the tests can be scheduled.

TEST SITE REQUIREMENTS AND A LITTLE ADVICE

It is advised that you arrive at the test site one hour before your exam. Take a little time to get comfortable with the surroundings at the test site, sign in at the registration desk, and take the time to study any charts and details that you feel are your weak points. Depending on the schedule of tests at the test site, you can generally take care of the paperwork, find a quiet area to do some last-minute cramming, and then go take the tests. If no one is scheduled before you, it may be possible to take the tests before your scheduled time.

You will be asked to provide two forms of identification at the testing site. A valid driver's license and a credit card are sufficient. One form of identification must be a photograph. When you are ready to enter the testing room, you will be given a blank sheet of paper and a marker or pencil. You cannot take any other books or notes with you. Cell phones are usually not allowed. If you are taking both A+ exams together, you will be allowed a quick break after the first one.

The CompTIA Certification Program has been changed recently to produce a more valuable and desired certification. This book is up to date with the current exams. For more information about the CompTIA A+ Certification Program and other CompTIA Certifications, visit the CompTIA Web site www.comptia.org.

HOW COMPUTERIZED ADAPTIVE TESTING WORKS

The adaptive testing software engine will evaluate your most recently answered question. If you answer the question correctly, the next question is generated from a group of more difficult questions until the testing software is satisfied that you have met the required level of knowledge on that subject

matter. If you answer the question incorrectly, a less difficult question is generated. This process continues as the testing engine accurately keeps track of your knowledge level. Picture a graph running behind the scenes keeping track of your answers. The more questions you answer correctly, the higher above the passing line you move. The more you answer incorrectly, the farther you fall below the passing line. If you are approaching question number 20 and you have answered most of the questions correctly, the testing software will determine that you know the subject matter and may end the test. However, if you are answering the questions inconsistently and riding the pass/fail line on the graph, you may be required to answer up to 30 questions until the software determines whether you pass or fail.

When you have answered the required number of questions, your score will be calculated and the test results displayed on your screen. You will know instantly whether you have passed or failed the test. Proceed to the test coordinator's desk and get your printed test results.

THE TEST DESIGN

Once you have signed in at the testing center, a testing coordinator will direct you to a computer that will have your test ready to go. You may be required to enter a security ID before you start the test. This ID is normally your Social Security number. The testing coordinator will inform you of any special procedures for the particular test center.

Here is a typical breakdown of the A+ exam design.

- You will be allotted 30 minutes to complete each test. A timer in the upper right hand corner of the test screen displays the amount of time you have remaining to complete the test.
- You will be required to answer 20 to 30 multiple-choice questions. Be careful—some questions require more than one answer. If there are circles next to your choices, you must choose only one answer. However, if you see squares next to your choices, you will have the option to select one or more answers. Read the questions carefully; they usually say "choose two" or "choose three." If a question asks you to "choose two" and you select only one answer, the test will prompt you to choose two before you can proceed. The same is true for "choose three" and so on.

- There will be questions that require you to click a graphic radio button to display a diagram or image. You'll be asked to select the correct answer or best choice from the displayed diagram or image. Some diagrams require you to select or identify several choices. You will be allowed to refer back to the diagram to make your selections. This is a good place to use scratch paper to keep your thoughts straight.
- You will not have the option to "mark" a question for later review, nor will you be able to review previously answered questions by going backward. Behind the scenes, the adaptive software grades the question as soon as you answer it and keeps a running tally.
- Possible scores range from 100 (all questions wrong) to 900 (all questions correct).
- The passing score for the A+ Core Hardware Service Technician exam is 683.
- The passing score for the A+ Operating Systems Technologies exam is 614.

The questions on the A+ Core Hardware Service Technician exam 220-221 will be drawn from the following topics and concepts (CompTIA calls them domains).

- Installation, configuration, and upgrading
- Diagnosing and troubleshooting
- Preventive maintenance
- Motherboards, processors, and memory
- Printers
- Basic networking

The questions on the A+ Operating Systems Technologies exam 220-222 will be drawn from the following topics and concepts (also known as domains).

- OS fundamentals
- Installation, configuration, and upgrading
- Diagnosing and troubleshooting
- Networks

Your State of Mind

It is important to focus when studying for and taking a certification test. Make sure that you give yourself time daily to study this book and its accompanying practice test CD-ROM without any distraction. It is not a good practice to study when you are tired and unable to retain the required information. You should be well rested and in a good frame of mind when you take these tests. Don't stay up all night before taking the exams trying to cram 15 years of technical information into your head.

Confidence, along with good study habits, plays a very big role in this process and increases your chances of success. When preparing to take a certification exam, not only should you prepare to pass, but you should also prepare to score as close to 100% as possible.

The A+ exams are usually the first certification tests taken by people interested in the technologies industry. Make sure this is a positive experience to set the stage for your future certification testing goals. Learn to develop good study habits early on in your certification career. This book is based on information, tools, and techniques that have springboarded thousands of students and professionals to A+ certification success and beyond.

Useful Tools, Tips, and Study Techniques

It is common for test takers to think that a 30-question CAT is easier to study for and pass than a traditional 70-question exam because there are fewer questions. These future test takers prepare by focusing only on certain areas of subject matter they assume will be on the exam. In my opinion, this is a huge mistake. The current A+ CATs are based on the same pool of questions as the traditional 70-question exams. To increase your chances of passing, it is important that you spread your focus of study across all identified areas of content in this book, based on the domains specified by CompTIA.

It seems that most certification preparation guides are geared to have you figure out some sort of magical strategy to answer questions correctly and ultimately pass the tests. From firsthand experience, I can tell you that

it's really quite simple. Prepare yourself well with proper study and choose the right answer to each question on the exam.

The book you are holding in your hands will help you become A+ certified. Read the entire book twice. It has been crafted with your certification success in mind.

The practice tests included on the CD-ROM are very accurate and are good simulations of the real tests. Take the practice tests repeatedly until you score 100% every time. When you take a test, whether it is a practice test or a real test, read each question carefully and go with your initial choice. Try not to read too much into the questions. Certification developers are great at making the wrong answers look good. They include key words in the questions to confuse you. The longer you sit there staring at the screen, the more likely you are to pick the wrong answer. Here is another useful tip: do not worry about the questions you have already answered. You cannot go backward. Focus on the questions in front of you, and try not to think of anything else. Learn to prepare yourself well, and always remember that the difference between pass and fail can be one question.

Test takers who have gone before you post "brain dumps" on many Internet sites. These are usually questions that they remember seeing on the test. Be very careful if you study these postings—many of them contain incorrect answers and information. These brain dumps may be helpful on the test, but you should really know the material.

If you study this book, take the suggestions, and do the groundwork, you should do well on the real tests.

BOOK STRUCTURE AND SAMPLE REVIEW QUESTIONS

This book is divided into two sections—Section 1: A+ Core Service Technician Study (CAT 220-221) and Section 2: A+ Operating Systems Technologies Study (CAT 220-222). At the end of each section, a TestTaker's section exam tests your cumulative knowledge of the chapters in each section.

At the end of each chapter in this book, you will be able to test your knowledge by answering several chapter content-related review questions. You may see questions relative to earlier chapters as you move forward. This design is in place to help you build on your skill sets as you move through the book. Use a piece of paper to cover the answers provided

underneath the questions (don't cheat). If you do not understand the question or the answer, you may have to go back and do some review work. Pay very close attention; you may see similar questions on the actual tests.

Notice the circles next to your choices. You will select one answer.

1. You are starting up your PC. The floppy diskette drive light stays on. What is most likely the problem?
 ○ A. The floppy drive is defective.
 ○ B. The data cable is defective.
 ○ C. The data cable is on backward.
 ○ D. The CMOS battery is bad.

 Answer: C

2. You want to improve hard disk access time in Windows 9X. Which utility should you use?
 ○ A. Task Manager
 ○ B. System Monitor
 ○ C. Control Panel
 ○ D. Disk Defragmenter

 Answer: D

Notice the squares next to your choices in the following questions. You will select one or more answers.

3. Which of the following represent types of video RAM? (Choose 3)
 ☐ A. SGRAM
 ☐ B. VRAM
 ☐ C. MRAM
 ☐ D. WRAM

 Answers: A, B, and D

4. Motherboards today usually include what types of expansion boards? (Choose 3)
 ☐ A. AGP
 ☐ B. EISA
 ☐ C. PCI
 ☐ D. ISA

 Answers: A, C, and D

CHAPTER SUMMARY

Chapter 1 introduced you to the new CompTIA A+ certification tests and the adaptive test-taking format. It provided you with a breakdown of the test structure and what you should expect to see from the start of the test to the finish. You were introduced to CompTIA's domain structures, from which your knowledge will be tested. You learned useful tips and study techniques that you should develop early on in your certification test preparation days (and nights) to save you time, money, and disappointment in the long run. Finally, you were introduced to review questions and their format. The best practice and preparation for any certification exam are relative practice questions.

A+ CORE HARDWARE SERVICE TECHNICIAN, CAT 220-221

MOTHERBOARDS, POWER, BIOS, AND EXPANSION BUSES

In This Chapter

- Motherboards and Form Factors
- Slots and Sockets
- Electricity and the Power Supply
- Preventive Maintenance and Safety
- CMOS, BIOS, Plug and Play
- POST and Error Codes
- Expansion Bus Architecture
- North and South Bridges
- PCMCIA (PC Cards)
- Chapter Summary
- Review Questions

MOTHERBOARDS AND FORM FACTORS

The motherboard, sometimes referred to as the planar or system board, is the central part of a computer that brings together all devices attached to the computer. The main components on the motherboard are the CPU

(central processing unit) and CPU chipset, the expansion bus, I/O (input/output interface), disk drive controllers, and random access memory (RAM). The motherboard's main function is to distribute power and data to all devices attached to it.

Motherboards have different form factors. *Form factor* simply describes the physical size and layout of the motherboard and its components. Several form factors and their features are described below.

ADVANCED TECHNOLOGY (AT) AND BABY AT

Up until 1997, the advanced technology (AT) and baby AT form factors were the most popular types of motherboards on the market. The main difference between the two is the width of the motherboards themselves. The AT motherboard is 12″ wide. The baby AT is 9″ wide by 10″ long. See Figure 2.1 for the baby AT and its components.

The AT and baby AT form factors placed the processor and memory socket locations toward the front of the motherboard. Very long expansion

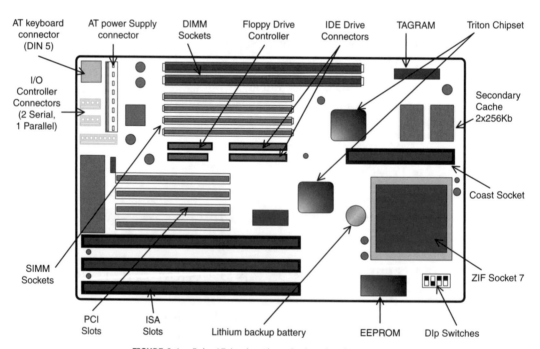

FIGURE 2.1 Baby AT (socket 7) motherboard and components.

cards were designed to extend over them, which made removing the processor difficult. One had to take the expansion cards out first to remove the processor or to get to the memory. It is important to note that an AT power supply gives an output of 12V and 5V to the motherboard. Additional regulators are needed on the motherboard if 3.3V cards (peripheral component interface, or PCI) or processors are used.

This design was acceptable when clearance and cooling were not an issue. With the advent of faster Pentium-class processors that required more cooling and memory sockets that extended off the motherboard, a better design of motherboard was needed.

Study the motherboard diagrams very closely. The A+ core test may show you a similar graphic representation that requires you to identify individual motherboard components.

LPX

In 1987, Western Digital introduced the Low Profile Extensions (LPX) motherboard form factor. This form factor was developed to meet the need for a slimmer desktop. This goal was accomplished based on the implementation of a riser card that extended from the motherboard and allowed expansion cards to be installed parallel to the motherboard.

NLX

As the need for more expansion slots and easier access to components increased, the LPX form factor was redesigned by Intel and named the NLX (InteLex) form factor. The NLX form factor moved the riser card from the center of the motherboard to the outside edge.

ATX

The ATX form factor was developed to solve the problems associated with the baby AT form factor design (Figure 2.2). This new design had many advantages that affected not only the motherboard but the system unit and power supply as well. The dimensions of the ATX form factor are 12″ wide by 9.6″ long. A mini ATX is typically 11.2″ by 8.2″ long.

The ATX design provides the following advantages.

- *Integrated I/O port connection.* Baby AT motherboards have cables connecting them to the physical serial and parallel ports mounted on the system unit. With the ATX form factor, this connection is

integrated into the motherboard. ATX form factor uses a 20-pin plastic power supply connector. This is called a *keyed connector,* and it can be plugged into the motherboard in one direction only.

■ *Integrated PS/2 mouse connector.* ATX motherboards have PS/2 mouse ports integrated into the motherboard. Most baby AT motherboards do not have a PS/2 mouse port. Older style AT motherboards required a serial mouse. (The serial interface is covered in Chapter 8.)

■ *Easier access to components.* The ATX motherboard was designed with functionality and accessibility in mind. It provides much easier access to components than the baby AT form factor and offers more room in general for additional components.

■ *Improved power supply connection.* The new ATX form factor incorporated a single 20-pin connector in place of a pair of 6-pin connectors used on the baby AT motherboard.

■ *Support for 3.3V.* The ATX motherboard supports 3.3V power from the ATX power supply. This voltage is used by most newer processors.

■ *"Soft switch" power support.* The ATX power supply uses a signal from the motherboard to turn itself off. This feature enables you to use the power management utilities offered with newer operating systems to shut down a computer, as opposed to physically turning it off with the power button.

■ *Better airflow.* The ATX power supply pulls air into the system (not out of the system, as with the AT form factor) and allows for better circulation of cool air across the motherboard's components. It is also very important for proper air circulation that you replace any slot covers on the back of a computer that may be missing as a result of expansion cards being removed.

Some very important facts to remember for the exam: most AT style motherboards use a 5-pin DIN keyboard connector. The ATX motherboard uses the smaller 6-pin mini DIN keyboard connector, which is more commonly referred to as a *PS/2 connector.* The keyboard PS/2 connector is identical to the mouse PS/2 connector. In addition, motherboards use "jumpers" to configure or adjust certain onboard settings such as the motherboard's clock speed (which is measured in megahertz, or MHz). Older motherboards used dual in-line package (DIP) switches to perform this function.

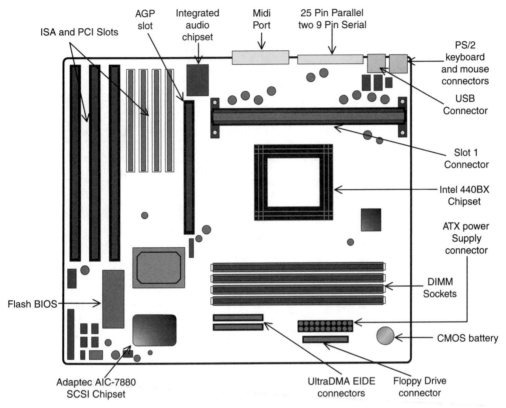

FIGURE 2.2 ATX (Slot 1) motherboard and its components.

SLOTS AND SOCKETS

There are two major ways that a CPU or processor can be installed on the motherboard: socket design and slot design. The socket design is square and is made for a pin grid array (PGA) or staggered pin grid array (SPGA) chip package. The socket itself is made up of many tiny holes that correspond to pins on the bottom side of the CPU. This socket is known as a zero insertion force (ZIF) socket. Socket design is also referred to as flat architecture (see Table 2.1).

Slot technology is implemented when a CPU that is already attached to an integrated circuit (IC) board is plugged into a slot on the motherboard. This slot is typically known as slot 1. Slot technology is pretty much the standard today. There are variations of slot and socket technologies designed to support specific CPUs (see Table 2.2).

TABLE 2.1 Major Sockets, Slots, and the CPUs They Support

Socket or Slot	CPU
Socket 7	Pentium (75MHz), MMX, X86, Cyrix MLL, AMD K-5, K-6
Socket 8	Pentium Pro
Socket 370	Pentium III PGA, Celeron PGA
Socket A	AMD Athlon PGA, AMD Duron
Slot 1	Pentium II, Pentium III SEC, and Celeron SEP
Slot A	AMD Athlon SEC
Slot 2	Pentium II Xeon, Pentium III Xeon

TABLE 2.2 Details of Major Slots and Sockets

Socket 7	321 pinholes (19 × 19) SPGA ZIF socket
Socket 8	387 pinholes (24 × 26) MSPGA ZIF socket
Socket A	453 pinholes (19 × 19) SPGA ZIF socket
Slot 1	242 leads. SEC slot
Slot A	242 leads. SEC slot
Slot 2	330 leads. SEC slot

ELECTRICITY AND THE POWER SUPPLY

The flow of electrons is known as electricity. When electricity flows in only one direction, it is called *direct current* (DC). When electricity flows in two directions or in a bi-directional fashion, it is called *alternating current* (AC). To understand the flow of electricity through a computer system and troubleshoot electrical issues in a computer system, you should be familiar with the following electrical terms.

CURRENT

Current is the amount of electricity moving across a wire. Current is measured in milliamperes or amperes (amps).

RESISTANCE

Resistance is a measure of how much an object resists or holds back the flow of current. When electrical resistance is increased, the amount of current is decreased. Resistance is measured in ohms.

VOLTAGE

Voltage is a measure of the pressure on electrons as they are being pushed through a medium. Voltage is measured in volts.

WATTAGE

Wattage is the amount of work that electrical current is capable of performing. Wattage is measured in watts. You should be very concerned about wattage and its effects when changing or repairing a power supply. A common practice is to simply replace a power supply that is defective.

The main function of your computer's power supply is to convert AC to DC. Current that enters the power supply from an electrical outlet in the wall is typically at 110V or 115V AC.

The power supply converts AC to the +5V, –5V, +12V, or –12V DC current that the motherboard and its components require. A useful tool to test power (voltage) coming from the power supply and going to the motherboard is a digital multimeter. The wires that extend from the typical power supply have different colors, and each represents a different voltage: red = +5V, white = –5V, yellow = +12V, and blue= –12V. Older motherboard form factors (such as AT) accept the P8 and P9 Molex type connectors from the power supply. These connectors plug into the motherboard side by side. When plugging the P8 and P9 connectors into the AT motherboard, you must remember to keep the black ground wires next to each other. If you don't, you may cause electrical damage to the board. The ATX form factor introduced a single "keyed" power connector that eliminated the risk of plugging the P8 and P9 connectors into the wrong power sockets on the motherboard. See Figure 2.3 for P8 and P9 power connectors.

If you are troubleshooting a "dead" computer, first verify that there is electricity coming from the AC wall outlet. Next, use a digital multimeter to measure the voltage going from the power supply to the motherboard. There are fuses in a computer system that can also be tested with a multimeter. A good fuse measures a resistance of zero ohms. If the fuse is bad, the multimeter registers a resistance of infinity ohms. If your system continuously reboots on its own, it may not be receiving enough power from the power supply.

UNINTERRUPTIBLE POWER SUPPLY

To protect your computer and data, your computer should be connected to an uninterruptible power supply (UPS), otherwise known as a battery backup. If it is not connected to a UPS, your computer may be subject to a power surge. If your computer screen is flickering, you may be experiencing

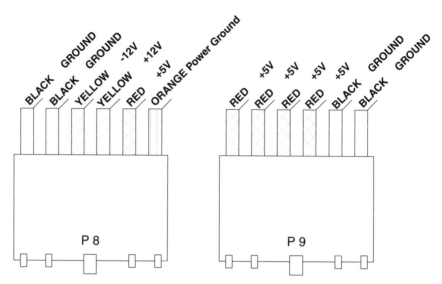

FIGURE 2.3 P8 and P9 power supply connector wiring.

simple power sag. The UPS (if properly maintained) provides power to the computer in the event of a power failure; it is not meant to be a long-term power-providing solution. There are three types of UPS: online, standby, and line-interactive. In an online UPS, the battery is contained in a circuit. In a standby UPS, the battery is not contained in the circuit. A line-interactive UPS has the best characteristics of the online and standby UPSs.

A laser printer should never be plugged into a UPS. A laser printer draws a large amount of electricity. It should be placed on its own electrical circuit separate from the system unit and other electrical devices.

PREVENTIVE MAINTENANCE AND SAFETY

An important acronym to be familiar with is *electrostatic discharge* (ESD). ESD is a phenomenon that occurs when electricity builds up (usually in a person's body) and is passed on to the computer and its components. ESD can cause serious damage to your computer and components. You should always wear a protective ESD wrist strap, which contains a resistor, when handling the components inside the system unit. Expansion cards, such as a network interface card (NIC) or video adapter card, have onboard memory and ROM chips that can be damaged by ESD. Always wear a protective wrist strap when installing these components. Never use a piece of wire to

ground yourself if you are using an ESD wrist strap. Instead, use a grounded ESD mat to absorb and discharge. In addition, you should never wear an ESD wrist strap when working on a monitor. A monitor can store high levels of voltage (about 15,000 volts), which can cause serious bodily harm when interacting with a resistor in an ESD strap. Warm and dry environments are a breeding ground for static electricity buildup. Place any spare electronic components, such as motherboards, hard drives, memory modules, and processors, in a reusable ESD protective bag and store them in a cool and dry environment. When cleaning the inside of your computer, be sure to use a special-purpose vacuum designed not to create ESD.

Use the following guidelines for keeping your system clean.

- *ROM media.* Dip media in a diluted cleaning solution. Let air-dry.
- *Inside of computer.* Spray with a can of condensed air. Use a small brush for the system unit itself.
- *Airflow.* Use two internal fans to keep the air cool and circulated inside your system. This prevents too much dust from settling between components.
- *Circuit boards.* Clean with a contact cleaning solution.
- *Electromagnetic interference* (EMI) is caused when electrical wires are placed too close to each other or when the wires cross each other. This can cause havoc with computer signals traveling down a wire.

Another consideration in an electronic environment is fire safety. You should have a plan in case of fire and have the proper equipment available and ready to use in case of fire. To extinguish an electrical fire, use a type C or multipurpose-type ABC extinguisher. In an environment with a built-in preventive sprinkler system, consider having protective plastic drop cloths available to cover your most important computer systems. If a fire detection sprinkler system is in place and fire is detected, you may lose electronic assets to water damage.

COMPLEMENTARY METAL OXIDE SEMICONDUCTOR (CMOS)

CMOS is a battery-backed bank of flash memory chips on the motherboard. The information and settings stored in CMOS can be *flashed,* meaning that they can be changed. The information stored in the CMOS is read by the system BIOS on startup. A lithium battery on the motherboard provides

power to hold the CMOS system settings when the computer is off. If the CMOS battery begins to lose some of its battery charge, a CMOS checksum error may appear when the computer starts up. If the battery loses its charge completely, chances are some or all of your system settings will be lost, including date and time, hard drive settings, and system password. Knowing that the system settings will be lost if the CMOS battery loses its charge or is removed from the motherboard can prove useful. If the user has forgotten the password to enter the system setup, you can remove the CMOS battery, wait about 3 minutes, and then put the battery back into the motherboard. This process clears the system settings, including the setup password that is locking you out. After clearing the CMOS settings and re-entering setup, you should first check to see if the system date and time are correct. Second, check the major hard drive settings for accuracy, including heads, sectors, and cylinders. Another way to clear settings is to shorten the CMOS jumper on the motherboard. In other words, locate the CMOS jumper on the motherboard and close or "shorten" the circuit with a plastic jumper. Consult the motherboard manufacturer's instructions for the location of the CMOS jumper and instructions for this process. You can modify your system setting by selecting F2 or Delete during system booting. This selection depends on what type of BIOS is installed on your computer. Here are some settings that you can change in system setup: system setup password, system date and time, boot sequence, parallel port settings, com/serial ports, hard drive type and size, memory, floppy drive, and plug and play options.

If the user plans to upgrade the CPU chip, the CMOS chip may have to be changed or upgraded as well. In addition, if a CMOS checksum error ever appears during the system startup, the BIOS may need upgrading.

THE SYSTEM BASIC INPUT/OUTPUT SERVICES

The system basic input/output service (BIOS) is made up of a group of tiny programs that control input and output services to devices internal to the computer. The BIOS itself is usually stored on a read-only memory (ROM) chip that is usually soldered onto the motherboard. Newer BIOSs come in the form of *flash ROM*, which is ROM that can be changed. The major manufactures of BIOS are Phoenix, Award, and AMI. You may have seen one of their names flash by on the computer screen as the BIOS carries out instructions during boot. From time to time, a user may want to upgrade, or flash, the current version of BIOS with software updates from the

manufacturer. It is important to know the make and model of the mother-board for BIOS updates. It is very important to document system configuration settings before upgrading the BIOS.

When a computer is booted, instructions are first available to the system from the ROM BIOS. The main functions of the BIOS are to carry out boot operations and to act as an intermediary between peripheral devices, software applications, and operating systems. As mentioned earlier, the BIOS is permanently stored on ROM chips. The next section describes some types of BIOS chips

PROGRAMMABLE READ-ONLY MEMORY (PROM) CHIPS

Programmable ROM (PROM) is a BIOS chip that cannot be changed. Data can only be stored on it once. A device known as a ROM burner is used to record information into the chip. If the PROM chip goes bad or loses its information, there is no way to reprogram it. The user has no choice but to get another chip from the manufacturer.

ERASABLE PROGRAMMABLE READ-ONLY MEMORY (EPROM) CHIPS

Erasable PROM (EPROM) BIOS chips look almost identical to PROM chips, with the exception of a little window that is used to shine an ultraviolet light through to erase their contents. This was great for upgrading the BIOS if you had a tool to erase the chip's contents.

Many BIOS chips in the past were EPROM chips. They were easily identified on the motherboard by the shiny label on the top of the chip that usually contained the manufacturer's name and version of the chip.

ELECTRONICALLY ERASABLE PROGRAMMABLE READ-ONLY MEMORY (EEPROM)

By applying a higher voltage to one of the pins on the EEPROM chip, the program on the chip is erased. A new program or set of instructions can then be electronically written to the chip. EEPROM is also known as flash ROM.

PLUG AND PLAY

Plug and play (PnP) was introduced with Windows 95. It was meant to auto-detect devices that were connected to the computer. This worked well if the devices were Plug and Play compliant. Unfortunately, not all devices met or meet this standard and must be configured manually. Three requirements

must be met in order to meet the industry standard definition for Plug and Play: PnP hardware, PnP BIOS, and PnP operating system.

A Plug and Play BIOS can auto-detect devices connected to the computer and automatically assign resources to them. If a new Plug and Play device is added to a system, the BIOS will check an ESCD database (a running list of active system resources assigned) stored on the CMOS chip to see what resources are unavailable and can be assigned to the new device. In modern computers, the Plug and Play settings are configured in the BIOS under the advanced settings option. Legacy or non-PnP devices are normally configured first; Plug and Play devices are configured next. The following operating systems are considered PnP compliant: Windows 9.x, Windows ME, and Windows 2000. For an operating system to use Plug and Play features and recognize new devices, the Plug and Play option in the system BIOS settings must be enabled.

POWER-ON SELF-TEST (POST) AND ERROR CODES

The power-on self-test (POST) is a self-diagnostic program that runs a test on RAM, I/O devices, and the CPU on system startup. The POST is stored in the ROM BIOS and requires at least a processor, memory, and video adapter to complete its diagnostic tests. The POST recognizes errors related to BIOS configuration settings and I/O connectivity, such as a stuck keyboard. Be forewarned: you may be asked to identify errors the POST might not recognize. Table 2.3 lists some examples of POST numeric error codes that you may encounter while using a computer. There is a good chance you may also encounter one or two POST numeric error code questions on the test.

TABLE 2.3 Common POST Error Codes

1XX	System board error
201	Memory error
301	Keyboard error
5XX	Monitor error
601	Floppy drive/adapter error
1101	Serial card error
1701	Hard drive controller error

TABLE 2.4 Common IBM Beep Codes

Beep Description	Error Associated with Beep
No beep	Motherboard or power failure
1 short beep	All POST operations completed successfully
2 short beeps	POST error
1 long beep, 1 short beep	Motherboard error
1 long beep, 2 short beeps	Video adapter failed
1 long beep, 3 short beeps	Video adapter error
3 long beeps	Keyboard failure

There are also sounds, or beep codes, associated with POST operations and system startup to alert you in the event of an error. BIOS manufacturers, such as IBM, Phoenix, and Award, each provide its own distinct set of beep codes. A list of IBM's common beep codes is provided in Table 2.4. It is likely that the test will focus on numeric error codes. If you are interested in learning more about beep codes specific to BIOS manufacturers that are not listed, you should consult that manufacturer's Web site.

EXPANSION BUS ARCHITECTURE

Electronic signals need a medium on which to travel on from one location to another. The motherboard is really a circuit board composed of little electronic data paths that allow all those 0s and 1s to travel from one location to another. These little "highways" are known as the motherboard's bus or I/O bus. The motherboard's I/O bus leads to expansion buses. The expansion buses are narrow slots on the motherboard, developed with different architectures, that accept integrated circuit boards, otherwise known as cards. These circuit boards, or cards, are used to communicate with devices such as monitors, printers, modems, and CD writers.

There are different buses for memory, processors, addresses, and expansion slots. Each of these buses may have different bus widths or number data paths associated with their architecture. In simple terms, if you are looking at an older motherboard that will only accept 8 bits of information at a time and a 16-bit processor to connect to that motherboard, a bottleneck will occur. The motherboard cannot utilize the full 16 bits of information from the processor.

TABLE 2.5 Popular Expansion Slots

Bus/Slot	Bits	Comments
ISA	8 or 16 bits	Operates 8 or 8.33MHz.
EISA	32 bit	Supports Plug and Play(PnP) and bus mastering. ISA slot compatible.
VL-Bus	32 bit	Supports bus mastering, compatible with ISA.
MCA	16 or 32 bits	Supports PnP and bus mastering. Older proprietary architecture.
PCI	32 bits	Supports PnP, bus mastering, and burst mode. Utilizes a host bridge to communicate with other expansion slots.
PCI-2	64 bits	Supports PnP, bus mastering, PCI slot compatible.
AGP	32 or 64 bits	Designed for accelerated graphics and video processing.

Table 2.5 lists the most popular expansion slots. An important note for the test: most modern motherboards utilize AGP, PCI, and industry standard architecture (ISA) slots.

UNIVERSAL SERIAL BUS (USB)

Universal serial bus (USB) is a fairly new serial bus Plug and Play architecture that uses the PCI bus to communicate between the CPU and memory and utilizes a 12 million bits per second (Mbps) data transfer rate. USB allows one to attach many low-speed devices to a computer without the need for an expansion card. Devices such as mice, keyboards, printers, and CD-ROMs have been designed with their own built-in controllers that accept the USB standard. You can connect up to 127 peripheral devices to a system with the use of one USB port. In other words, let's say you want to connect a USB keyboard and a USB mouse to your system. These two USB devices together will only require one system resource interrupt request (IRQ).

NORTH AND SOUTH BRIDGES

PCI architecture is based on the concept of *bridging*. A PCI bus has a north bridge and a south bridge. The north bridge communicates with the CPU and is used to send signals to devices that run at higher speeds, such as memory and high-speed graphics ports. The south bridge communicates

with a super I/O chip and is used to send signals to slower devices, such as ISA slots, COM, and LPT ports.

PCMCIA (PC CARDS)

Personal Computer Memory Card International Association (PCMCIA) is a standard for laptop computer expansion cards. There are three types of PCMCIA cards that you should be familiar with for the exam. These three PCMCIA card types and their thickness are as follows.

- Type I is used for memory and is 3.3mm thick.
- Type II is used for network interface cards or modems and is 5mm thick.
- Type III is 10.5mm thick and is used for hard drives.

CHAPTER SUMMARY

In this chapter, you were introduced to motherboards and their form factors, slots and sockets, expansion board architecture, power, POST, BIOS, and other important information. On the test, be prepared to list the major motherboard components by form factor, answer basic power-related troubleshooting questions, and know whether slot or socket technology is implemented. Many questions on the A+ Adaptive Core Test are likely to be related to topics that were discussed in this chapter.

REVIEW QUESTIONS

1. Your computer will not start. There are no lights whatsoever. What would you do first to troubleshoot this problem?

 ○ A. Buy a new hard drive.
 ○ B. Change the CMOS battery.
 ○ C. Test the power supply.
 ○ D. Verify that the AC wall outlet has power.

 Answer: D

If you are troubleshooting a "dead" computer, first verify that there is electricity coming from the AC wall outlet.

2. Which of the following devices are compatible with an AGP slot?
 ○ A. Type II PC card
 ○ B. Parallel port
 ○ C. Serial port
 ○ D. Video card

Answer: D

The AGP slot was designed for accelerated graphics and video processing.

3. You have replaced a bad CMOS battery. What should you check next?
 ○ A. COM port settings
 ○ B. Hard drive settings
 ○ C. Date and time
 ○ D. BIOS version

Answer: C

After clearing the CMOS settings and re-entering setup, you should first check to see if the system date and time are correct.

4. You have experienced a floppy drive failure. What error code will your POST most likely display?
 ○ A. 301
 ○ B. 161
 ○ C. 601
 ○ D. 1701

Answer: C

Table 2.3 identifies common POST error codes. Error code 601 identifies a floppy drive or adapter error.

5. A computer is always rebooting on its own. What is most likely the problem?
 ○ A. There is a ghost in the machine.
 ○ B. The CMOS battery is losing its charge.
 ○ C. You are experiencing ESD.
 ○ D. The system is not getting enough power.

Answer: D

If your system is always rebooting on its own, it may not be receiving enough power from the power supply.

6. You cannot remember your password to get into the system settings on boot. How can you address this? (Choose 2)

 □ A. Remove the CMOS battery.

 □ B. Use a multimeter.

 □ C. Shorten the CMOS jumper.

 □ D. Press Ctrl+Alt+Del.

 Answers: A and C

 Removing the CMOS battery or shortening the CMOS jumper will clear the CMOS settings, which include a previously stored password. This will allow you to re-enter CMOS and change the system settings.

7. Label all the components specified on the diagram in Figure 2.4.

 Answers: see Figure 2.1.

FIGURE 2.4 Baby AT motherboard.

8. Label all the components specified on the diagram in Figure 2.5.

 Answers: see Figure 2.2.

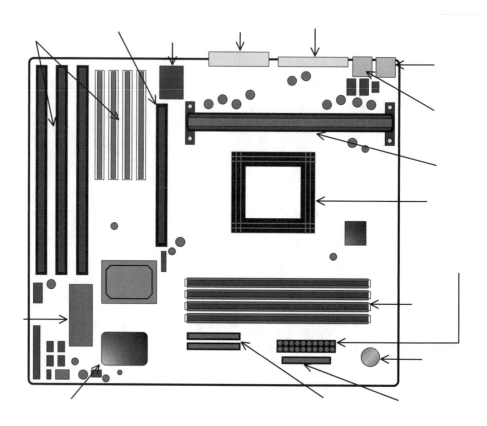

FIGURE 2.5 ATX motherboard.

PROCESSORS AND CACHE

IN THIS CHAPTER

- CPU Defined
- Clock and Bus Speeds
- Cache, Levels 1 and 2
- Chipsets and Controllers
- SEC and SEP
- PGA and SPGA
- Processors and Modes
- Cooling Fans and Heat Sinks
- Chapter Summary
- Review Questions

CPU DEFINED

The CPU, also known as a microprocessor, is the core or central intelligence of a computer system. The CPU accepts data input, processes the data, and carries out instructions. The CPU handles logical and mathematical functions. It is important to have as fast a CPU as possible for quick calculation and manipulation of data. The speed of the CPU (measured in MHz) and the motherboard (clock speed) determines the amount of time it takes to complete a desired function or task.

A motherboard and its components (including the CPU) are always in danger from ESD. As mentioned in Chapter 2, ESD can damage the circuitry on a motherboard and destroy a CPU. Always transport components in an antistatic ESD-protective bag and wear a protective ESD wrist strap when upgrading a CPU.

The new A+ Core Hardware Service Technician CAT will likely test your knowledge of newer microprocessors, their motherboard speeds, the slot or socket technology they are associated with, Level 1 and Level 2 caches, and basic processor troubleshooting.

CLOCK AND BUS SPEEDS

The motherboard contains an oscillating system crystal, or oscillator. This built-in timer or clock controls the speed at which the CPU can transfer information to and from memory and communicate with peripheral devices. The measurement of clock speed is normally displayed in megahertz (MHz). For example, if you have a 550MHz Pentium III processor, the clock speed is 550MHz. One MHz is equal to 1 million cycles per second of the oscillating clock .The clock speed on the motherboard can be configured with little plastic jumpers located on the motherboard itself. Most motherboards are designed to run at multiple clock speeds. It is important to set the CPU and other motherboard components to run at the maximum clock speed of the motherboard; the wrong settings can result in an overheated processor. Also, if a processor fan on top of your processor is being used for cooling purposes, every so often you should verify that it is working properly. If it has failed, the system may lock up and the processor may suffer irreversible damage due to overheating.

Looking at a motherboard, you can see little pathways that lead from component to component. These pathways are actually tiny wires that carry information from place to place. These wires make up the system bus. Bus speed is measured by the width of the bus. The width of the bus is calculated by the number of bits of information the bus can move at a given time. The actual speed of the bus is provided in the form of megahertz. Typical bus widths are 16, 32, and 64 bits. Most systems today have 64-bit-wide buses that run at 100MHz. There are newer chipsets on the market that run at 133MHz.

THE EXTERNAL DATA BUS

The external data bus is made up of tiny wires integrated into the motherboard that the CPU uses as a means to communicate with peripheral devices.

THE ADDRESS BUS

The CPU uses the address bus, which is also made up of tiny wires integrated into the motherboard, to access areas of memory by the memory controller chip (MCC). The address bus keeps track of locations in memory called memory addresses. The number of memory addresses in a system is based on the size or "width" of the address bus.

CACHE, LEVELS 1 AND 2

The processing and calculation of information takes place inside the processor itself. When the processor needs quick, predetermined information, it relies on cached memory. *Cached memory* is a special set of memory chips that are internal or external to the processor itself. Cached memory is physically closer to the CPU than RAM and is therefore much faster. Cache memory is designed for quick access by the processor.

Level 1 cache, otherwise known as internal or primary cache, is internal to the processor. It is not part of any other memory and is not restricted by the system clock. It is fast memory that the CPU uses first for quick storage and calculation. Unfortunately, Level 1 cache is not very large in storage capacity. Its storage capability ranges from 8K to 64K. Level 2 cache, otherwise known as external or secondary cache, is external to the processor. It is slower than Level 1 cache but can provide more than 512K of storage space. Performance gains are mostly realized from the storage capacity of the Level 2 cache.

CHIPSETS AND CONTROLLERS

CPUs are generally faster than the devices they communicate with. So that smooth communication can take place between CPUs and peripheral devices, interfaces known as chipsets have been developed to handle this

transition, or *buffering*, of information. Early computers used separate chips to control the transition of data for specific tasks. Some of the early chips and notable controller interfaces were these:

- *The bus controller chip.* Handles or "supervises" the flow of information on the different motherboard buses.
- *The DMA controller.* The Direct Memory Address (DMA) controller allows devices to utilize addressed memory without interacting with the CPU.
- *Math coprocessor.* Supervises the flow of information between the math coprocessor and the CPU.

SUPER I/O CONTROLLER

The super I/O controller was a great advancement. It combined the functions of older separate controller chips into one "smart chip." The super I/O controller chip became a welcomed standard. Some of the major functions controlled by the super I/O include control of serial port Universal Asynchronous Receiver/Transceiver (UART), control and support for floppy disk and tape drives, and control functions related to parallel ports and their enhanced capabilities.

CHIPSET CONTROLLERS (BUILT-IN)

Chipsets are designed to support specific devices, motherboards, CPUs, and computers that they will control. Several built-in devices and controllers included with common chipsets are worth mentioning.

- *EIDE controller.* The Enhanced Integrated Drive Electronics (EIDE) or IDE controller is used to communicate and support devices such as hard disk drives, floppy disk drives, CD-ROMs, and other storage devices. Most computers today have chipset support for two EIDE on-board controllers.
- *Memory controller.* The memory controller controls the flow of data in and out of memory. Devices that need access to the system memory or RAM must first pass through this controller.
- *PCI bridge.* As mentioned in Chapter 2, PCI bridging, or north and south bridge, is used to connect the PCI interface on the motherboard with older devices, such as ISA.
- *DMA controller.* This manages the availability and support for ISA and AT attachment (ATA) devices. (ATA is a set of rules or

specifications that apply to the IDE controller. Both are described in Chapter 7.)

- *SCSI adapters, network interface cards, and sound cards.* All these use DMA channels to move data in and out of system memory without assistance from a CPU. This controller provides the ability for the previously mentioned devices to access the system memory. SCSI adapters are discussed in Chapter 8.
- *Real-time clock (RTC).* Controller support is provided for the RTC. The RTC controls system date and time.
- *PS/2 mouse.* This controller provides a direct interface between the PS/2 mouse and the processor.
- *Keyboard controller.* Controls functions between the keyboard and the CPU.
- *IRDA controller.* Infrared controller packaged with most laptop computers.

RISC VERSUS CISC

There are two important terms that apply to the programming and instruction sets of chipsets: reduced instruction set computer (RISC) and complex instruction set computing (CISC).

RISC is a technology used in high-end computing systems. It uses a limited number of instructions and fewer transistors than CISC does. The result is a less expensive chipset. Most Sun computing systems incorporate RISC technology.

Most conventional computing systems utilize CISC. CISC architecture is capable of supporting many more instructions than RISC. Pentium systems utilize CISC technology.

SEC AND SEP

In Chapter 2, you became familiar with slot and socket technology. *Slot technology* integrates the processor onto a circuit board or IC board. The circuit board is then plugged into a motherboard slot. The actual edge of the circuit board that is plugged into the motherboard comes in two forms: single edge connector (SEC) or single edge processor (SEP). Most modern processors, including the Celeron, AMD Athlon, Pentium II, and Pentium III, use either SEC or SEP packaging and employ slot technology. Intel's SEC design contains both a CPU and a Level 2 cache.

PGA AND SPGA

Socket technology typically uses a ZIF socket on the motherboard that awaits a processor with many tiny pins extending from the bottom side of the square processor. The configuration of these pins is called a PGA package. A second design of the PGA standard is SPGA, in which the tiny pins underneath the processor are staggered, thereby allowing the processor to be smaller.

PROCESSORS AND MODES

In 1978, the Intel 8086 processor was introduced. Recently, many of the processors on the market have been based on the characteristics of the 8086 processor. Several modes and advancements in early processors designed to maintain backward compatibility with the original 8086 processor are worth mentioning.

REAL MODE

Provided by the 8086 (XT) processor, real mode processing offers the processor access to the limited memory space or environment of 1MB (1024K of memory addresses). Real mode uses a 16-bit data path and has a direct access path to RAM.

PROTECTED MODE

Introduced with the 80286 processor, protected mode allows the processor access to memory above 1MB (1024K) and up to 16MB. Protected mode allows programs to use a 32-bit data path.

VIRTUAL REAL (PROTECTED) MODE

Introduced with the 80386 processor, virtual real (protected) mode allows multiple programs to run at the same time in their own protected separate memory addresses or virtual machines (VMs). If one of these programs or VMs fails, the other programs are not affected.

386DX

Made of CMOS material, the 386DX provides 32-bit processing power and can run in virtual real mode. A 386 operates at +5V, is capable of address-

ing up to 4GB of memory, and has an internal cache. The clock speeds for 386DX range from 16MHz to 33MHz.

386SX

Released in 1988, the 386SX is a scaled-down version of the 386DX. It has a smaller 16-bit external bus and 24-bit memory address bus that addresses 16MB of RAM. This makes the 386SX less expensive than the 386DX. It was available from 16MHz to 33MHz.

386SL

In 1990, the 386SL was introduced to meet the demand for a smaller processor with lower power consumption. This need came from the desire for laptop computing systems that required smaller components. The 386SL is basically the 386SX designed for laptops and their power management capabilities. The 386SL was offered with a 25MHz clock speed.

486DX

The 486DX featured 32-bit internal and external memory address buses. It offered internal Level 1 cache at 8K. This processor introduced burst mode memory and had a coprocessor or floating-point unit (FPU) integrated into the CPU chip.

486SX

The 486SX is a scaled-down version of the 486DX processor. The math coprocessor was disabled by the manufacturer and sold as a lower-cost alternative to the DX model.

486DX2

The 486DX2 was designed to run at double the speed (with the exception of the external bus) of its predecessor the 486DX. The 486DX2 processor operates at +3.3V.

AMD 5x86 (K5)

The AMD K5 was offered as a 75MHz to 133MHz processor released by AMD. It was produced to be competitive with early Pentium CPUs. It offered 50, 60, and 66 bus speeds and an internal (primary) cache of 24K. The AMD K5 uses Socket 7 technology. The K5 has a Level 1 cache of 24K.

CYRIX 5x86

A Socket 7 type CPU released to compete with early Pentiums.

THE EARLY PENTIUMS (60MHZ TO 200MHZ)

The first Pentium processor, which became known as the classic Pentium, was offered in 1992. The first Pentium was backward compatible with previous Intel processors. The early Pentiums operated with a data bus of 64 bits, an address bus of 32 bits, and a 64-bit memory bus. It offered 16K of Level 1 cache. The first Pentiums introduced the single-cycle instruction technology known as dual pipelining.

PENTIUM PRO

The Pentium Pro offered onboard Level 1 cache at 16K and Level 2 cache at 256K, 512K, or 1MB, which answered the need for large amounts of cached memory. It introduced the concept of quad pipelining and dynamic processing. The Pentium Pro worked well for a program-intensive workstation or server. Unfortunately, it did not handle 16-bit (DOS) application code well.

AMD K6

The K6 was developed as competition for the Pentium Pro. Speeds available were 166MHz, 200MHz, 233MHz, 266MHz, and a Super Socket 7 version designed to run at 100MHz motherboard bus speed and higher clock speeds. The AMD K6 has an internal cache size of 64K.

CYRIX 6x86MX

In order to compete with the Pentiums, AMD and Cyrix developed a processor rating (PR) system designed to match up equivalent competitor clock speeds. The Cyrix 6x86MX processors ranged from PR-166 to PR-366. The 6x86 had an external bus speed of 75MHz.

CELERON

Introduced as a lower-end Pentium II, the Intel Celeron processor came to the market to answer the need for less expensive chips that could keep the pace with the Pentiums. Depending on its version, the Celeron could be purchased in PII- or PIII-comparable speeds. Celeron packages came in PGA or FC-PGA format and required a 66MHz motherboard. The Celeron is compatible with multimedia extensions (MMX). It has a Level 1 cache of 32K.

XEON

The Xeon processor succeeded the Pentium Pro. It was meant to be a server computer processor primarily because of its choices of Level 2 cache, available at 512K, 1MB, or 2MB. It was also noted for its ability to support up to eight processors in one computer and up to 64GB of memory.

PENTIUM II

The Pentium II processor is available in 233MHz, 266MHz, 300MHz, 333MHz, 350MHz, 400MHz, and 450MHz clock speeds. This processor is designed to take full advantage of MMX technology. MMX introduced new hardware technology processing integrated into the system for better calculation and acceleration of multimedia. The Pentium II provides a larger pipeline cache size than its predecessor, the Pentium I. It has a Level 1 cache of 32K and a Level 2 cache of 512K. The Pentium II uses slot 1 technology. In Table 3.1, you can see a comparison of Pentium II processor speeds to their corresponding motherboard clock speeds.

PENTIUM III

Pentium III offers 32K of Level 1 cache. It fully supports Level 2 cache at 512K. It is offered with clock speeds that range from 450MHz to 1GHz. It is available in a second-generation SEC package known as SECC2. Remember, the Pentium III utilizes slot 1 technology.

PENTIUM IV 1.8 AND 1.6 GHZ (NOT INCLUDED IN CURRENT TEST)

Introduced July 2, 2001, the Pentium IV 1.8 gigahertz (GHz) and 1.6GHz processors are alive and doing very well. Their clock speeds measure far

TABLE 3.1 Pentium II Processor and Motherboard Speed Comparison

PII Processor Speed	Motherboard
233MHz	66MHz
266MHz	66MHz
300MHz	66MHz
333MHz	66MHz
350MHz	100MHz
400MHz	100MHz
450MHz	100MHz

greater than 1GHz, with bus speeds in excess of 400MHz. The 2GHz version was released in the third quarter of 2001.

AMD ATHLON AND DURON

A newer processor available through AMD is the AMD 1GHz Athlon processor. It replaces the AMD K-6 series. It uses slot A technology and boasts a 200MHz to 400MHz Alpha EV-6 bus.

The AMD Duron, released to the public in 2000, was meant to be the Celeron's major competition. The AMD Duron was developed for the midrange workstation market. The Duron processor clock speeds are 600MHz, 650MHz, and 700MHz. The Duron uses slot A technology, has the Level 2 cache internal to the processor (unlike the Athlon, which has the Level 2 cache external to the processor), and is rated at a motherboard speed of 100MHz.

COOLING FANS AND HEAT SINKS

All the components inside the system unit can generate heat. This heat can be very dangerous to your processor. The processor itself is one of the main heat-generating components inside the system unit. When a system is on for a while, the processor, expansion cards, and memory chips heat up. When the system is turned off, these components cool down. Such continual changes in temperature can result in expansion and contraction of the mentioned components. Over time, these components can work their way out of their sockets and slots. This phenomenon is known as *thermal card* or *chip creep*. It is very important to maintain proper temperatures in the system unit to protect the components.

Most computers today incorporate the use of processor cooling fans and heat sinks to maintain a temperature between 90 and 110 degrees Fahrenheit. The cooling fan usually sits on top of the processor, drawing heat from it and pushing it out and away from the motherboard, where it can be drawn out of the system unit by the power supply fan. Some CPUs need more than a cooling fan. In these cases, a heat sink can be placed between the processor and the cooling fan to assist with the extraction of heat from the processor.

The test is likely to present you with questions that test your knowledge of processor/motherboard compatibility and speed. For example, you should know that early Pentiums, such as the 75MHz Pentium, were designed to run at a 66MHz motherboard bus speed. The original Pentium through the Pentium II 333MHz processors were designed to run at 66MHz

motherboard bus speed. The Pentium II 350MHz through the Pentium III series processors are intended to run at 100MHz motherboard bus speed.

CHAPTER SUMMARY

As you have learned in this chapter, the CPU is the core of a computing system. Supporting components and technology that enhance its features surround the CPU. Bus architecture and cache play a major role in the overall performance of a processor. In this chapter you were guided through a general history of the processor, from the early 8086 to the new Pentium IV processors. As you have seen, competition has clearly kept the manufacturers continually striving to make a better, faster, more affordable CPU.

As mentioned earlier in this chapter, the new A+ Adaptive core test is likely to focus on newer processors and bus speeds. You will probably be tested on basic processor troubleshooting and maintenance. Let's get serious and focus: your future as a skilled technician may depend on it. Imagine that you just paid $132 to take the next practice test. One question wrong and you lose your money and your shot at getting certified.

REVIEW QUESTIONS

1. Which of the following are valid AMD processors? (Choose 2)

 □ A. Athlon

 □ B. Celeron

 □ C. K6

 □ D. K9

 Answers: A and C

 The AMD Athlon and the AMD K6 are valid AMD processors. Intel developed the Celeron processor. K9 is used as a description for police dogs.

2. Which of the following processors runs at 66MHz motherboard speed?

 ○ A. Pentium III 500

 ○ B. Pentium IV

 ○ C. Pentium II 300

 ○ D. 80386

Answer: C

The Intel Pentium II 300 runs at 66MHz motherboard speed. See Table 3.1 for a comparison of the Pentium II processor and motherboard speed.

3. Which of the following processors runs at 100MHz motherboard speed?
 ○ A. Pentium III 500
 ○ B. XT
 ○ C. Pentium I
 ○ D. 80386

Answer: A

The Pentium II 350MHz through the Pentium III series processors are intended to run at 100MHz motherboard bus speed.

4. Your processor fan has malfunctioned. What result might you expect? (Choose 2)
 ☐ A. Serial port errors
 ☐ B. Processor damage
 ☐ C. 601 POST error
 ☐ D. System halts

Answers: B and D

If a processor fan has failed or malfunctioned, the system may lock up (halt) and the processor may suffer irreversible damage due to overheating.

5. What should you always put your processor and other components in when storing or transporting?
 ○ A. An EMI bag
 ○ B. An FDISK bag
 ○ C. A grocery bag
 ○ D. An antistatic ESD bag

Answer: D

An antistatic ESD bag will protect your processor as well as other electronic computer components from ESD.

UNDERSTANDING MEMORY

IN THIS CHAPTER

- Memory Defined
- Random Access Memory
- Memory Types and Characteristics
- Memory Packaging
- Memory Parity and ECC
- Logical Memory
- Chapter Summary
- Review Questions

MEMORY DEFINED

Memory is where the computer stores electronic instructions and data temporarily. Computing systems have different types of memory, which produce different results. For example, when a processor needs to store and retrieve information quickly in order to carry out a specified function or calculation, it stores and retrieves data from cache memory that is internal to the processor. If access to information isn't needed as quickly, the data or instructions may be stored in RAM (main memory).

There are many different types of physical and logical memory to suit specific operational needs. The memory types addressed in this chapter are those you need to be familiar with to successfully prepare for the CompTIA A+ exams.

Random Access Memory

RAM, known as primary storage or main memory, is where the CPU and applications store information and instructions for future use. RAM is considered volatile memory. Volatile memory loses all its stored information when it is disconnected from its power source. In other words, when you turn off the computer, you lose all the information stored in RAM. For example, if you are entering data into a document and suddenly experience loss of power to the system, you will lose the information you have entered into the document unless it has been saved to a permanent storage location, such as the hard disk, CD, Zip disk, or floppy disk.

The CPU uses unique locations of RAM called memory addresses to store information. Memory addresses vary in size depending on how much RAM is available in the system. The CPU can store and retrieve information from specific memory addresses in a random or direct fashion.

RAM Speed

RAM access speed is measured in nanoseconds (billionths of a second). Older computers operated with RAM access speeds that ranged from 80 to 120ns. Today, it is common to find RAM access speeds at 50ns and faster. Memory speeds can vary greatly depending on the type of memory being used. You can determine the access speed of memory by looking at the last printed number on most DRAM chips; for example, BAC4G302H-05 means the access speed is 50ns. An important consideration when installing new memory in a system is to match the speed of the memory to the speed of the motherboard's bus.

For the test, it is important to remember that the RAM speed is faster in nanoseconds as the number decreases, that is, 6ns is faster than 10ns.

RAM Size

The smallest unit of information measured in a computer system is a bit. A bit is represented in electronic computer terms as a (binary) 0 or 1. There are 8 bits in 1 byte (see Chapter 5 for more information on binary conversion).

RAM size and storage capacity are measured in multiples of bytes known as megabytes, gigabytes, and terabytes. Table 4.1 will assist you with RAM units of measure.

Some important considerations when purchasing memory or a new computer are what type of memory and how much memory will be

TABLE 4.1 RAM Units and Size

Unit Measured	Size of Unit
Bit	Binary digit equal to 0 or 1
Byte	8 bits
Kilobyte	1024 bits
Megabyte	1,048,576 bytes
Gigabyte	1,073,741,824 bytes
Terabyte	1,099,511,627,776 bytes

needed. Specific types of memory serve different functions. Memory types are discussed later in this chapter. For most home and office workstations, 128MB of RAM should be sufficient to support most of today's memory-hungry applications. High-end server computers require more memory to process, calculate, and serve applications to workstations. Server computers today generally have at least 1GB of RAM installed.

MEMORY TYPES AND CHARACTERISTICS

Many forms of memory have been available since the first computer was introduced. Table 4.2 provides a quick reference to the conceptual aspects of memory that you should be aware of before taking the A+ core test.

TABLE 4.2 Memory Concepts

Memory Type	Packaging	Volatile	Nonvolatile
Main, DRAM	DIP	X	
Main, SRAM	SIMM	X	
Main, SDRAM	DIMM	X	
Main, RDRAM	RIMM	X	
Main, VRAM	Adapter	X	
Cache, Level 1	IC card	X	
Cache, Level 2	IC card X		
ROM BIOS	Chip		X
Virtual memory	Swap file on hard drive		X

READ-ONLY MEMORY (ROM)

You should recall from Chapter 2 that read-only memory (ROM) contains small programs installed at the factory. ROM is installed on the motherboard and on some types of expansion boards. ROM chips contain the system BIOS, whose main function is to carry out boot operations by communicating with I/O devices and programs.

DYNAMIC RANDOM ACCESS MEMORY (DRAM)

DRAM is the most common type of memory in use today. It is considered affordable, and it is the memory most often used by modern CPUs. DRAM is volatile memory that will lose all its stored information if it is disconnected from power. A DRAM chip is made up of little storage units called cells. Each cell contains a capacitor. A capacitor is an electronic device that can hold an electrical charge, which can be positive or negative. If the charge is positive, the capacitor registers a binary digit 1. If the charge is negative, the capacitor registers a binary digit value of 0. The capacitors in DRAM must be electronically refreshed continuously in order to hold their information. DRAM is considered a very slow type of memory, with speeds of approximately 50ns. Originally, DRAM chips were mounted on the motherboard using dual inline packages (DIPs). DIPs are long chips with flimsy pins that are very difficult to install on the motherboard. DIPs tended to heat up quickly due to thermal cycling and often caused the DRAM chips to creep out of their sockets. This creeping effect is known as chip creep. Today, DRAM chips are soldered onto integrated circuit boards that are inserted into the motherboard more securely.

STATIC RANDOM ACCESS MEMORY

SRAM or static RAM is memory that also holds data as long as there is power available to the chip. Power is provided to the SRAM chip by the system battery. SRAM does not require the use of capacitors and does not need to be constantly refreshed, as does DRAM. Instead, SRAM uses a flip-flop method of regenerating its contents by means of transistors.

Through the use of its own internal clock, SRAM is synchronized with the motherboard's bus speed, thereby helping SRAM achieve higher speeds than DRAM.

Level 2 memory cache (fast memory frequently accessed by the processor) is stored on SRAM chips. SRAM typically comes in sizes of 128MB to 4MB and is more expensive than DRAM.

POPULAR DRAM ADVANCES AND TECHNOLOGIES

Many technological improvements have been made to DRAM in order to create a faster type of memory. The following section describes some of these improvements.

Fast Page Mode (FPM) DRAM

FPM DRAM is faster than DRAM but relatively slow compared to other enhancements. With FPM, the memory controller knows ahead of time to look in the pages of addressed memory after the CPU's read or write requests. This reduces the amount of time the memory controller has to wait to take instructions from the CPU and read from or write to memory. FPM DRAM is not suitable for motherboard bus speeds greater than 60MHz.

Extended Data Output (EDO) DRAM

EDO DRAM was the first memory introduced with the ability to hold several pieces of information at a time without having to be refreshed. In other words, if the CPU needs to access the same information several times, the information can wait in EDO memory until the CPU is through accessing it. The information does not have to be continuously reloaded or reregistered into memory. EDO was intended to run with Pentium systems rated between 60MHz and 75MHz.

EDO is faster than FPM memory. EDO memory was advertised to increase system performance by 60%. True benchmarks of EDO showed a 10% to 15% increase in performance.

Burst EDO (BEDO) DRAM

Burst EDO memory is a form of EDO DRAM that can process multiple (up to four) memory addresses at a time in small bursts. Burst EDO did not have great success because it could not retain its synchronization with the processor for long periods.

Synchronous Dynamic Random Access Memory (SDRAM)

SDRAM is similar to DRAM. What distinguishes SDRAM is that it uses an internal clock to synchronize input and output operations with the CPU. The synchronization between the memory and CPU results in enhanced performance. SDRAM uses burst mode (automatic retrieval of data before it is requested) for read and write operations. SDRAM sends data in high-speed bursts by utilizing burst mode.

RDRAM (Rambus) DRAM

Rambus RDRAM is proprietary memory from Rambus, Inc. RDRAM improves on memory latency by transferring data in and out of memory at about 600MHz. RDRAM can achieve this speed by synchronizing directly with the memory bus instead of the motherboard bus. Rambus memory uses a narrow bus width and comes on proprietary memory modules called RIMMs. Rambus RDRAM is being used in conjunction with the newer Pentium IVs offered by Intel.

VIDEO MEMORY

The need for high-speed graphics acceleration, higher resolution, and faster video refresh rates has spawned a growing need for better-engineered video memory. For the A+ core test you need to be familiar with the following three types of video memory.

Video Random Access Memory (VRAM)

A computer screen is made up of many tiny dots called pixels. The bit depth is the number of bits assigned through VRAM to each pixel. The more VRAM that can be assigned to each pixel, the greater the bit depth will be. This results in better resolution and color scale. The larger the monitor, the more pixels there are to fill, and thus the greater need for video memory.

VRAM is memory specifically designed for video. VRAM acts as a buffer between the CPU and the monitor. It is designed with two access paths (or dual ports), which provide separate passages to the same area of memory or memory address. This means that two devices can access VRAM at the same time. With this design, the video adapter chip known as RAMDAC (RAM digital-analog converter) can convert the digital signals to analog to be displayed on the screen, and at the same time the video controller (processor) can bring more data into VRAM. VRAM does not need to be refreshed as often as DRAM.

Windows Random Access Memory (WRAM)

Do not be confused—WRAM does not mean Microsoft Windows™ memory. WRAM is similar to VRAM, with the exception that WRAM makes better use of the dual ports available through VRAM. WRAM can take advantage of more memory address storage space, resulting in better color depth and resolution (1600 × 1200). WRAM is faster than VRAM.

Synchronous Graphics RAM (SGRAM)

SGRAM is a form of DRAM that uses a single port. SGRAM uses its own program instructions, called masked write and block write commands, to provide better throughput for graphic-intensive applications. SGRAM is synchronized with the CPU clock speed and can support up to 100MHz.

If you ever receive a nonmaskable interrupt error you are probably experiencing defective RAM or SGRAM.

CACHED MEMORY

As mentioned in Chapter 3, cached memory is memory the processor uses for very fast access to information. It is very important to remember that Level 1 cache is considered primary cache and is internal or built into the processor itself. Level 2 cache is secondary cache that is external to the processor. With memory caching, a memory cache controller anticipates (about 90% correctly) what the processor is going to require from memory. This method eliminates the processor's constant need to access the slower DRAM.

VIRTUAL MEMORY (SWAP FILE)

Today's popular operating systems are typically installed with a predetermined amount of hard drive space set aside to act as a memory buffer area for main memory (RAM). This area of hard drive space is referred to as *virtual memory, swap file,* or *page file* (the different names refer to the same area of hard drive space). Data is temporarily moved or *swapped* between memory and the hard drive. Moving data out of main memory and placing it into a swap file frees up valuable space in main memory for other purposes. The swap file size can vary depending on the amount of free space available on the hard drive. You can manually configure the swap file size or let the operating system take care of its configuration.

If you are running an application that uses up all the current RAM, the extra memory needed to run the application can be provided automatically from virtual memory. This memory area is managed differently than main memory. As you may recall, data is stored in memory addresses within RAM. These addresses are known as *real memory addresses*. With virtual memory, the operating system logically divides the set-aside hard drive space into memory pages that contain virtual memory addresses. These virtual memory pages can typically hold more memory addresses than RAM can. The process by which these virtual memory addresses are

converted into real memory is called memory mapping. In order for virtual memory to be utilized, the operating system must be able to run in protected mode. Disk operating system (DOS) was only able to run in real mode. Microsoft Windows 3.X introduced 386 enhanced mode, which paved the way for virtual memory utilization.

MEMORY PACKAGING

We have discussed memory types and how they function. Now we will focus on how memory is packaged together and attached to the motherboard.

A DRAM chip is considered one unit or a single chip. When several DRAM chips are soldered onto a circuit board, a bank of chips is formed. The combination of DRAM chips soldered onto the circuit board make up a memory module or memory package. The memory modules are inserted into the motherboard to form rows of memory banks. There are several types of memory modules, each of which has its own characteristics and design.

Pay very close attention to the packaging methods discussed in this chapter. The A+ core test is very likely to test your knowledge on memory modules, including SIMMs, DIMMs, and possibly RIMMs. You will likely be shown a graphic and be asked to describe the memory module being displayed. See Table 4.3 for a quick memory module reference.

GOLD AND TIN EDGE CONNECTORS

SIMMs and DIMMs both have edge connecters (or leads) that are pushed into the motherboard's memory slots. These edge connectors come in two distinct forms, tin (silver colored) and gold colored. There is not much of a difference between the two forms, but it is very important that the color of the connector match the color of the inside of the motherboard's memory slot. The inside of the motherboard's memory slot is either gold or tin. In short, match the gold-edged SIMM or DIMM connector to the gold memory slot on the motherboard. Match the tin (silver-colored) edge con-

TABLE 4.3 Memory Module Quick Reference

Module Type	Number of Pins	Memory Bus Width
SIMM	30 pins	8 bits
SIMM	72 pins	32 bits
DIMM	168 pins	64 bits

nector to the silver-colored memory slot on the motherboard. The two different metal forms have different chemical composition; a mismatch in color may result in corrosion and eventually cause the system to fail or become unbootable.

SINGLE INLINE MEMORY MODULE (SIMM)

A SIMM is a memory module that has either a 30-pin or 72-pin edge connector that inserts into the motherboard memory sockets at a 45-degree angle. A 30-pin SIMM (Figure 4.1) has DRAM chips soldered onto one side of its circuit board. Older, 30-pin SIMMS used FPM technology and generally came in sizes of 256K to 4MB with an 8-bit memory bus width. The newer 72-pin SIMMS use EDO technology and come in sizes ranging from 1MB to 128MB with a 32-bit bus width. A 72-pin SIMM (Figure 4.2) can have DRAM chips soldered on one or both sides of the circuit board. As you learned earlier in this chapter, memory speed is measured in nanoseconds. Most SIMMS run at 60ns, 70ns, or 80ns.

DUAL INLINE MEMORY MODULE (DIMM)

Systems that provided 64-bit or wider memory buses opened the door for the DIMM. Most modern computers provide memory slots on the motherboard that support the 168-pin DIMM memory module (Figure 4.3). A

FIGURE 4.1 A 30-pin SIMM (memory module).

FIGURE 4.2 A 72-pin SIMM (memory module).

FIGURE 4.3 A 168-pin DIMM (memory module).

DIMM is larger than a SIMM and has an additional set of leads that make it impossible to install the DIMM improperly. DIMM comes in different voltages (3.3V and 5.0V) and are available in buffered or unbuffered form. When purchasing new DIMMs, you should consult the motherboard manufacturer's guide.

SMALL-OUTLINE DUAL INLINE MEMORY MODULE (SODIMM)

A SODIMM is a smaller, 144-pin DIMM with a 64-bit transfer rate designed specifically for laptop computers.

RAMBUS INLINE MEMORY MODULE (RIMM)

Special RDRAM chips are placed on the proprietary RIMM. RIMM uses a special circle-like technology that rotates data in a unidirectional looped system between the RIMM modules and special blank memory banks called continuity RIMMs (C-RIMMs), which must be placed between RIMMS. This looping system eliminates the bottleneck that resulted from DRAM and its bidirectional bus, which caused data to wait before being sent down a row of memory modules.

INSTALLING SIMMS AND DIMMS

There was a time when installing memory modules into a computer could be very painful on your fingers. Older motherboards did not have the clip and spring features supported by today's motherboard memory slots, which allow the memory modules to be easily pushed into place.

Here are the basic steps for installing SIMMs and DIMMs into your computer.

1. Unplug power to the computer.
2. Remove the system unit case cover.
3. Make sure you are wearing an ESD wrist strap.
4. Identify SIMM or DIMM slots.
5. With both hands, line up the SIMM or DIMM with the open mother-board memory slot.
6. Push firmly on both sides of the SIMM OR DIMM until it is seated in the slot. (SIMMs should be inserted into the motherboard at a 45-degree angle.)
7. Replace the system unit case.
8. Take off your ESD wrist strap.
9. Plug the power cord back into the computer and turn the computer on.

In newer computers, you will see that the new memory has been added when the POST runs its memory count. Your memory will be automatically configured. In older systems, you may have to make changes to your memory settings in the system BIOS configuration utility before the new memory is recognized.

When installing or adding memory to a memory bank, you should avoid mixing different types of memory modules together. You can mix different speeds of memory within the same memory bank. However, the speed of the slowest module within a bank of RAM will become the speed used by the system.

SIMMs should be installed in increments of two or four memory modules per memory bank.

DIMMs can be installed in units of one (one module) per memory bank.

MEMORY PARITY AND ECC

The integrity of memory and its contents are crucial to the successful operation of a computing system. There are two logical diagnostic memory tools that serve as a system of checks and balances for the contents of DRAM. These two forms of memory checking are called parity and error correction code, or error checking and correction (ECC).

PARITY

As you may recall, there are 8 bits in 1 byte. Parity checking adds another bit, called a parity bit (ninth bit), to each byte of information that is stored in memory to verify its integrity. In other words, an even or odd parity bit is added to every byte of information (8 bits). The parity bit for each byte of information is made to force all bits or units to have either an odd or even number of bits. Later, when the byte of information is needed, the computer checks to verify the even or odd state of the byte; if it does not match its original assignment of even or odd parity, a memory parity error occurs and the system may halt. Some parity errors may show up on the computer screen if the parity check fails. A parity error 1 indicates that the parity error or check has failed on the motherboard. A parity error 2 indicates that the error has most likely occurred on a memory expansion board. An important fact to remember is that parity is a tool used only to detect errors in memory—parity does not fix memory problems.

Calculating the number of parity bits associated with memory is fairly simple. If one parity bit is assigned to every byte (8 bits) of data, we can

calculate that 16 bits have 2 parity bits, 32 bits have 4 parity bits, and 64 bits have 8 parity checking bits.

Less expensive memory modules are available that provide fake parity. Fake parity does not provide a valid test of data stored in memory; it simply fools the system into believing that any results from memory are acceptable.

Another way of manufacturing a less expensive memory module or chip is to disable parity altogether.

Inexpensive or used memory is often to blame for parity errors and general protection faults (GPFs). Generally, GPFs occur when more than one application or program attempts to access or write to an area of memory already assigned to another application.

ERROR CORRECTION CODE, OR ERROR CHECKING AND CORRECTION (ECC)

ECC works in conjunction with the memory controller not only to detect errors found in data as it passes out of memory, but also to fix single-bit errors with its built-in logic. ECC adds a special bit to data, called an error correction code bit, which is decoded by the memory controller for accuracy.

Some SDRAM chips support ECC. DIMMs (which normally have 8 chips on a circuit board) that have a ninth chip show the presence of ECC. You can look in the BIOS configuration to see if ECC is enabled. ECC is worth the extra money it costs because of its reliability.

LOGICAL MEMORY

Chances are that the current A+ exams will not drill you on the use of logical memory, as did previous tests. The current exams are likely to test your knowledge of loading device drivers and configuration files that support more current operating systems. (See Section 2, "A+ Operating Systems Technologies, CAT 220-222," of this book for information on operating systems.) However, newer operating systems must remain backward compatible to support older applications, so it is a good idea for you to understand the concepts of logical memory.

Operating systems and software divide areas of memory into logical sections in which applications and programs can run. Today's popular operating systems, such as Windows NT, Windows 9.x, Millennium, Windows 2000, and the newly released Windows XP, automatically divide and main-

tain logical memory areas. Older operating systems, such as DOS, PC DOS, and Windows 3.x, required manual configuration of logical memory areas by skilled technicians who were very familiar with the configurations of DOS and logical memory management software tools.

Logical memory is divided into four basic divisions, as shown in Table 4.4.

TABLE 4.4 Logical Memory Divisions

Memory Area	Memory Description
Conventional memory	The first 640K of system memory addresses is used to load and run device drivers, programs, and applications. Also referred to as lower memory area.
Upper memory area (UMA)	The first 384K of memory above conventional memory is used for device drivers, video RAM, and ROM BIOS. Also referred to as expanded or reserved memory.
High memory area (HMA)	The first 64K of extended memory minus 16 bytes. Provides "real-mode" support to operating system.
Extended memory (XMS)	All memory addresses above 1MB and up to 4GB. Used primarily for most programs and applications.

CONVENTIONAL MEMORY

In the early days of personal computing, the original PC and software developers created 640K of addressable memory space and named it *conventional memory*. At the time, it was assumed that 640K would be more than enough memory to store the entire operating system, software device drivers, and applications. This amount of memory was acceptable in the early 1980s, when operating systems were small and applications ran one at a time. As the future progressed, the need for addressable memory space increased greatly. Today's computing systems require very large amounts of memory for operating systems, graphical user interfaces (GUIs), and multitasking applications.

UPPER MEMORY AREA (UMA)

The upper memory area, also referred to as reserved memory, is the first 384K of memory addresses directly above conventional memory. The first section of upper memory addresses is reserved for video RAM and ROM. The top section of memory addresses in upper memory is reserved for the system BIOS. (You may have heard the term *shadowing* before. In computer terms, *shadowing* refers to moving ROM BIOS information into the reserved

area of memory.) BIOS programs for expansion boards other than video are located or "mapped" to the memory addresses between video RAM and the system BIOS. Table 4.5 lists the areas in reserved memory with associated computer hexadecimal memory addresses. Unused memory addresses in upper memory are referred to as upper memory blocks (UMBs).

TABLE 4.5 Reserved (Upper) Memory Map

Reserved Memory Area	Assigned Memory Address Range (Hexadecimal)
System BIOS	F000–FFFFF
Optional BIOS area	C8000–EFFFF
Video BIOS	C0000–C7FFF
Color text	B8000–BFFFF
Mono text	B0000–B7FFF
VGA/EGA	A0000–AFFFF

As applications grew more sophisticated, the need for more conventional memory space increased. To meet this demand, developers redesigned the UMA into expanded memory. Special DOS memory management programs and device drivers, such as EMM386.exe, Memmaker, and Himem.sys, were developed to move device drivers out of conventional memory and into expanded memory, freeing up space for the operating system and applications.

EMM386.EXE uses Limulation (conversion of extended memory to expanded memory) to open access to the UMBs. This makes it possible to load programs and device drivers into memory using the AUTOEXEC .BAT and CONFIG.SYS files of DOS.

Memmaker was introduced with DOS 6.0. It is a utility that allows you to free up conventional memory by loading device drivers and terminate-and-stay-resident programs (TSRs) into UMBs.

Himem.sys is a memory device driver that also opens the HMA and directs programs to memory addresses in extended memory. Himem.sys must be loaded in the config.sys file for access to extended memory.

HIGH MEMORY AREA (HMA)

The high memory area is the first 64K of extended memory minus 16 bytes. This area of memory is controlled by Himem.sys and is the only area of extended memory available to a processor running in real mode.

EXTENDED MEMORY (XMS)

Extended memory includes all addressable memory above reserved memory (above 1MB) and up to 4GB. You must have at least a 286 processor to take advantage of extended memory.

CHAPTER SUMMARY

This chapter introduced you to computer memory types and characteristics. At this point, you should be able to physically identify the types of RAM packages discussed. You should also be able to describe the three main types of video memory, have a basic understanding of memory error detection and correction, and have conceptual knowledge of logical memory. For the exam, you should focus on valid memory acronyms and physical RAM packages. The following relative review questions will help you to familiarize yourself further with these concepts.

REVIEW QUESTIONS

1. Which of the following are valid types of memory modules used in a computer? (Choose 3)

 ☐ A. ZIMM

 ☐ B. SwapSIM

 ☐ C. RIMM

 ☐ D. DIMM

 ☐ E. ZDRIMM

 ☐ F. SIMM

 Answers: C, D, and F

 RIMM, DIMM, and SIMM are valid memory modules. All others listed are not.

2. Of the following types of RAM, which is the fastest?

 ○ A. Page Fault RAM

 ○ B. FPM DRAM

 ○ C. EDO RAM

 ○ D. Swap File RAM

Answer: C

EDO is faster than FPM memory. Page Fault RAM and Swap File RAM are made-up names intended to trick you.

3. Which type of memory is internal to the processor?
 ○ A. Level 1 Cache
 ○ B. Bus RAM
 ○ C. BEDO RAM
 ○ D. EDO RAM
 ○ E. Parity with ECC

Answer: A

Level 1 cache is considered primary cache and is internal or built into the processor itself.

4. Which type of memory uses burst mode to send data?
 ○ A. CD-RW RAM
 ○ B. SDRAM
 ○ C. Hi-speed RAM
 ○ D. Coast RAM

Answer: B

SDRAM uses burst mode (automatic retrieval of data before it is requested) for read and write operations. SDRAM sends data in high-speed bursts by utilizing burst mode.

5. What type of memory module is displayed in Figure 4.4?

FIGURE 4.4 A memory module.

 ○ A. 168-pin DIMM
 ○ B. 72-pin SIMM
 ○ C. RIMM
 ○ D. 30-pin SIMM

Answer: D

6. What type of memory module is displayed in Figure 4.5?

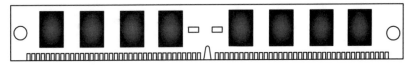

FIGURE 4.5 A memory module.

- ○ A. 168-pin DIMM
- ○ B. 72-pin SIMM
- ○ C. RIMM
- ○ D. 30-pin SIMM

Answer: B

7. What type of memory module is displayed in Figure 4.6?

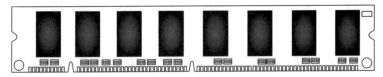

FIGURE 4.6 A memory module.

- ○ A. 30-pin SIMM
- ○ B. 72-pin SIMM
- ○ C. SGRAM
- ○ D. 168-pin DIMM

Answer: D

8. How many DIMMs are required per memory bank on a motherboard?

- ○ A. 2
- ○ B. 1
- ○ C. 1,073,741,824
- ○ D. 8

Answer: B

DIMMs can be installed in units of 1 (one module) per memory bank. In other words, you can install one DIMM on a motherboard if you so choose.

SYSTEM RESOURCES AND INPUT DEVICES

IN THIS CHAPTER

BINARY

Humans use a base 10 numbering system. Computers operate using a base 2 numbering system called binary. Binary works well with computers because there are only two values or digits that a computer recognizes: 0 and 1.

As you may recall from Chapter 4, the smallest unit of measure in a computer is a negative or positive electrical charge held in a cell within a capacitor. If an electrical charge is negative, a 0 digit is represented. If the charge is positive, a 1 is represented. A 0 or a 1 represents a single bit. There are 8 bits (combinations of 0s and 1s) in 1 byte. In human terms, a computer uses 1 byte of information to determine a single character, symbol, space, number, or letter. A group of bytes together form a word.

There are two ways to convert a binary number to a decimal number or a decimal number to binary. The simplest way is to use a scientific calculator. The software calculator installed by default with most versions of Windows is handy for this task. Click Start>Programs>Accessories>Calculator, and change the view to scientific. Enter a number in decimal and click the radio button Bin; the decimal number will be converted to binary. Click the radio button Dec to convert the binary number back to a decimal number. The Windows calculator can also be used to convert decimal numbers to hexadecimal format (hexadecimal is discussed later in this chapter). Use the Hex radio button for this purpose.

Manually converting a binary number to decimal is a little more difficult.

Figure 5.1 represents an 8-bit byte 00101101. The top row of numbers in the figure represents base 2 increments (increasing powers of 2 from right to left).

To convert the binary number 00101101 to a decimal number, simply multiply the 0s and 1s by their corresponding power of 2. Add the eight results together and you will have the decimal equivalent to 00101101. You can replace the binary number 00101101 in Figure 5.1 with any combination of bits to calculate a different binary number's decimal equivalent. See Table 5.1 for examples of other binary numbers and their decimal equivalents.

128	64	32	16	8	4	2	1
0	0	1	0	1	1	0	1

FIGURE 5.1 8-bit byte and base 2 increments.

TABLE 5.1 Binary Numbers and Their Decimal Equivalents

Binary Number	Decimal Equivalent
00000000	0
00000001	1
00000010	2
00000011	3
00000100	4
00001010	10

Use Figure 5.1 to calculate the decimal equivalent of 00101101 by multiplying the 0s and 1s by their corresponding power of 2.

$$0 \times 128 = 0$$
$$0 \times 64 = 0$$
$$1 \times 32 = 32$$
$$0 \times 16 = 0$$
$$1 \times 8 = 8$$
$$1 \times 4 = 4$$
$$0 \times 2 = 0$$
$$1 \times 1 = 1$$

Add the eight results together.

$0 + 0 + 32 + 0 + 8 + 4 + 0 + 1 = 45$ (the decimal equivalent of 00101101)

HEXADECIMAL

Hexadecimal is a base 16 numbering system associated with memory and other addresses in a computer. The hexadecimal numbering system consists of the following 16 numbers and letters: 0, 1, 2, 3, 4, 5, 6, 7, 8, 9 and A, B, C, D, E, F. The letter A represents a decimal equivalent of 10, B = 11, C = 12, D = 13, E = 14, and F = 15. Hexadecimal numbers use an h suffix to identify the address as a hexadecimal number, for example 10h. Hexadecimal is easier to read because it is based on groups of 4 bits (known as a nybble), unlike binary, which uses groups of 8 bits.

Table 5.2 displays decimal, binary, and hexadecimal equivalents.

TABLE 5.2　Decimal, Binary, and Hexadecimal Equivalents

Decimal	Binary	Hexadecimal
0	0000	0
1	0001	1
2	0010	2
3	0011	3
4	0100	4
5	0101	5
6	0110	6
7	0111	7
8	1000	8
9	1001	9
10	1010	A
11	1011	B
12	1100	C
13	1101	D
14	1110	E
15	1111	F

OVERVIEW OF SYSTEM RESOURCES

There are many devices inside or attached to a computer system that require communication with the system's processor and memory in order to send and receive data and instructions. There are three built-in mechanisms that allow this communication to take place: interrupt requests (IRQs), direct memory access channels (DMAs), and I/Os.

INTERRUPT REQUESTS (IRQS)

An IRQ is a wire incorporated into the motherboard's bus that is used by a device, such as a printer or a keyboard, as a mechanism to capture the attention of the CPU for a request of service.

The default IRQ assignment for a standard 101 keyboard is IRQ 1. When you enter data using the keyboard, you are requesting the CPU to

stop what it is doing and take notice of your request to input data. Your request is sent to the CPU by the use of IRQ 1.

There are 16 IRQ assignments in a computer system. (Refer to Table 5.3 for typical system default IRQ settings.) Early computers had eight IRQs. As the need for more devices increased, another eight IRQs were added.

For the exam, remember that the system reserves IRQ 2 to connect the two sets of eight IRQs. In other words, IRQ 2 is "cascaded" to IRQ 9, which provides the usage of IRQs 9 through 15. Of the 15 IRQs available, 10 are used for I/O devices and 5 are reserved for system devices.

An IRQ is connected to every port, slot, and device on the motherboard. The IRQ assignments are typically handled by the system BIOS settings on startup. Some expansion cards and peripheral devices (usually legacy, non-Plug and Play devices) are configured manually through the use of jumpers on the motherboard or on the device. A network interface card (NIC), for example, may allow you to change the memory address and IRQ settings with the use of plastic jumpers on the card. It is important to note that an IRQ can only be assigned to one active device at a time. Multiple devices can be assigned to the same IRQ. If two devices attempt to use the same

TABLE 5.3 Typical System Default IRQ Assignments

IRQ	Device Assigned
0	System timer
1	Standard 101/102 keyboard
2	Interrupt controller (cascaded to 9)
3	COM2 and COM4 (serial ports 2 and 4)
4	COM1 and COM3 (serial ports 1 and 3)
5	LPT2 (extra printer or sound card)
6	Floppy drive controller
7	LPT1 (parallel port)
8	Real-time clock (RTC)
9	Cascaded to IRQ 2
10	Available (advanced audio)
11	Available (SCSI or VGA card)
12	PS/2 mouse
13	Math coprocessor
14	Primary hard drive controller (IDE)
15	Secondary hard drive controller

IRQ at the same time, an IRQ conflict may occur. IRQ conflicts typically occur when new devices, such as sound cards, modems, and NICs, are added to a system with their manufacturer's default settings. For example, suppose a sound card is installed that is assigned to IRQ 5. You install a NIC that has a preassigned manufacturer's setting of IRQ 5. You reboot the system and notice that the new NIC is not recognized or won't function. Chances are that the sound card is currently using IRQ 5 and a conflict has occurred. You will have to manually assign the NIC to an open IRQ.

To check for any device conflicts on a system (assuming use of Windows 2000), click Start>Settings>Control Panel>System>Hardware> Device Manager. If you see a yellow diamond containing a black exclamation point, you have a device conflict.

IRQ 14 is reserved for the primary IDE or ATA controller (hard drive controller). Two devices can be attached to the primary IDE controller. The first device is the *master* or primary hard drive. The second device attached to your primary IDE/ATA controller is the *slave* or secondary device. This secondary device is typically another hard drive, CD-ROM, DVD-ROM, or DVD-R. If you wanted to add a third and fourth drive you would need to use the secondary IDE controller and IRQ 15, which also allow two more devices to be attached. Refer to Figure 5.2 for a typical Windows 2000 display of IRQ assignments.

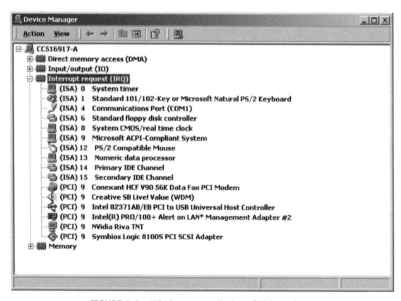

FIGURE 5.2 Windows 2000 display of IRQ settings.

The old A+ core exams asked simple IRQ questions, such as, "What is IRQ 2 used for?" The current A+ core test will likely have you resolve at least one basic IRQ conflict. The review questions at the end of this chapter help you to sharpen your IRQ conflict-resolution skills.

DIRECT MEMORY ACCESS CHANNELS (DMAS)

DMA is a memory controller with a straight path to memory. DMA channels, unlike IRQs, allow DMA devices to access memory directly, without interrupting the CPU. This allows the CPU to carry out more important functions and the DMA devices themselves to process requests faster.

DMA controller chips are integrated into the motherboard and control the DMA channels. DMA devices such as ISA (non-Plug and Play) cards and IDE/ATA controller interfaces have access to DMA services. DMA does not support PCI or AGP technology.

Early computing systems, such as the AT-class computer, provided only one DMA controller with only four DMA channels, which supported 8-bit and 16-bit cards. Today's computers are equipped with two DMA controllers and eight DMA channels, DMA0 to DMA7. Table 5.4 shows standard DMA channel device assignments. Refer to Figure 5.3 for a Windows 2000 display of DMA channels. You need to be familiar with DMA channel assignments 2 and 4 for the test. You may also be asked to identify which DMA channels are available by default for use with peripheral devices.

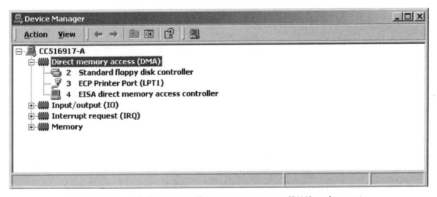

FIGURE 5.3 Windows 2000 direct memory access (DMA) assignments.

TABLE 5.4 DMA Channel Device Assignments

DMA Channel	Device Attached
0	Available
1	Available
2	Floppy drive (possible tape drive)
3	Available
4	Second DMA controller (cascades to DMA channels 0–3)
5	Available
6	Available
7	Available

As with IRQs, there can only be one active device using a DMA channel at a time. If more than one device attempts to access a DMA channel already in use, a DMA conflict will occur.

Different forms of DMA technology are available. Third-party DMA is the original implementation of the DMA. The DMA controller chip resides on the motherboard and is designed for supporting ISA devices. Newer first-party DMA is very popular. With first-party DMA, the DMA controller resides on the peripheral device. This allows the peripheral to actually take control of the system bus to handle the transfer of data in and out of memory. This process is referred to as *bus mastering*. Newer DMA modes are available, such as ultra DMA, offering even faster transfer rates of data.

INPUT/OUTPUT ADDRESSES (I/OS)

In order to be recognized by an operating system and programs, input and output devices attached to a computer system require unique identifications in memory. These unique identifications are called memory addresses. They are also referred to as I/O addresses and I/O port addresses.

It is likely that you will encounter memory address questions on the exam. In a question such as, "Which address does a particular device use?" the address in question is the memory address. Table 5.5 identifies memory address assignments. *(Memorize this table.)*

TABLE 5.5 Base Memory Address Assignments

Memory Address	Device
00F0	Math coprocessor
060h	Keyboard controller
170h	Secondary IDE hard-drive controller
1F0h	Primary IDE hard-drive controller
220h	Sound card
300h	NIC
330h	SCSI adapter
3F2h	Floppy drive controller
3F8h	COM1
2F8h	COM2
3E8h	COM3
2E8h	COM4
378h	LPT1
278h	LPT2
C000–C7FFF	Video adapter (memory address)

Devices attached to the motherboard perform I/O operations by accepting instructions sent to them by operating systems and programs. The instruction sets are first sent to preassigned unique memory addresses or memory address ranges that represent each attached device. Devices require different amounts of memory for processing. The size of memory allocated to a device's memory address can vary. The average device in a system uses 4, 8, or 32 bytes of memory address space. A video card, which requires significant amounts of memory to process output, may need more memory space assigned to its I/O address than a mouse would. The bus architecture of a device is the determining factor for the amount of memory space allocated to it.

Many memory addresses are available in a typical computer system. However, an I/O memory address conflict may occur if a device attempts to use the same memory address space already assigned to another device. It is possible to change a device's I/O address. The process of changing a device's I/O address is called *memory-mapped I/O.*

Once a device is mapped to a legitimate I/O address, the CPU can recognize it.

INPUT DEFINED

Input is defined as anything that goes into a computer in the form of data, graphics, commands, or sounds. Devices used to place or feed information into a computer, such as a keyboard or a mouse, are called input devices. Many devices can serve as both input and output devices, including hard disks, diskettes, and writable CD-ROMs. The main input devices used today and addressed on the CompTIA A+ core test are described below.

KEYBOARDS

The keyboard is the one of the most widely used peripheral input devices. It allows manual entering of characters, numbers, punctuation, and symbols that represent data and commands into a computer system. Keyboards are available in many different forms, shapes, and sizes. Most are manufactured to meet the English standard computer keyboard layout known as QWERTY. QWERTY is the first line of character keys on the top left side of the keyboard. The keyboard keys are laid out into three main groups: alphanumeric, punctuation, and special function keys. You can configure a keyboard's setting through the use of the keyboard applet in most Windows-based operating systems.

There are actually three types of keyboards: the original PC keyboard with 84 keys, the AT-style keyboard (also has 84 keys), and the enhanced keyboard with 101 keys. The main differences between the three designs are the layout and placement of the special function keys. Today's keyboards are designed with interchangeable connecters that allow them to be used with different systems. A 6-pin mini-din (PS/2) connector is most commonly used today to connect a keyboard to a computer. (See Chapter 8 for more on keyboard connectors.)

Keyboard Technologies

There are two main keyboard technologies: switch technology, which is mechanical, and capacitive technology, which is nonmechanical. Each technology has its design and usefulness.

Switch Technology

When you enter data using a keyboard, you are actually pushing on a keycap that is attached to a key switch. The key switch closes a circuit, which creates a signal. This electronic signal is converted to a digital scan code by

the keyboard's processor and is manipulated until it is finally readable by an application in American Standard Code for Information Interchange (ASCII) format.

There are two contact key switches worth mentioning:

- *Foam element and foil key switch.* This key switch is a combination of stem, foam element, foil, and spring. When a key is pressed, the stem pushes on the foam, foil, and spring combination, which eventually touches copper contacts on the keyboard's circuit board to create a signal. The spring pushes the stem back up to its original position and awaits the next keystroke.
- *Rubber dome key switch.* This key switch technology uses a rounded rubber dome with carbon material on its underside. When a key cap is pressed, a stem pushes on the rubber dome, which in turn pushes the carbon material onto the circuit board, thus completing the circuit.

Capacitive Technology

Capacitive technology, the nonmechanical keyboard technology, uses a switch housing that contains two conductive plates and a stem. When a key is pressed, the stem pushes the top plate toward the bottom plate, causing a change in capacitance within the switch housing. The keyboard controller recognizes the change in capacitance, and a signal is created. This technology is expensive, with good reason: it lasts longer than switch technology and has a good level of tactile feedback.

Keyboard Troubleshooting and Maintenance

Keyboards are considered field-replaceable units (FRUs). FRUs are computer parts or components that a technician can easily replace while troubleshooting computer systems in a work area or on a job site. The best way to fix a broken or defective keyboard is to replace it. Keyboards are inexpensive components. Like a computer monitor, it can cost more to have a keyboard repaired than replaced.

The keyboard is connected to a port, which is connected to the motherboard. If you think you have a bad keyboard, you should verify that the problem exists with the keyboard itself and not with the motherboard. Follow these simple steps to verify if your keyboard is bad.

1. Turn the computer off.
2. Carefully unplug the keyboard connector from the back of the system.
3. Plug a known working keyboard with a similar keyboard connector into the system.
4. Turn the computer on.

If the known working keyboard is functional, the original keyboard or its connector is bad. If the known working keyboard is not functioning, you most likely have a motherboard-related issue.

Keyboard problems are rare. Common keyboard issues are typically related to stuck keys or loose keyboard connectors and are most likely detected by the POST at system boot with a 301 error (refer to POST error codes in Chapter 2).

Keeping a keyboard in good working order requires regular cleaning. To clean a keyboard, follow these basic steps.

1. Turn the computer off.
2. Carefully unplug the keyboard connector from the back of the system.
3. Turn the keyboard upside down and shake it until any foreign material is dislodged.
4. Use a can of compressed air to spray out dust and other particles.
5. Use a very diluted combination of soap and water applied with a nonabrasive cloth to remove stains from the keycaps. Alternatively, soak the keyboard in distilled demineralized water.
6. Carefully plug the keyboard back into the system. (Verify that the keyboard is completely dry before doing so.)
7. Turn the computer on.

If a keyboard has been subjected to a major soda, coffee, or other chemical spill, you can rinse it off with water or run it through the rinse cycle in a dishwasher (no-heat cycle; this is recommended only for mechanical keyboards, not capacitive). For best results, replace the keyboard.

MICE AND POINTING DEVICES

The PC mouse was developed as an ergonomic device that allows its user to select data, and menus and adjust the location of an insertion point (cursor). The invention of the GUI, such as Windows, spawned the demand for the mouse. Today, if you notice a computer without a mouse attached, it probably has a touch-screen video display for inputting data and selecting menus. Many types of mice are available today. The main types of mice you should be familiar with for the exam are as follows.

- *Mechanical.* The most common type of mouse in use. A mechanical mouse contains a hard rubber ball, wheels, and sensors. When the mouse unit is moved, the rubber ball moves in the same direction, which makes the wheels supporting the ball spin. The mouse's built-in sensors detect the movement of the wheels. The sensors send the detected signal to the computer. If your mouse pointer does not respond correctly as you move about the screen, you may need to inspect the rubber ball inside the mouse unit for foreign particles.
- *Optical.* There no moving parts in the optical mouse. This type of mouse uses an optical system with a sensor to calculate the X and Y coordinates of the screen cursor.
- *Optomechanical.* A combination mechanical and optical mouse. A rubber ball is used in conjunction with a photo-interrupter disk. Light-emitting diodes are used to detect mouse movements.

SERIAL MOUSE

Almost every computer has at least one serial port (COM port). A serial mouse's female DB-9 connector attaches to the computer's male DB-9 (9-pin) serial port. (See Chapter 8 for more information on connectors.) Before connecting a serial mouse to a serial port, you should check your BIOS configuration settings to verify that a COM port is available for the serial mouse to use. Remember, IRQs are assigned to COM ports. If the COM port you want to use has already been assigned to a modem, the serial mouse may not work.

A serial mouse can be connected to a PS/2 mouse port with a serial-to-mini-din adapter.

PS/2 MOUSE

Today, it is standard for new PCs to come with PS/2 mouse and keyboard ports. The PS/2 mouse is a PnP device that uses IRQ12 by default. This default IRQ assignment frees up a COM port that was previously needed to support a serial mouse.

It is important that you do not unplug a PS/2 mouse when the system is turned on. Unplugging an "active" mouse can cause serious damage to your system and your mouse.

USB MOUSE

A Universal Serial Bus (USB) mouse is a hot-swappable PnP device. This means it can be plugged into an already powered-up system and will automatically be detected by the operating system. With most new operating systems, the USB mouse drivers (software used to support the mouse) are automatically installed.

TRACKBALLS

A trackball is mouse with a plastic ball housed on its topside that uses less desk space than a traditional mouse. A thumb or finger is used to maneuver the ball. Trackballs use optomechanical technology and are connected to a system with a PS/2 or USB connection.

INFRARED WIRELESS MOUSE

The wireless mouse uses infrared (IR) technology. A beam of infrared light goes from a receiver, which gets its power from a serial or PS/2 port, to the mouse. There must be a clear path from the mouse to the receiver in order for the mouse to work properly. This is called line-of-site infrared technology.

TOUCHPADS

A touchpad is a small pad that is sensitive to the touch. It is used as a pointing device with most laptop computers. You direct the mouse pointer on your computer screen by sliding your finger across a square or rectangular pad. Programs can be started and objects selected by tapping on the pad. A touchpad does everything a mouse can do and eliminates the need for a mouse-tail (wire).

JOYSTICKS

Joysticks are used mostly for computer games and computer-aided design (CAD) programs. A joystick is a pointing device that is attached to a sound or video card's Musical Instrument Digital Interface (MIDI) port, also known as a game port. The exam just might ask you to identify the MIDI (game) port on a sound card. Do not confuse this port with a 15-pin video connection (see Chapter 8 for connectors). Like a mouse, a joystick can move the screen pointer in all directions.

MODEMS

The current Adaptive A+ core exam is likely to target your knowledge of analog dial-up modem commands and troubleshooting customer-related modem issues.

There are many types of modems on the market today. Popular modem types include cable, wireless, digital subscriber line (DSL), and analog dial-up modems. For the purpose of the A+ hardware service technician core exam, we will focus on analog dial-up modems.

Modem is an acronym for modulate demodulate. A computer sends data from the CPU to a modem in digital format. The modem (modulator) converts digital data to analog format, which can be sent over a Plain Old Telephone Service (POTS) line. When the analog signal reaches the receiving modem, it is converted back to digital format, which can be understood by the receiving computer.

Typical 56K analog modems are connected to a system internally or externally. An internal modem is inserted into an expansion slot on the motherboard. An external modem is connected to an RS-232c standard serial port with a 9- or 25-pin modem cable or a USB port with a USB cable connector. After an analog modem has been connected to the computer system either internally or externally, it can then be connected to a traditional phone jack with an RJ11 connector.

As discussed earlier in this chapter, a computer works with data in units of 8 bits, called a byte. A serial port transmits data only one bit at a time. A Universal Asynchronous Receiver Transmitter (UART) chip is used to break down incoming bytes into bits that can be transmitted serially (one bit at a time) out of the serial port. There are three types of UART chips:

- *8250.* The first UART chip. Used in XT and AT computers. It has a 1-byte buffer.
- *16450.* Introduced in the AT with a 2-byte buffer.
- *16550A.* Introduced with the 486 computers. Common in Pentiums. Uses 16-byte first-in first-out (FIFO) buffering.

A modem, like any other device attached to a computer, requires a software driver to be recognized by the operating system. If a modem software driver is outdated, the user may experience intermittent problems with the connection to the Internet or another modem. Another consideration is that if your dial-up connection to the Internet is unusually slow or unstable,

you should first contact your local phone company and have them clear the noise on the phone line.

You can test the ability of an analog modem to send and receive signals properly with an analog loopback adapter or a loopback plug.

AT MODEM COMMANDS

The Hayes Microcomputer Products Company developed some of the earliest modems. Many modems are compatible with the modem standards set forth by Hayes (*Hayes-compatible*). Hayes developed a set of modem commands that can be used to control modems manually. Today, the control and configuration of modems is generally handled by the operating system. Table 5.6 identifies some of the basic Hayes-compatible AT modem commands that you should be familiar with for the A+ core exam.

TABLE 5.6 AT Modem Commands

AT Command	*Command Action*
ATA or A0	Answer call
ATD or ATDT	Dial the number specified
ATE	Echo (show) command on screen
ATH and ATH0	Hang up or disconnect modem
ATZ	Reset the modem
XON/XOFF	Modem flow control

MODEM FLOW CONTROL (HANDSHAKING)

When using dial-up communications, it is typical for a sending device to deliver data faster than a receiving device can accept it. *Flow control,* or *handshaking,* is a verification process that two communication devices use to verify that proper communication is taking place. Several flow control protocols are available to assist with the smooth transmission of data from a Data Terminal Equipment (DTE) device, such as a serial port, to Data Communication Equipment (DCE) device, such as a modem, and vice versa. These protocols are as follows.

- XON/XOFF. This software flow control mixes control characters in with the data to perform handshaking between devices. When the receiving device's buffer is full, it sends a request or XOFF message to the sending device. When the buffer on the receiving device is ready to accept more data, an XON message is sent to the sending

device, and transmission resumes. This is a commonly used type of flow control, although it does have a high margin of error.

- RTS/CTS (request to send and clear to send). A dependable, commonly used form of hardware flow control between a computer and a modem. The RTS signal represents a computer, and the CTS signal represents a modem. If a computer is not ready to receive data, it drops its RTS signal. Its attached modem in turn drops its CTS signal and refuses to accept incoming data. When the computer is ready to receive data, it raises its RTS signal, which in turn raises its attached modem's CTS signal, and data acknowledgment can resume.

- XMODEM. An error-checking method used to verify that data is not corrupted or lost. XMODEM sends data in 128-byte blocks.

- YMODEM. Sends data in 1024-byte blocks over a dial-up connection. YMODEM error checking protocol is faster than XMODEM and less reliable than ZMODEM.

- ZMODEM. Also sends data in 1024-byte blocks. ZMODEM protocol is faster than XMODEM. ZMODEM can resume or restart a file transfer at the point it previously failed.

SCANNERS

A scanner is an input device that captures analog images in the form of text, photographs, or drawings, and converts them to digital information (0s and 1s) that can be recognized by a computer system and supporting scanner software. A scanner uses a sensor to capture the reflection of light from a desired object to create a digitized image. Scanner software or supporting applications can be used to modify the digital image to suit the needs of the user. Finally, the image can be duplicated, printed, saved as a file, or sent as an e-mail attachment.

Optical scanners and digital cameras use charge-coupled devices (CCDs) to sense variations in light reflected off an image. These tiny CCDs are lined up in rows or arrays.

A CCD represents a pixel. A pixel (picture element) is an area in a graphic image. Computer monitors, for example, are split into sections that are represented by millions of pixels. The more pixels there are to an area, the sharper the graphic image or monitor resolution. Scanner resolution is measured in optical dots per inch (DPI). In simple terms, a CCD in

a scanner represents one dot on a graphic image. The more CCDs there are per area in a scanner, the sharper the final image will be.

Scanners are available in various forms and offer different delivery methods:

- *Flatbed scanner.* The most common type of scanner. Larger flatbed scanners that bind documents together are often seen in business environments. With a flatbed scanner, a document or image is placed on a flat glass surface. A light source and an array of sensors (CCDs) pass below the document.
- *Single sheet-fed scanner.* Smaller, single-feed flatbed scanners can be purchased at reasonable prices for home use. This type of scanner uses a set of rollers to feed the image to be scanned past the light source and sensors. This is not a useful scanner for large amounts of information to be scanned.
- *Handheld scanner.* A handheld scanner is a flexible device that allows you to scan stationary objects or images. It is also a useful tool for gathering inventory information; for example , a bar code scanner can be used to gather stock information at a grocery store or warehouse.

There are several ways to interface a scanner to your computer system, including parallel, SCSI, and USB connections. These types of connectors are discussed in detail in Chapter 8.

SOUND CARDS

A sound card can act as an input or output device. It combines all the technology needed to convert audio signals to digital and digital signals to audio through the use of digital-to-analog converters (DACs) and analog-to-digital converters (ADCs).

A sound card can be integrated into the motherboard, or it can be an expansion card that is connected to the motherboard through a PCI or ISA expansion slot. As is the case with every peripheral device attached to the motherboard, a sound card requires the use of system resources such as an IRQ, a DMA channel, and an I/O address. PCI sound cards are fairly easy to install. If the system has a Plug and Play operating system and BIOS, you just install the card into an open PCI slot and the BIOS takes care of the

system resources and configuration for you. The majority of ISA sound cards on the market are preconfigured with a set of onboard jumpers that specify the use of IRQ 5. This can cause an IRQ conflict if you already have an LPT2 (a second printer port) or another device, such as a NIC, already configured to use IRQ 5. Some sound cards use special software drivers that are installed into system files, such as DOS's AUTOEXEC.BAT and CONFIG.SYS. These system files run when the computer is started and tell the operating system to recognize that there are sound-related devices attached to the computer.

Most sounds cards are connected to a CD-ROM by a wire known as a CD audio cable that comes standard with a CD device. This allows the sound card to act as an input device between your CD-ROM and the computer system. If you are using your CD-ROM as a music device and there is no sound coming from your PC speaker or attached sound system speakers, you should verify that the wire is connected between the sound card and the CD-ROM.

Sound cards are a combination of components that allow audio to be manipulated and transferred in and out of a computer system. Some of the important components that make up a sound card are these.

- An *ADC*, which is a circuit used to convert infinite analog wave signals, in the form of human voice, music, or camera, to digital signals (0s and 1s) that can be understood, manipulated, and stored by a computer system.
- A *DAC* is a circuit used to convert stored digital data back to infinite analog wave signals that are outputted to audio devices such as a microphone and speakers.
- *Analog inputs* are sound cards designed with input jacks that accept low-level voltage input from devices such as musical instruments, CD players, and microphones.
- *Analog outputs* are designed to support sound card output to speakers. There are normally two analog outputs found on a sound card. For novices, this is where you plug in your PC speakers.
- A *MIDI/game port* is a sound card port that provides support for a joystick (external gaming device attachment). It also provides support for musical instruments and synthesizers. The MIDI/game port is often mistaken for a video card connector on the back of a computer. It is possible that on the core exam you will see a graphic of a sound card asking you to identify the joystick/MIDI port or speaker output jacks.

- Many newer sound cards have a *synthesizer chip* built onto the sound card. This chip is used to support external MIDI devices and uses a technology known as wave-table synthesis.

DIGITAL CAMERAS (IN BRIEF)

Digital cameras have taken the world by storm. They are considered an input device used to capture images that can be downloaded to a computer system. Once downloaded, the digital images can be fine-tuned and manipulated with graphical software applications to suit the needs of the end user. The final result can then be stored, e-mailed, or printed.

Like scanners, most digital cameras use CCDs to capture images. Most digital cameras are connected to a computer system using a USB port or serial port that is IEEE 1394 compliant. They can use infrared technology to download images to a system.

CHAPTER SUMMARY

In this chapter, you learned how a computer converts digital information to a readable format that humans can understand. This chapter also addressed important input devices and the system resources they utilize to communicate with the computer's main components. To be a proficient computer technician, it is essential that you are aware of how computer resources work together. So that you can properly install, upgrade, diagnose, and troubleshoot a system, it is imperative that you understand IRQs, DMA channels, and base I/O memory addresses. It is a safe bet that the A+ core exam is going to focus on these areas.

REVIEW QUESTIONS

1. What action would you take first if your mouse pointer were not responding correctly?
 - A. Check DMA channel 2.
 - B. Check the mouse ball for debris.

○ C. Check COM2 settings.
○ D. Cascade IRQ2 to IRQ9.

Answer: B

Debris collected on the mouse roller ball can cause the mouse pointer to respond incorrectly. The debris actually gets collected by the rubber mouse roller ball and affects the internal components of the mouse.

2. What is the default address used by the primary IDE controller?
 ○ A. C000–C7FFF
 ○ B. 1F0h
 ○ C. 378h
 ○ D. 3F8h

Answer: B

C000–C7FFF is used for the video adapter memory address; 378h is the memory address reserved for LPT1; and 3F8h is the memory address reserved for COM1.

3. What is the default address used by the secondary IDE controller?
 ○ A. 170h
 ○ B. 1F0h
 ○ C. 378h
 ○ D. 3F8h

Answer: A

The address 1F0h is the memory address reserved for the primary IDE controller; 3F8h is the memory address reserved for COM1; and 378h is the memory address reserved for LPT1.

4. What is the default I/O address for COM2?
 ○ A. 170h
 ○ B. 1F0h
 ○ C. 378h
 ○ D. 2F8h

Answer: D

The address 170h is reserved for the secondary IDE controller; 1F0h is the memory address reserved for the primary IDE controller; and 378h is the memory address reserved for LPT1.

5. Which DMA channel does the floppy drive controller use?

○ A. 1
○ B. 2
○ C. 4
○ D. 7

Answer: B

DMA channel 2 is used for a floppy drive or a possible tape drive unit. DMA channels 1 and 7 are available. DMA channel 4 is used for the second DMA controller (cascades to DMA channels 0–3).

6. How many devices can you attach (chain) to a single IDE controller or channel?

○ A. 1
○ B. 2
○ C. 4
○ D. 127

Answer: B

Two devices can be attached to a single IDE controller. For example, the first device attached to the primary IDE controller would be the master, or primary hard drive. The second device attached to the primary IDE/ATA controller is the slave, or secondary device.

7. Which IRQ is reserved for the system timer?

○ A. 0
○ B. 1
○ C. 2
○ D. 9

Answer: A

IRQ 1 is reserved for a standard 101/102 keyboard. IRQ 2 is an interrupt controller (cascaded to IRQ 9). IRQ 9 is cascaded to IRQ 2.

BASIC OUTPUT DEVICES

IN THIS CHAPTER

- Output Types and Devices
- Video Display Devices
- Cathode Ray Tube (CRT)
- Video Display Standards
- Monitor Shapes and Sizes
- Liquid Crystal Display
- Printers
- Parallel Port Standards
- Dot Matrix and Inkjet Printers
- Laser Printers
- Chapter Summary
- Review Questions

OUTPUT TYPES AND DEVICES

Output is defined as data or information that is sent out of a computer system, program, or device. Output can take many forms, including electronic characters, numbers, symbols, signals, sounds, paper, and graphics.

Output is generally categorized into two main types: transient and final. *Transient output* is temporary output that is produced in the form of

electronic signals or data moving from one location to the next to be used for only a short period. An example of transient output is an electronic request from one device to another to carry out a specific function, such as an operating system sending a request or message to a printer to print. The request to print is temporary. Transient output can be in the form of information stored in RAM or a temporary swap file on a hard drive. It exists to serve a temporary purpose. In other words, transient output is output that is not stored or saved.

Final output is more permanent. It is data or information that can be saved, recorded, or physically held on to. Some examples of final output are a printed report, an image displayed on a video display monitor, a sound that comes from computer speakers, a file stored in a permanent location, such as a hard drive, floppy disk, or writable CD-ROM.

An output device is any machine or peripheral device that is capable of producing information from binary data that it receives from the CPU. Typical output devices are printers, plotters, video displays, computer speakers, and synthesizers. To list all the various output devices available on the market is beyond the scope of this book. However, this chapter will prepare you well for the A+ core exam topics that relate to output devices and their functions.

VIDEO DISPLAY DEVICES

The computer monitor is by far the most common computer output device in use today. It is the window to the electronic world. Think about it: how many people around the world are staring at a computer screen at this very moment?

A computer monitor is a vehicle by which information that has been processed is presented to the end user. The components involved in producing a final image from a computer system are a video adapter (or video card) and a monitor. The computer monitor has had many names since its inception. In the early days of computing (DOS days), the monitor was called a console, or CON, for short. It has also been called a CRT, which is an acronym for cathode ray tube.

Computer monitors are categorized into two main groups: CRTs and liquid crystal displays (LCDs).

Before we continue, here are a few important tips for the test. A computer monitor uses a DB15-pin style male connector to attach to the 15-pin

female connector on the back of a computer. If one of these pins is bent or broken, the display screen may flicker, turn many strange colors, or show nothing at all. In addition, it is essential to know that most of today's video adapters contain their own BIOS chip, which interacts between the video card and the system processor.

CATHODE RAY TUBE (CRT)

A CRT is based on the same technology used in a television set. An electronic beam is directed to the back of a glass screen that has a phosphorus coating. The beam is directed to the screen by a glass vacuum tube that uses an electron gun. When the beam of electrons hits the phosphorus material, moving from the top of the slightly curved glass to the bottom, the phosphors combine to form pixels, and a visible light representing a viewable image is displayed.

There are two types of CRTs: monochrome (single color plus background) and color (multiple colors). A monochrome monitor uses two colors, a solid color (usually black or grayscale) that represents the background and either amber, green, or white for the foreground. A single beam from the electron gun illuminates the foreground area with a single color.

Color monitors use three electron gun beams to represent each of the three colors of light from the basic colors (primary pigments) of red, green, and blue (RGB). These are the primary colors from which all other colors are derived. Solid colors are derived from the three primary colors to form the colors cyan, magenta, and yellow (CMY). If you take a look at a typical desktop color printer's ink cartridge, you will see the CMY solid colors. The combination of the three electron beams projected from the electron gun form a triangular representation of the three primary colors. This is called a triad picture element, or pixel (Figure 6.1). The final image displayed on the CRT screen is a combination of many pixels with different intensities. The more pixels or dots that can be grouped together, the greater the color depth (i.e., number of possible colors).

Here are some important CRT terms that you should be familiar with.

- *Shadow mask.* A thin metal sheet that the electron gun beams must pass through. The shadow mask ensures that the electron beam hits the correct phosphor.

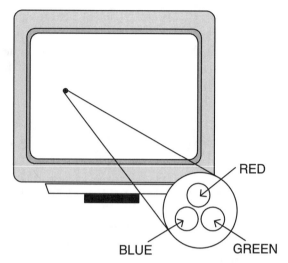

FIGURE 6.1 Representation of a triad pixel element.

- *Degauss.* Degaussing is a method used to remove any magnetic fields that may cause the shadow mask to become magnetized. For example, placing a magnetic speaker too close to a CRT can cause the visual image to become distorted. Degauss normally runs when you turn your monitor on. Most modern CRTs have a manual degauss button.

DOT PITCH, RESOLUTION, AND COLOR DEPTH

A pixel is basically a dot on a CRT or LCD display. As stated earlier, the more pixels that can be grouped together, the more defined the final image will be. Dot pitch, which is measured in millimeters (mm), is the distance between pixels. For example, a 0.28 dot pitch measurement means that the pixels are 0.28 mm apart from each other on the display. When purchasing a monitor, it is important to get as low a dot pitch measurement as possible for a clear, well-defined image. Popular dot pitch measurements are 0.31mm, 0.28mm, 0.27mm, 0.26mm, and 0.25mm. Resolution is the total number of pixels that can be displayed on a screen at one time. To calculate resolution, you add the number of pixels per horizontal row by the number of vertical rows of pixels. For example, standard VGA resolution is 640×480, which equates to 307,200 pixels. Color depth is the total amount

TABLE 6.1 Video Color Depths

Color Name	Available Colors	Color Depth (measured in bits)
Monochrome	2	1
VGA	16	4
256 (colors)	256	8
High color	65,536	16
LCD color	262,144	18
True color	16,777,216	24
True color	4,294,967,296	32

of pixels that a screen or monitor can display. To be more specific, the total number of bits used to represent a pixel stored in video memory is referred to as *color depth*. Commonly used color depths are 32-bit, 24-bit, 16-bit, and 8-bit. Early computing systems used 8-bit color. Each pixel uses 1 byte of video memory. Each pixel can select one of 256 colors. The software that creates the image using either 18 or 24 bits per pixel defines these colors; therefore, 256 colors can be displayed on the monitor, selected from a palette of 262,144 or 16,777,216 colors. Table 6.1 shows video color depths.

You will not have to do pixel calculation on the A+ core exam. You may be required to know video adapter types, their resolution, and the number of colors they represent. Table 6.2 shows an overview of video adapters and their corresponding resolution and colors.

TABLE 6.2 Video Standards, Resolution, and Colors

Video Adapter	Resolution	Colors
MDA (monochrome display adapter)	720 × 350	2 (text only)
CGA (color graphics adapter)	320 × 200	4
	640 × 200	2
EGA (enhanced graphics adapter)	640 × 350	16
VGA (video graphics adapter)	640 × 480	16
	320 × 200	256
SVGA (super video graphics adapter)	800 × 600	16
	1024 × 768	256
	1280 × 1024	256
	1600 × 1200	256

REFRESH RATES

The tiny phosphors inside a CRT lose their illumination very quickly. They must be refreshed many times per second so that the image displayed on the screen does not fade or flicker. The electron gun inside the CRT must redraw the image continuously in order to keep the phosphors active. This process is called a CRT's *refresh rate.*

A CRT's refresh rate is measured in hertz. The higher the number of hertz (Hz), the faster the CRT's refresh rate. Common video refresh rates are 60, 75, and 80Hz. An 80Hz refresh rate means that a screen will be re-drawn or "refreshed" 80 times per second.

It is very important not to set your refresh rate (in an operating system's display panel settings) faster than the recommended refresh rate stated by the monitor's manufacturer. This may cause your monitor to go blank.

Two scan rates are used to determine the ultimate speed of the refresh rate. The horizontal scan rate is the speed at which the phosphors are re-freshed from left to right. The vertical scan rate is the speed at which the entire screen is refreshed.

Interlacing is a refresh process in which every other row of pixels (even or odd) is refreshed by the electron gun in order to increase monitor reso-lution. The electron gun refreshes the odd number of rows in a display and then returns to refresh the even rows. Although interlacing helps to in-crease resolution, it also causes the display to jitter or flicker.

Non-interlacing is when every row of pixels is refreshed consecutively. This reduces jitter and screen flicker and generally provides for a better viewing experience. When purchasing a monitor, it is a good idea to buy a non-interlaced display.

High resolution requires video memory (VRAM.) The higher you set your display resolution, and the more colors you choose to support, the more VRAM your system will require. The A+ core test may ask you to identify the amount of memory needed to support a particular resolution with a defined number of colors. For example, how much memory is needed to support a resolution of 1024 × 768 using 24-bit, true color? Answer: 4MB. Table 6.3 provides the answer to this question, along with other video resolutions and VRAM requirements.

You can also use the following mathematical formula to assist you with calculating VRAM requirements: Memory requirement = horizontal pixels × vertical pixels × color depth.

TABLE 6.3 Video Resolution and VRAM Requirements

Video Resolution	8 bits 256 Colors	16 bits 65,000 Colors	True Color, 24 bits 16.7 Million Colors
640 × 480	512K	1MB	1MB
800 × 600	512K	1MB	2MB
1024 × 768	1MB	2MB	4MB
1280 × 1024	2MB	4MB	6MB

VIDEO DISPLAY STANDARDS

The very first video adapter was an MDA. MDA has a resolution of 720 × 350 pixels and is cable of supporting text, but not graphics or color. CGA and EGA were the early display standards for monitors. CGA was capable of producing just two colors with a resolution of 640 × 200. EGA could produce 16 colors with a resolution of 640 × 350. These video technologies were used in the early to mid 1980s. If you worked for extended periods using these technologies in the 1980s, your eyesight may be the worse for it now.

VIDEO GRAPHICS ARRAY (VGA)

VGA is the standard for all graphic devices such as monitors and video cards. It has a resolution of 640 × 480 with a color depth of 16 colors or 320 × 200 with 256 colors. VGA uses analog signals, as opposed to the digital signals used by its predecessors CGA and EGA. The original implementation of the VGA standard introduced the following video subsystem standards to assist with processing and ultimately produce a better image.

- *Frame buffer.* A memory buffer used to store data before it is displayed. The amount of information stored before it is sent to the display is called a *frame.*
- *Graphics command language.* With VGA, the CPU manages all the work of producing an image. Graphics command language introduced a set of simple commands that alleviated some of the CPU's video-related tasks.
- *CRT controller.* Produces signals that control and reset the electron guns inside the monitor.
- *Sequencer.* The sequencer is basically a timer on the video adapter. It loads display addresses into memory and operates with a 16-bit internal counter.

- *Serializer.* Used to serialize data held in video memory before it is sent to an attribute controller.
- *Attribute controller.* Houses a color template that determines the *value,* or color, of a pixel.
- *Display memory.* A bank of 256K DRAM separated into four 64K color planes. Its function is to store screen-displayed information.
- *Graphics controller.* Carries out logical functions and calculations on data being placed in display memory.

VGA introduced many advantages, including these subsystems. Unfortunately, it didn't use resources fast enough to support the demands of GUIs and applications that were hungry for new standards. VGA circuitry is directly tied to the processor. It relies on the processor to do most of its work, which takes a toll on the processor's performance.

8514/A

The IBM standard of 8514/A was introduced at the same time as the VGA standard. It provided three new graphics modes that enabled higher resolution and color and was well suited for IBM's proprietary Micro Channel Bus. The 8514/A standard provided some processing capabilities. It supports a resolution of 1024×768 and 256 colors in graphics mode.

EXTENDED GRAPHICS ADAPTER

Extended graphics adapter (XGA) cards were introduced in later IBM PS/2 model computers. The XGA adapters use either 512K or 1MB of VRAM and are capable of bus mastering using IBM's Micro Channel Architecture (MCA). Using 1MB of VRAM, XGA supports a graphics resolution of 1024×768 and 256 colors, or 640×480 using high color (16 bits).

SUPER VGA AND ULTRA VGA

Today's video cards are called Super VGA (SVGA) cards. Technically, SVGA and Ultra VGA (UVGA) are not distinct video standards; they are words that describe a video card's capability to achieve higher resolution and colors. Manufacturers of SVGA and UVGA video cards each provide their own sets of instructions and software drivers to maximize the performance of the cards they produce. A group of graphic and video card manufacturers known as the Video Electronics Standards Association (VESA) has standardized video rules. SVGA was originally by developed by VESA as competition to IBM's proprietary 8514/A and XGA technologies. All varieties of SVGA support a palette of 16 million colors. The basic SVGA resolutions are 800×600, 1024×768, 1280×1024, and 1600×1200.

MONITOR SHAPES AND SIZES

Today, monitors are available in many shapes, sizes, and colors. Monitor size is calculated in inches. Popular monitors are available in the following sizes: 15, 17, 19, and 21 inches. The viewable size of the display on a monitor is measured diagonally from the bottom right corner to the top left corner; this is known as the monitor's *nominal size*. The actual viewable size of the display is typically at least an inch smaller than the advertised nominal size of the monitor. For example, a 19-inch monitor (nominal size) actually has a viewable size area of less than 18 inches. A 17-inch monitor has a viewable display area of 15.6 inches. The monitor's *bezel,* which is the black plastic boundary that supports and surrounds the edge of the glass screen, reduces the viewable size of the display area.

Smaller monitors (generally 15-inch and lower) have trouble displaying higher resolutions because they cannot support very small pixels. A larger monitor that supports smaller pixels is handy for higher-resolution settings and fitting in more icons on the desktop. If you increase the resolution settings in the Windows 2000 Display Properties window, the icons on the desktop become smaller (Figure 6.2).

FIGURE 6.2 Windows 2000 Display Properties window.

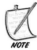

If you change your monitor's resolution, video card drivers, or NIC drivers and then cannot reenter the Windows GUI, you can enter the operating system through the use of Safe Mode. Safe Mode loads only the drivers needed to enter the operating system for troubleshooting purposes. Higher-resolution changes and other drivers are not loaded when you enter Safe Mode.

GRAPHICS

Two technical drawing methods are used to draw an image on a video screen, raster graphics and vector graphics.

- *Raster graphics.* Raster images are digital images that are created from a grid of X (horizontal) and Y (vertical) coordinates. The X and Y coordinates represent the locations of pixels on a display screen. Raster is the most common method used to produce an image. Some of the more common types of raster formats are JPEG, BMP, and TIFF images. These raster image types are produced from software graphics applications such as Microsoft Paint. Most monitors and printers produce information in raster format and are considered raster output devices.
- *Vector graphics.* Vector graphics programs produce a sharper image than raster. Vector is based on mathematical equations that define where and how an image is to be drawn or sized on a display. Vector graphics programs such as Corel Draw, Microsoft Visio, and Adobe Illustrator are used to create scalable detailed drawings. Two- and three-dimensional graphic animations are created using vector graphics technology and software.

LIQUID CRYSTAL DISPLAY

LCDs are a flat-panel display technology and are used in most laptop computers. LCD technology can be used for other display devices, such as car radio displays, clocks, desktop computers, and any other display devices that can take advantage of flat-panel technology. The biggest advantages of LCD flat screens are that they reduce physical space requirements, they are lightweight and portable, and they require less energy to operate (laptop LCDs are powered by low-voltage DC). Traditional CRTs take up more desktop space than LCDs and require more energy to operate. With an

LCD display, what you see is basically what you get. Unlike CRTs, in which the nominal size is less than the described measurement of the monitor, the measurement of an LCD screen is accurate. In other words, if you purchase a 15-inch LCD, you get a 15-inch display.

LCD technology uses two panels of a polarizing substance and places a liquid crystal solution between the two panels. An electric charge is sent through the crystals, causing them to form a shield from light. The crystals either allow or disallow the passage of light and eventually form an image.

Different types of LCDs serve different purposes and provide various levels of display quality. Some of the more common types are as follows.

- *Passive matrix LCD.* A passive matrix display uses LCD elements, electrical current, and a grid of wires to control the passage of light. It has a fixed resolution of pixels.
- *Active matrix LCD.* This LCD type is based on Thin Film Transistor (TFT) technology. It constantly refreshes each pixel, providing a consistently sharp image. This technology provides better visual quality than passive matrix and is more expensive.
- *Dual scan.* With dual scan, the LCD screen is divided in two. Each half of the screen is refreshed separately. This process increases the resolution rate, but decrease the brightness (contrast) level of the LCD.

MONITOR POWER MANAGEMENT

A monitor uses a tremendous amount of AC from an AC outlet. The Environmental Protection Agency (EPA) came up with a program and a set of standards known as Energy Star to reduce the amount of energy used by monitors and PC-related equipment. To see if a monitor is Energy Star compliant, click Start>Settings>Control Panel>Display>Screen Saver. If the monitor is compliant, you will see the Energy Star logo and "Energy saving features of monitor" (Figure 6.3).

PRINTERS

A printer is an output device that accepts information from a computing system and produces output, usually text and graphics, to the end user in paper form. Many printing devices and printing technologies are available today. For the purpose of studying for the A+ Adaptive core exam and its

FIGURE 6.3 Windows Energy Star compliance.

printer troubleshooting questions, we will focus on the current printer port standards, dot matrix, inkjet, and laser printer technologies.

Printers can be categorized into groups based on the way they apply an image or text to a consumable product, such as paper. The three most popular printer groups are impact printers, thermal ink printers, and laser printers.

- *Impact printers.* Impact printers include dot matrix and daisy wheel printers. They typically use a print head (which can get very hot) with pins to strike against an ink ribbon to create a character, number, or symbol. They are very noisy and are considered old-fashioned technology. Their main purpose in today's world is printing multipart forms with carbon paper between them.
- *Thermal ink printers.* Thermal ink printers include the very popular inkjet and bubble-jet printers. Small nozzles are used to disperse ink onto paper to form an image. These printers are considered affordable and are commonly used in households across the world.

- *Laser printers.* Laser printers use an electrophotographic process to place an image on paper. This more expensive technology is well worth the price for the speed at which it can print as well as the quality it can produce. Laser printer speed is measured by the number of pages per minute (PPM) that the printer can produce. Laser printers can be found in most business environments.

PARALLEL PORT STANDARDS

Printers can be connected to a computer using several methods and special connectors (connectors are discussed in detail in Chapter 8.) Currently, the fastest available connection for a printer is realized through USB technology and a USB connection. Older printers were connected to a computer system's DB-9 male serial port connector, which is capable of transmitting only 1 bit of information at a time in a half-duplex manner (i.e., it is incapable of sending and receiving information at the same time.)

Today, most printers are connected to a computer system using a data bus (DB) 25-pin male connector that inserts into a DB 25-pin female connector on the back of the system. This is known as an LPT/parallel port connection (or LPT1). Parallel transmission of data is bidirectional, meaning that the parallel port can communicate with the CPU during transmission. Parallel communication transfer rates are 8 bits at a time. The opposite end of the DB 25-pin male connector cable is connected to a printer with a Centronics 36-pin connector.

The Institute of Electrical and Electronics Engineers (IEEE) has developed a set of parallel port communication standards that control the flow of data between computer systems and print devices. These standards (protocols) are known as IEEE 1284.

 Questions on the test may refer to printer cables and the IEEE standard they represent. Remember that the IEEE 1284 is a standard for parallel
NOTE communication and printer cables.

There are five modes (IEEE standards) of parallel communication that you need to know for the test. Keep in mind that bidirectional is considered a standard.

- *Compatibility mode.* An obsolete, unidirectional, parallel communication, forward-only mode implemented with the original 36-pin Centronics connector.

- *Nibble mode.* Also obsolete, nibble mode is a used to reverse the communication between a printer and a host by two 4-bit pieces of information at a time. Nibble mode complements compatibility mode and is also considered bidirectional.
- *Byte mode (SPP).* Byte mode is a very common mode of parallel reverse communication that sends 8 bits of information at a time, side by side. Picture a typical parallel cable with eight separate "highways" next to each other. One bit of information travels down each "highway" at the same time.
- *Extended capabilities port (ECP) mode.* ECP mode is the fastest form of bidirectional printer-to-host, parallel port transmission standard available. It uses both forward and reverse transmission techniques and sends data 8 bits wide at a time. ECP also supports hand-shaking and compression.
- *Enhanced parallel port (EPP) mode.* EPP mode is similar to ECP in its ability to support forward and reverse communication and 8-bit-wide transmission of data. EPP does not support handshaking.

PRINT QUEUES AND THE SPOOLER SERVICE

Before a printed request is sent to a physical printer, it is typically held temporarily in a print queue (buffer) in the operating system. If you send multiple print jobs to a printer, they wait in the print queue until the previous print job completes. If a print job errors out or gets stalled in the print queue, all jobs waiting to print in the queue will not print until the stalled or "hung" print job is deleted or canceled. Figure 6.4 shows a Windows print queue display with print jobs waiting to print. Most current operating systems run a system service known as the spooler service. The

Document Name	Status	Pages	Size	Submitted
Microsoft Word - Document1	Printing	1	30.3 KB/128 KB	8:23:00 PM 8/4/2001
Microsoft Word - Document1		1	30.5 KB	8:23:06 PM 8/4/2001
Microsoft Word - Document1		1	30.5 KB	8:23:10 PM 8/4/2001
Microsoft Word - Document1		1	30.6 KB	8:23:14 PM 8/4/2001
Microsoft Word - Document1		1	30.7 KB	8:23:19 PM 8/4/2001

hp deskjet 950c series — Printer Document View Help — 5 document(s) in queue

FIGURE 6.4 Windows print queue with print jobs waiting to print.

spooler service controls the print queue. If simply canceling or deleting the stalled print job does not allow waiting print jobs to print, you may have to stop and start the spooler service.

DOT MATRIX AND INKJET PRINTERS

A dot matrix printer is a form of impact printer whose technology closely resembles that of a typewriter. They have survived based on their ability to print multiple-part forms and their paper-feeding capabilities. It is common to find dot matrix printers in stores, doctor's offices, banks, and any other location where multiple-part paper forms and receipts are needed.

Dot matrix printers contain their own print buffer. This buffer is a storage location for the information to be printed after it is sent from the CPU. After the information has been sent to dot matrix print buffer, the printer's processor calculates the best approach to printing the lines and characters needed and makes adjustments to the paper feeders if necessary.

The dot matrix printer has a magnetic print head that contains either 9 or 24 pins. A 24-pin print head is used to print letter-quality pages. A 9-pin print head is used for draft quality. Each of the pins on the print head has its own solenoid, spring, and coil. A dot matrix printer uses a series of dots or dots per inch (DPI) to form an image, symbol, character, or number. When the printer processor receives enough information from the print buffer to begin printing, a signal is sent to the magnetic print head. A combination of events takes place, and the pins attached to the print head hit an ink ribbon, which is held in place by a platen, that is between the pins and the paper. After the pin has applied its dot, it is pulled back and the next pin applies its dot until a character is complete. All this happens very quickly. The friction caused by the constant movement of the print head can make it get extremely hot. When working on a dot matrix printer, never touch the print head until it has time to cool down. Dot matrix printer speeds are measured in printed characters per second (cps). Characters-per-second speeds differ based on print quality and manufacturer. Dot matrix printers are capable of up to 500 cps.

Dot matrix printers use either a pressure roller or tractor-feed method of pulling continuous-form paper through the printer one line at a time. The continuous use of a dot matrix printer without proper maintenance can cause the tractor-feed rollers and platen to become misaligned. This commonly results in ink fading as it is applied from left to right or uneven

lines of output across the paper. Lack of proper maintenance can also result in constant paper jams. Use a can of compressed air regularly to spray out any loose particles around the tractor rollers. Rubber-cleaning solutions should be used to clean the tractor belts and rollers.

Inkjet printers are a very popular type of printer and are used in many homes and small businesses. Inkjet technology is typically faster than dot matrix, but not as fast as the average laser printer. Its main benefits are its affordability and ease of maintenance compared to laser printer technology.

Inkjet printers use a type of print head that houses many tiny little nozzles, sometimes referred to as jets. These jets spray or drop fast-drying ink into a condensed area to form tiny dots that make up a character. A thermal resistor actually heats up the ink until it expands and is eventually forced out of the print nozzle in the form of a bubble or droplet. The ink bubble is then sprayed or dropped onto paper. The ink droplets can tend to smear or splatter when they hit the paper, which causes the dot created on the paper to become somewhat distorted. To refine this process, the thermal resistor bubble-creation process was replaced with piezoelectric crystal. The piezoelectric process uses crystals that react to electric charge. When charged, a crystal draws or pulls ink from an ink storage unit held above the crystal. In simple terms, the piezoelectric process can cut or refine the exact amount of ink needed to refine the dot placed on paper. This reduces the smudging affect of traditional inkjet technology and provides for better printer resolution. In fact, this process allows resolutions greater than 1440 dpi.

Inkjet printers accept paper one sheet at a time. This process, called *single-sheet form feed,* involves pulling paper into the printer with rollers. The paper is aligned under a print mechanism that moves across the paper to apply an image.

If sheets of paper connected into one long sheet and placed in printer guides with plastic teeth, the printer is said to be a continuous form-feed printer. Inkjet printers use single-sheet form feed technology. Dot matrix printers use the continuous form-feed process.

LASER PRINTERS

The previous A+ Hardware Technician core exams used to bombard the examinee with questions relating to the minute details in the stages of the laser printing electrophotographic process. The current exam may also address some of these details. It is very important that you understand this

process and its intricacies, as well as the laser printer paper-feeding process. Equally important, however, is to focus your study on printer troubleshooting and maintenance in general. The current A+ core test laser printer questions seem to be headed in the direction of the over all use of the technology. For example, you may know that a uniform charge of −600V is applied to the laser printer's photosensitive drum by the primary corona wire during the conditioning phase of the EP process. That knowledge will not help you on the test if you can't answer a question asking you how to dispose of a toner cartridge properly.

A laser printer is a popular type of nonimpact printer that is capable of producing resolutions of 1400 dpi or greater, with a usual minimum requirement of 600 dpi. Laser printers use technology similar to that of photocopiers.

A laser printer also puts many dots on paper that eventually form an image. Unlike the previously mentioned printing technologies, however, the laser printing process uses plastic toner particles that bond to an electrophotosensitive drum to create an image. These toner particles are actually a combination of organic material, plastic, and iron. A toner cartridge houses the powder toner and is inserted into the laser printer itself. A used toner cartridge should be sent back to the toner cartridge manufacturer for proper disposal or possible refilling. Note for the exam that toner, paper, and disposable ribbons are considered printer-consumable items. If laser-printed output begins to appear wavy or inconsistent, the problem may be an empty or malfunctioning toner cartridge.

The laser printing process begins after you send a document or image from your computer to the laser printer. After the image is accepted by the laser printer, a laser beam and a mirror are used to write an electrostatic representation of the image to a photosensitive drum. The electronically charged drum then rolls through the toner, which adheres to the drum to form an image. At this stage of the process, a sheet of paper is fed into the printer, where it receives an electrostatic charge. The paper is then rolled over the drum and the toner image is transferred to the paper. In the next process, the toner is heated and fused to the paper. The final output is directed out of the printer and the printer awaits the next document or image. This process is repeated every time a page of information is sent to the printer.

PRINTER QUALITY TYPES

Printer quality type standards refer to the quality of the printed dots produced mainly by dot matrix printers. Printer quality types can also apply to

other printing technologies, such as laser printing. You should be familiar the following printer type qualities for the A+ core test.

- *Letter quality (LQ).* LQ is the standard for printing today; it is the best quality type available and requires a device that can support a minimum of 300 dpi. LQ produces characters that are crisp and clear. There are no noticeable spaces between the dots printed on paper. LQ is used mostly in higher-end dot matrix and laser printers.
- *Near letter quality (NLQ).* Dot matrix and inkjet printers that produce output at 150 dpi utilize NLQ. The dots that make up a character, number, or symbol are printed over twice, which gives them a better look than draft quality. Unfortunately, the tiny printed dots are still somewhat noticeable.
- *Draft quality.* Draft output is a very low-grade print quality. All the dots that make up a printed image are noticeable.

RASTER IMAGES

Raster is a rectangular area or grid of the monitor's display area used for images or for the mathematically created vector drawing processes. The size of the raster area depends on the resolution of the display area. Monitors use autosizing to calculate the raster grid size of a display area. A *raster image processor* (RIP) is used to translate complicated raster images and vector drawing sent to a laser printer. The RIP requires memory to store large images before they are processed. If there is not enough memory in the printer to support the image stored, it is more than likely that you will get a "Memory Overflow" error message. Resolution enhancement technology (RET) allows a printer to print raster images at a higher resolution than the printer is technically capable of. RET used a combination of technologies to fill in the spaces between dots on an image for better visual quality. Decreasing the printer's resolution and decreasing the RET can also help to reduce the frequency of "Memory Overflow" error messages.

LASER TECHNOLOGIES

Laser printer manufactures utilize different laser printing technologies and processes to attain the same result of producing a high-quality image on final output. For the A+ core test, we are focusing on the EP process. There are three important laser-printing processes that you should be familiar with.

- *LCD process.* The LCD process technology replaces the laser used in the EP process with an LCD panel or grid to write an image to the photosensitive drum.
- *Light-emitting diode (LED) process.* LEDs are used in this technology in place of a laser beam to provide a light source to the photosensitive drum.
- *Electro photographic (EP) process.* The EP process is by far the most common printing process in use today. A laser beam, mirror, toner, and EP drum are used to produce a final image.

THE EP LASER PRINTING PROCESS

The stages of the EP laser printing process that you need be familiar with for the A+ Adaptive core exam are listed below. Figure 6.5 shows a diagram of the EP laser printing process.

1. *Cleaning.* The EP drum must be cleaned, erased, and desensitized of any electronic charge it may have as a result of a previous process. A rubber blade is used to remove any toner or particles from the drum. The used toner is disposed of into a cleaning unit or bucket. A fluorescent lamp is used to remove any electronic charge retained by the EP drum from a previous process. This preparation stage is vital; the drum must be properly prepared in order to produce a sharp image. Think about it: if your camera lens is dirty, you are probably not going to get a clear picture.

2. *Conditioning.* At this point, the EP drum cannot hold an image; it needs to be conditioned to do so. This is accomplished with a charge of −600V applied to the EP drum by the primary corona wire. The charge is evenly distributed across the entire drum, creating an electronic field. This process enables the drum to become photoconductive and prepares it for the writing phase.

3. *Writing.* At this stage of the process, the printer's laser beam writing unit and a series of mirrors are used to draw tiny dots on the EP drum, which represent the final image to be produced. The area of the drum that the laser beam comes in contact with loses some of its negative charge (by approximately −100V) and becomes relatively more positive (the charge is still considered negative, just not as negative as the areas not hit by the laser beam). When the laser beam has finished creating the image on the relatively positive EP drum, the printer's controller starts the paper sheet-feed process by pulling a

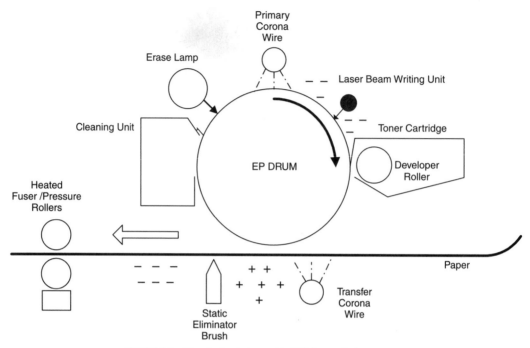

FIGURE 6.5 The electrophotographic (EP) laser printing process.

sheet of paper into the printer. The paper stands ready at the printer's registration rollers until the controller directs it farther into the printer.

NOTE Paper-feed rollers have sensors to control the proper flow of paper out of the paper tray. It is a common occurrence to receive a "paper jam" error on the printer LED display but on investigation, you find that there is no paper in the tray. Chances are there is a particle of foreign matter in the way or the sensor is dirty.

4. *Developing.* At this point in the process, the EP drum is ready to accept toner on the areas or dots that have a more positive charge. The toner cartridge houses a toner-developing roller that is magnetized and constantly turning. The magnetized roller attracts the toner particles located near it and dispenses the toner to the positively charged areas (dots) on the rotating EP drum. The EP drum now has a "picture," or mirrored duplicate of the image, to be placed on the paper.

5. *Transferring.* It's time to get the image, drawn in toner, from the drum to the paper. Keep in mind that the toner is being held on the EP drum with a relative negative charge. At this point, the paper has been pulled into the printer. The paper passes by the transfer corona wire, or in some printers a transfer roller, where it receives a highly positive charge on its backside. The paper then passes under the negatively charged EP drum and the toner is transferred onto the highly charged paper. A static charge eliminator, otherwise known as an eliminator comb, is used to keep the paper from wrapping itself around the EP drum.

6. *Fusing.* The toner must now be fused or bonded onto the paper. A fuser assembly, which is a quartz heating lamp inside a roller tube, is situated above a rubber roller pressure assembly. The paper and its toner are fed between the two devices. The toner is heated (melted) by the fuser assembly and pressed onto the paper permanently by the pressure rollers. It is important to note that there is a built-in temperature sensor on the heated rollers. If the temperature during this process rises above 180 degrees Fahrenheit, the sensor will shut down the printer.

 Silicon oil is used to lubricate the fusing rollers during the fusing process to keep paper from sticking to the rollers.

7. *End of cycle.* A cleaning pad is used to remove excess toner and residue from the heated rollers. The paper containing the final image is rolled out of the printer.

CHAPTER SUMMARY

This chapter introduced some of the most common types of output devices in use today. You should have paid close attention to monitor types and their associated resolutions, colors, and technologies. At this point you should also have a good understanding of dot matrix and laser printing technology, including the EP laser printing process. If you have trouble answering the chapter review questions at the end of this chapter, go back and read the chapter again. If you want to pass the core test, you are going to have to master questions very similar to these questions relating to output devices.

REVIEW QUESTIONS

1. A video adapter resolution of 800×600 represents which video standard?

 ○ A. CGA

 ○ B. VGA

 ○ C. SVGA

 ○ D. Monochrome

 Answer: C

 As displayed in Table 6.2, a resolution of 800×600 is supported by SVGA. CGA supports 320×200 and 640×200. VGA supports 640×480 and 320×200. Monochrome supports 720×350.

2. Which of the following relates to time required for the electron gun to redraw the display?

 ○ A. Interlace

 ○ B. Refresh rate

 ○ C. Dot pitch

 ○ D. Pixel triad

 Answer: B

 The electron gun inside the CRT must redraw the image continuously in order to keep the phosphors active. The speed at which the CRT accomplishes this process is called its refresh rate. Interlace, or interlacing, is a video technique used to scan all odd-numbered lines of a video display in succession, followed by the even lines. Dot pitch is the distance measured between pixels. A pixel triad is the combination of the three electron beams projected from the electron gun to form a triangular representation of the three primary colors.

3. What problem would a bent or broken DB-15 male connector pin cause?

 ○ A. FRU displacement

 ○ B. Monitor problems

 ○ C. 800×600 pixels

 ○ D. Fragmentation

Answer: B

A DB-15 male connector is used to plug a monitor into a computer system. If one of the pins on this connector is bent or broken, you will most likely experience monitor problems. Fragmentation refers to files being stored on a hard disk in noncontiguous clusters.

4. You should not use it while working on a monitor. However, you should use it when installing a video adapter card. What is it?

 ○ A. An electron gun
 ○ B. Antiphosphorus beam
 ○ C. A multimeter
 ○ D. An ESD wrist strap

 Answer: D

 You should never wear an ESD wrist strap while working with the components inside of a monitor. An electronic reaction may occur that can be deadly. You should, however, wear a protective wrist strap while installing adapter cards in a system to protect them from ESD. An electron gun is used in a monitor to direct an electronic beam to the back of a glass screen that has a phosphorus coating. A multimeter is a device used to measure wattage.

5. You have changed your display settings while using Windows 98 and have rebooted your system. Windows will not come up. What mode would you use to troubleshoot this problem?

 ○ A. 386 Enhanced Mode
 ○ B. Safe Mode
 ○ C. Graphics Mode
 ○ D. SVGA Mode

 Answer: B

 You can enter Windows 98 Safe Mode by pressing the F5 key on startup. Safe Mode loads a generic VGA driver for basic video. This allows you to reenter the operating system and change your video adapter driver and display settings as needed. The 386 enhanced mode is a processor mode introduced with the Intel 80386 processor that allows Windows 3.x to offer multitasking abilities.

6. Which of the following are printer-consumable items? (Choose 3)
 □ A. Platen
 □ B. Print buffer
 □ C. Toner cartridges
 □ D. Printer drivers
 □ E. Printer paper
 □ F. Printer ribbons

 Answers: C, E, and F

 Toner cartridges, paper, and disposable ribbons are considered printer-consumable items.

7. Several users have been trying to print reports to a networked printer. The users complain that their reports are not printing. What would you do to solve this issue?
 ○ A. Press the reset button on the printer.
 ○ B. Go into Safe Mode and remove the print driver.
 ○ C. Realign the platen.
 ○ D. Delete the reports from the printer queue (buffer), then stop and start the print spooler service.

 Answer: D

 With a networked printer, print jobs are typically queued in a printer buffer that is managed by the print spooler service. If print jobs are not printing to a networked printer, this process clears the print queue and allows print jobs to be resubmitted and printed.

8. Your printed output appears to be fading from left to right. What is causing this problem?
 ○ A. The printer ribbon is old.
 ○ B. The print driver is outdated.
 ○ C. The platen is out of alignment.
 ○ D. The print head is wearing out.

 Answer: C

 A misaligned platen commonly results in a faded level of ink application to the paper from left to right or in uneven lines of output across the paper.

9. A laser printer is producing inconsistent, wavy output. What very common cause is associated with this problem?

 ○ A. The rollers are broken.
 ○ B. The fuser is damaged.
 ○ C. The platen is out of alignment.
 ○ D. The toner cartridge is empty.

 Answer: D

 If the laser-printed output begins to appear wavy or inconsistent, the problem may be an empty or malfunctioning toner cartridge.

STORAGE DEVICES AND INTERFACES

IN THIS CHAPTER

- The Floppy Drive
- The Hard Drive
- Drive Controllers and Interfaces
- Device Installation, Configuration, and Troubleshooting
- Optical Storage Devices
- SuperDisks and Zip Drives
- Chapter Summary
- Review Questions

In Chapter 4 we discussed RAM, which is temporary or primary storage. In this chapter, we discuss forms of permanent or secondary storage devices, such as hard drives, floppy drives, Zip drives, tape devices, and optical storage. Permanent storage devices are sometimes referred to as mass storage or auxiliary storage devices. We also explore the interfaces and technologies used to connect storage devices to a computing system. Some of the more common interfaces are IDE/ATA and SCSI.

The core exam is likely to test your knowledge of the proper methods of configuring, connecting, and troubleshooting storage. It seems that the recent A+ core exam focuses heavily on storage devices. The test will probably concentrate on your ability to install and configure multiple hard drives

and dwell on the details of SCSI configurations and priorities. Pay close attention to the topics discussed in this chapter; they may make the difference on whether you pass or fail the core exam.

THE FLOPPY DRIVE

A *floppy drive* is an internal device that reads or writes information to and from magnetic floppy disks and communicates with the system's CPU. The floppy drive is typically mounted into an available drive bay inside the system unit. A floppy drive adapter kit may be necessary if you are installing a floppy drive unit into a large drive bay. Older computing systems used 5.25-inch floppy drives that required a larger bay. Today, most computing systems come with a standard 3.5-inch floppy drive installed. Similar to a hard drive, a floppy disk stores information on magnetic media. A hard drive's storage medium is called a platter. A floppy drive's storage medium is called a floppy disk. The major advantage of a floppy disk is that it is portable. You can store files on a floppy disk and take it wherever you go. The major disadvantages of floppy disks are that they are slow to access and cannot store as much information as a hard disk.

A floppy disk must receive both a low-level format and a high-level format before it can be considered useful.

A *low-level format* prepares the floppy disk with an organized structure by creating sectors, tracks, and clusters on the floppy disk. A *high-level format* prepares the floppy disk with a file allocation table (FAT) and adds a root directory to it. You can format a floppy from a DOS command prompt or through the use of an operating system GUI, such as Windows. Preformatted floppy disks can be purchased just about anywhere computer supplies are sold.

To format a floppy disk from a DOS prompt, simply place the disk in the floppy drive "A:" and type "format a:" from the DOS prompt. A low-level format as well as high-level format will be carried out on the disk. When the format process is complete, the floppy will be ready to have files saved to it. See "The Hard Drive" section later in this chapter for more information on the formatting process.

There are two basic forms of floppy disk media available:

- *5.25-inch.* This style of floppy disk was popular in the1980s. The 5.25-inch floppy came with two common data storage capacities:

360K and 1.2MB. The 5.25-inch floppy disk used a 5.25-inch floppy drive that is now considered obsolete.

- *3.5-inch.* This floppy drive is found in most computers today. The 3.5-inch floppy disk can store 720K (double density) or 1.44MB (high-density) of data.

FLOPPY DRIVE COMPONENTS

A floppy drive's components are similar to that of a hard drive. The basic components that make up floppy drives include the *read-write heads*, which read and write data onto the floppy media and work in tandem with an erase tunnel mechanism to erase information, if requested by the floppy drive's controller. The *head actuator,* sometimes referred to as a stepping motor, is controlled by the floppy disk controller; it moves the drive's read/write heads in and out of place. A *spindle motor,* driven by a belt system, makes the floppy disk spin or rotate at the desired speed. The speed at which the floppy disk spins is measured in revolutions per minute. A floppy drive uses a *circuit board,* also known as a logic board, which controls all the floppy drive's components and communicates with the computer system. Finally, there are two floppy drive connectors. One is used to connect the floppy drive to the system's power supply and the other is used to connect the floppy drive to the motherboard's floppy drive controller.

FLOPPY DRIVE CONFIGURATION AND TROUBLESHOOTING

A floppy drive is connected to a floppy drive controller on the motherboard with a data cable. The data cable has a red stripe that runs down its right side. The red stripe represents pin 1 on the data cable. When plugging the data cable connector into the floppy drive controller on the motherboard, you must match pin 1 on the data cable connector to pin 1 on the controller. The same is true when connecting the other end of the data cable to the floppy drive itself. If you plug the floppy drive's data cable in backward, the LED light on the front of the floppy drive unit will stay lit, and you will not be able to access the floppy drive.

A computer system reserves certain letter designations for its components. The primary hard drive gets the letter designation of C by default. The letters A and B are reserved by the system for assignment to the floppy drives. A typical 3.5-inch floppy drive is attached to the far end of a ribbon data cable (after the twist in the ribbon cable) and gets the A letter assignment. If you have a second floppy drive, such as a 5.25-inch floppy drive,

it should be attached to the middle connector on the floppy data cable, and it gets the B assignment.

Over time, floppy drives and floppy disks can get dirty and warped. This can cause them to fail mechanically or render them incapable of data storage and retrieval. If you attempt to access your floppy drive and receive an error message such as "Drive A is not ready, Abort, Retry or Fail," either your floppy disk is bad or your floppy drive needs cleaning and or maintenance.

There are times when you may need to boot up your computer with a bootable floppy disk installed in the A drive. This is frequently done for troubleshooting purposes, maintenance, or operating system installation. If you are unable to boot to your bootable floppy disk, check your boot sequence settings in the BIOS configuration and verify that your system is set to boot to the A drive before the C or D drive. Otherwise, the system will not look for your bootable floppy at startup.

One of the most common mistakes people make is leaving a nonbootable floppy disk in a floppy drive and then restarting the system. This can cause the error message "Nonsystem disk or disk error; replace and strike any key to continue." Ejecting the nonbootable floppy from the drive and pressing any key on your keyboard will bypass this error message, and your system will continue to load. (By the way, there is no such thing as an "any" key.)

Exchanging floppy disks with others and using them in your system without proper virus protection poses a serious virus threat to your computer. The two most common sources of virus attack come from floppy disks and the Internet. Always scan your floppy media for viruses.

THE HARD DRIVE

There have been many names associated with the hard drive since its inception. It has been called the hard disk, the fixed disk, direct access storage device (DASD), and the C drive. For the purposes of our A+ core test study focus, we will use *hard drive* and *hard disk*.

The hard drive is a component attached to a computer system unit in a fixed manner. It is usually installed in a drive bay that is inaccessible from the front of the system unit. When purchasing a computer, it is important to consider a system unit that has enough drive bays available to support

multiple hard drives. You may wish to expand your storage capabilities in the future.

The hard drive is used as a mass storage device for data and programs. The hard drive is made up of metal platters, a spindle motor, an actuator arm, and a set of read/write heads. Hard drive space is measured in kilobytes, megabytes, and gigabytes.

Today's hard drives generally have a storage capacity between 10GB and 40GB and rotation speeds between 5200 and 7400 revolutions per minute.

In order for data to be stored, organized, and retrieved from a hard drive in a timely, organized fashion, the hard drive's media (platters) must be divided into separate tracks, sectors, cylinders, and clusters. The sizes of these separations are collectively known as a hard drive's geometry.

As mentioned earlier, a hard drive's components are similar to a floppy drive. Some of the main components and organizational units that make up a hard drive are listed below.

- *Platter.* A hard drive has many platters. A platter is a circular magnetized disk that holds information and programs. The platters that make up a hard drive are stacked on top of each other with head actuators and read/write heads between them. Platters can store information on both sides.
- *Landing zone.* Older hard drives used the landing zone as a place to position the read/write heads of a hard drive when they where not in use. The landing zone is an area of the hard disk that does not have data stored. The landing zone is now obsolete.
- *Read/write heads.* Hard drives and floppy drives have read heads that read and write data to the hard drive's platters. Most hard drives have two heads for each platter. One head is used to read and write data to the top of the platter, the other is used to read from and write to the bottom side of the platter. Six platters (or magnetic disks) have a total of 12 heads.

 If you hear a grinding noise coming from inside your computer, your read/write heads may be "crashing" onto the hard drive's platter. This will most likely result in a hard drive failure.

- *Tracks.* A hard drive platter is divided into many tracks. Picture a horseracing track with separate lanes all lined up next to each other forming a circle. The platter is the entire racetrack. The tracks are

separate lanes running parallel to each other in a circle. The tracks are numbered consecutively for organizational purposes. The first track is track 0. It is located closest to the outside edge of the platter. Floppy disks also have tracks. The average floppy has 80 tracks.

- *Sectors.* The smallest measurable area on a hard drive is a sector. A sector can hold a maximum of 512 bytes of information. A sector is a section of a track. Picture the racetrack again. A single lane is broken down into smaller units called sectors. A platter on a typical hard drive contains approximately 63 sectors per track (this number can vary depending on your system BIOS settings). Figure 7.1 illustrates the single side of a platter and identifies a sector within a track. A group of sectors is called a cluster.

- *Cylinders.* Cylinders are a logical grouping of similar numbered tracks on all the platters combined. For example, if you have six platters, you would have a total of 12 surfaces or sides. Each side of the platter would have its own track 4. Remember, the tracks are numbered starting with track 0 from the outside edge of the platter. If you combine the four tracks on the 12 surfaces, you will have a logical cylinder 28. Typical BIOS configuration settings allow for a total of 1024 cylinders.

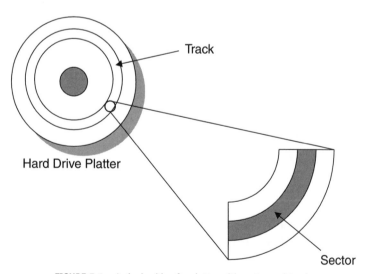

FIGURE 7.1 A single side of a platter with sector and track.

When your computer is powered on, the system BIOS looks for the boot sector or master boot record (MBR) on a hard drive for operating system load instructions. The boot sector is assigned to head 0, cylinder 0, track 0, and sector 0 on the first platter of a hard drive. If your boot sector becomes damaged or corrupt, you will most likely receive a "Bad or missing operating system" error message. This is a really good time to be happy about the daily backups you have been performing on your system. You may need to restore data back to the hard drive after you repartition and reformat the damaged disk. Read on for partitioning and formatting.

HARD DRIVE PARTITIONING AND FORMATTING

Two primary methods are used to prepare hard drives for supporting operating systems and applications: partitioning and formatting. Without being partitioned and formatted with an organized, logical file structure, a hard drive would be nothing more than a large metal paperweight. A hard drive must have the following processes done to it to be useful.

Partitioning

A hard drive normally receives a low-level format and is partitioned at the factory. If you receive or purchase a hard drive without a preinstalled operating system, you will need to partition and format the drive yourself.

Partitioning is the process of dividing one physical hard drive into separate areas of storage. In other words, you can create several logical hard drives out of one physical hard drive. This is useful for file storage purposes, installing multiple operating systems, and supporting multiple file system structures, such as FAT32 and NTFS. Two partition types can be created on a hard drive, primary partitions and extended partitions.

- *Primary partitions.* A primary partition is a partition that contains an active bootable operating system, such as DOS or Windows. It is the partition that provides the system files necessary to boot into the operating system. A hard drive can be divided into four primary partitions, but only one of the four primary partitions can be set as the active partition. The active partition is specifically designated the boot partition. It contains the MBR. The system BIOS looks to the active partition for boot-up commands. This partition is always labeled "C:".
- *Extended partitions.* Extended partitions can be separated into units called logical partitions. There can be up to 23 logical partitions on one hard drive. Each logical partition receives a different alphabetic assignment, such as d, e, or f. These partitions are used mostly for

file and applications storage. Any partition other than the primary partition is considered an extended partition.

DOS, Windows 3.X, and the early versions of Windows 95 are FAT16 operating systems and will allow you to create only a single partition size, up to 2GB. If you want to use more than 2GB of hard drive space with these operating systems, you will need to create multiple partitions of 2GB. If you want to use more than 2GB for a single partition on a single hard drive, you will need to use a newer operating system that supports FAT32 or NTFS file systems. Windows 98, Windows 2000, and Microsoft Millennium allow you to create a single partition of up to 4TB terabytes (TB).

FDISK

FDISK is a common DOS utility program that allows partitioning of a hard drive. FDISK is located on a DOS bootable disk and is run from the command prompt.

To use FDISK, simply enter "FDISK" at a command prompt. If your hard drive is larger than 512MB, a menu appears that asks if you would like to enable large disk support. You have the option of replying "Y" for yes or "N" for no. Pressing "Y" accepts the default of yes and you are presented with the FDISK Options menu. At the FDISK Options menu, you can create one large partition for the whole hard drive. However, if you plan on dividing your hard drive into primary and extended partitions, you will need to use options 1, 2, and 3 to partition the disk accordingly. If you create more than one primary partition, you will need to set one of them as the active bootable partition. After creating partitions with FDISK and formatting partitions for operating systems and files, you can always use FDISK again to create new partitions. The FDISK Options menu has an option for displaying partition information, which can be a useful tool to assist you with making the right partition choices to suit your needs.

Third-party partitioning programs can be purchased that will allow you to partition a hard drive through the use of a GUI.

For the test, you can use FDISK to divide a hard drive into 3 primary partitions and 1 extended partition. The extended partition can be divided into 23 logical partitions. If you are installing a new hard drive and receive an "Invalid Media Type" error message after booting the computer, you will need to use the FDISK utility to repartition the drive and set the active partition. If you run FDISK after installing a large hard drive, and the entire space available on the new drive is not recognized, chances are your BIOS did not recognize the hard drive changes or was not updated before you ran FDISK.

FORMATTING

Before an operating system or application can be installed on a partitioned hard drive, the drive must be formatted. Formatting is a two-layer process that prepares a partition on a hard drive to accept an operating system, along with files and programs.

Two types of formatting are implemented before the operating system is installed.

- *Low-level format.* A low-level format is usually done at a factory before the hard drive is shipped. A low-level format is a type of physical formatting process that erases all information and prepares the hard drive for a logical structure. This type of format also looks for bad areas on the drive and marks them so that they are not used as potential storage locations. A low-level formatting creates tracks and a sector on the hard drive platters and determines what type of disk controller will be able to access the hard drive; the controller may be IDE/ATA, EIDE, or SCSI. A low-level format takes place before the hard disk is partitioned.
- *High-level format.* High-level formatting is often referred to as "formatting a hard drive." A high-level format creates a FAT and root directory on the hard drive. This is the process that actually prepares the drive for an operating system. The FAT is a logical structure that keeps track of which sectors certain files are stored in on the hard drive. The FAT has the ability to identify good and bad sectors on a hard drive. When you install a newer operating system or upgrade your current operating system to a newer version, the formatting process is normally done for you automatically. A high-level format takes place after the hard drive has been partitioned.

FORMAT.COM is a DOS utility program that is also run from the DOS command prompt. The FORMAT command will allow you to format the hard drive in preparation for an operating system. You can also format the hard drive from within an operating system, such as Windows, if the operating system supports FORMAT.

From a DOS command prompt, type

```
FORMAT D:
```

You can replace D: in this example with the letter of any drive you wish to format.

Scandisk and Defrag

Over time, the constant use of your hard drive can cause the sectors to get worn out or damaged. Utility programs such as Scandisk, Norton Utilities, and Check It are available that help you identify bad sectors on a hard drive. If you are developing bad sectors on your hard drive, it is a good idea to run Scandisk and select the "thorough" option in the Scandisk settings options. This runs a complete scan of your hard drive and attempts to fix any bad sectors it finds.

When files are written to a hard drive, they are not stored in contiguous order (one file written directly after another file). Files are stored in a non-contiguous order (anywhere there are available blocks of space). After a while, this can cause the clusters on your drive to become fragmented. It takes time for the CPU to request a file from the hard drive, and it takes even more time if the files are not in any order. Windows offers a built-in utility program called Disk Defragmenter that will help put clusters of files into a contiguous structured order. Running Disk Defragmenter, or defrag, can increase the disk access time and the overall performance of your system. If a customer complains that his or her system is getting slower over time, running the defragmenter utility will most likely assist you with restoring the customer's disk access time. It is important to note that Windows 9.x, Windows Me, and Windows 2000 offer built-in defragmenter utility. Windows NT does not. This is discussed in more detail in Section 2 of this book.

DRIVE CONTROLLERS AND INTERFACES

A hard drive uses its own internal controller board and processor to manage the interaction of read/write operations. The controller board also provides support for interfaces such as IDE/ATA, EIDE, or SCSI.

Before we continue with interface specifications, it is important for you to understand the basic connectors located on the back of a typical hard drive (Figure 7.2). Two main connectors and a set of jumpers are usually located at the rear of the hard drive. The first connector is a 5-pin power connector that receives 5V and 12V DC power from the system's power supply. The 5V power is the "dangerous power" used by the hard drive's circuit board. If the 5V power fluctuates, your hard drive's circuit board and components may be in danger. The 12V power is used to power the hard drive's motor and actuator heads. The second connector is an IDE 40-

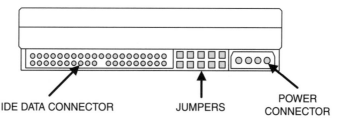

IDE DATA CONNECTOR JUMPERS POWER CONNECTOR

FIGURE 7.2 A hard drive with built-in connectors.

pin data connector or a SCSI connector. This connector is used to transmit and receive information and instructions from the computer's processor.

Plastic jumpers are used with IDE interfaces to set the configuration of the hard drive as either a master or a slave drive along with the use of a data cable that supports multiple or shared interfaces. SCSI devices use plastic jumper blocks to uniquely identify SCSI drives or controller cards.

A hard drive communicates with a computer system through the use of an interface. Several communication transfer interfaces and standards ensure that a hard drive will be compatible with a system's motherboard and processor. These standards are in place to assist manufacturers with a common set of electronic rules for interfaces.

ST506 INTERFACE

Now obsolete, the ST506 was the first standard interface developed in 1980 by Seagate Technologies (ST). This interface required the installer to modify the CMOS configuration manually, provide a low-level format, partition the drive manually, and finally, provide a high-level format. This standard was universally accepted based on its ability to attach to a standard interface data cable.

ESDI INTERFACE

Introduced in 1983, the Enhanced System Device Interface (ESDI) standard for hard drives was the first interface standard to have a controller actually reside on the hard drive itself. It required a compatible ESDI controller installed on the motherboard. ESDI technology was several times faster than ST506 and was much more expensive as a result.

IDE/ATA INTERFACE

The IDE/ATA is currently the most widely accepted interface standard. The IDE is an interface controller built into the hard drive. ATA is actually

a set of rules or specifications that apply to the IDE controller. ATA allows you to have a master drive (drive 0) and a slave drive (drive 1). ATA also provides a way for multiple hard drives to communicate with the same system bus. If your motherboard does not have an IDE/ATA interface, or your system only has one IDE controller, you can purchase an IDE add-on expansion card, such as a PCI card that supports this technology. This will allow you to have up to four devices.

One of the major advantages of IDE is that it can provide sector translation. This allows you to change the drive's properties in CMOS configuration settings. It also allows computer systems to recognize hard drives larger than 528MB by utilizing Logical Block Addressing (LBA) support. LBA is considered a type of IDE transaction. You can enable LBA support, if available, in your BIOS configurations settings for your hard drive.

There are two common transfer methods or protocols used to communicate information between memory and an IDE/ATA hard drive controller.

- *Programmable input/output (PIO)* is a standard whereby the transfer of information between memory and the drive is controlled by the system's processor. PIO is measured in megabytes per second. Most versions of IDE/ATA can utilize PIO modes 0 and 1. Table 7.1 shows PIO modes and transfer rates per second. IORDY is a CMOS configuration that controls the speed of a disk head as it moves across a platter. IORDY is used with PIO modes 3 and 4.
- *Direct Memory Access (DMA).* All IDE/ATA hard drives support DMA. As mentioned in Chapter 5, DMA is used to transfer information from memory directly to a peripheral, such as a hard drive, without interrupting the processor.

Several improvements have been made to the original implementation of the ATA standard interface. These improvements allow more devices to be attached to an ATA interface and increase the speed at which data can

TABLE 7.1 PIO Modes and Transfer Rates per Second

PIO Mode	Transfer Rate Per Second
0	3.3MB
1	5.2MB
2	8.3MB
3	11.1MB
4	16.6MB

pass between an ATA interface and a device. Some of the ATA standards that you should be familiar with are listed below.

- *ATA*. Traditional ATA, also known as IDE, provides support for up to two hard drives per controller. ATA has a 16-bit interface and utilizes PIO modes 0, 1, and 2.
- *ATA-2*. ATA-2 provided support for LBA (support for drives larger than 504MB) and is sometimes referred to as Fast ATA. ATA-2 provides support for PIO modes 3 and 4. ATA-2 is basically the same technology as EIDE (which is discussed in the next section). It is an improvement on the original IDE/ATA standard that allows for up to four devices to be connected to one motherboard interface controller, for a total of eight devices in a typical system.
- *Ultra-ATA*. Known as Ultra-DMA, ATA-33, or UDMA/-33, Ultra-ATA provides support for multiword DMA mode 3 running at 33 MBps. The technology assists with keeping the CPU synchronized with faster hard drives.
- *ATA/66*. ATA/66 is a newer version of ATA that doubles the traditional ATA throughput to 66 MBps. An ATA/66 data cable is different from an ATA/33 cable. You can differentiate the two by the number of wires in each data cable.

EIDE (SIMILAR TO ATA-2) INTERFACE

Enhanced IDE (EIDE) technology is the same technology as IDE/ATA. It improves on the original IDE standards by allowing ATA drives to utilize PIO modes 3 and 4. An EIDE interface can support up to four drives on the same interface, including CD-ROMs, DVD-ROMs, and tape drive units. EIDE uses Advanced Technology Attachment Packet Interface (ATAPI) standards to allow a controller to communicate with CD and tape drive devices.

SCSI INTERFACE

If you need more than four devices and want the fastest throughput available for storage devices, than a SCSI chain is what you want. A SCSI chain is a group of SCSI devices attached together with a centralized SCSI controller that requires only one IRQ for the entire chain of devices. SCSI is not technically defined as an interface; it is really an I/O bus in itself.

SCSI technology supports peripheral devices such as hard drives, hard disk arrays, tape units, and CD-ROMs.

If you want to attach a tape drive unit to a SCSI interface you must enable
INT 13h support on the SCSI controller card.

SCSI devices have unique SCSI ID numbers associated with them. These
ID numbers are typically set with a jumper block on the SCSI device that
includes three switches. Each switch setting represents a series of binary
numbers that set a unique ID for each device. Each number represents the
device's position on the SCSI chain; these numbers are 0 through 7 for a
SCSI 1 chain. The highest ID that can be assigned on a three-jumper SCSI
1 device is 7. A typical SCSI 1 chain can have up to eight devices (numbered
0 to 7) attached to it. A SCSI controller card is considered a device and uses
SCSI ID number 7. That leaves seven SCSI IDs (0 to 6) available for pe-
ripheral devices.

A SCSI controller card, otherwise known as a SCSI adapter card, can be
plugged into any available PCI, VESA local (VL-Bus), EISA, or ISA expan-
sion slots.

SCSI priorities are applied from the highest ID number on the SCSI
chain to the lowest number. For example, on a SCSI 1 chain, the controller
with the unique SCSI ID of 7 has the highest priority. The priority de-
creases as you move down the SCSI chain to device 0. The same is true for
the more popular SCSI 2 chain, which allows for 16 devices numbered 0 to
15. Device 15 would have the highest priority on the chain; device 0 would
have the lowest priority.

A SCSI chain must be terminated at both ends. Most SCSI devices come
with a built-in terminator (*terminator* is another word for *resistor*). A *ter-
minator* absorbs a signal so that the signal is not sent back from where it
came, causing a signal collision to occur. If you have a SCSI chain with
hard drive and a CD-ROM, you will need to terminate both ends of the
SCSI chain for proper signal transmission to occur. In this case, you would
terminate the SCSI hard drive and the SCSI CD-ROM.

There have been several improvements made to SCSI technology since
its original implementation. The following list stresses the important facts
in reference to SCSI advances.

- *SCSI-1.* Original implementation of SCSI technology. SCSI 1
 implements an 8-bit data bus and supports 4Mbps data transmission
 rates. It requires a host adapter and can support up to seven other
 devices. SCSI-1 uses a 25-pin DB connector.

- *SCSI-2.* Similar to SCSI-1, except that SCSI-2 uses a 50-pin Centronics connector. SCSI-2 is the most common implementation of SCSI. It supports up to 16 devices, including the controller card. SCSI 2 introduced the concepts of bus mastering and command queuing to SCSI. These improvements increased transfer rates and allowed SCSI devices to handle multiple instruction sets.
- *SCSI-3.* Also referred to as Fast/Wide SCSI, SCSI-3 is a combination of SCSI specifications. SCSI-3 utilizes a 16-bit bus and supports data transfer rates to 40 mbps. SCSI-3 includes three subsets that are known as SCSI parallel interface or SPI specifications. These specifications are SPI-1 (Ultra SCSI), SPI-2 (Ultra 2 SCSI), and SPI-3 (Ultra 3 SCSI). Each specification adds to the functionality and throughput capabilities of SCSI-3. For the A+ test, 16-bit Fast/Wide SCSI is the most common implementation of SCSI.

DEVICE INSTALLATION, CONFIGURATION, AND TROUBLESHOOTING

A typical IDE/ATA interface supports two devices per motherboard controller. Most systems today have two separate motherboard controllers, allowing for a total of four devices to be attached. An EIDE interface can support up to four devices per controller for a total of eight devices. EIDE is the same as ATA-2. ATA-2 is an improvement on IDE/ATA that also allows for up to four devices per controller, which equates to eight total devices.

For the purposes of the A+ core exam we will focus on the traditional IDE/ATA standard interface that allows for two devices to be attached to each of the two motherboard controllers. This allows us to have a total of four devices; for example, two hard drives, a CD-ROM, and a tape drive unit.

IDE hard drives, CD-ROMs, floppy drives, and other storage devices have jumper settings that determine the role they will play on an IDE interface. A jumper is a plastic and metal clip that is placed on two or more pins, which protrude from a device or a motherboard, to close a circuit. With these jumpers, you can set the hard drive to be a master or slave drive or choose cable select settings.

 If you want to specify a certain connector on an IDE data cable, set your jumpers for cable select.

A motherboard typically has a built-in primary and secondary controller (interfaces). A ribbon cable, with a red stripe that represents pin 1, connects the hard drive and an optional device, such as a second hard drive or CD-ROM, to the motherboard's primary IDE controller. Your primary master hard drive should be attached to the connector at the far end of the ribbon cable. When connecting the data cable to the hard drive, make sure that you match pin 1 on the adapter to pin 1 on the hard drive. The slave device should be connected to the middle connector. And finally, attach the other end of the data cable to the motherboard's controller, verifying again that pin 1 on the cable matches pin 1 on the controller. The secondary controller can be used to connect two more devices to the motherboard. If you are only using the primary controller to connect devices, you can disable the secondary controller in the BIOS to free up IRQ 15 for other peripheral devices. The first device attached to the secondary controller is known as the secondary master. The second device attached is called the secondary slave.

If you install a second device to an IDE interface, such as a hard drive, and the operating system is Plug and Play, the operating system will automatically assign a letter designation to the new device.

If you are installing two new hard drives on the same IDE channel, you need to configure one to be the master drive and one to be the slave drive. If you reboot and the slave drive is not recognized by the system BIOS, you should test the slave drive by configuring it to be the master drive, remove the original master, and reboot the system. This will tell you if you have an incompatible or bad drive.

If you notice that a hard drive's LED light indicator is constantly lit or pulsing, this is a sign that you need to install more memory.

Following are the basic steps to installing a hard drive.

1. Unplug the power cord that is connected to the back of the computer. Put on your antistatic wrist protector.
2. Remove the screws or clips that attach the computer's case to the system unit itself.
3. Determine whether the hard drive will be installed as a master or a slave device and make the necessary jumper changes on both drives to reflect your decision.

4. Plug one end of the data cable into the hard drive. Ensure that pin 1 on the data cable matches pin 1 on the drive. Plug the center connector into the slave drive if required. Plug the other end of the ribbon cable into the motherboard, also matching pin 1 of the cable to pin 1 on the motherboard's controller.

5. Connect an available system power connector into the hard drive's power socket. Do the same for the slave drive if using a slave drive.

6. Anchor the hard drive or drives into an open drive bay with screws.

7. Replace the system unit's cover. Take your wrist strap off. Plug the computer's power cord back into the system. Power the computer on.

8. If the CMOS hard drive settings are set to auto-detect, the hard drive or drives should be detected for you. If not, you will have to manually set the drive's geometry, including the number of cylinders, sectors, and heads in the BIOS settings.

9. Partition and format the drive or drives if no operating system is present.

OPTICAL STORAGE DEVICES

Optical storage devices and the usefulness of optical storage media such as the compact disk read-only-memory (CD-ROM), compact disk recordable (CD-R), compact disk rewritable (CD-RW), and digital versatile disk (DVD) have taken the computer industry by storm. Optical media were originally intended as a replacement for recordable cassette tapes in the music industry, but as we know, optical media offer many advantages to the data storage world and has put the beloved 1.44MB floppy disk to shame. Although optical storage devices have a much slower access time than hard drive technologies, they offer many benefits. We can store books, music, pictures, and files on optical storage media. We can watch movies with DVD technology. The possibilities are almost endless, at least until the next form of storage media comes around.

CD-ROM

A CD-ROM is an optical storage disk capable of storing large amounts of data. A typical CD-ROM can hold 600 to 800MB of information. This is equal to the storage capacity of about 700 1.44MB floppy disks. CD-ROMs

are well suited for storing graphics files, movies, and music. A CD-ROM is typically written to, or "burned" to, once with information provided by the manufacturers of the CD. Optical media such as CDs have information burned into them by a laser beam. Actually, the term *burned* is used quite loosely here. For information to be written to a CD, the actual process involves changing the reflective properties of an organic dye that covers a CD by use of a laser. The data can only be written to a disk one time. Reading the data on a CD-ROM requires the use of a CD-ROM device or player.

CD players and writers can be installed internally or connected externally to a computer system. Most computers today come with an internal CD player installed. An internal CD device is typically installed as a slave device on either the primary or secondary IDE controller. An external CD device is connected to a SCSI, parallel, or USB port.

MSCDEX.EXE (Microsoft CD-ROM Extension) is a file that contains a 16-bit software driver, which enables older operating systems such as DOS and Windows 3.X to interact with and control CD-ROM players. MSCDEX was later replaced in Windows 95 by the 32-bit CD-ROM File System (CDFS), which offered better performance.

CD-R

A CD-R is an optical form of media that allows information to be written to the CD one time and read many times by the end user. It is sometimes referred to as write-once, read-many (WORM). To create CDs using CD-R technology, you need a compact-disk recordable drive and a CD-R software program installed in your system.

CD-R technology is excellent for storing personal data and providing data backup capabilities. When purchasing such a unit and software, make sure that it has the capabilities for multisession recording. This is the ability to add files to a section of the CD that has not yet been written to. CD-R technology has become more affordable and is now commonplace.

CD-RW

CD-RW is the most popular CD technology at the present time. A CD-RW disk, with the use of a CD writing device, allows you to write information to the entire disk many times (approximately 25 times). CD-RW disks are more expensive than CD-R but are well worth the price for the capabilities they offer. CD-RW technology will most likely be replaced by DVD technology when DVD storage advances become somewhat affordable.

DVD

DVD is quickly becoming the optical player and storage technology of choice. It has the capability to store up to 17GB of data, which is many times that of a CD-ROM, and can support several full-length motion pictures on one disk. DVD uses Motion Pictures Expert Group (MPEG) compression standards to provide its tremendous storage capabilities. Another great feature of DVD technology is that it backward-compatible with CD-R and CD-RW. This means that DVD can read CDs that you have created with CD-R or CD-RW technology.

Several types of DVD technology are available today.

- *DVD-ROM.* The DVD drive installed in your computer.
- *DVD-R.* Similar to CD-R technology. The DVD-R disk can record or be written to one time. It is capable of recording up to 3.95GB of information.
- *DVD-RW.* A DVD-based technology, this disk has the ability to be written to many times. It can store data on either side of the disk.

TEST-RELATED TIPS FOR OPTICAL DEVICES

If a CD or DVD unit has become inoperative and you need to open the tray that holds the CD or DVD media, you can insert a pin or paper clip into the tiny hole on the front of the unit. This forces open the tray.

If you have inserted a music CD into your CD device and no sound is coming from the PC or connected stereo speakers, verify that the CD or DVD's audio cable is connected to an installed sound card.

If you install a new CD-ROM, CD-RW, or DVD device into a computer and it doesn't work after the installation, the first troubleshooting step should be to verify that the jumper settings on the device are configured properly.

SUPERDISKS AND ZIP DRIVES

SuperDisks and Zip drives are used to store substantial amounts of information, which can help you free up hard disk space. They are an excellent portable storage alternative when you need more storage capability than a 1.44MB floppy can provide.

The average SuperDisk can store 120MB of data while remaining compatible with the average 1.44MB floppy disk. SuperDrive technology supports IDE, PCMCIA, USB, and parallel connectivity.

Zip disks resemble floppy disks but are about twice as thick. Zip disks can store either 100MB or 250MB, which is convenient for storing graphics or any other large files or programs for archival purposes and exchanging large amounts of information. Zip drive technology supports a parallel or SCSI connection. The Zip drive can be external or internal to the system unit.

CHAPTER SUMMARY

This chapter covered very important material in relation to the current A+ core exam and its heavy focus on storage devices and their interfaces. We covered the installation, configuration, and troubleshooting of the major storage devices and their components. There are many Internet sites available that go into far more detail with storage device engineering than is required for the goal and scope of this book. In order to be a proficient computer technician, you need hands-on practice installing and troubleshooting storage devices and computer-related equipment.

REVIEW QUESTIONS

1. A technician installs a 2GB hard drive and proceeds to run the FDISK utility. FDISK only shows a 540MB hard drive. What action did not take place?

 ○ A. FDISK recognizes 540MB only by default.

 ○ B. The version of FDISK was not updated.

 ○ C. The BIOS was never updated.

 ○ D. The technician should have run Defrag.

 Answer: C

 When installing a new hard drive it is important to verify that the hard drive settings have been updated in the system BIOS settings. If the BIOS settings for the hard drive are set to AUTO (auto-detect), the full capacity of the hard drive should be recognized.

2. What is the maximum number of devices, not including the SCSI controller card, that can be attached to a Fast/Wide SCSI-2 bus?

○ A. 1

○ B. 7

○ C. 10

○ D. 15

Answer: D

A Fast/Wide SCSI-2 bus can support 15 devices, *not including* the SCSI controller card. SCSI-1 can support seven devices.

3. Which numbers display the SCSI priorities for devices on a SCSI chain from lowest to highest?

○ A. 1–8

○ B. 7–1

○ C. 0–15

○ D. 2–14

Answer: C

On a SCSI-1 chain, the controller with the unique SCSI ID of 7 has the highest priority. The priority decreases as you move down the SCSI chain to device 0. The same is true for the more popular SCSI 2 chain, which allows for 16 devices, numbered 0 to 15. Device 15 would have the highest priority on the chain; device 0 would have the lowest priority.

4. Your computer made a grinding noise and then the screen goes blank. What is the most probable cause?

○ A. The read/write heads crashed onto the hard drive's platter.

○ B. A virus caused your resolution to exceed itself.

○ C. Your computer went into hibernation mode.

○ D. The hard drive cable was installed backward, resulting in a crash.

Answer: A

If you hear a grinding noise coming from the computer, the read/write heads may be crashing onto the hard drive's platter. This will most likely result in a hard drive failure.

5. You have noticed that your system is running slower over time and that you have several bad sectors. What two utilities would you run to rectify this situation?

○ A. FDISK and FORMAT from the command prompt.

○ B. COMMAND.COM and Defrag.

○ C. Create 23 logical partitions and make one active.

○ D. Scandisk with the "thorough" option and Defrag.

Answer: D

If the hard drive is developing bad sectors, it is a good idea to run Scandisk and select the "thorough" option in the Scandisk settings options. Running a defragmenter utility places the files stored on the hard drive in contiguous order, resulting in better file access performance.

6. You want to add a second IDE hard drive to a system. You have only one IDE controller on your motherboard, and it is already connected to a hard drive and a CD-ROM. What would you do?

○ A. Install an IDE add-on card.

○ B. Use a hard drive on the network.

○ C. Unplug the CD-ROM and attach the second hard drive when you want to use it.

○ D. Connect the second hard drive to a floppy drive controller.

Answer: A

If the motherboard does not have an IDE/ATA interface, or the system has only one IDE controller, you can purchase an IDE add-on expansion card, such as a PCI card, that supports this technology. This will allow you to have up to four devices.

7. You install a 5.25-inch floppy drive. When you power the computer on, the floppy drive light stays on. Where did you go wrong?

○ A. You plugged the floppy drive cable in backward.

○ B. You have an incompatible slave drive configuration.

○ C. You dislodged the onboard video card.

○ D. You didn't update the BIOS.

Answer: A

If you plug the floppy drive's data cable in backward, the LED (light-emitting diode) light on the front of the floppy drive unit will stay lit, and you will not be able to access the floppy drive.

8. You power up the computer and receive a "Bad or missing operating system" message. What is most likely the cause of this message?

 ○ A. The memory is corrupt.

 ○ B. There is an incompatible slave drive configuration.

 ○ C. There is a missing or corrupt boot sector.

 ○ D. The SCSI controller card has a priority of 15.

 Answer: C

 If the boot sector becomes damaged or corrupt, you will most likely receive a "Bad or missing operating system" error message.

9. A SCSI adapter card can be used with which available expansion slots? (Choose 3)

 □ A. PCI

 □ B. VL-Bus

 □ C. EISA

 □ D. USB

 □ E. AGP

 Answers: A, B, and C

 A SCSI adapter card can be plugged into any available PCI, VESA local (VL-Bus), EISA, or ISA expansion slots.

CABLES, CONNECTORS, AND PORTS

IN THIS CHAPTER

- External Ports
- Asynchronous and Synchronous Transmission
- Parallel Ports and Connectors
- Serial Ports and Connectors
- Keyboard and Mouse Connectors
- Video Connectors
- USB Connections
- FireWire (IEEE 1394)
- Wireless Connections
- SCSI Connectors
- Networking Connectors and Cables
- Chapter Summary
- Review Questions

Computing systems and other electronic devices use cables, connectors, and ports as a means to connect to and communicate with other devices. A cable is used to connect two devices. On each end of a cable is a connector; connectors are characterized as male or female. A cable's male connector plugs into a female port, which may reside on a computer system or peripheral device. A female connector is connected to a male port, which may also be located on a system or peripheral device. Ports can be classified as internal or external to a system. Internal ports reside inside the system unit and connect components and devices directly to the motherboard. External ports are

an extension of the motherboard or a peripheral device's circuit board that protrudes from the system or device. A port on the back of a system unit is often referred to as a connector. It is important for the purposes of the test that you realize the term *port* can be used interchangeably with the term *connector*. As you go through this chapter, you will be introduced to some of the finer details relating to cables and connectors. It is important to keep in mind that the exam will focus on the DB 25-pin and 36-pin Centronics D-shell parallel connector, 9-pin serial (COM) connector, DB 15-pin video connector, game/MIDI port connector, and 50-pin SCSI cable connector.

EXTERNAL PORTS

On the back of a computer system you will find ports that are an extension of the motherboard's form factor. You may find port extensions for devices such as NICs, AGP cards, modems, or sound cards. The expansion cards that these ports are attached to are inserted into the motherboard's form factor. Most motherboards today are based on the ATX form factor, as described in Chapter 2, and include external connections for a parallel port, two serial ports, USB or FireWire (IEEE 1394) ports, a game controller port with microphone and speaker jacks, and a video port. Figure 8.1 shows the external ports associated with the ATX form factor. Pay special attention to the keyboard and mouse PS/2 connectors—the exam may focus on your ability to identify these in a graphic.

The central focus of this chapter is these ports and the connectors associated with them. Before we continue with the fine details of ports and

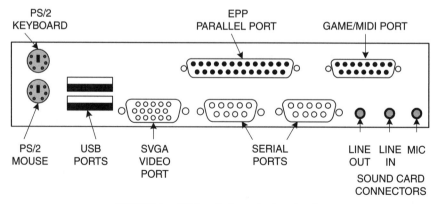

FIGURE 8.1 ATX form factor and external ports.

connectors, it is important to understand the transmission methods that many devices are capable of using.

ASYNCHRONOUS AND SYNCHRONOUS TRANSMISSION

Most peripheral devices, such as printers, scanners, and modems, utilize asynchronous transmission methods. With asynchronous transmission, data is not synchronized. Unlike synchronous transmission, data is not sent as a steady stream in a predetermined fashion. Instead, a start bit and a stop bit are placed between each piece, or "packet," of information. Asynchronous transmission methods are typically used for devices attached to parallel or serial ports.

Unlike asynchronous transmission, synchronous transmissions are steady streams of data that are predetermined by a clock or counter. The CPU communicates with internal devices synchronously, basing the transmission of data and instructions on its own internal clock.

TRANSMISSION MODES

When two devices connect to each other, they establish and utilize a transmission mode. The transmission mode established between the two devices depends on the technology and configuration of the devices. Three general transmission modes are available that determine whether the transmission of data between two devices will occur one way only, one way at a time, or both ways at the same time. These transmission modes are simplex, half-duplex, and full-duplex.

- *Simplex.* The simplex form of data transmission goes only one way; data or information can be transmitted in only one direction. A radio and speakers are examples of devices that utilize simplex communication.
- *Half-duplex.* With half-duplex data transmission, data can be transmitted in both directions but can only be transmitted in one direction at a time. An example of this transmission method is walkie-talkie: both parties can speak, but only one party can speak at a time.

Note: If two devices are set up so that they cannot send and receive data at the same time, they are utilizing half-duplex data transmission.

■ *Full-duplex.* In full-duplex transmission, or simultaneous transmission, data or voice can be transmitted at the exactly the same time. Human speech or a regular phone conversation is an example of full-duplex transmission that doesn't work well. Two parties can speak at the same time, although they might not understand each other. For the exam, serial communication is not capable of full-duplex transmission.

PARALLEL PORTS AND CONNECTORS

A parallel port, otherwise referred to as LPT1 or LPT2, is an external interface associated with the IEEE 1284 standard that is used to connect a computer to peripheral devices such as printers, CD players, scanners, or tape unit devices. Figure 8.1 shows a standard parallel port. A parallel port uses parallel transmission methods to transmit or send data 1 byte at a time to a peripheral device. A parallel cable has eight internal wires, and each wire is capable of sending 1 bit of information at a time. (Remember, there are 8 bits in 1 byte). Information is transmitted 8 bits across all at once, for a total of 1 byte, in only one direction at a time, using parallel transmission.

It is important to note for the core exam that parallel transmission methods are faster than serial transmissions. Serial transmission methods will be discussed shortly.

A parallel port on the back of a computer system is a female DB-25 connector that accepts a DB 25-pin male connector on one end of a parallel cable. The other end of a parallel cable has a 36-pin male Centronics D-shell connector that connects to a Centronics connector located on the back of a printer or device. Figure 8.2 shows the connectors on both ends of a typical parallel printer cable. Printer and scanner Centronics connectors typically use two clips to secure the connector to the port located on

FIGURE 8.2 A parallel printer cable.

the back of the device. In addition, it is important to note that a parallel cable can also be used to connect or network two computers together.

To ensure that the signals traveling down a parallel wire do not become distorted, the length of a parallel cable should not exceed 10 feet. Remember for the core exam that parallel transmission occurs 1 byte at a time and is faster than serial transmission.

SERIAL PORTS AND CONNECTORS

Today's computers typically come equipped with one or two RS232c-compliant serial ports that are also located on the back of a computer system. (Refer to Figure 8.1 for a standard serial port.) A serial port transmits data one bit at a time. To transmit a byte (eight bits) serially, eight separate bits are transmitted one at a time, one after another. For example, try to picture pouring eight marbles into a funnel all at the same time. Only one of the marbles can exit the funnel at a time. All the other marbles will follow the first marble until the funnel is empty. Serial transmission is much slower than any of the parallel transmission techniques.

An operating system identifies serial ports in the BIOS setup program and references the serial ports as COM ports. The first serial port is referenced as COM1, the second serial port is referenced as COM2, and so on for COM3 and COM4.

Serial ports can come in the form of a DB 9-pin or older style DB 25-pin male connector. Most systems today have one DB 9-pin (male) serial port that is used for a serial mouse or a communications device such as a modem.

Two basic serial cables are available that are used to connect a device to a serial port. The most common serial cable in use today has a DB 9-pin female adapter on one end of the cable that plugs into the DB 9-pin male serial port on the system unit. The other end of the cable has a DB 25-pin male connector, which is connected to a DB 25-pin female connector on a device such as a modem. An older-style serial cable is the DB 25-pin female to DB 25-pin male, which can connect two devices that have DB 25-pin serial ports. Yes, serial cables can network two computers together, but you should expect very slow transmission rates. Regardless of which serial cable is in use, the maximum length of a serial cable should not exceed 25 feet. Figure 8.3 displays the pin array configurations for male and female DB 9-pin and DB 25-pin serial connectors.

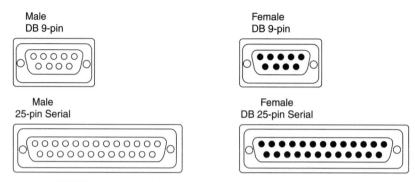

FIGURE 8.3 Male and female DB 9-pin and DB 25-pin serial connectors.

KEYBOARD AND MOUSE CONNECTORS

There are three main types of connectors used for keyboards and mice: the 5-pin Deutsche Industrie Norm (DIN) connector, the 6-pin mini-DIN (PS/2) connector, and USB mouse and keyboard connectors. Modern ATX form factor motherboards use PS/2 connectors for both the mouse and the keyboard. Older AT systems typically used a 5-pin DIN connector for the keyboard and a serial mouse. Figure 8.4 shows a 5-pin DIN and a 6-pin mini DIN (PS/2) connector.

The 5-pin DIN keyboard connector was used in AT and XT class computers for a keyboard connection. It is much larger than a 6-pin mini-DIN connector and requires its own 5-pin port. The more popular 6-pin mini-DIN, otherwise known as a PS/2 connector, is the standard connector in use today for mice and keyboards. Nearly all systems today support PS/2 connections for mice and keyboards. See Figure 8.1 for PS/2 mouse and keyboard ports on the back of a system using the ATX form factor.

Newer systems support USB mice and keyboard connections, which are very easy to install, support, and use. USB connectors will be discussed shortly.

Older systems use a serial port DB 9 connector for what is commonly referred to as a bus mouse. A bus mouse requires the use of a free COM port and IRQ.

FIGURE 8.4 A 5-pin DIN and 6-pin mini DIN connector.

Following are some very important facts to remember about mice and keyboards for the core exam.

The most important feature to look for when replacing a mouse or keyboard is the connectors associated with the device.

- A PS/2 mouse and an ATX-style keyboard connector look identical. It is easy make the mistake of plugging the keyboard connector into the mouse port or vice versa.

 You should only connect a PS/2 mouse or keyboard to a system unit if the system is powered off. If the system is on when you make a keyboard or mouse swap, it is possible that the mouse or keyboard may not be recognized.

- USB mice and keyboards can be replaced, or "hot-swapped," while a system is running.

VIDEO CONNECTORS

All computer monitors have at least one thing in common: they all connect to a female DB 15-pin port on the back of a computer system. (Figure 8.1 shows a standard female DB 15-pin video port on the back of a system unit.) The DB 15-pin port may be attached directly to the motherboard, or it may be located on a video expansion card.

The female DB 15-pin port has three rows of five pinholes that await a male DB 15-pin connector, which is attached to the end of the monitor's cable. Each of the 15 pins on the monitor's DB-15 connector has a different pin assignment, which carries out a specified video function related to power, color, or refresh rate. Many monitor-related problems can occur if one of these pins get bent or broken. It is very important to take great care when connecting a DB 15-pin connector to a DB 15-pin port on the back of your system. Table 8.1 displays the functionality of each of the 15 pins on a DB 15-pin video connector.

The A+ core exam is likely to present you with a question or diagram that tests your knowledge of the difference between a DB 15-pin video connector and a game/MIDI port, otherwise known as a joystick/MIDI port on a sound card. (See Figure 8.1 for a game/MIDI port.)

 Remember for the exam that a female DB 15-pin video port has three rows of 5 pinholes. A joystick/MIDI port on a sound card has two rows of pinholes: one of 8 pinholes and one of 7 pinholes.

TABLE 8.1 Individual Pin Assignments for a DB 15-pin Video Connector

Pin Number	Video Function
1	Red video
2	Green video
3	Blue video
4	Monitor identification 2
5	Ground pin/unused
6	Red video return
7	Green video return
8	Blue video return
9	Unused
10	Ground
11	Monitor identification 0
12	Monitor identification 1
13	Horizontal synchronization
14	Vertical synchronization
15	Unused

USB CONNECTIONS

As mentioned in Chapter 2, USB is a fairly new technology that supports mice, keyboards, scanners, printers, and digital cameras. USB is an external serial bus that supports both low-speed and high-speed devices and offers data transfer rates of up to 12Mbps. Some of the advantages that USB technology has to offer are listed here.

- USB can support up to 127 devices with the use of one system resource.
- USB is Plug and Play-compliant. USB devices are automatically recognized and configured by the operating system.
- The cables and connectors that are used to attach USB devices to a system are standardized.

USB devices can be "hot-swapped" while an operating system is up and running. This means that you can attach or detach a USB mouse or keyboard when a computer is powered on.

FIGURE 8.5 A typical type A USB connector.

There are two types of USB connectors in use today. Type A USB connectors have one of their connectors permanently attached to a device such as a keyboard or a mouse. Type B USB connectors are totally detachable from both a device and a port. Figure 8.5 displays a typical type A USB connector.

One end of a type A connector is actually built into the peripheral device. The other end of a type A connector connects to a type A port located on a host or USB hub. A type A connector is flat and rectangular. Type B USB connectors are square and plug into a type B USB port on both the device and the host. Figure 8.1 also displays USB ports.

FireWire (IEEE 1394)

FireWire is associated with Apple Computer Company's implementation of the IEEE standard 1394. The IEEE 1394 standard references high-speed serial transmissions of up to 400Mbps. FireWire is Plug-and-Play-compatible and hot-swappable; it also allows up to 63 devices to be connected to one port. A FireWire connector is similar in shape to a USB connector. The main difference is that a FireWire connector is larger and more square than a typical USB connector. Figure 8.6 displays a FireWire connector.

FireWire technology and other forms of the IEEE 1394 standard are expected to replace most serial and parallel connections in the future. For now, the IEEE 1394 standard is well suited for devices that require high speeds and large throughput, such as video equipment. FireWire is much faster than USB, supporting data transfer rates of 100Mbps to 400Mbps. As a result, FireWire is also much more expensive than USB.

FIGURE 8.6 A FireWire connector.

The A+ core exam may ask, "Which technology is faster, IEEE 1394 or USB?" Make sure that you are prepared to identify technologies by their IEEE association. You may know all there is to know about connecting devices together, but if you can't identify technologies and standards, you will not be able to pass the core exam.

WIRELESS CONNECTIONS

All those messy, dangling computer wires and connectors will soon be a thing of the past. Wireless technology is becoming very popular and affordable. In fact, you can set up a small wireless network at home for about $400. All you really need to set up a wireless network is a couple of transmitters, receivers, and a pair of wireless NICs. The operating system configuration for a wireless network is another story in itself.

There are two main forms of wireless technologies in use for connecting computers together: radio frequency (RF) and infrared (IR).

RADIO FREQUENCY

Many computer peripheral devices today utilize radio frequency (RF) technology. With RF, a wireless mouse, keyboard, or modem can communicate with a host system as long the distance between the peripheral and host does not exceed a specified distance. RF devices use transmitters, receivers, or transceivers (or a combination of these devices) to communicate back and forth. A typical RF mouse or keyboard transmits data through a built-in transmitter to a waiting receiver, which is attached to a system unit through a PS/2 or serial connection. RF devices are designed to meet the IEEE 802.11 standards that apply to wireless networking.

INFRARED

Infrared transmission is a wireless form of transmission that also uses a transmitter and receiver. Instead of sending information with radio signals, however, infrared uses a beam of light that is not visible to the human eye to transmit data between two devices. Line-of-sight is a very popular type of infrared technology used to connect wireless devices such as a mouse or keyboard to a host system. The Infrared Data Association (IrDa) is the organization that is responsible for infrared transmission standards. Infrared

technology has become very popular with laptop computers, personal data assistants (PDAs), and digital cameras. With the infrared IrDa standard 1.1, the maximum transmission rate is 4 Mbps, with a data size of 2048 bytes.

Some of the common uses available for infrared transmission are these.

- Messages can be sent between PDAs or between laptop computers.
- Faxes can be sent from any device utilizing IR technology.
- Pictures or images from a digital camera can be sent to desktop or laptop computer.
- Letters or documents can be sent from a desktop or laptop computers to a printer.

SCSI CONNECTORS

As mentioned in Chapter 7, SCSI interfaces can be attached internally or externally to a computer system. For example, a SCSI hard drive can be attached to an internal SCSI controller on the motherboard. A device such as a SCSI printer or SCSI CD-ROM can be connected to an external SCSI controller card that extends out of the back of a computer. The devices that attach to SCSI controller cards have SCSI interfaces built onto them. There are internal and external SCSI connectors that reflect the SCSI standard being implemented on the device or controller. The most common SCSI interface connectors in use today are 50-pin and 68-pin SCSI internal and external SCSI connectors, as well as the 80-pin internal SCSI SCA connector. Devices such as printers and CD-ROMs utilize a SCSI 50-pin or 68-pin cable and connectors. SCSI SCA 80-pin connectors are used for hot-swappable hard drives, most commonly with internal Redundant Array of Independent Disks or Redundant Array of Inexpensive Disks (RAID) configurations. The SCA SCSI adapter card includes a built-in power connection to support its special voltage requirements. Figure 8.7 shows the basic SCSI connectors and SCSI pin configurations. Remember, the exam will most likely focus on the 50-pin or 68-pin SCSI cable.

 SCSI technology offers the fastest available printing capabilities.

NOTE

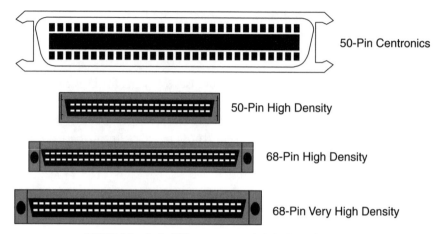

FIGURE 8.7 Basic SCSI connectors and their pin configurations.

Here are several useful tips to remember about SCSI technology and interfaces.

- Most SCSI cables are 50-pin.
- SCSI WIDE refers to a 68-pin parallel interface cable.
- SCSI-3 is considered ultra-wide and can have up to 16 devices, including the controller card.
- SCSI-3 is backward-compatible with previous forms of SCSI technology.
- Each SCSI device must have a unique SCSI ID.
- A SCSI chain must be terminated at both ends.
- You cannot network two computers together with a SCSI cable.

NETWORKING CONNECTORS AND CABLES

There are more than 2500 types of cable in use for connecting computers and peripherals. The majority of computers today still use some type of wire or cable to transmit data from one system to another. There are three main types of network cables in use that you need to be familiar with for the core exam: coaxial, twisted-pair, and fiber-optic. Each of these cable

types has characteristics that set them apart from the others, such as cost, distance limitations, data transfer methods, data transfer rates, and installation methods used. The exam will focus on your ability to identify which technology is used by a certain cable category and which cable medium should be used to connect two or more specific devices.

COAXIAL CABLE

Thicknet

Thicknet coaxial cable, also known as 10Base5, is approximately half an inch thick; it is a heavy type of cable with a copper core that was used with early mainframe computers and early networks. Thicknet coaxial still exists but is very limited in its ability to achieve the high data transfer rates that are needed to support today's bandwidth-hungry computers and applications.

Thicknet coaxial cable has the ability to carry 10 megabits of data a total distance of 500 meters, or approximately 1500 feet. Thus, the naming convention scheme of 10Base5 has been established for coaxial cable. In other words, 10Base5 means that 10 megabits of information can travel over a baseband medium, or base, a total of 500 meters: $5 \times 100 = 1500$ feet (the true measurement is closer to 1640 feet). The naming convention drops the last two zeros.

Thicknet coaxial cable was and sometimes still is used as a backbone connection that connects to a small thinnet cable by use of a vampire tap and an Attachment Unit Interface (AUI) connector.

Thinnet

Thinnet coaxial cable, also known as 10Base2, is approximately a quarter-inch thick. It is a thinner, more flexible type of coaxial cable that is usually connected directly to a NIC with a BNC or BNC T-connector. Figure 8.8

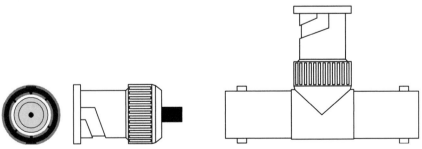

FIGURE 8.8 A BNC and BNC T-connector.

displays a BNC and BNC T-connector. Thinnet is much easier to install and work with than thicknet, but thinnet only carries a data signal the distance of 185 meters, or approximately 607 feet.

Both thicknet and thinnet coaxial can make up a network referred to as a bus network. (Bus networks are described in Chapter 9.) A bus network must be terminated at both ends of a cable or the bus network will fail. Thus thicknet and thinnet both require terminators at both cable ends.

TWISTED-PAIR CABLE

Twisted-pair cable, or TP for short, arose from the need to replace the distance and other limitations associated with coaxial type cable. TP is referred to as 10BaseT. Once again, the 10 refers to the transmission rate of data, *Base* refers to a baseband media type, and the T refers to the twisted pair or wiring twists in the cable itself.

There are two types of twisted-pair wiring: shielded twisted pair (STP) and unshielded twisted pair (UTP).

Shielded Twisted Pair

STP is basically the same type of wire as UTP with the exception that STP uses a woven copper braided shielding and foil wrapping that protect the twisted wire pairs from outside interference, such as electromagnetic interference (EMI). This shielding makes an STP wire less susceptible to crosstalk from other wires. STP is more expensive than unshielded twisted pair based on its extra protection and ability to transmit a data signal over a greater distance than UTP.

Unshielded Twisted Pair

UTP is also a 10Mbps baseband cable. UTP, generally referred to as 10BaseT, is the most common type of Ethernet cable in use today and is found mostly in what is called a star typology network. (Star typology networks are discussed in detail in Chapter 9.) UTP in its simplest form is two insulated copper wires that can carry a data signal 100 meters, or approximately 328 feet.

To keep wiring standards uniform, there are five categories of UTP wiring, as specified by the Electronics Industries Association and the Telecommunications Industries Association (EIA/TIA).

- *Category 1 (CAT1).* CAT1 is the original implementation of UTP used for telephone cable. It is capable of transmitting voice, but not data. This type of phone wire was installed before the mid-1980s.
- *Category 2 (CAT2).* CAT2 is a UTP cable type made up of four twisted pairs of wires. It is cable of transmission rates up to 4Mbps.
- *Category 3 (CAT3).* CAT3 can transmit data up to 10Mbps. It has four twisted pairs that are twisted three times per foot.
- *Category 4 (CAT4).* CAT3 cable is capable of data transmissions up to 16Mbps. It has four twisted pairs of wire.
- *Category 5 (CAT5).* CAT5 cable is capable of data transmission rates of up to 100Mbps. It is also made of four twisted pairs of wire. CAT5 UTP is also referred to as, 100BaseT, or 100BaseTX. It carries a data signal 100 meters, or approximately 328 feet.

 CAT5 UTP is the most popular UTP cable in use today and will most likely be the focus of UTP category questions on the core exam.
NOTE

Twisted-Pair Connectors

There are two types of UTP connectors you need to know about for the test: RJ-11 connectors and RJ-45 connectors.

An RJ-11 phone connector is used for early categories of UTP to connect a modem to a typical phone jack or your phone to a phone jack. In technical circles, an RJ-11 wire is a simple phone wire that houses four wires or connections. See Figure 8.9 for an RJ-11 connector.

An RJ-45 connector is the most common type of TP data cable connector in use. It houses eight wire traces. The RJ-45 connector on one end of a TP wire plugs into an NIC that is installed into a system. The RJ-45 connector on the other end of the TP cable plugs into a network hub, router, or RJ-45 wall jack. Figure 8.10 shows an RJ-45 connector.

FIGURE 8.9 An RJ-11 connector.

FIGURE 8.10 An RJ-45 connector.

Crossover Cable

A crossover cable is a type of Ethernet TP cable that is commonly used to connect two computers in a peer-to-peer fashion. The crossover cable switches the transmit and receive lines of the cable, which allows two computers to communicate directly with each other without the use of a hub or router. If you want an inexpensive alternative to purchasing a hub, a crossover cable is the way to go to connect two computers.

A null modem cable can also be used as a crossover cable to network two computers. A null modem cable is serial cable that is connected to the serial ports of two system units.

Fiber-Optic Cable

Fiber-optic cable, otherwise known as 10BaseFL, is the network wire of choice. It is capable of extremely fast transmission rates over long distances without interference.

A fiber-optic cable has a core that is composed of plastic or glass. A glass cladding or sheath covers the core. Finally, a Kevlar fiber jacket surrounds the entire wire. Data can be transmitted through a fiber-optic cable with a laser or LED at a rate of 2GBps or higher. The data signal on a fiber-optic wire can travel up to a distance of 100 kilometers (about 60 miles) depending on which technology is being implemented with the fiber and if a repeater is used. Fiber-optic cables use special ST and SC type connectors to attach to NICs and fiber-optic ports. These connectors are precisely crafted and specially designed to suit fiber-optic cable connection requirements.

Fiber-optic cable needs great care and consideration when being installed. Specially trained certified fiber installers are usually empowered to carry out this task. Because of its high transmission speeds and specialized installation methods, fiber-optic technology is quite expensive.

Refer to Table 8.2 for a comparison chart of the major networking cables described in this chapter.

TABLE 8.2 Cable Comparison Chart

Cable Type	Transmission Speed	Distance
10BaseT	10Mbps	100M/328ft
10Base2	10Mbps	185M/607ft
10Base5	10Mbps	500M/1500ft
100BaseT	100Mbps	100M/328ft
Fiber	100Mbps to 2GBps	100K/60 miles

CHAPTER SUMMARY

This chapter introduced you to several of the many types of cables and connectors used to attach devices together. There are literally thousands of connectors, wire types, and media used to make connections and data transfer possible between devices. The Internet is a great tool to utilize if you are interested in finding out more details on the subject matter discussed in this chapter. By now, you should have a good basic understanding of cables and connectors.

REVIEW QUESTIONS

1. Which of the following can connect or "network" two computers together? (Choose 3)

 ☐ A. A 6-pin mini-DIN
 ☐ B. A serial cable
 ☐ C. 10Base2
 ☐ D. A parallel cable

 Answers: B, C, and D

 You can connect two computers with a serial cable, an Ethernet thinnet 10Base2 cable, or a parallel cable. A 6-pin mini-DIN connector is used to connect a PS/2 mouse or keyboard to a computer.

2. How does a parallel port transmit data to a device?

 ○ A. 1 bit at a time
 ○ B. 1 byte at a time
 ○ C. Serially
 ○ D. By use of a parallelogram

 Answer: B

 A parallel port uses parallel transmission methods to transmit or send data to a peripheral device 1 byte at a time. A serial port transmits data 1 bit at a time.

3. If two devices cannot send and receive data and information simultaneously, they are using which form of data transmission?

○ A. Full duplex
○ B. Quarter duplex
○ C. Half duplex
○ D. Half simplex

Answer: C

With half-duplex transmission, data can be transmitted in both directions but can only be transmitted in one direction at a time. Full duplex is simultaneous transmission that allows data or voice to be transmitted at exactly the same time.

4. A parallel printer cable has a different connector on each end. Name the two types of connectors on a parallel printer cable. (Choose 2)

□ A. DB 25-pin male connector
□ B. DB 9-pin connector
□ C. An RS232c-compliant cable
□ D. 36-pin Centronics connector

Answers: A and D

A parallel port on the back of a computer system is a female DB 25-pin connector that accepts a DB 25-pin male connector on one end of a parallel cable. The other end of a parallel cable has a 36-pin male Centronics D-shell connector that plugs into a Centronics connector located on the back of a printer or device. A DB 9-pin connection is used for connecting a modem or serial mouse to the back of a system. RS232C is a serial port standard.

5. A connector that has two levels of 15 total pins is which type of cable?

○ A. Monitor cable
○ B. Modem cable
○ C. Serial port
○ D. Game port

Answer: D

A game or MIDI female port on the back of system has two levels of 15 total pins that accept a male connector with two levels of 15 total pins.

6. Which is the fastest technology available for printers?

 ○ A. SCSI
 ○ B. Parallel
 ○ C. USB
 ○ D. Serial

 Answer: A

 The fastest technology available for printers today is SCSI.

7. Which technology has the fastest data transfer rates?

 ○ A. IEEE 1394
 ○ B. Parallel
 ○ C. USB
 ○ D. A fast crossover cable

 Answer: A

 FireWire is much faster than USB or parallel; it supports data transfer rates of 100Mbps to 400Mbps.

8. Which motherboard form factors used a 5-pin DIN connector for keyboard connections? (Choose 2)

 ☐ A. ATA
 ☐ B. ATX
 ☐ C. AT
 ☐ D. XT

 Answers: C and D

 Both AT and XT motherboard form factors use a 5-pin DIN connector. The ATX form factor uses a 6-pin mini DIN connector, more commonly known as a PS/2 connector, for keyboard connections. ATA is a hard drive adapter interface standard.

9. Name the minimum category cable type that can be used to support 100BaseT.

 ○ A. CAT2
 ○ B. CAT3
 ○ C. CAT4
 ○ D. CAT5

 Answer: D

CAT5 UTP supports 100BaseT or 100BaseTX. CAT2, CAT3, and CAT4 cable types do not support 100BaseT.

10. Name the minimum category cable type that can be used to support 10BaseT.

 ○ A. CAT3
 ○ B. RJ-11
 ○ C. CAT4
 ○ D. CAT5

Answer: A

The minimum cable type needed to support 10BaseT is CAT3. An RJ-11 phone connector is used for earlier categories of UTP to connect a modem to a typical phone jack or a phone to a phone jack.

BASIC NETWORKING

In This Chapter

- IEEE 802 Specifications
- OSI Reference Model
- Network Categories
- Network Topology
- Protocols
- Bridges and Routers
- Network Interface Cards
- The Internet and Viruses
- Cable, ISDN, and DSL
- Firewalls
- Chapter Summary
- Review Questions

In Chapter 8, you were introduced to some of the important cables and connectors that are used to link computers and peripherals. Many of the topics discussed in the previous chapter were intended to prepare you for this chapter on basic networking. In this chapter, we focus on the various types of networks, the communication methods computers use to talk to each other, and some of the important hardware used in various network

typologies. We will also focus on troubleshooting network-related connectivity issues, as well as harmful threats that may come in the form of an uneducated user or a computer virus.

It is very important for anyone studying networking architecture and concepts to be familiar with the IEEE 802 specifications for networking components and the Open Systems Interconnect (OSI) reference model, which provides a set of standards for computers to communicate. These two topics are the foundation on which networks are based. However, it is unlikely that the A+ core exam will tax you with detailed questions on these two topics. The IEEE 802 standards that you may need to know for the exam will be identified.

IEEE 802 SPECIFICATIONS

The IEEE is a technical organization that develops standards for local area networks (LANs) and wide area networks (WANs). The IEEE 802 project standards were developed in the 1970s as a set of specifications or rules that manufacturers and users can use as a sort of road map for understanding and developing networks and network-related devices. The IEEE specifications are associated with certain networking layers of the OSI networking model, which is discussed in this chapter.

Throughout this book, you have been introduced to some of the IEEE standards and the particular technologies to which they apply. For example, in Chapter 8 you were introduced to the IEEE standard 1394, which applies to high-speed serial transmission, as well as IEEE 1284 standard, which applies to parallel transmission. Project 802 was developed to address standards for NICs, network cables, and WANs. There have been many additions and addendums added to the IEEE 802 standards as technology has progressed.

The original 12 categories of the 802 specifications and their associations are as follows.

- 802.1—Internetworking
- 802.2—The Logical Link Control (LLC) sublayer of the OSI networking model
- 802.3—Carrier sense multiple access with collision detection (CSMA/CD) LANs (Ethernet)
- 802.4—Token bus LAN

- 802.5—Token ring LAN
- 802.6—Metropolitan area network (MAN)
- 802.7—Broadband Technical Advisory Group
- 802.8—Fiber Optic Technical Advisory Group
- 802.9—Integrated voice and data networks
- 802.10—Network Security Technical Advisory Group
- 802.11—Wireless networking
- 802.12—Demand priority access LAN 100BaseVG—any LAN

The two IEEE 802 standards that are most important for A+ study purposes are 802.3, which represents Ethernet, and 802.5, which refers to token ring or token passing. Later in this chapter we will discuss topologies such as bus, star, and ring. It is important to remember that the 802.3 Ethernet standards apply to bus and star networks that utilize CSMA/CD access methods, whereas token ring topologies utilize token-passing methods to place a data signal on a wire.

As mentioned earlier, the IEEE 802 standards apply mostly to the physical aspects of networking components. For example, they have to do with how a NIC is connected to a network or what types of media transmission methods are used to carry a signal down a physical wire.

Just about every networking component manufactured today is designed to meet one of the above-mentioned IEEE standards. If you purchase a hub, cable/DSL router, NIC, or wireless network component, take a look at the specifications on the packaging or in the advertisement. You will see that the product was manufactured to meet one of the standards set forth by the IEEE.

OSI REFERENCE MODEL

As networking became more popular in the world, a well-organized, logical framework for connecting networks and developing applications was needed. In the late 1970s, the International Standards Organization (ISO) developed the OSI networking reference model.

The OSI reference model is a seven-layered logical approach to network communication that includes specifications for the actual hardware connection to the network at the bottom layers and rules for applications and more complicated functions at the higher layers. Networking rules for

communication, also known as *protocols,* exist at almost every layer of the OSI model. The more complicated the protocol, the higher up on the model it resides. Network transmission, security, session connection information, and hardware are each associated with a particular layer.

Picture yourself sitting at your computer working on a Microsoft Word document. You are actually utilizing functions that reside at the top layer of the OSI reference model, known as the application layer, or layer 7. You decide to attach the Word document to an e-mail message and send it to a co-worker. The message or signal that you are sending is directed from the application layer (layer 7) down to the physical layer (layer 1), where it is placed in converted format (0s and 1s) on a network medium, such as a wire, and transmitted to your co-worker. Your co-worker on the receiving end accepts the message through his or her physical layer (layer 1). The message is converted back to a readable format from 0s and 1s and is presented to your co-worker's application layer (layer 7).

Here are the seven layers of the OSI reference model, starting with layer 7.

7. *Application Layer.* Applications, e-mail, FTP, user authentication, and any other major services that the end user directly interacts with are associated with this high-level layer. Network access and forms of error recovery are handled at this layer. High-level devices, such as gateways, are present at this layer. Application-specific protocols such as X.500, SMTP, SNMP, Telnet, and SMB reside at this layer, as well as presentation and session layers.

6. *Presentation Layer.* Data on the sending computer is converted into a format that can be transmitted over media to another computer. On the receiving end, data is converted into a format that the end user or application layer can understand. Encryption and data translation occur at this level. The network redirector operates at this level.

5. *Session Layer.* The session layer establishes, holds, and controls sessions or connections between two applications. It provides checkpoint and synchronization service between two communication sessions. Security is handled at this layer.

4. *Transport Layer.* The transport layer's primary concern is flow control and data handling. Large forms of data are broken down into manageable packets that can be presented to the higher layers on the receiving end. The successful transmission of data is

acknowledged at this layer. If the transfer of information is incomplete or interrupted, this layer is responsible for a request of the information to be retransmitted by the sending application or session. Transfer protocols such as TCP, NetBEUI, NWLink, and SPX reside at this layer.

3. Network Layer. The network layer is responsible for the routing of information to correct network, device, or computer. Logical names are converted to physical names at this layer. In other words, computer Internet protocol (IP) addresses are converted to their Media Access Control (MAC) equivalents. Priority of connection and quality of service are also handled at this layer. A network router and switch reside at this layer, as do network protocols, such as IP and IPX.

2. Data Link Layer. Data frames received from the network layer are converted into bits (0s and 1s) at the data link layer in preparation for the physical layer. On the receiving end, bits are packaged together into frames that can be understood by the higher layers. Frame synchronization, flow control, and error handling are addressed at this level. The data link layer has two sublayers, known as the logical link control (LLC) and MAC layers. The LLC sublayer is associated with IEEE standards 802.1 and 802.2 and is responsible for the implementation and placement of service access points (SAPs). The MAC sublayer is associated with IEEE standards 802.3, 802.4, 802.5, and 802.12. The MAC sublayer communicates directly with an NIC. It is responsible for error-free communication between network interfaces. Devices called *bridges,* which segment network traffic, operate at this layer.

1. Physical Layer. The physical layer is the physical adapter or connection to the network wire or medium. It is where bits or bit streams of information are prepared to go across the network medium. Incoming bits of information are organized and prepared to move through the higher layers.

If you are interested in pursuing a career in networking, it is very important that you understand the theory behind the OSI reference model. You will also need a solid understanding of the OSI reference model and the IEEE specifications if you are interested in passing CompTIA's Network+ certification examination. However, that is another story altogether—or is it? This book has been designed as a springboard to your

computer certification future. You will already have a great start toward Network+ when you complete this book.

NETWORK CATEGORIES

A *network* is defined as two or more computers attached to each other that share information. Networks can be formed to make up a local area network (LAN) or a wide area network (WAN). A LAN is a network that resides in one physical location, such as a building. It usually has a limited number of computers attached to it and is designated a certain scope or range of computer IP numeric addresses. A WAN is a larger network that usually combines two or more LANs together over a larger physical distance. For example, a business may have two LANs in different buildings or different cities. The two LANs can be connected to form a WAN. A WAN typically has a larger range of computer IP addresses and is used to control communication between LANs. Access to a WAN is usually accomplished through use of a leased or dedicated T1 line, or a dial-up modem connection using ISDN, cable, or DSL.

There are two basic types of networks in use today: peer-to-peer and server-based. Each of the two network categories has its own set of built-in characteristics that differentiate it from the other.

PEER-TO-PEER NETWORKS

A *peer-to-peer network* is a small network, usually of 10 or fewer computer systems, connected without the use of a larger specialized server computer. In peer-to-peer networks, a workstation can function as both a client and a server computer. In other words, a single computer can share information or devices attached to it or act as its own entity to carry out day-to-day workstation functions.

A peer-to-peer network does not require a high-end server computer to provide login authentication or a highly trained staff to secure and administer network resources. A peer-to-peer network uses password-protected shares that utilize share-level security at the workstation level. The user of the workstation decides who will be able to read, write, execute, or delete files that exist. Windows 3.11, 95, 98, ME, NT, 2000, and XP operating systems can all provide peer-to-peer capabilities.

Many small businesses and home enthusiasts implement peer-to-peer networks. They are a less expensive alternative to server-based networks and are fairly easy to maintain as long as you remember all the passwords that may be associated with all the files, folders, and devices.

SERVER-BASED NETWORKS

A server-based network is typically implemented for networks that have more than 10 computers and that require quick access to services that specialized high-end servers can provide. A server-based network is designed to centralize the control and administration of network access and resources. When a user logs on to a server-based network, a specialized server that controls network access authenticates the user by utilizing user-level security. A network administrator or manager is typically empowered in a server-based network to control, monitor, and carry out the daily network maintenance associated with this type of network. Some examples of operating systems that can provide server-based functionality are Microsoft Windows NT Server, Windows 2000 Server, Novell Netware, and Unix.

Server computers are designed to provide specific services to client computers. Some of the different types of server computers are listed in Table 9.1.

TABLE 9.1 Types of Network Server Computers

Server Type	Server Function
Authentication server	Centralized location of security accounts database that allows users access to the network. Example: Windows NT Primary Domain Controller.
Database server	Houses a common database. Responsible for storage and management of data warehouse services. Example: Microsoft SQL Server.
Application server	Handles high-end operations to take the load off client computers. Application software is installed on server. Client computers request services from backed application server.
Print server	Handles all client side requests for network printing. Manages network printers and print queues.
Communications server	Responsible for e-mail, fax, Internet access, and dial-up modem connections. Microsoft Exchange Server is an example of a communications server application.

Network Redirector

The network redirector is software that is built into the code of a network operating system. The redirector intercepts requests made by the system's processor and decides whether the request should be forwarded to another system on the network or remain local to the system. If a request is made from a client workstation for a particular instruction, such as printing to a network printer, the redirector grabs the request and sees that is forwarded to the network to commence print operations.

Universal Naming Convention

A UNC name is used to access a particular share on a particular workstation or server on a network. If you want to access a resource such as a printer or folder that has been shared on the network, you can gain access to it by typing in the UNC name from the Start>Run option in Windows. A UNC name always follows the format `\\Servername\sharename`. For example, suppose you want to access a folder on the network named Certified. The Certified folder resides on a server named Bigserver. You would go to Start>Run and type in `\\Bigserver\Certified`. If you have rights to the Certified folder, you can have access to it.

NETWORK TOPOLOGY

A network's topology is the actual physical layout of the network. The topology of a network is based on factors such as the number of workstations and servers required, the communication methods that will be implemented, and the cables and specialized equipment that are available.

The three standard network topologies are bus, star, and ring. Be sure that you can identify the three main typologies and the cable type associated with each. The core exam is likely to present you with a topology diagram similar to the three figures you will see in this chapter or to ask which cable type is associated with each topology. For example, 10Base2 is associated with a bus topology network.

The three topologies and their associated characteristics form the framework from which most networks are based. All three topologies are described next.

BUS

An Ethernet bus topology, otherwise known as a linear bus, is a topology designed for a limited number of computers that are typically attached to a single wire, or trunk, in a straight line. As more workstations are added to a bus topology, performance decreases. Figure 9.1 displays a typical bus topology.

The main type of cable implemented in a bus topology network is 10Base2 (described more fully in Chapter 8). Devices called terminators must be placed on both ends of a bus network or wire to keep the data signal placed on the wire from bouncing back and forth (a phenomenon referred to as *signal bounce*). All computers on the bus listen for the data signals. If the signal is addressed to a particular workstation, the workstation accepts the signal. If the physical wire or connection that makes up the bus topology is damaged or breaks, the individual computers on the bus will still be able to operate independently but will not be able to accept data signals and communicate with other computers on the bus network.

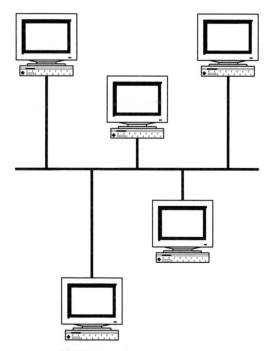

FIGURE 9.1 A bus topology network.

Bus and star networks utilize CSMA\CD media access control methods to place a signal on a wire. CSMA\CD is an Ethernet error-detection method used to ensure proper data handling on a wire.

BNC and BNC barrel connectors are used to attach a bus cable to a device or connect one piece of the bus cable to another. A device called a repeater is used to boost or regenerate the signals placed on a 10Base2 or bus network. Adding a repeater to a bus can extend the length of the entire bus network. For distances associated with a bus network, refer to Chapter 8 and 10Base2 distance capabilities.

STAR

A star topology physically looks like a star. Figure 9.2 shows a simple star topology network. A star topology utilizes a central device, which can be a hub, a router, or a switch. We will refer to a simple hub for the central connection point in a star network.

All devices in a star topology network are typically connected to a hub with twisted pair, otherwise known as 10BaseT cable. A star topology net-

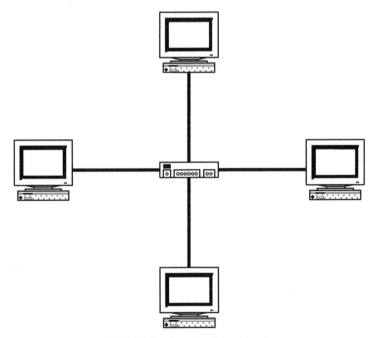

FIGURE 9.2 A star topology network.

work is known to require large amounts of cable for larger networks. The hub provides a central location at which the network can be managed and tested. If one computer fails on a star network, the other computers connected to the hub can still function and communicate with one another. If the hub fails, however, all communication between devices will cease.

RING

A ring topology network is best understood by picturing an actual circle of cable. Workstations and servers are all connected to the circle of cable. Each computer attached to the circle regenerates the data signal sent in the form of a token. The circling of the token to each of the servers and workstations on the ring is known as *token passing*. If the wire that makes up the ring is damaged, all network activity on the ring ceases. Keep in mind that IEEE 802.5 is a standard that applies to token-passing technology. Figure 9.3 displays a simple token ring topology.

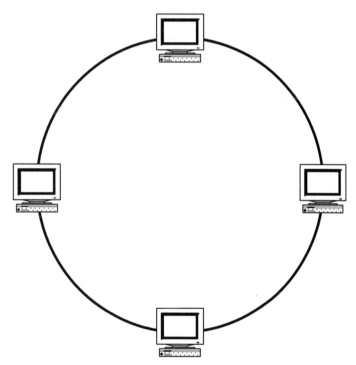

FIGURE 9.3 A ring topology network.

PROTOCOLS

As mentioned earlier in this chapter, *network protocols* are a common language or set of rules that computers use to communicate with one another. Protocols come in packages known as protocol stacks. Individual protocols reside at each layer of the OSI reference model in order to carry out a specified function. If the core exam tests you on protocols, it will most likely focus on the TCP/IP and IPX/SPX protocol stacks. There are many network protocols in use. We will focus on the protocols you need to know for the core exam.

TCP/IP

Transmission Control Protocol/Internet Protocol (TCP/IP) is the most popular protocol in use today. It is the protocol of choice for the Internet. TCP/IP is commonly used with Ethernet, token ring, and Internet or network dial-up connections. Every computer on a TCP/IP network uses an IP address as a unique numeric identification. An IP address is a 32-bit numeric combination of four period-delimited octets, each of which can be a number from 0 to 255. An IP address can be up to 12 digits long.

An example of an IP address is 209.15.176.206. This IP address is associated with the domain name address, which is provided by a domain name system (DNS) server of the publisher of this book, charlesriver.com. From a DOS prompt, I used the TCP/IP ping utility to test my connection to the Charles River Media Web site. Try it. Using Windows 2000, navigate to a DOS prompt. At the DOS prompt, type `"Ping charlesriver.com."` You should receive an associated IP address of the Web site as well as four echo replies. Another popular TCP/IP utility is the tracert command. The tracert will tell the route you are using to establish a connection with a destination computer. In other words, it gives you all the TCP/IP addresses and domain names of the computers you are using to reach your final destination. Try the tracert command from a DOS prompt. From a DOS prompt, type `"tracert charlesriver.com."` You will receive the IP addresses and domain names of the computers you are hitting to get to the Charles River Media Web site. The time it takes for your request to go from each destinations' IP address is measured in units of time called *hops*. A subnet mask is used to specify which particular network a TCP/IP address belongs to.

You can check the IP configuration of your computer using two popular commands. If you are using Windows 95 or 98, type `"winipcfg"` at a

DOS prompt. If you are using Windows NT or 2000, type `"ipconfig"` or `"ipconfig/all"` at a DOS prompt. Your computer's IP address, subnet mask, and default gateway settings will be displayed.

If your computer is unable to communicate with other computers on the network and all the other computers are functioning correctly, you should first check your computer's IP address configuration settings. They may not be properly configured. If this is the case, your computer can only access itself.

IPX/SPX

Internetwork Packet Exchange/Sequenced Packet Exchange (IPX/SPX) is a protocol stack used in Novell networks that supports routing. There are several versions of Novell operating systems in use today. When connecting a system to a Novell network, it is often necessary to bind a specific frame type to your NIC for connection to various Novell operating system versions. Frame type specifications are beyond our study focus; just remember that if you having trouble connecting to a Novell network, you should first verify that proper frame type is bound to your NIC.

BRIDGES AND ROUTERS

As the number of computers or nodes on a network increases, a network requires specialized equipment to expand its length, direct its flow of traffic, and provide a centralized location for troubleshooting and maintenance. Two popular devices used specifically for the above-mentioned purposes are network bridges and routers.

BRIDGES

Bridges are hardware devices that operate at the MAC sublayer of the OSI reference model's data link layer. Bridges are used to segment or separate LANs. Separating a larger network into smaller, more manageable segments can improve network performance and provide a way to isolate network bottlenecks.

A bridge reads the MAC hardware address that is stored in the NIC card of every computer or node installed on either side of the bridge. The bridge knows where all the computers are on the network and can forward information to a particular computer by the use of its NIC MAC address. Let's

say you are sitting at a computer that resides on network segment number 1. You want to send Brian, whose computer is located on network segment number 2, a Word document. There is a bridge that separates you on network segment number 1 from Brian on network segment number 2. The bridge can identify both of your computers by their respective NIC's MAC addresses. Therefore, when you send a Word document to Brian, it is forwarded to his network segment by the use of the bridge.

Bridges can provide the following services.

- Reduce network traffic that results from too many computers being attached to a network
- Connect different types of media connections, such as coaxial cable and twisted-pair cable
- Expand the length of a network segment
- Connect different network typologies together, such as token ring and Ethernet

Although bridges serve their primary purpose, they are limited in their capabilities. If a destination's MAC address is not found in a bridge's internal table, the bridge will proliferate or broadcast (pass traffic) to all network segments. This can result in a broadcast storm that can slow or take down a network.

As networks grew larger, the demand increased for a more intelligent device that could handle more attached computer nodes and direct network traffic in more efficient manner. The router was technology's answer to this demand.

ROUTERS

A router is another device that connects different network segments, but unlike a bridge, a router does not use a computer's MAC address to forward information. Instead, a router operates at the network layer of the OSI reference model and has the ability to forward information based on a network or an individual computer's TCP/IP address. This allows a router to connect entirely separate networks and to filter information to the proper network or network segment. In other words, a router has the ability to send a request to a specific location without broadcasting to all the other computer nodes on a network or network segment.

Routers are very intelligent. They hold sophisticated routing tables and have the ability to remember previous connections that were used as pathways from one computer node to another. Routers can actually decide

which path is most efficient for a packet of information to take in order to reach its final destination.

Routers are primarily used for the following tasks.

- Provide filtering of packets and reduce broadcast storms
- Segment networks into smaller, more manageable pieces
- Provide a network security layer between separate networks (a firewall)

Routers use specialized protocols such as Internet Control Message Protocol (ICMP), Open Shortest Path First (OSPF), and Routing Information Protocol (RIP) to communicate with each other and carry out their advanced functions.

NETWORK INTERFACE CARDS

A NIC is a circuit board that is inserted into an available bus expansion slot on a computer system's motherboard. It allows a computer to connect to and communicate with other computers on a network or LAN.

A NIC operates at the MAC sublayer of the OSI reference model's data link layer and has a 10-digit unique MAC address stored on its ROM chip. As mentioned earlier, a device such as a bridge can identify a computer on the network by its MAC address.

ROM chips such as EEPROM on a NIC store vital information such as the NIC's I/O address, IRQ, and MAC address.

On a 10BaseT Ethernet network, a twisted-pair wire with an RJ-45 connector is plugged into the back of a typical 10/100Mbps PCI-bus NIC. If the NIC has been properly attached to the network, the green and amber LEDs on the back of the NIC will flicker on and off.

NIC cards are typically available at network access speeds of 10Mbps, or both 10Mbps and 100Mbps. If your network can support transmission speeds of higher than 10Mbps and you are only using a 10Mbps NIC, you will not be able to take full advantage of your network's bandwidth. Your NIC will cause what is known as a bottleneck.

NICs are fairly easy to install if you have purchased a popular brand name and are utilizing a Plug and Play operating system. Most newer operating systems have fully compliant software drivers built in that support newer NICs. However, if you are using an ancient, legacy NIC or your

operating system does not support Plug and Play, it will be necessary to use the software driver that came with the NIC. If you do not have the installation software or drivers for the NIC, you should consult the NIC manufacturer's Web site for a possible free driver download.

There are several ways that settings on NICs can be configured. Older, legacy NICs were configured with the use of jumpers or DIP switches on the card itself. Today, most NIC settings are configured with the use of software provided by the manufacturer or simply by letting Plug and Play make the necessary setting automatically.

NICs and their connections are notorious for causing network-related trouble if they are malfunctioning or improperly connected. If you or a customer cannot connect to your network, first verify that the NIC and the patch cable connected to it are in working order. If the all the hardware is intact and you see flashing lights on the back of the NIC, you may want try typing in the correct password to access your network resources.

THE INTERNET AND VIRUSES

The Internet is a huge network that connects millions of host computers, with unique IP addresses, all over the world. It is the largest source of information available. The Internet offers a vast array of services: you can buy almost anything, see just about anywhere, and talk or chat with anyone who is connected.

Here are some important Internet-related terms that you should be familiar with.

- Uniform resource locator (URL). The URL is the line typically located at the top of the browser, such as http://www.charlesriver.com. The first part of the line is the Internet protocol to be used, for example, http:. The second part of the URL line is used for the Internet address you are trying to access. It can be an IP address or a domain name, such as charlesriver.com.
- DNS server. Converts fully qualified domain names to IP addresses. This server or service makes it possible for you to enter `"charlesriver.com"` into your Web browser instead of entering a 12-digit IP address.
- Hypertext Transfer Protocol (HTTP). Internet protocol used to transmit instructions to the World Wide Web from a Web browser.

- Hypertext Markup Language (HTML). Allows Web pages to be formatted with graphics and symbols other than plain text. HTML provides the Web page with a set of instructions pertaining to how the page should be displayed to the end user.
- Extensible Markup Language (XML). XML is similar to HTML, but XML offers developers and designers more flexibility in creating Web pages through the use of call tags.

The Internet also offers a vast array of threats to you and your computer. You can lose your good credit standing if certain personal information is obtained and used for illegal purposes. Computers are vulnerable to computer viruses, as well as full-scale marketing attacks.

The Internet offers many unfriendly computer viruses. A computer virus is a program or piece of code that is typically designed to store itself in your computer's memory or on your hard drive. Most viruses make copies or duplicate themselves over and over until your memory or hard drive become inoperable. If you are interested in protecting the integrity of your stored data or the business you may be responsible for, it is very important to utilize a good virus protection program and update your antivirus .DAT files on a regular basis. ".DAT" is the file extension used for a file or program that contains a list of the most current viruses. If you are running an enterprise network, you should incorporate a good enterprise antivirus solution. The top manufactures of antivirus software offer single-user or multiuser versions of their antivirus software programs. It is important to remember that computer viruses are most commonly obtained from the Internet and floppy disks.

 Never open an e-mail attachment if you are not sure of the identity of its sender. That incredibly interesting free offer may make you reformat your hard drive.

CABLE, ISDN, AND DSL

Most connections to the Internet are accessed through an Internet service provider (ISP). A local or national ISP provides an IP address that can be used to gain access to the Internet. Although many individuals and businesses still use a 56K analog dial-up connection to access the Internet, broadband services, such as cable, ISDN, and DSL are becoming more and more popular based on their high transmission speeds and instant accessibility.

CABLE

Broadband cable modem connections seem to be the Internet connectivity tool of choice for today's home users. All you really need for this technology is a cable modem, a NIC, RJ-45 cable, a coaxial cable, and an ISP. This technology allows Internet access speeds of around 1.5Mbps. It provides a connection similar to that of cable television. The signal is always at the end of the cable wire, waiting to be accessed; in other words, the connection is always available. There is no need to reconnect to the ISP every time you want to access the Internet.

INTEGRATED SERVICES DIGITAL NETWORK (ISDN)

ISDN is a baseband transmission technology that is well suited for the transmission of audio and video at rates of up to 128Kbps. ISDN utilizes an adapter that is included with ISDN router in place of a standard analog modem.

There are two types of ISDN services typically available by ISP or local phone carrier: Basic Rate Interface and Primary Rate Interface.

- Basic Rate Interface (BRI). BRI is an ISDN technology made up of two 64Kbps B channels that carry data and voice and a 16Kbps D-channel that is responsible for control information. BRI implementations are common for small business and home use.
- Primary Rate Interface (PRI). PRI is an ISDN technology that is used with larger businesses, such as ISPs and telecommunication companies. PRI is made up of 23 B channels and one D channel.
- PRI typically utilizes the bandwidth capabilities of a T1 connection.

DIGITAL SUBSCRIBER LINE (DSL)

DSL is a connection technology over a copper wire that utilized a regular phone line to bring access speeds of up to 6.1Mbps to homes or businesses. In actuality, DSL offers upload speeds of up to 128Kbps and download speeds of 1.5Mbps for individual connections. DSL also utilizes a modem and is well suited for high-speed transmission of audio and video. DSL has provided major competition to the cable modem.

FIREWALLS

A firewall is an implementation of software, hardware, or a combination of both specifically designed to keep unauthorized users, programs, and other threats from entering a computer system or network. A typical firewall analyzes every packet of information that attempts to enter or exit a network or computer system. If the packet does meet the specifications implemented by the firewall, the packet or connection is denied access. Several implementations of firewall techniques are provided through the use of a packet filter, a proxy server, an application, or a circuit gateway. For our test study focus, you should be aware that a software firewall is installed or located on a hard drive. For more protection from outside influences, you should also consider the use of data encryption.

CHAPTER SUMMARY

The primary focus of this chapter was to get you up to speed with the basic concepts of networking. At this point, you should be familiar with the basic network categories and topologies and the media access methods used for networks. You should also have a basic understanding of TCP/IP and be able to troubleshoot simple network connectivity issues.

This chapter was designed to help you handle just about any networking questions the A+ core exam may ask. Once again, however, there is no substitute for hands-on training. If you studied this chapter in detail, you should have a good foundation for preparation to study for CompTIA's Network+ certification exam if you so choose.

REVIEW QUESTIONS

1. A computer on your network is unable to communicate with other computers. What would you check first?
 - ○ A. That other computers are working
 - ○ B. That your Internet connection is functional
 - ○ C. The computer's IP address configuration
 - ○ D. The IP address configuration of the network file server

Answer: C

If a single computer on your network cannot communicate with other systems on the same network, it is probable that its IP address is invalid or the system has not received an IP address from a DHCP server, which hands out IP addresses randomly on the network.

2. In order for two computers to communicate with each other, they must have a common language. What is this common language called?

 ○ A. Binary conversion
 ○ B. Data translation
 ○ C. IPCONFIG/ALL
 ○ D. Protocol

 Answer: D

 In order for two computers to communicate, they must have a common language or set of rules known as a protocol. Binary conversion is a process used to convert binary numbers to decimal. IPCONFIG/ALL is a TCP/IP command used to display TCP/IP configuration settings.

3. What are two tools you can use to test a modem? (Choose 2)

 ☐ A. A loopback plug
 ☐ B. A digital multimeter
 ☐ C. An analog loopback adapter
 ☐ D. A small brush and compressed air

 Answers: A and C

 A loopback plug or analog loopback adapter can be used to test the integrity of a modem. A digital multimeter is used to troubleshoot system power-related issues. A small brush and compressed air are used to clean a system unit.

4. You want to connect a new computer to your Ethernet network. What device must you install to do so?

 ○ A. An internal modem
 ○ B. A switch
 ○ C. An IP converser
 ○ D. A NIC

 Answer: D

In order to communicate with your Ethernet network, you would need to install and configure a NIC with associated software drivers.

5. Ten users on your network have all downloaded a fancy game from the same Internet site. Unfortunately, not one of the 10 computers will work anymore. What question would you ask each of the 10 users?

 ○ A. Is the game really worth it?
 ○ B. Did you do this on company time?
 ○ C. Did your virus scan the game's executable program before running?
 ○ D. What version of BIOS is installed on your computer?

 Answer: C

 If you get this question wrong, please start reading this book from page one again. *Always virus-scan any programs you download from the Internet!*

6. Where do most computer viruses come from? (Choose 2)

 □ A. A borrowed floppy disk
 □ B. A mosquito
 □ C. The Internet
 □ D. Software provided by the manufacturer
 □ E. A big wooden horse from Greek mythology

 Answers: A and C

 Most computer viruses arrive through a borrowed floppy or other removable media disk or are acquired via the Internet.

7. A customer cannot log into the network. Others on the network segment can log in without difficulty. You log into the network using your computer and the customer's ID and password without a problem. What is most likely causing the login problem at the customer's workstation? (Choose 3)

 □ A. The customer is entering the wrong password at the workstation.
 □ B. The NIC in the customer's workstation is malfunctioning.
 □ C. The patch cable that attaches the customer's workstation to the network is bad.
 □ D. The entire network is experiencing RFI (radio frequency interference).

☐ E. The switch that both you and the customer are attached to has been powered off.

Answers: A, B, and C

A, B, and C are valid choices. If the entire network were affected by RFI, more than one user would have problems. A network hub or switch is used to connect several computers on a network. If the hub or switches were powered off, all users on that particular network would be affected.

8. What type of connections can be used with TCP/IP? (Choose 3)

☐ A. Ethernet

☐ B. Token ring

☐ C. Can and string

☐ D. Analog modem dial-up connection

Answers: A, B, and D

Ethernet, token ring, and modem connections can all be configured to use TCP/IP.

9. How can configuration settings on a NIC be changed? (Choose 3)

☐ A. Jumpers

☐ B. Wire traces

☐ C. Configuration software

☐ D. Operating system's Plug and Play features

Answers: A, C, and D

You can configure your NIC settings with onboard jumpers or NIC configuration software, usually provided by the manufacturer. If you are using a Plug and Play operating system, your NIC setting can be configured automatically in most cases.

A+ CORE HARDWARE SERVICE TECHNICIAN TESTTAKER'S CUMULATIVE PRACTICE EXAMINATION

The questions in this practice exam are based on topics that have been presented in Chapters 2 through 9 of this book. The answers to the following questions as well as the chapter headers they are taken from are provided at the end of the exam.

If you can answer all the questions in this practice exam correctly, as well as understand the theory behind each topic mentioned, there is a good possibility that you may pass the CompTIA A+ Core Hardware Service Technician examination.

1. Which of the following will work with slot 1 architecture? (Choose 2)
 - A. AMD AT
 - B. AMD K6
 - C. Pentium II
 - D. Pentium III

2. What advantages does the ATX form factor have over AT? (Choose 2)
 - A. Dual power supplies
 - B. PS/2 integration
 - C. Micro channel
 - D. "Soft switch" power support

3. You are plugging the connectors from an AT power supply into the motherboard. What wire colors must match up?

 ○ A. Red and red

 ○ B. Orange and orange

 ○ C. Black and red

 ○ D. Black and black

4. Where are the system settings stored when the computer is off?

 ○ A. CMOS

 ○ B. RAM

 ○ C. A permanent swap file

 ○ D. Disaster recovery site

5. You are planning to upgrade the CPU on your motherboard. What else must you consider?

 ○ A. SCSI chain priorities

 ○ B. Upgrading the CMOS chip

 ○ C. Upgrading the operating system

 ○ D. Adding an RS232c

6. Intel's single edge connector technology incorporates a processor and what else in its design?

 ○ A. CMOS

 ○ B. Level 2 cache

 ○ C. Centronics D-shell

 ○ D. Level 3 caches

7. What is a major difference between the original Pentium (I) and the Pentium II?

 ○ A. IEEE 1394

 ○ B. LBA support

 ○ C. Pipeline cache size

 ○ D. File allocation table

8. The Pentium III is designed for what type of technology?
 - ○ A. Slot A
 - ○ B. Slot B
 - ○ C. Slot 1
 - ○ D. Slot III

9. There are three programs running in protected mode. One program fails. What happens to the other two programs?
 - ○ A. Both programs fail.
 - ○ B. One fails, one does not.
 - ○ C. Neither program fails.
 - ○ D. Only the program in slot 1 fails.

10. Which of the following are valid types of video memory? (Choose 3)
 - ☐ A. RWAM
 - ☐ B. VRAM
 - ☐ C. XRAM
 - ☐ D. WRAM
 - ☐ E. XGRAM
 - ☐ F. SGRAM

11. What is the memory bus width of a 30-pin SIMM?
 - ○ A. 8 bits
 - ○ B. 4 bits
 - ○ C. 1 bit
 - ○ D. 1024

12. What is the memory bus width of a 72-pin SIMM?
 - ○ A. 8 bits
 - ○ B. 4 bits
 - ○ C. 32 bits
 - ○ D. 64 bits

13. What is IRQ 4 reserved for?
 - ○ A. COM2 and COM4
 - ○ B. COM3 and COM4
 - ○ C. COM1 and COM4
 - ○ D. COM1 and COM3

14. You connect to the Internet with a 56K modem. At times, your access speed is faster than others. What can you do maximize your potential access speed? (Choose 2)

 □ A. Get the most recent driver update for your modem.
 □ B. Use a crossover cable.
 □ C. Change your RJ11 connector to RJ45.
 □ D. Resolve your IRQ5 conflict.
 □ E. Have the telephone company clear the phone line.
 □ F. Grant full-access permission to your 56K modem.

15. You need to reset your modem manually. Which AT modem command would you use?

 ○ A. ATA
 ○ B. ATH
 ○ C. ATZ
 ○ D. ATREST=ALL

16. By default, which IRQ is reserved for the real-time clock?

 ○ A. IRQ0
 ○ B. IRQ1
 ○ C. IRQ7
 ○ D. IRQ8

17. There is no sound coming from your speakers as you play a CD. What is most likely the problem?

 ○ A. Your floppy drive cable is connected backward.
 ○ B. You need to refresh your sound card RAM.
 ○ C. Your CD-ROM audio cable is disconnected.
 ○ D. Your sound card drivers have become corrupt.

18. What is the default IRQ for COM2?

 ○ A. 3
 ○ B. 4
 ○ C. 2
 ○ D. 5

19. A customer is trying to print very large documents to a laser printer and consistently receives memory overflow error messages. How can you resolve this issue? (Choose 3)
 □ A. Decrease the print resolution.
 □ B. Increase the size of the toner cartridge.
 □ C. Add more memory to the printer.
 □ D. Use a SCSI cable connector.
 □ E. Press Ctrl+Alt+Delete twice.
 □ F. Decrease the resolution enhancement technology.

20. What component of a dot matrix printer strikes a ribbon and leaves a character, number, or symbol on the paper?
 ○ A. A print hammer
 ○ B. A toner impaction device.
 ○ C. A pin
 ○ D. A ribbon presser

21. A customer informs you that a printer is displaying paper jam error messages. You observe that there is no paper in the paper feed tray. What would you look at next to fix this problem?
 ○ A. The daisy wheel.
 ○ B. The printer's I/O memory address.
 ○ C. The printer's paper feed sensors.
 ○ D. The printer rollers.

22. You have collected several used laser printer toner cartridges. What is the standard procedure for disposal of such items?
 ○ A. Put them in the dumpster out back.
 ○ B. Send them back to the manufacturer.
 ○ C. Do not dispose. Shake the cartridges to free up loose toner. Toner is very expensive.
 ○ D. Empty toner into a half-used cartridge. Put the empty toner cartridge into a recycle bin.

23. How many pins does a dot matrix print head typically have?
 ○ A. 9 or 24
 ○ B. 27 or 16
 ○ C. 14 or 7
 ○ D. 1 or 4

24. What are the stages of the laser printing process collectively known as?

 ○ A. Electric photomagnetic process
 ○ B. Electronic laser photographic process
 ○ C. Electrophotographic process
 ○ D. ELO imaging process

25. Which of the following are considered valid parallel port standards? (Choose 3)

 ☐ A. Bi-directional
 ☐ B. ECP
 ☐ C. Encapsulated PostScript
 ☐ D. Reverse DNS lookup
 ☐ E. EPP
 ☐ F. Serial

26. At what stage of the laser printing process is the image melted onto the paper?

 ○ A. Writing
 ○ B. Developing
 ○ C. Conditioning
 ○ D. Fusing

27. When working on the inside of a laser printer, what should you never touch because of its extremely high temperatures?

 ○ A. A toner cartridge
 ○ B. The print head
 ○ C. The fuser
 ○ D. The power supply

28. Your computer is Plug and Play. You install a second hard drive. What will determine its drive letter?

 ○ A. You
 ○ B. The ribbon cable position
 ○ C. The jumpers and dip switches
 ○ D. The Plug and Play operating system

29. You need to terminate a SCSI bus that has an external CD-ROM and an internal hard drive. What devices would you terminate?

 ○ A. The SCSI controller and the motherboard.
 ○ B. The hard drive and the CD-ROM.
 ○ C. The motherboard, the SCSI controller, and CD-ROM.
 ○ D. You do not have to terminate both ends of a SCSI chain.

30. You want to install two new IDE drives on the same ATA controller and configure them as master and slave. You install drive 1 as master and drive 2 as slave. Your BIOS does not detect drive 2 on startup. What would you do next to troubleshoot drive 2?

 ○ A. Install an IDE add-on card.
 ○ B. Set up drive 2 as the master. Remove drive 1 and reboot.
 ○ C. Configure both drives as master.
 ○ D. Set the BIOS hard-drive detection method to cable select.

31. What would you have to enable on a SCSI controller card in order to use a tape device?

 ○ A. Direct Memory Access
 ○ B. Termination
 ○ C. C000–C7FFF
 ○ D. The INT 13h support

32. You are trying to access your A drive. You keep getting an error message "Drive not ready; abort, retry or fail." What is causing this problem? (Choose 2)

 ▢ A. You need to change the jumpers on your floppy drive back to slave.
 ▢ B. You have bad media inserted in your floppy drive.
 ▢ C. The spindle motor needs adjustment.
 ▢ D. Your physical floppy drive needs cleaning. Use compressed air.

33. Which of the following devices are compatible with SCSI technology? (Choose 3)

 ▢ A. A tape drive unit
 ▢ B. A modulation device
 ▢ C. A network interface card
 ▢ D. A hard drive
 ▢ E. A CD-ROM

34. What is the highest ID assignment on a SCSI 1 device with a block of three jumpers?
 ○ A. 0
 ○ B. 7
 ○ C. 1024
 ○ D. 15

35. Name the minimum category cable type that can be used to support 100BaseTX?
 ○ A. Category 6
 ○ B. Category 43
 ○ C. Category 4
 ○ D. Category 5

36. Modems use which type of connector?
 ○ A. BNC
 ○ B. RJ-45
 ○ C. RJ-11
 ○ D. Kevlar

37. What technological communication method is most popular with PDAs today?
 ○ A. USB
 ○ B. 10BaseT
 ○ C. The fourth OSI layer
 ○ D. Infrared technology

38. What types of connectors are used with coaxial cable? (Choose 2)
 □ A. BNC
 □ B. RJ-45
 □ C. RJ-11
 □ D. BNC T

39. What type of connector is most commonly used with twisted-pair cabling?
 ○ A. RJ-11
 ○ B. RJ-45
 ○ C. BNC
 ○ D. STP

40. What is the best choice of cable for connecting two computers in a peer-to-peer network without a hub?

 ○ A. Crossover cable
 ○ B. RJ-45
 ○ C. BNC
 ○ D. STP

41. What IRQs by default are available for additional devices in a computer system? (Choose 3)

 □ A. IRQ9
 □ B. IRQ11
 □ C. IRQ15
 □ D. IRQ10
 □ E. IRQ4

42. If a device such as a network interface card has an ST or SC connector, it will most likely be used with which type of cable?

 ○ A. Thicknet
 ○ B. 100BaseTX
 ○ C. Fiber-optic
 ○ D. Shielded twisted-pair

43. Name three characteristics of a peer-to-peer network. (Choose 3)

 □ A. Password-protected shares.
 □ B. Ten or fewer workstations.
 □ C. Individual workstations can act as both client and server.
 □ D. A user must authenticate with a security accounts manager database.

44. What device would you use to extend the length of a 10Base2 bus segment?

 ○ A. A gateway
 ○ B. A bridge
 ○ C. A hub
 ○ D. A repeater

45. A star typology typically uses which type of cable to connect workstations?

○ A. Token ring cable

○ B. FDDI cable

○ C. Twisted-pair

○ D. Fiber-optic

46. A 10Base2 would be implemented in which type of network typology?

○ A. Ring

○ B. Bus

○ C. Star

○ D. FDDI

47. What type of network would be implemented if users need to be authenticated before they can access resources?

○ A. Peer-to-peer

○ B. Standalone

○ C. Server-based

○ D. Share-level permission

48. What does 10/100 mean?

○ A. 10 users for peer-to-peer 100 for server based

○ B. 10 or 100Mbps transmission

○ C. A processor that utilizes 10 threads and 100 processes

○ D. A Sonet technology term for high-speed access

49. An EEPROM chip on a network interface card is capable of storing certain settings. Name three of these settings. (Choose 3)

☐ A. MAC address

☐ B. IRQ

☐ C. I/O

☐ D. IP address

50. A customer is trying access a Novell network using an NIC with the IPX/SPX protocol bound to it. The customer cannot access the network. What is most likely the problem?

○ A. Incorrect frame type setting.

○ B. Incorrect IP configuration.

○ C. The IPX/SPX protocol should be first in the binding order.

○ D. IPX/SPX and TCP/IP cannot run together.

ANSWERS

Answer Key	Question Taken From (Chapter and Section)
1. C and D	Chapter 2 "Slots and Sockets"
2. B and D	Chapter 2 "Motherboards and Form Factors"
3. D	Chapter 2 "Electricity and the Power Supply"
4. A	Chapter 2 "Complementary Metal Oxide Semiconductor (CMOS)"
5. B	Chapter 2 "Complementary Metal Oxide Semiconductor (CMOS)"
6. B	Chapter 3 "SEC and SEP"
7. C	Chapter 3 "Processors and Modes"
8. C	Chapter 3 "Processors and Modes"
9. C	Chapter 3 "Processors and Modes"
10. B, D, and F	Chapter 4 "Memory Types and Characteristics"
11. A	Chapter 4 "Memory Packaging"
12. C	Chapter 4 "Memory Packaging"
13. D	Chapter 5 "Interrupt Requests (IRQs)"
14. A and E	Chapter 5 "Modems"
15. C	Chapter 5 "Modems
16. D	Chapter 5 "Interrupt Requests (IRQs)"
17. C	Chapter 5 "Sound Cards"
18. A	Chapter 5 "Interrupt Requests (IRQs)"
19. A, C, and F	Chapter 6 "Laser Printers"
20. C	Chapter 6 "Dot Matrix and Inkjet Printers"
21. C	Chapter 6 "Dot Matrix and Inkjet Printers
22. B	Chapter 6 "Laser Printers"
23. A	Chapter 6 "Dot Matrix and Inkjet Printers"
24. C	Chapter 6 "Laser Printers"
25. A, B, and E	Chapter 6 "Parallel Port Standards"
26. D	Chapter 6 "Laser Printers"
27. C	Chapter 6 "Laser Printers"
28. D	Chapter 7 "The Hard Drive"
29. B	Chapter 7 "Drive Controllers and Interfaces"
30. B	Chapter 7 "Drive Controllers and Interfaces"
31. D	Chapter 7 "Drive Controllers and Interfaces"

Answer Key	*Question Taken From (Chapter and Section)*
32. B and D	Chapter 7 "The Floppy Drive"
33. A, D, and E	Chapter 7 "Drive Controllers and Interfaces"
34. B	Chapter 7 "Drive Controllers and Interfaces"
35. D	Chapter 8 "Networking Connectors and Cables"
36. C	Chapter 8 "Networking Connectors and Cables"
37. D	Chapter 8 "Wireless Connections"
38. A and D	Chapter 8 "Networking Connectors and Cables"
39. B	Chapter 8 "Networking Connectors and Cables"
40. A	Chapter 8 "Networking Connectors and Cables"
41. B, C, and D	Chapter 5 "Interrupt Requests (IRQs)"
42. C	Chapter 8 "Networking Connectors and Cables"
43. A, B, and C	Chapter 9 "Network Categories"
44. D	Chapter 9 "Network Topology"
45. C	Chapter 9 "Network Topology"
46. B	Chapter 9 "Network Topology"
47. C	Chapter 9 "Network Categories"
48. B	Chapter 9 "Network Interface Cards"
49. A, B, and C	Chapter 9 "Network Interface Cards"
50. A	Chapter 9 "Protocols"

A+ OPERATING SYSTEMS TECHNOLOGIES, CAT EXAMINATION 220-222

OPERATING SYSTEM FUNDAMENTALS AND DOS

IN THIS CHAPTER

- Operating System Fundamentals
- Introduction to DOS
- DOS System and Configuration Files
- DOS File Name Structure
- DOS Commands, Switches, and Wildcards
- DOS Windows Utilities
- Memory Management Utilities
- Windows Initialization Files
- Chapter Summary
- Review Questions

Welcome to the first chapter of our CompTIA A+ Operating Systems Technologies study.

You may have noticed that the chapters in Section 2 of this book are titled by individual operating systems, as opposed to the CompTIA domain structure titles. This structure is in place so as not to confuse the reader by going back and forth between operating systems within the same chapter, as many other books do. It is very important for you to learn and retain the concepts and functionality of each operating system individually. We will

refer to and compare some of the functions in different operating systems within the same chapter, but the intention is to keep your focus on the particular operating system at hand.

CompTIA states that you should have at least six months of hands-on experience with the operating systems you will be tested on. These include DOS, Windows 9.x, Windows NT, and Windows 2000. Be forewarned, however, that two years of hands-on experience with these operating systems is not enough to pass this tough examination if you do not focus on the specific concepts and theory required to answer the test questions correctly.

Please keep in mind that this section of the book is designed to prepare you to take and pass the CompTIA A+ Operating Systems Technologies CAT. It is not a substitute for hands-on experience, nor does it explain the entire history and every detail of all the operating systems covered.

The A+ Operating System Technologies exam will ensure that you are knowledgeable about the underlying command prompt (or line) functions associated with Windows 9.x, Windows NT, and Windows 2000. Many of the DOS commands and utilities you will learn about in this chapter can be utilized through the command prompt provided with newer operating systems. It is therefore highly recommended that you pay close attention to the details and concepts in this chapter so that you are prepared for the command line functions and utilities discussed in the chapters that follow.

In this chapter, we focus on DOS (or disk operating system) commands, procedures, and utilities. We also address system configuration files and DOS memory management.

Before we begin our focus on DOS, it is important for you to understand the basic functions of an operating system.

Operating System Fundamentals

To run applications and interact with input and output devices, every functional computer system must have an operating system. An operating system is the core software platform of a computer system. It is the underlying program or set of programs on top of which applications reside.

Some of the more popular operating systems in use today are DOS, Windows, Novell Netware, OS/2, Unix, Linux, and Mac OS.

An operating system controls computer access and processing and provides a user interface by which human beings interact with a computer system and its resources. Operating systems such as DOS and Unix provide a text-based user interface or environment. With a text-based interface, letters, numbers, and symbols are entered on a command line to communicate with the OS, whereas other OSs, such as Windows 9.x, Windows NT, and Windows 2000, provide a GUI (or graphical user interface) environment.

In a GUI environment, graphic representations of commands such as icons and menu bars are used to interact with the OS. What about Windows 3.x? For the record, Windows 3.x is a GUI that sits on top of DOS. It is not technically considered an operating system. Windows 9.x is a true multitasking GUI operating system that consists of three basic core files. They are GDI.EXE, KRL386.EXE, and USER.EXE.

An operating system is primarily responsible for the following.

- Providing a user interface used to store and manage data and programs
- Providing a platform on which applications and commands can be run
- Acting as a mediator for input and output devices

The major Microsoft operating systems are these.

- MS-DOS
- Microsoft Windows 3.x
- Microsoft Windows 95 OEM Release, Win95A (OSR1), Win95B (OSR2), Win95C (OSR2). (We refer to all versions of Windows 95 as Windows 9.x.)
- Microsoft Windows 98
- Microsoft Windows 98 Second Edition (SE)
- Microsoft Windows Millennium Edition (ME)
- Microsoft Windows NT 3.51
- Microsoft Windows NT 4.0 (Workstation and Server)
- Microsoft Windows 2000 (Professional and Server)

Before we move forward, it is important for you to understand the level of detail involved with the operating system test questions. The exam poses very specific questions that compare various operating system concepts and technologies. A good example of the comparison between operating system technologies is shown by the following sample question.

You have one connection to the Internet that you want to share with other systems. Which operating systems will allow you to do this?

□ A. Windows 2000

□ B. Windows NT 4.0

□ C. Windows 98

□ D. Windows 98 SE

Answers: A and D

The question refers to Internet Connection Sharing (ICS), which is available in Windows 98 SE and Windows 2000. This type of detail is what makes the test so tough. You may know one or two operating systems inside and out, but you must remember the details of all the major systems in order to pass this test.

Keep in mind the following concepts of each operating system as we proceed.

- The file system structure of each operating system
- The minimum hardware requirements needed to install the operating system
- The boot or startup file sequence for each operating system
- The emergency repair operations and procedures for each operating system (creating an emergency boot disk)
- The ability of an operating system to support new applications and APIs, or application programming interfaces
- The methods used by each operating system to access, move, delete, copy, and rename files, as well as methods used to access certain hidden system files
- The methods used by each operating system to change and configure display, printer, modem, and Internet options and settings

CHECKING THE OPERATING SYSTEM VERSION

Operating systems are packaged in different releases and versions, each of which has its own set of characteristics and updates. Our study of operating systems focuses on the popular versions of MS-DOS, Windows 9.x, Windows NT 4.0, and Windows 2000.

The exam will most likely test your ability to display an operating system's version by using Control Panel in Windows or entering the VER (version) command at the command prompt.

To determine which operating system version of Windows 95/98, Windows NT, or Windows 2000 is currently running on a computer, follow these steps.

1. Click the Start button, select Settings, and click Control Panel.
2. Double-click the System icon in Control Panel.
3. Verify that the General tab is selected.
4. Look under the System heading for the operating system, version, and any service packs applied. You should also notice the total memory installed under the Computer heading. Figure 10.1 shows the Windows 2000 System Properties window of the installed operating system, version, service pack, and memory.

To determine which operating system version of DOS or Windows you are running from a command prompt, use the VER command. In a true DOS environment, type the VER command at the DOS command prompt (as follows) and press Enter.

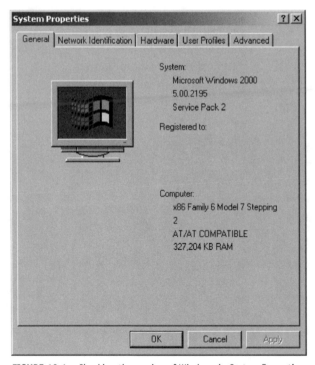

FIGURE 10.1 Checking the version of Windows in System Properties.

```
C:\VER
```

The version of DOS will be displayed.

In a Windows 2000 environment, navigate to the command prompt by selecting Start>Programs>Accessories>Command Prompt and type VER on the command line. Press Enter, and the version of Windows will be displayed. Figure 10.2 displays the VER command and the version of Windows at a Windows 2000 command prompt.

MULTITASKING

Multitasking is defined as the ability of an operating system to handle more than one function or carry out more than one task at the same time. Older operating systems, such as DOS, were designed to handle only one task at a time. Newer operating systems can handle many tasks at once. If you are using a relatively new OS, you can download MP3 files, run an application program, and take the A+ practice tests on the CD-ROM included with this book, all at once. There are two types of multitasking you should be familiar with:

- *Cooperative multitasking.* With cooperative multitasking, the application or task is in control of the CPU until it is finished with processing. Cooperative multitasking is not considered true multitasking. Although more than one task at a time appears to be

FIGURE 10.2 Checking the Windows version at a Windows 2000 command prompt.

running, only one task actually gets the CPU cycle at a time. Windows 3.x utilizes cooperative multitasking techniques.

- *Preemptive multitasking.* With preemptive multitasking, the operating system hands out CPU time slices to applications or programs. The operating system is in control of how much time the application can have. When the period allotted expires, the OS stops the processing cycle and allots time to another application. Newer versions of Windows, such as Windows 9.x, NT, and 2000, as well as Unix, utilize preemptive multitasking techniques.

INTRODUCTION TO DOS

DOS is a 16-bit (FAT16), command line–driven, text-based operating system. Microsoft's version of DOS is called MS-DOS. IBM's version of DOS is called PC-DOS. Our study and the current CompTIA exam focus on MS-DOS, which we refer to from now on simply as DOS. Microsoft has introduced 12 versions of pure DOS since the original 1.0 version. There is no need for you to study or memorize the fine details of each separate DOS version for this exam. However, it is important for you to understand how a "pure DOS" environment works in order to understand how and why we still use the command prompt in newer releases of Windows. It is also important to note that not all DOS commands and functions are interchangeable between DOS versions and operating systems.

Windows 3.x and Windows 9.x require DOS and DOS system files in order to boot and function properly. These operating systems are basically GUI's that sit on top of DOS. Windows 95 attempted to make a separation from "pure DOS" with its implementation of DOS version 7.0. Windows NT 4.0 and Windows 2000 include specialized system files that allow them to boot and function without the necessity of DOS.

COMMAND INTERPRETER

All Windows operating systems use a command interpreter. The command interpreter, also called a command processor, is a program built into an operating system that has the ability to interpret entries and make decisions based on the data entered with a mouse, keyboard, or other input device.

DOS, Windows 3.x, and Windows 9.x use the DOS file COMMAND .COM as the *shell,* or command interpreter. COMMAND.COM basically

waits for instructions to be entered at a command prompt. It then makes a decision on whether to pass the instructions on to a program or display a result such as an error message to the screen.

Windows 2000 also uses COMMAND.COM to launch a command prompt. Unlike the version of DOS used with Windows 3.x and Windows 9.x, a file named CMD.EXE actually carries out the instructions entered at the Windows 2000 command line.

The DOS file COMMAND.COM is actually a utility program that contains internal DOS commands, such as the DIR and COPY commands.

DOS SYSTEM AND CONFIGURATION FILES

Three files make up the core of DOS: IO.SYS, MSDOS.SYS (which are hidden system files), and COMMAND.COM (visible files). All three of these files are located on the primary active boot partition and are stored at the root of drive C:. All three files are required to successfully boot a system into DOS. They are also the minimum files required for booting Windows 9.x to a DOS prompt. If one of these files is corrupt or missing, the message "Missing or unknown operating system" will be displayed.

Although these three system files meet the minimum requirements to boot to DOS on a Windows 9.x DOS prompt, the complete DOS boot order is as follows.

1. IO.SYS—interacts with the BIOS to determine the hardware environment

2. MSDOS.SYS—houses the DOS kernel and interacts with programs and devices

3. CONFIG.SYS—used primarily to load device drivers

4. COMMAND.COM—translator or interpreter of commands entered

5. AUTOEXEC.BAT—used to configure specific user settings

 The exam may ask for the overall system starting order, regardless of what operating system you are running. The overall system start order is **POST, BIOS, Boot Sector,** and **GUI.** See the Windows 9.x Startup section in Chapter 11 for further details.

The major functions of the DOS system and configurations files, as well as their relationships with newer operating systems, are explained next.

IO.SYS

IO.SYS is a binary (uneditable) executable hidden file that is loaded first when a computer system is booted. IO.SYS works with the systems BIOS to determine what hardware is to be used by the operating system. IO.SYS is like a scout that discovers the physical layout of a system by looking at the CONFIG.SYS file, which is used to load hardware drivers and control DOS memory. Keep in mind that Windows 9.x comes with a newer version of IO.SYS that replaces the old IO.SYS and MSDOS.SYS utilized in "pure DOS." The new version of IO.SYS eliminates the need for use of the AUTOEXEC.BAT and CONFIG.SYS files in newer operating systems. Newer operating systems still allow the use of AUTOEXEC.BAT and CONFIG.SYS to maintain backward compatibility with legacy programs and hardware.

MSDOS.SYS

MSDOS.SYS is a hidden system text file that contains the DOS kernel. The kernel is the core software code of an OS that is retained in memory to control all processes.

The kernel that resides in the MSDOS.SYS file and the kernel used in newer operating systems are two totally separate things.

MSDOS.SYS is loaded after IO.SYS and is responsible for the interaction of software applications and hardware settings. MSDOS.SYS controls whether the computer will be booted into a DOS, Windows 3.x, or 9.x GUI environment. If you want to set up Windows 9.x for dual booting purposes, you can modify the `BootGUI=0` to `BootGUI=1` entry under [Options] in the MSDOS.SYS file.

The BOOT.INI file is modified in Windows NT 4.0 and Windows 2000 for dual booting purposes.

CONFIG.SYS

The CONFIG.SYS file is the first editable DOS configuration text file that you can modify at system startup. Its primary function is to load 16-bit Real Mode device and memory management drivers for a DOS environment. At system startup, MSDOS.SYS loads the device drivers and

instructions specified in the CONFIG.SYS file before continuing on to AUTOEXEC.BAT.

In DOS, typing "EDIT CONFIG.SYS" or "EDIT AUTOEXEC.BAT" and pressing Enter at the DOS command prompt opens the DOS utility editor known as EDIT.COM. You can use EDIT.COM to view and make changes to the CONFIG.SYS and AUTOEXEC.BAT files. This can be very useful for troubleshooting if you encounter errors on startup with settings in either of these files.

The CONFIG.SYS is available in Windows 9.x for backward compatibility with legacy devices. It can be edited by running the SYSEDIT program at the Start>Run line in Windows 9.x. Simply click Start>Run; then type in "SYSEDIT" and press Enter. Windows NT 4.0 and Windows 2000 have basically replaced the CONFIG.SYS file with the file CONFIG.NT. You can also edit either of these files by using any available text editor in Windows, such as Notepad.

Next, we look at a typical CONFIG.SYS file that is used to configure hardware- and memory-related settings for a DOS Windows environment. Each of the lines in the following CONFIG.SYS file are described.

```
DEVICE=C:\WINDOWS\HIMEM.SYS
DEVICE=C:\WINDOWS\EMM386.EXE NOEMS
DEVICE=C:\DOS\SETVER.EXE
FILES=40
STACKS=9,256
BUFFERS=10
FCBS=16,0
DOS=HIGH,UMB
SHELL=C:\DOS\COMMAND.COM C:\DOS /P /E:1024
DEVICE=C:\WINDOWS\IFSHLP.SYS
DEVICEHIGH=C:\WINDOWS\COMMAND\ANSI.SYS
DEVICEHIGH=C:\MTMCDAI.SYS /D:MSCD0001
LASTDRIVE=Z
```

- *DEVICE=C:\WINDOWS\HIMEM.SYS-HIMEM.SYS* is a memory device driver that allows device drivers to be loaded into the upper memory area. It is necessary for a Windows 3.x operating system load.

- *DEVICE=C:\WINDOWS\EMM386.EXE NOEMS* loads the EMM386 memory manager that manages the extended memory area.

- *DEVICE=C:\DOS\SETVER.EXE* loads the SETVER program that is used to instruct whichever DOS program is being run to recognize

the MS-DOS version table that is currently loaded into system memory.

- *FILES=40* sets the number of files that can be opened by DOS at one time. In this case, DOS can open or access 40 files.

- *STACKS=9,256* is a rarely used line-handled access to hardware interrupts. It was sometimes necessary to increase or decrease the STACKS value when receiving "Stack overflow" or "Internal stack failure" error messages.

- *BUFFERS=10* allows disk buffers to be loaded into memory for Windows to utilize.

- *FCBS=16,0* specifies the number of File Control Blocks that windows can have open and share at any one time. FCBS can be set from 1 to 255. Today's programs rarely require the use of FCBS.

- *DOS=HIGH,UMB* should always be placed after the HIMEM.SYS line. It is used to load DOS into the upper memory block in the high memory area.

- *SHELL=C:\DOS\COMMAND.COM C:\DOS /P /E:1024* The SHELL command specifies the location and particular command interpreter that you wish DOS to use. In this case, the SHELL command is telling the system to use the COMMAND.COM interpreter that is located in the C:\DOS directory.

- *DEVICE=C:\WINDOWS\IFSHLP.SYS*, otherwise known as the Installable File System manager, is a driver that assists with the integration of 32-bit APIs.

- *DEVICEHIGH=C:\WINDOWS\COMMAND\ANSI.SYS* ANSI.SYS is a driver that configures color, cursor, and keystroke settings in a DOS environment.

- *DEVICEHIGH=C:\MTMCDAI.SYS /D:MSCD0001* is used to load the Real Mode CD-ROM driver that will be used for operating system. The CD-ROM driver in this statement must match the CD-ROM driver specified in AUTOEXEC.BAT.

- *LASTDRIVE=Z* is used to specify the last drive letter that can be addressed by the system. If you are using this command, the letter assignment must be equal to at least the number of drives in your system. For example, if you have A, B, C, and D drives, the minimum setting for the LASTDRIVE= statement would be LASTDRIVE=D.

COMMAND.COM

As mentioned earlier in this chapter, COMMAND.COM is responsible for translating what you input into the computer into information that the OS can understand. COMMAND.COM processes information entered and passes it back to MSDOS.SYS, where the operating system's kernel resides.

In DOS, COMMAND.COM is responsible for providing a user interface such as the DOSSHELL or command prompt. With a default installation of DOS, Windows 3.x, or Windows 9.x, COMMAND.COM is stored in the root directory of the C: drive. Windows 9.x also stores a backup copy of COMMAND.COM in the C:\Windows directory. The AUTOEXEC.BAT file uses the SET COMSPEC= command to place COMMAND.COM in a location other than the root directory of C:\. With Windows NT and 2000, COMMAND.COM is stored in the C:\WINNT\SYSTEM32 directory.

It is important to note that the DOS COMMAND.COM file should be from the same version of DOS installation as IO.SYS and MSDOS.SYS files. If it is not, you may receive the error message "Incorrect DOS version" at system startup.

AUTOEXEC.BAT

The AUTOEXEC.BAT (automatically executed batch) file is the second editable DOS batch file that is used at startup to create an environment for the operating system. The AUTOEXEC.BAT file sets the stage for programs to run. It holds terminate and stay resident (TSR) programs, such as DOSKEY and MOUSE.COM, which are held in RAM and can be quickly accessed and easily loaded by the system. The AUTOEXEC.BAT sets environment variables with the PATH= statement, which is used to tell the system where to look for files and executable programs. The AUTOEXEC.BAT file is the last program run in the DOS boot sequence. It is important to remember that any command that is in the AUTOEXEC.BAT file can be run from the command prompt.

Now we will look at a typical AUTOEXEC.BAT file that is used to configure user-related and environment settings for a DOS Windows environment.

Each of the lines in the following AUTOEXEC.BAT file is described following the file listing.

```
@ECHO OFF
SET COMSPEC=C:\DOS\COMMAND.COM
SET TEMP=C:\TEMP
PROMPT $P$G
```

```
PATH=C:\;C:\WINDOWS;C:\DOS
REM LH C:\WINDOWS\COMMAND\MSCDEX.EXE /D:MSCD0001
DOSKEY
CLS
LH C:\MOUSE\MOUSE.EXE
WIN
```

- *@ECHO OFF.* This line instructs DOS to turn ECHO off, which disables the display of DOS batch file messages on screen when a batch file is executed.
- *SET COMSPEC=C:\DOS\COMMAND.COM.* The SET command is used to specify or set environmental variables each time the AUTOEXEC.BAT is run. This SET statement sets a variable for the command interpreter. The *SET TEMP=C:\TEMP* statement is setting a variable for the location of temporary files.
- *PROMPT PG.* This line configures how the DOS prompt will display on screen. For example, PG displays C:\. You can change the prompt line to display date, time, and DOS version, just to name a few possibilities.
- *PATH=C:\;C:\WINDOWS;C:\DOS.* Please remember for the exam that the PATH= statement or "line" is located in the AUTOEXEC.BAT file. This statement sets an environment variable that simply finds the location of a program. For example, if you are in the C:\Windows directory and want to run a program that is located in another directory, such as C:\DOS, that program can be executed from the C:\Windows directory as long as the C:\DOS directory is specified in the AUTOEXEC.BAT. You can tell the system where to look for a program on the fly by simply typing `"PATH=(name of directory where file is located)"` at a DOS prompt and pressing Enter.
- *REM LH C:\WINDOWS\COMMAND\MSCDEX.EXE /D:MSCD0001.* Notice the REM statement at the beginning of this line; *REM* means remark out. Any statements contained in the AUTOEXEC.BAT or CONFIG.SYS files that begin with the REM statement will not be processed when the file is loaded at system startup. The statement that is being remarked out here contains the file MSCDEX.EXE. This file contains the driver necessary for DOS and Windows 3.x to recognize and run a CD-ROM device. Remember for the test that Windows 9.x has replaced the 16-bit MSCDEX.EXE with the 32-bit CD-ROM File System (CDFS).

- *DOSKEY.* DOSKEY is a TSR program used to remember commands that you have entered at the DOS command line. It keeps a history of what you have entered. If DOSKEY is loaded into memory, you can use the up arrow or down arrow keys on your keyboard to scroll through recently entered commands.
- *CLS.* This is a DOS command used to clear the screen. Only the DOS command prompt is left on the screen after the CLS command has been entered.
- *LH C:\MOUSE\MOUSE.EXE.* This line is loading the mouse executable program into upper memory, which will make more conventional memory available for other programs to run. Remember Chapter 4 and memory utilization? For the test, remember that LH statements are used in the AUTOEXEC.BAT file. DEVICEHIGH statements are used in the CONFIG.SYS file.
- *WIN.* This command calls on the file WIN.COM. WIN.COM is used to configure the system automatically to boot directly into the Windows 3.x GUI. If the WIN statement is not in AUTOEXEC.BAT, the system will boot to a DOS prompt. Four switches can be added to the WIN command; each switch starts Windows 3.x in a different mode. The four switches used with the WIN command are /R, which starts Windows 3.x in Real Mode; /S, which starts the OS in Standard Mode; /3, which starts 3.x in Enhanced Mode; and /B, which is used to keep a log file of Windows 3.x startup problems.

 WIN.COM is built into Windows 9.x.

DOS FILE NAME STRUCTURE

DOS files are stored in directories or subdirectories. In today's Windows world, directories are called *folders.* In DOS, specific rules apply to creating and naming files and directories.

DOS uses what is called an 8.3 file naming structure, otherwise known as *eight dot three.* This simply means that a file name can be up to eight characters long and have a three-character extension representing the file type. A period is used to separate the file name from the extension. The

total length of the DOS file name plus the extension cannot exceed 11 characters. The file extension is not necessary unless the file is associated with a particular function. Table 10.1 displays a list of common DOS Windows file extensions with their associations.

Let's use the DOS file name AUTOEXEC.BAT as an example. AUTOEXEC segment is the DOS file name. The .BAT extension specifies that the file is a batch file. The same is true for the CONFIG.SYS file. CONFIG is the name of the file, and the .SYS extension identifies the file as a system file.

Following are rules that apply to DOS file and directory name creation.

- A file or directory name can be no more than eight characters long.
- An extension can be no more than three characters long.
- No spaces can be included in the file, extension, or directory name.
- Certain characters (? * , ; = + < > | [] / \) are illegal and cannot be used.

TABLE 10.1 DOS Windows Common File Extensions

File Extension	*Association*
.BAK	DOS backup file
.BAT	DOS file housing a sequence of commands
.BMP	Windows bit-mapped graphics file
.CAB	Windows 9.x cabinet file (CAB files)
.COM	DOS command program file
.DLL	Windows dynamic link library file
.DOC	Text document file (usually MS Word)
.EXE	DOS executable program
.GRP	Windows 3.x program group file
.HTM	Hypertext Markup Language file
.ICO	Windows 3.x icon file
.INI	DOS Windows initialization file
.SYS	DOS system driver/hardware configuration file
.TMP	Temp or temporary file
.TXT	Text file created by DOS or Windows text editor
.VXD	Virtual Device Driver file

LONG FILE NAMES (LFNS)

Windows 9.x and Windows 2000 support long file names (LFNs). LFNs can be up to 255 characters in length. Although these newer operating systems support LFNs, they still allow for backward compatibility with the 8.3 naming structure associated with DOS by creating an associated 8.3 file name for every new file created. LFNs are broken into 12-byte sections that allow the use of up to 255 characters, as in the following.

LFN = BEST CERTIFICATIONBOOK.DOC

8.3 associated file name = BESTCE~1.DOC

Notice that the space after BEST is eliminated in the 8.3 associated file name. Windows automatically removes any spaces or invalid characters and truncates the file name.

It is important to note that the Windows 9.x root directory (C:\) can hold only 255 files. The truncation of LFNs to 8.3 names can quickly fill up this 255-file storage limitation and cause your system to halt. For this reason and others, it is good practice to avoid storing files in the root directory of any operating system.

FILE ATTRIBUTES

System files in DOS and Windows 9.x, such as IO.SYS and MSDOS.SYS, are hidden, read-only system files. This means that they cannot be viewed or deleted unless their file attributes are modified. Four major attributes can be assigned to DOS and Windows files: R (read-only), A (archive), H (hidden), and S (system).

In DOS the ATTRIB command can be used to modify the attributes of a file at the command line. For example, to change the attributes for the system file MSDOS.SYS from a read-only/hidden file, enter the following command at a DOS prompt:

```
C:\ATTRIB -R -H MSDOS.SYS
```

This command removes the read-only and hidden attributes associated with the file. You will then be able to read and delete the file. Please don't delete MSDOS.SYS until you are certified. You can add the attributes back to MSDOS.SYS by issuing the following command at the DOS prompt:

```
C:\ATTRIB +R +H MSDOS.SYS
```

In Windows 9.x, NT, and 2000, the attributes of a file can be viewed and changed by simply right-clicking a file in Windows Explorer.

To locate the file MSDOS.SYS in Windows 9.x, right-click the Start button. Left-click Explore, then left-click View (located on the top menu bar). Left-click Folder Options, then left-click View. Under the Files and Folders/Hidden Files section, left-click "Show all files" then left-click Apply and left-click OK. Close the Folder Options window. The MSDOS.SYS file, along with other system files, will now be visible on the right side of screen. Find the MSDOS.SYS file and right-click it. Left-click Properties. You should now see a window similar to the one shown in Figure 10.3. You can remove the selected file attributes by removing the check marks or add desired attributes by adding check marks. Keep in mind that folders as well as files also have attributes.

FIGURE 10.3 Windows 9.x display of file attributes.

DOS COMMANDS, SWITCHES, AND WILDCARDS

DOS has its own set of commands that are entered at a DOS command prompt to instruct the operating system to carry out specific instructions or tasks. DOS commands are defined as internal or external.

- Internal DOS commands reside in the DOS file COMMAND.COM. They are the most commonly used DOS commands implemented at the DOS command prompt. Some examples of internal DOS commands are COPY, DIR, DEL, RD, and CLS.
- External DOS commands are typically located in the C:\DOS directory. They are usually associated with running a program or a task. External DOS commands are most often associated with file extensions such as .COM, .BAT, and .EXE. External DOS commands are often implemented by more advanced users. Some examples of external DOS commands are DELTREE, ATTRIB, EDIT, and MEM.

You should be familiar with the important DOS commands and switches displayed in Table 10.2. Practice using these DOS commands.

SWITCHES

Switches are symbols used in conjunction with DOS commands that instruct DOS to carry out specific functions, such as displaying a screen in wide view or pausing a screen after a certain number of lines have been displayed.

The most common switch is the forward slash (/). It is often used in conjunction with the DIR command. For example, if you enter "DIR /P" switch at a DOS or Windows command prompt, 23 lines will be displayed at a time. You can then press Enter for the next 23 lines to display, and so on. This lets you read what is listed one page at a time instead of watching many pages scroll by. If you enter the "DIR /W" switch, a wide view of the files in the current directory will be displayed to the screen.

A very useful switch to utilize in a DOS or Windows environment is the forward slash question mark switch (/?). When this switch is entered in combination with a DOS command, you are presented with a screen that displays all the switches that can be used with that DOS command, as well as the function of each. Figure 10.4 displays the DIR /? switch and its results at a Windows 2000 command prompt.

TABLE 10.2 DOS Commands and Switches

Command	Function	Switches Used
ATTRIB	Displays or sets the attributes of a file	+R/-R,+A/-A,+S/-S,+H/-H
CD	Changes to another directory	\ Takes you to the root
COPY	Copies the files and directories	
XCOPY	Copies file directories and subdirectories	/H Copies hidden files /S Copies system files /V-Verifies each file copied
DISKCOPY	Copies the entire disk	
DEL	Deletes a file	
DELTREE	Deletes the directory, subdirectory, and files	
TREE	Displays directory and subdirectory structure	\| more View one screen
DIR	Displays all files in current directory	/P Pauses each screen /W Displays wide view
MEM	Displays memory used and available	/C Detail memory list
MD	Creates or makes a directory	
MOVE	Moves a file	
RD	Removes a directory or subdirectory	
REN	Renames a file	
SETVER	Updates the current DOS version table	
SYS	Makes a drive bootable by copying the three main system files to it; used to create bootable DOS disks	
VER	Displays the version of DOS installed	

WILDCARDS

Two wildcards used in DOS and Windows allow you to find or display multiple occurrences of similar file name associations. In other words, wildcards are used to find or identify common directories and files. DOS reserves the question mark (?) and the asterisk (*) to be used as wildcards. These wildcards can also be used through a Windows GUI at the command prompt, or in Windows 2000, by selecting Start>Search>For Files or Folders and entering the required criteria in the Search for files or folders named selection box.

```
C:\WINNT\System32\cmd.exe                                          _ □ X
Microsoft Windows 2000 [Version 5.00.2195]
(C) Copyright 1985-2000 Microsoft Corp.

C:\>dir /?
Displays a list of files and subdirectories in a directory.

DIR [drive:][path][filename] [/A[[:]attributes]] [/B] [/C] [/D] [/L] [/N]
  [/O[[:]sortorder]] [/P] [/Q] [/S] [/T[[:]timefield]] [/W] [/X] [/4]

  [drive:][path][filename]
              Specifies drive, directory, and/or files to list.

  /A          Displays files with specified attributes.
  attributes   D  Directories                R  Read-only files
               H  Hidden files               A  Files ready for archiving
               S  System files               -  Prefix meaning not
  /B          Uses bare format (no heading information or summary).
  /C          Display the thousand separator in file sizes. This is the
              default. Use /-C to disable display of separator.
  /D          Same as wide but files are list sorted by column.
  /L          Uses lowercase.
  /N          New long list format where filenames are on the far right.
  /O          List by files in sorted order.
  sortorder    N  By name (alphabetic)        S  By size (smallest first)
               E  By extension (alphabetic)   D  By date/time (oldest first)
               G  Group directories first     -  Prefix to reverse order
  /P          Pauses after each screenful of information.
  /Q          Display the owner of the file.
  /S          Displays files in specified directory and all subdirectories.
  /T          Controls which time field displayed or used for sorting
  timefield    C  Creation
               A  Last Access
               W  Last Written
  /W          Uses wide list format.
  /X          This displays the short names generated for non-8dot3 file
              names. The format is that of /N with the short name inserted
              before the long name. If no short name is present, blanks are
              displayed in its place.
  /4          Displays four-digit years

Switches may be preset in the DIRCMD environment variable. Override
preset switches by prefixing any switch with - (hyphen)--for example, /-W.
C:\>
```

FIGURE 10.4 The /? switch results displayed at a Windows 2000 command prompt.

- Asterisk (*). The asterisk symbol replaces the characters to the right of itself and finds all instances of the specified criteria. For example, if you enter "DIR *.*" at the C: prompt in DOS, all the files in the ROOT directory of C:\ are displayed. If you are in the C:\Windows directory and enter "DIR *.ini" all the .INI files in the C:\Windows directory are displayed.

- Question mark (?). The question mark wildcard is similar to the asterisk, except that the question mark can represent only one character at a time for each question mark specified. For example, if you wanted to find all of the .INI files stored in the C:\Windows directory from a command prompt, you would enter the following:

 C:\WINDOWS\DIR *.INI

- To display the .INI files with up to three characters in the file name, enter the following:

 C:\WINDOWS\DIR ???.INI

DOS WINDOWS UTILITIES

Several DOS command prompt utilities can be very useful to a computer technician in terms of memory configuration and hard drive and floppy disk preparation. A few of the more useful DOS utilities are described next, with an emphasis on how some of them are used through the GUIs of newer operating systems.

FDISK AND FORMAT

The two DOS command line utilities FDISK and FORMAT are described in detail in Chapter 7. It is important to remember that FDISK is a disk-partitioning utility used to separate one physical hard drive into 24 logical partitions for more efficient use of storage. FDISK also makes it possible for you to install multiple operating systems on one physical drive.

Before you run FDISK, consider which operating system or systems you are going to install and how much space you need to allocate for each partition. Keep in mind that different BIOS settings can affect the size of the partitions you can create and that various file systems require different cluster sizes.

DOS uses a FAT16 partition table. The maximum size of a FAT16 partition is 2.1GB. Windows 95 B and C and Windows 98 use a FAT32 partition table that allows for a single partition to reach 2TB (terabytes) in size.

Following are some important notes about FDISK.

- You can use the FDISK command FDISK/MBR from a DOS prompt to construct a new master boot record (MBR) if yours has become corrupt or infected by a virus.
- You can partition a disk in Windows 2000 using disk management (this is discussed in Chapter 13).
- FDISK is accessible from a bootable floppy disk, which can be useful for troubleshooting undetected hard drive issues. For example, suppose you have a desktop or laptop system that does not detect a hard drive when booted. You can boot to a bootable floppy disk and run the FDISK utility on the undetected hard drive to see if the drive is configured properly.

The FORMAT utility is used to prepare a hard disk or floppy for a file system. Remember, FORMAT.COM creates the FAT (file allocation table) and the root directory on a hard disk or floppy.

The syntax for formatting a floppy disk from a DOS or Windows command prompt is as follows.

```
C:\FORMAT A: /S
```

The /S option copies the three system files necessary to make the disk bootable.

To format a floppy disk in Windows 9.x or Windows 2000, simply insert a blank floppy disk into your 3.5-inch floppy drive, navigate to Windows Explorer, and right-click the 3.5-inch Floppy icon (drive A:). Next, left-click Format. The Format A: window appears. Click Start to begin the formatting process.

SYS

As mentioned above, SYS is really a DOS command. It is used to copy the three main DOS system files (IO.SYS, COMMAND.COM, and MSDOS .SYS) to a disk. The proper syntax for using the SYS command is `C:\SYS A:`. The message "System transferred" appears after the command has been entered.

This is an easy way to transfer the system files to a disk without going through the whole format routine. If you are missing the important system files on your hard drive, you can also use the SYS command to SYS C: from a floppy.

CHKDSK AND SCANDISK

CHKDSK is an old DOS utility that was used to search out bad clusters and lost allocation units on a hard drive. It was common to implement the CHKDSK /F command to attempt to repair bad clusters. The CHKDSK utility has been for the most part replaced by the Scandisk utility. Scandisk is a Microsoft disk analysis and repair utility that is used to recover and repair lost or bad clusters on a disk. Windows 9.x utilizes a GUI version of Scandisk that can be accessed and run by selecting Start>Programs>Accessories>System Tools>ScanDisk. You can use the GUI version of Scandisk to scan your floppy or hard disk. You will have the option of running a standard scan, which checks files and folders for errors, or a thorough scan, which also scans the disk surface for errors. For best results, make sure that you select the thorough option and place a check mark in the "Automatically Fix Errors" box before you start the scan. Windows NT and Windows 2000 do not use Scandisk.

DEFRAG

Defrag is a DOS and Windows utility that improves system performance by placing files that are fragmented into a contiguous order on a hard or floppy disk. In the Windows world, the program is actually called Disk Defragmenter. This tool can be run from Windows 9.x or Windows 2000 by selecting Start>Programs>Accessories>System Tools>Disk Defragmenter. Alternately, you can open My Computer, right-click the C: drive, left-click Properties, select Tools, and select Defragment now. Windows NT does not come with a Defrag utility.

Keep in mind that there are usually at least three ways to accomplish the same task in a typical Windows GUI. You must practice these concepts and explore others if you want to become a well-rounded technician. See if you can find a third way to use the defragmenter utility in Windows 9.x. Here is a hint: Start>Run>

SMARTDRV.EXE

SMARTDRV.EXE and SMARTDRV.SYS make up a 16-bit disk caching utility that is used to improve the access speed to data stored on a hard drive in a DOS or Windows 3.x environment. The SMARTDRV line is only used in the AUTOEXEC.BAT file. Windows 9.x uses a 32-bit program known as VCACHE in place of SMARTDRV. VCACHE can automatically adjust the hard drive's cache size based on the needs of the operating system and programs.

MSD.EXE

MSD is a DOS-based utility that is executed at the command prompt. It is used to view information in system configuration, including devices, memory, video display, mouse, disks, ports, and TSR programs. In the old DOS days, MSD was a very useful program that provided vital information for troubleshooting. Although MSD is included on the Windows 9.x installation CD, most people prefer to use the device manager in Windows 9.x for troubleshooting purposes.

POWER.EXE

POWER.EXE is an optional program that is loaded in CONFIG.SYS. If your computer supports Advanced Power Management (APM), the POWER.EXE driver can be loaded to reduce the amount of power a system uses when it is idle.

The syntax for loading the POWER device driver in the CONFIG.SYS file is as follows.

```
DEVICE=[drive:] [path] POWER.EXE
```

POWER.EXE has proved to be a very useful tool for conserving battery life in laptop computers.

LABEL.EXE

The LABEL utility is used to create, change, or remove the name of a disk. The LABEL command can be used in DOS, Windows 9.x, Windows NT, and Windows 2000 to create a volume name of up to 11 characters, including spaces. Use the following syntax to label a floppy disk.

```
C:\LABEL a: [Enter a label name up to 11 characters in DOS.]
```

DEBUG.EXE

DEBUG.EXE is simply a DOS program that is used to debug or test programs. Changes made to programs using DEBUG.EXE cannot be undone; therefore, only advanced users should use it.

MEMORY MANAGEMENT UTILITIES

In Chapter 4, you were introduced to the basic DOS memory model and concepts. You should recall that conventional memory is used primarily for programs and applications. *Conventional memory* encompasses the first 640K of memory used in the DOS memory structure. *Expanded Memory Specification* (EMS) is extended or reserved memory that emulates conventional memory. It ranges from the top of the 640K barrier to 1024K. The high memory area (HMA) utilizes the top 384K of expanded memory in the DOS memory model. The *eXtended Memory Specification* (XMS) is above the HMA. It includes all the memory addresses over 1088K. If you need more information about this structure, refer to Chapter 4 for a refresher.

Several DOS memory management utilities and software drivers organize and make better use of available memory.

- MEMMAKER is a DOS memory utility program that is run from a DOS command line. It loads device drivers and TSRs into upper memory blocks (UMBs). This helps to free up conventional memory space for programs.

- HIMEM.SYS is a DOS device driver loaded in the CONFIG.SYS that allows applications to run in extended memory. HIMEM.SYS is also present in Windows 9.x. In fact, both Windows 3.x and Windows 9.x require HIMEM.SYS for booting up.
- EMM386.EXE is a DOS memory management utility that opens the door to UMBs so that software drivers and programs can be loaded. EMM386.EXE uses limulation. *Limulation* is a technique used to translate or change extended memory to expanded memory.

VIRTUAL MEMORY AND SWAP FILES

A portion of a hard disk that is set aside for a certain range of memory address is referred to as *virtual memory*. This space on the hard drive acts as a sort of overflow buffer for RAM, or "real memory," as more memory is needed. A process called memory paging is used to create and swap memory addresses into and out of the hard drive's allocated virtual memory space. The main purpose of virtual memory is to allow the CPU to use hard drive space as memory. The virtual memory manager controls virtual memory. If the virtual memory manager cannot allocate memory requested by a specific application in Windows 9.x, a page fault will occur.

Virtual memory space is allocated on a hard drive in two ways: as a temporary swap file and as a permanent swap file.

- A *temporary swap file* is hard drive space that is used temporarily for memory overflow. If the computer is powered off, all information in the temporary swap file is lost. In other words, a temporary swap file is considered volatile memory. The original temporary swap file was named WIN386.SWP in Windows 3.x.
- A *permanent swap file* doesn't go away when the computer system is turned off. It handles the memory paging process faster than a temporary swap file. The permanent swap file was called 386part.par in Windows 3.x.

The procedures for changing virtual memory settings in Windows 9.x, NT, and 2000 are discussed in the chapters pertaining to each (that is, Chapters 11, 12, and 13).

THE VIRTUAL MACHINE

When you start a DOS session or go to the command prompt from within Windows, the OS actually creates a separate memory space for your session to run in. This is called a virtual machine (VM). It was evident in Windows

3.x that multitasking was occurring because the user could open several "DOS windows" or VMs at once.

The most important thing to realize about VMs is that they are run in their own protected memory space. This means that if one program running in its own VM fails, other programs running in separate VMs are not affected. In other words, you can open multiple DOS or command prompt sessions. If one of the sessions fails, the other sessions will not be affected. That explains why the core components of an operating system, such as KERNEL.EXE, GDI.EXE, and USER.EXE, are designed to run in a protected memory space—so that they are protected from other programs that may fail.

In Windows 3.x we used program information files (PIFs) to allocate specific amounts of memory to our separate DOS VMs. In newer operating systems, you can still create a PIF files and assign properties to VMs.

To display the assigned properties of the MS-DOS prompt in Windows 95, click Start>Programs, right-click the MS-DOS prompt, and left-click Properties. You will see the following tabs: General, Program, Font, Memory, Screen, and Misc. If you click the Memory tab, you will see the conventional, expanded, and extended memory assigned to the DOS VM. If you click the Program tab and select Advanced, the window shown in Figure 10.5 will display. If you are trying to run a DOS application in a Windows 95 environment and receive the message "This Program cannot be run in Windows," you should make sure that the "Prevent MS-DOS-based programs from detecting Windows" box (shown in Figure 10.5) is checked for the advanced properties of the DOS prompt properties associated with the application. Click OK twice and run your DOS application again.

WINDOWS INITIALIZATION FILES

Initialization files are Windows plain ASCII configuration text files that have an .INI extension. Windows 3.x used the SYSTEM.INI, WIN.INI, PROGRAM.INI, and PROTOCOL.INI files to configure almost all its settings and device drivers. Newer operating systems such as Windows 9.x and 2000 still make use of .INI files, such as the SYSTEM.INI, to load old 16-bit drivers for backward compatibility. However, the newer operating systems do not need these files to boot up, as did Windows 3.x.

The main Windows initialization files and the text editors used to view and modify them are described next.

FIGURE 10.5 MS-DOS prompt advanced program settings.

THE SYSTEM.INI

The SYSTEM.INI file got its start in Windows 3.x. It is a configuration file that is used to load 32-bit VxDs and 16-bit device drivers. It is often said that the SYSTEM.INI is the Windows version of the DOS file CONFIG.SYS because it deals mostly with device settings and drivers.

The SYSTEM.INI file in Windows 3.x is divided into two main sections: the [386Enh] section, where most 16-bit device drivers are loaded, and the [boot] section, which contains information on Windows 3.x startup operations.

As mentioned above, the SYSTEM.INI file in newer versions of Windows is maintained for backward compatibility with 16-bit drivers. Most of the device drives and environmental settings stored in the early operating system initialization files are now stored and loaded by the registry in newer operating systems. The registry is discussed in Chapters 11 through 13.

THE WIN.INI

The Windows WIN.INI file is often compared to the DOS file AUTOEXEC.BAT based on its configuration of environment and user-related settings. The WIN.INI is also an ASCII text file. It is used to configure

settings such as fonts and date, time, and language. When Windows is started, the system looks first at the SYSTEM.INI and then at the WIN.INI. The following lines are from a typical WIN.INI file found in Windows 2000.

```
; for 16-bit app support
[fonts]
[extensions]
[mci extensions]
[files]
[Mail]
MAPI=1
CMC=1
CMCDLLNAME=mapi.dll
CMCDLLNAME32=mapi32.dll
MAPIX=1
MAPIXVER=1.0.0.1
OLEMessaging=1
[MCI Extensions.BAK]
```

There are two items here that are important to note. Notice the first line of the WIN.INI file:

```
; for 16-bit app support
```

The semicolon (;) is used to remark out the line. This line is being used for informational purposes only. The semicolon can also be used in the SYS-TEM.INI to exclude a line from being processed.

The semicolon is used in .INI files to remark out information. In AUTOEXEC.BAT and CONFIG.SYS files, the REM statement is used to remark out information.

TEXT EDITORS

Text editors such as SYSEDIT.EXE, Notepad, and WordPad, can be used in Windows to view and edit the SYSTEM.INI, WIN.INI, CONFIG.SYS, and AUTOEXEC.BAT files. The SYSEDIT utility in particular can be used in any of the major operating systems for this purpose. For example, in Windows 9.x, NT, or 2000, click Start>Run, enter "SYSEDIT" on the Open: line, and click OK. The SYSTEM.INI, WIN.INI, CONFIG.SYS, and AUTOEXEC.BAT files will open as displayed in Figure 10.6.

FIGURE 10.6 The results of SYSEDIT in Windows 2000.

NOTE The SYSTEM.INI, WIN.INI, CONFIG.SYS, and AUTOEXEC.BAT files display different results on different systems. The display depends on which operating system you are running and what else you have installed on your system.

CHAPTER SUMMARY

This has given you a solid foundation in operating system basics, DOS, and command prompt functionality in Windows. It is meant to prepare you for the chapters that follow. In fact, this entire book has been preparing you for the study of Windows 9.x, Windows NT 4.0, and Windows 2000 operating systems.

In this chapter, you should have gained an understanding of the underlying files and utilities that were used to create and maintain the operation of early operating systems. Although many DOS and Windows 3.x details were not covered in this chapter, the concepts needed to prepare you for the core operating systems components of the test have been well defined.

REVIEW QUESTIONS

1. What term is used to describe an operating system's ability to control and delegate the processor's time to different tasks?
 - ○ A. Preemptive multitasking
 - ○ B. Time slice
 - ○ C. Cooperative multitasking
 - ○ D. Multiprocess collaboration

 Answer: A

 With preemptive multitasking, the operating system hands out CPU time slices to applications or programs. The operating system is in control of how much time the application can have. With cooperative multitasking, the application or task is in control of the CPU until it is finished with processing.

2. Which entry is not found in the CONFIG.SYS file?
 - ○ A. Buffers=
 - ○ B. Device=
 - ○ C. Files=
 - ○ D. C:\path

 Answer: D

 The C:\path entry is found in the AUTOEXEC.BAT file. All other entries listed can be located in the CONFIG.SYS file.

3. The DIR and COPY commands are considered internal DOS commands. Where do internal DOS commands reside?
 - ○ A. C:\Windows\Command
 - ○ B. C:\Winnt\System32\Drivers\ETC
 - ○ C. C:\Windows\System\Command
 - ○ D. COMMAND.COM

 Answer: D

 Internal DOS commands are considered part of COMMAND.COM. External DOS commands are typically located in the C:\DOS directory, although their location can be modified.

4. What file should you change to set up your Windows 9.x operating system to dual boot?

○ A. COMMAND.COM

○ B. IO.SYS

○ C. MSDOS.SYS

○ D. BOOT.INI

Answer: C

The file MSDOS.SYS in Windows 9.x can be modified for dual booting purposes. The BOOT.INI file is used for similar purposes in Windows NT. COMMAND.COM is a utility program that contains internal DOS commands, such as the DIR and COPY commands. IO.SYS interacts with the BIOS to determine the hardware environment.

5. Your computer has Windows 9.x installed. You want to boot the computer to a DOS prompt. What are the three files necessary to do this? (Choose 3)

□ A. IO.SYS

□ B. MSDOS.SYS

□ C. CONFIG.SYS

□ D. COMMAND.COM

□ E. AUTOEXEC.BAT

Answers: A, B, and D

IO.SYS, MSDOS.SYS, and COMMAND.COM are all located on the primary active boot partition and are stored at the root of C:\. All three of these files are required to successfully boot a system into DOS. The files CONFIG.SYS and AUTOEXEC.BAT are not required.

6. You have received a message on startup that a line in your CONFIG.SYS is incorrect. What DOS command line tool can you use to correct the problem?

○ A. AUTOEXEC.BAT

○ B. SYSEDIT

○ C. EDIT.COM

○ D. CONFIG.EDITOR

Answer: C

You can use DOS utility EDIT.COM to view and make changes to the CONFIG.SYS and AUTOEXEC.BAT files. This can be very useful for troubleshooting if you encounter errors on startup with settings in either of these files. SYSEDIT is a GUI text editor that can be used to edit these files from within an operating system. CONFIG.EDITOR is invalid.

7. Which line can be found in the CONFIG.SYS file?

 ○ A. `PATH=C:\WINDOWS`

 ○ B. `PROMPT PG`

 ○ C. `SET TEMP=C:\TEMP`

 ○ D. `DEVICE=C:\WINDOWS\HIMEM.SYS`

 Answer: D

 `DEVICE=C:\WINDOWS\HIMEM.SYS` is used to load HIMEM.SYS from within the CONFIG.SYS file. All other choices are located in the AUTOEXEC.BAT file.

8. You have accidentally deleted COMMAND.COM while using Windows 95. Where can you get a backup copy of COMMAND.COM that will be compatible with your particular operating system?

 ○ A. C:\DOS

 ○ B. C:\Windows

 ○ C. C:\Winnt\System32

 ○ D. Just go to the COMMAND.COM Web site and download your version.

 Answer: B

 Windows 9.x stores a backup copy of COMMAND.COM in the C:\Windows directory.

9. What file should you change to set up your Windows 2000 operating system to dual boot?

 ○ A. COMMAND.COM

 ○ B. IO.SYS

 ○ C. MSDOS.SYS

 ○ D. BOOT.INI

 Answer: D

The BOOT.INI file is used in Windows NT and Windows 2000 to configure a system for dual booting. MSDOS.SYS is used for dual booting in Windows 9.x.

10. DOS uses COMMAND.COM as its command line interpreter. What does Windows 2000 use as a command line interpreter?

 ○ A. COMMAND.COM

 ○ B. A bilingual expert

 ○ C. CMD.EXE

 ○ D. The Windows 2000 HAL

Answer: C

The command interpreter for Windows 2000 and Windows NT is CMD.EXE. The command interpreter for DOS and Windows 9.x is COMMAND.COM.

WINDOWS 9.X

IN THIS CHAPTER

- Overview of Windows 9.x
- Installation and Upgrading
- The Windows 9.x Startup Process
- The Windows 9.x Registry
- Utilities and Settings
- Printers
- Windows 9.x Networking
- Diagnosing and Troubleshooting Test Tips
- Chapter Summary
- Review Questions

OVERVIEW OF WINDOWS 9.X

In this chapter we will focus on the Windows 9.x family of operating systems. As stated in Chapter 10, by *Windows 9.x* we mean Windows 95 and Windows 98 in general. Windows 95 and Windows 98 are considered true 32-bit operating systems that are backward compatible with Windows 3.x and DOS. Windows 95 had two major release versions: Windows 95A (OSR1) and Windows 95B (OSR2). Windows 98 also had two release versions: Windows 98 and Windows 98 Second Edition (SE).

Windows 95B (OSR2) and both versions of Windows 98 come packaged with the ability to provide hard drive partitions above the 2GB barrier that was a limitation of Windows 95A (OSR1).

The Windows 9.x family as a whole has introduced many major improvements to the computing world, including the following.

- Plug and Play (PnP) support
- Preemptive multitasking abilities
- Improved network capabilities and Internet sharing
- Better support for multimedia devices and applications
- Dynamic support for 32-bit applications and supporting devices
- Long file name support (up to 255 characters)
- Support for Protected Mode vs. Real Mode device drivers
- Installation and support Wizards to assist with installation and operating system administration
- The implementation of a Windows Registry that is used to support environments and devices in place of initialization files

These are just a few of the important improvements that were introduced by the operating system that changed the world. We will discuss these improvements as well as other operating system characteristics specific to Windows 9.x throughout this chapter.

INSTALLATION AND UPGRADING

Manufacturers of operating systems provide minimum and recommended hardware specifications that should be considered before installing or upgrading an OS.

The current A+ Adaptive Operating Systems Technologies exam is not likely to focus on specific questions about the amount of memory or hard disk space required to install a particular OS. Instead, it will most likely focus on operating system installation processes and the techniques used to troubleshoot or debug failed installations.

BEFORE YOU START

The following steps should be considered in preparation for a full Window 9.x installation or an upgrade from a previous version of DOS or Windows.

First, you should always check the manufacturer's recommended hardware requirements for a Windows operating system installation. Do not count on study guides or books for this information. For some reason, all operating systems seem to have their own special set of specifications.

Second, verify that you are using the correct CD-ROM for your choice of operating system installation or upgrade. Windows 9.x is available in many versions, as stated in Chapter 10. A full Windows 9.x installation can be performed on a blank hard drive without a previously installed OS, but an upgrade requires the presence of a previously installed Windows version. OEM operating system releases, such as the Windows 95 OEM release, are designed for specific systems and do not work as a full installation on all systems.

 The test may get tricky and ask you why a Windows 95 installation keeps failing for no apparent reason. Remember: using the nonbootable OEM Windows 95 release CD-ROM that is not intended for the system you are installing it on could cause this problem.

Next, consult the Microsoft Hardware Compatibility List (HCL) at http://www.microsoft.com/hcl/default.asp to see if your hardware is supported by the Windows operating system you want to install.

Finally, you should consider the type of file system that will be used to support the OS.

If you are going to do a full installation or an upgrade to Windows 95B or Windows 98, you should consider configuring your hard disk as FAT32 in order to take advantage of its many benefits. Some of the benefits of FAT32 include 4K cluster sizes that make better use of the hard disk's space. Smaller 4K cluster sizes increase the overall storage efficiency and file access speed of the disk. FAT32 makes better use of system resources than FAT16, which in turn provides better use of storage. FAT32 also allows for the ability to support more than 65,535 files with fewer resources.

If you plan to install Windows 9.x, it is best to install Windows 98 SE. It has many advantages over its predecessors, Windows 95 and Windows 98. It can handle larger hard drives and support newer technologies such as USB, FireWire, and Internet connection sharing.

If you need to maintain backward compatibility with older versions of DOS and Windows, need to configure for dual booting scenarios, or plan on installing the original version of Windows 95 that doesn't support FAT32, you should configure your system for FAT16. However, if you configure a partition using FAT16, you will not be able to take advantage of

features such as encryption and disk quotas that are offered in newer operating systems.

Windows 98 comes with a powerful FAT32 drive conversion utility program called Drive Converter, which has the ability to convert an already formatted FAT16 partition into a FAT32 or NTFS partition. The only caveat here is that it is said to be impossible to go back to FAT16 once the Drive Converter program has been run and the partition has been converted. (My own personal preference is to use partitioning tools such as Power Quest Partition Magic 7.0. With this utility, you can convert back to FAT16 if you like.) Keep in mind that the correct order of preparing a hard disk before a Windows 9.x installation is to partition with FDISK, format the drive, and finally reboot the system.

INSTALLATION OR UPGRADE PROCESS

The processes for installing Windows 9.x to blank hard drive or upgrading from an earlier version of Windows 9.x are almost the same. The only exceptions are in the early stages of the installation or upgrade processes. Installing a full version of Windows 9.x requires you to first format and partition the drive. After you have prepared the hard drive for a new operating system, all you have to do is run the SETUP.EXE program from the Windows 9.x installation CD. You may need a boot disk that contains your particular CD-ROM drivers in order to support the CD-ROM device. For the test, remember that the minimum files required on a boot disk to support a CD-ROM device are AUTOEXEC.BAT, COMMAND.COM, and MSCDEX.EXE. It is also recommended that you have the following files on a high-density 1.44MB boot disk for troubleshooting and diagnostic purposes.

- IO.SYS
- MSDOS.SYS
- SYS.COM
- EDIT.COM
- ATTRIB.EXE
- REGEDIT.EXE
- CHKDSK.EXE
- SCANDISK.EXE
- UNINSTAL.EXE
- FDISK.EXE
- FORMAT.EXE
- EDB.SYS

If you are performing an upgrade of Windows, simply place the Windows 9.x upgrade CD into the CD-ROM drive in the current version of Windows. You will be presented with the Windows 9.x upgrade prompt. Here is where it all comes together. At this point, the install or upgrade processes are basically identical. Both methods check the system for the minimum set of requirements necessary for the installation or upgrade to continue. After a restart, you are presented with the Windows Setup Wizard Setup Options menu, which gives you the option of choosing a Typical, Portable, Compact, or Custom setup type. After you choose the setup type you want, you are prompted with the Windows Product Key screen. Enter the Product Key, excluding any dashes, and click the next radio button.

Next, you are prompted to select a directory in which Windows is to be installed. By default, the C:\WINDOWS directory is selected for you. If you are upgrading from Windows 95 to Windows 98, you must install Windows 98 to the same directory that contained your previous Windows 95 files; otherwise, Windows 98 installs itself without consideration of the existing settings and applications, leaving them useless. Now you are asked if you wish to create a startup disk. I usually bypass this step and create a startup disk from the Add/Remove Software option in Control Panel after the installation is complete.

From there you go on to network options, starting with the option to configure the NIC. In my experience, it is better to bypass this option and configure the NIC and network settings after the Windows 98 upgrade has been completed. At this point, a huge copying phase takes place, followed by the hardware detection phase. The Windows 98 PnP features make this phase quite painless. After all that, the point you will need to remember for the exam is that the upgrade from Windows 95 to Windows 98 is considered the easiest of all upgrades.

INSTALLATION LOG FILES

Windows 9.x keeps track of problems that may arise with the setup process in a group of log files stored in the root directory. These log files keep track of devices detected during the installation process as well as successes and failures associated with the various stages of the installation process. The main installation log files are the following.

- SETUPLOG.TXT. A log of the entire setup process; it tracks all successes and failures that occur during the installation process. It is a good tool for finding the last process that may have failed, causing the system to halt.

- DETLOG.TXT. A log file that keeps a record of all hardware detected. It is a viewable version of DETCRASH.LOG.
- DETCRASH.LOG. An unreadable log file is created if setup fails during the hardware-detection phase. If the entire setup process completes without error, this file is removed from the system.
- BOOTLOG.TXT. Logs all device drivers and programs during the installation.
- NETLOG.TXT. A log file used to track the network portion of setup.

THE WINDOWS 9.X STARTUP PROCESS

The overall system starting order for a typical system is covered in Chapter 10. As you may recall, the exam may look for POST, BIOS, boot sector, and GUI as the overall system starting order. To reveal what happens behind the scenes when a computer system is turned on and booted into Windows 9.x, we will break down the start order into the POST/BIOS, Real Mode load, Protected Mode load, and GUI load.

POST/BIOS

When the system is first powered up, the POST is loaded by the ROM BIOS. Next, the MBR is read by the Bootstrap loader, which determines the operating system that is loaded into the system's memory.

REAL MODE LOAD

After the system BIOS has run and the OS is loaded into memory, 16-bit Real Mode drivers are loaded. This is how Windows 9.x maintains backward compatibility with DOS and Windows 3.x. In this sequence of the startup process, IO.SYS, MSDOS.SYS, CONFIG.SYS, COMMAND.COM, and AUTOEXEC.BAT are processed.

 As mentioned in Chapter 10, Windows 9.x uses its 32-bit drivers in place of the AUTOEXEC.BAT and CONFIG.SYS files. These files are not needed by Windows 9.x; they are there simply to maintain backward compatibility.

PROTECTED MODE LOAD

In this phase of Windows 9.x startup process, WIN.COM is used to start up Windows 9.x. Next, VMM32.VXD, which contains an entire package of

Windows 9.x 32-bit virtual device drivers, loads necessary drivers (VxDs) into memory.

 The VMM that was used to load 16-bit and 32-bit device drivers for Windows 3.x is replaced in Windows 9.x with VMM32.VXD.

Finally, the SYSTEM.INI file is processed for any device drivers it may contain that need to be loaded.

GUI LOAD

In the final phase of the Windows 9.x startup process, the KERNEL32.DLL, KRNL386.EXE, GDI.EXE, GDI32.EXE, USER.EXE, and USER32.EXE are loaded until the user is finally presented with the Windows interface screen known as Explorer.

STARTUP MENU AND OPTIONS

If the operating system cannot boot into Windows 9.x successfully, the Windows 9.x Startup Menu will most likely appear. The Startup Menu interacts with MSDOS.SYS (which should have a minimum size of 1024K for a stable OS environment) and is used to isolate and troubleshoot problems related to system startup. You can access the Startup Menu manually by pressing the F8 function key just before the Windows 9.x splash screen appears on your display. The Startup Menu offers eight configuration options for various diagnostic and configuration purposes. The Startup Menu and its eight options are explained next.

1. Normal. This option is used simply to boot the system up normally. No special drivers are added or removed from this configuration.

2. Logged (BOOTLOG.TXT). This option is similar to the Normal option. The only exception is that the steps of the startup process are written to the file BOOTLOG.TXT.

3. Safe Mode (F5). This is considered the most useful mode for troubleshooting purposes. Safe Mode loads a generic VGA driver for basic video, a keyboard driver, and HIMEM.SYS (which manages extended memory). Safe Mode does not load the configuration files AUTOEXEC.BAT and CONFIG.SYS. It does not load NIC, modem, and other specialized drivers. Safe Mode is an excellent tool for troubleshooting drivers that do not work properly with the operating system. For example, if after installing a new advanced video driver,

you can no longer view the screen, simply reboot the computer and enter Safe Mode. Safe Mode loads a basic set of drivers that allow you to remove the new video driver from the system and reboot normally.

 You can also enter Safe Mode directly by pressing the F5 function key before the Windows 9.x splash screen is displayed.

4. Safe Mode with network support (F6). This option also allows you to enter Safe Mode and loads support for networking devices and connections. By pressing the F6 function key before the Windows 9.x splash screen is displayed, you can directly enter Safe Mode with network support.

5. Step-by-step configuration (Shift+F8). When this option is used, you are prompted as to which configuration files and file lines will be executed on startup. For example, if you press the Shift+F8 keys before the Windows 9.x splash screen is displayed, you will be asked if you would like to process such files as the CONFIG.SYS and AUTOEXE.BAT. If you enter "Y" for yes, you will be asked if you would like to process each line of each of these files. This is an excellent way to troubleshoot individual devices and settings that are loaded by each file, one line at a time.

6. Command prompt only (Shift+F5). This option is used to start up the system in MS-DOS. It is often used for troubleshooting purposes if Safe Mode doesn't work.

7. Safe Mode command prompt only. This option is used to start DOS without network support. The major configuration files are bypassed and you are directed to a command prompt.

8. Previous version of DOS (F4). Available if a previous version of DOS is installed on your system. Pressing the F4 function key before the Windows splash screen appears will get you there.

THE WINDOWS 9.X REGISTRY

The Windows 9.x Registry, as well as the registries implemented in Windows NT and Windows 2000, are hierarchal databases made up of special Registry Keys that hold most of the operating system's software, hardware,

and application settings. The Windows 9.x Registry was developed with the intention of replacing the dependency on the WIN.INI, SYSTEM.INI, AUTOEXEC.BAT, and CONFIG.SYS files for loading system initialization, device, and user environment settings.

The Windows Registry is sort of a common ground that is used to link applications, programs, objects, and settings. Windows 3.X utilized the object linking and embedding (OLE) functionality of a binary file called REG.DAT. *Object linking* is a method whereby a program or application can use an object or part of a program that is created by another program.

The Windows 9.x Registry is made up of two important files, called USER.DAT and SYSTEM.DAT. These files are stored as hidden, read-only, system files in the C:\WINDOWS directory. The USER.DAT file stores user-related Registry settings, such as user preferences and desktop settings. The SYSTEM.DAT file is used to store device settings. Every time Windows 9.x is started, the system looks for USER.DAT and SYSTEM .DAT to create and load the operating system's environment and related device settings. If these two files are not found, the system automatically looks for the files USER.DA0 and SYSTEM.DA0, which are backup copies of the two main Registry files maintained by the operating system.

VIEWING AND MODIFYING THE REGISTRY

Warning! Great care should be taken when entering or making changes to the Windows 9.x Registry—or any Registry, for that matter. Making improper changes to the binary values stored in the Registry or installing certain software that can cause Registry corruption may leave you with a system that is unstable at best. If your users or customers observe strange happenings, such as a missing taskbar, blank icons, or programs that won't load, they are most likely experiencing a corrupt Registry or virus activity. You should always manually back up the Registry before making any changes to it. Windows 98 comes with an excellent tool, called Registry Checker, that works well for this purpose. If your Registry becomes corrupted, you can use SCANREG utility from a DOS prompt to restore a backup copy of the Registry. The command used for restoring a Registry from a DOS prompt is SCANREG/RESTORE.

Using the Windows 9.x Device Manager and Control Panel options to change settings and devices is considered the safest way for common users to make edits to the Registry. It is more common for advanced users to edit the Registry in Windows 9.x with the REGEDIT.EXE program stored in C:\WINDOWS in Windows 9.x by default. To enter the 95 Registry, simply

FIGURE 11.1 The Windows 9.x Registry.

click Start>Run and then type in "`REGEDIT`" on the Run line. The window shown in Figure 11.1 will appear.

The six major Registry Keys are displayed in Figure 11.1. Each of these keys and their subkeys are responsible for holding system and device settings and information. The current A+ Operating Systems Technologies exam will expect you to be familiar with the techniques used to edit, back up, and restore the Windows 9.x Registry. For exam purposes, you should know the functionality associated with HKEY_LOCAL_MACHINE.

The functions of each of the six major Registry HKeys are as follows.

- HKEY_CLASSES_ROOT. Stores file extensions and OLE information.
- HKEY_USERS. Stores all user preferences for each separate user with a profile located on the local system.
- HKEY_CURRENT_USER. Stores all information as it pertains to the specific user who is currently logged into the local system.
- HKEY_LOCAL_MACHINE. Stores all the software, hardware, and operating system settings of all configurations used on the system.
- HKEY_CURRENT_CONFIG. Stores the current hardware profile for peripheral devices, such as monitors and printers.
- HKEY_DYN_DATA. Stores all current performance data, such as the results of running System Monitor.

UTILITIES AND SETTINGS

Windows 9.x has many useful utilities for managing and maintaining the integrity of the operating system. This section is dedicated to the many utilities, configuration options, and settings that are available in Windows 9.x. Pay close attention to the details listed in this section—it is very likely that they will appear on the exam.

SYSTEM MONITOR AND SYSTEM RESOURCE METER

System Monitor is an excellent troubleshooting tool used to monitor the system's performance in a real-time graphics snapshot. It can be used to view the system's CPU, virtual memory, and network client/server resources used on the local system only, just to name a few. If System Monitor is not installed on your system, you can install it by navigating to Start>Settings>Control Panel>Add/Remove Programs>Windows Setup> System Tools, >System Monitor. Select the OK button and you will be prompted to insert the Windows Installation CD. After System Monitor is installed, you can locate and run it from Start> Programs>Accessories> System Tools. Figure 11.2 displays a snapshot of System Monitor.

FIGURE 11.2 System Monitor.

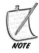

Remember that System Monitor is not used to monitor the network utiliza-
tion of other client and server computers.

Many other useful tools, including the Windows 9.x Resource Meter, which is used to monitor System, User, and GDI heap resources, are installed through the Add/Remove Program applet in Control Panel.

TASK MANAGER

The Task Manager is by far one of the most useful tools available in most Microsoft operating systems. Pressing Ctrl+Alt+Delete displays the Task Manager and programs that are currently running on the operating system. If a process or program is stalled or not responding, you can select the program and press the End Task radio button to remove it. Pressing Ctrl+Alt+Delete twice restarts the system. Figure 11.3 displays some of the many system processes in the Task Manager of Windows 2000.

FIGURE 11.3 Windows Task Manager.

DR. WATSON

Dr. Watson™ is a program error debugger tool used in Windows 9.x, NT, and 2000 to detect and log critical error information pertaining to system halts. Dr. Watson also attempts to point you in the right direction by offering possible tips for problem and error resolution. The question at hand does not seem to be "Dr. Watson, I presume?" Instead, the question seems to be, "Dr. Watson, where are you storing your log files?" The Dr. Watson tool stores its information in log files located in various places. In Windows 9.x, the Dr. Watson log file is called WATSONXXX.WLG and is stored in C:\WINDOWS\DRWATSON. In Windows NT, Dr. Watson creates two log files named DRWTSN32.LOG and USER.DMP that are stored in C:\WINNT. When Dr. Watson intercepts a program fault in Windows 2000, the file DRWTSN32.LOG is produced and is stored in the C:\DOCUMENTS AND SETTINGS\ALL USERS\DOCUMENTS\DRWATSON. Dr. Watson offers a standard view and an advanced view for diagnostic reporting purposes.

DEVICE MANAGER

Device Manager is probably the most useful utility ever created for viewing, troubleshooting, and installing devices that are attached to a computer system. As mentioned earlier in this book, Device Manager can be used to view or change system resources such as IRQs, I/Os, and DMAs. Device Manager is available in Windows 9.x and Windows 2000. It is not available in Windows NT.

There are two easy ways to navigate to the Device Manager utility in Windows 9.x. A quick way to access it is to right-click the desktop icon My Computer, select Properties, and choose Device Manager. You can also access Device Manager by clicking Start>Settings>Control Panel, double-clicking the System icon, and choosing the Device Manager tab. The Device Manager opens, and you see a display similar to that shown in Figure 11.4.

The Properties button depicted in Figure 11.4 allows you to view more information about the device that you select. If you click Computer and select Properties, you can view information regarding the IRQs, DMAs, I/Os, and memory of your particular system. The Refresh button forces the system to refresh the device through a process called enumeration. This means the system will simply start the Plug and Play process for the device. The Remove button forces the device to be deleted from the operating system's Registry. The Print button prints out a report based on the devices listed in Device Manager. You can expand and view more information for

FIGURE 11.4 Windows 9.x Device Manager.

a particular device by clicking on the plus (+) sign that is located to the right of it.

Device Manager places specific symbols on its list of devices to notify you if a particular device is having a problem or has been disabled. The most common Device Manager symbols and their meanings are as follows.

- A black exclamation point (!) in a yellow circle represents a device in a problem state. The device in question may still be operational; the error may be related to the system's ability to detect the device or to a device driver issue.
- A red X means that the device in question has been disabled by the system. A resource conflict or a damaged device usually causes this error.
- A blue I on a white background is used to show that a device's system resources have been manually configured. It is the least common symbol of the three and is used for informational purposes only.

What do you do if you are having trouble with devices in Device Manager?

Here are a few important tips.

1. It is important to understand that Device Manager may not always be able to list a device's properties. If you have a device that seems to be running properly but you cannot list its properties in Device Manager, you are most likely using a CONFIG.SYS file to load older Real Mode drivers for the device. This often occurs when running older CD-ROM devices with Windows 9.x.

2. If a device is displaying a black exclamation point (!) on a yellow circle, you should check the properties of the device and identify any resource conflicts. You may have to reassign an IRQ for the device in question before the system can utilize it. You can also troubleshoot this error by starting the Hardware Conflict Troubleshooter that is located in Windows Help. To practice using the Windows 98 troubleshooters, select Start>Help and select Troubleshooting.

Device Manager should always be your first-choice utility to view and modify device resources.

NOTE

The Windows 95 installation CD contains several useful hardware diagnostic tools, such as MSD.EXE and HWDIAG.EXE. MSD.EXE is based on the old DOS diagnostic reporting tool. HWDIAG.EXE is a more robust diagnostic tool that will provide detailed information about hardware devices. Neither of these tools loads by default; your best bet is to use Device Manager.

WINDOWS UPDATE

All current versions of Windows operating systems include the Windows update feature known as Windows Update Manager. This utility is used to keep your operating system up to date with current patches, fixes, service releases, and other information offered by Microsoft. Simply select Start>Windows Update. You will be directed to http://windowsupdate.microsoft.com/. Follow the instructions on this site to bring your operating system up to date.

DISPLAY SETTINGS

When you experience display-related problems, start by navigating to the Windows 9.x Display Properties Window. Select Start>Settings>Control Panel and double-click on the Display icon. The Display Properties

Settings Window should appear by default (Figure 11.5). You can also get to this window by right-clicking the Windows desktop, selecting Properties, and clicking the Settings tab.

Figure 11.5 shows the Display Properties Settings window for the second time in this book—and for good reason. The current as well as past A+ Operating System exams focus on your ability to resolve display-related issues with this graphic. For example, If you are running 640 × 480 pixels, as shown in Figure 11.5, and you are unable to view entire Web pages through your Internet browser or you want to fit more icons on your desktop, simply use the mouse to move the Screen Area Bar to 800 × 600 pixels or more. If your video card supports higher resolution, you will be able to fit more into the viewable screen area with this method. If you select the Advanced>Performance button, you will have the option of changing the Graphics Hardware acceleration settings.

The exam may try to confuse you here. Another way to navigate to the Graphics Hardware acceleration settings is Control Panel>System> Performance>Graphics.

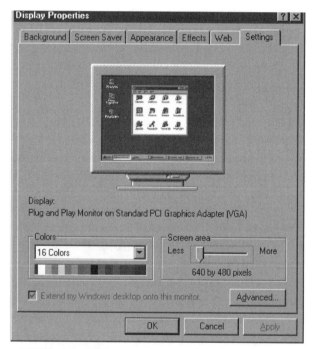

FIGURE 11.5 Windows 9.x Display Properties Settings window.

Changing these settings can be useful if you are having trouble with how fast your system is handling graphics. If you select Advanced>Adapter, the system's video Adapter/Driver information will look like that shown in Figure 11.6. If you select the Change radio button on this screen, the Update Device Driver Wizard window will appear and lead you through the process of updating the video adapter driver. Remember, there are usually several ways to achieve a single goal in a Windows operating system. You can update your video adapter driver, as well as many other device drivers, through Device Manager.

VIRTUAL MEMORY SETTINGS

In Chapter 10 we discussed virtual memory and swap files. You should recall that Windows 9.x has the ability to use a portion of free hard disk space as a temporary storage area or memory buffer area for programs that need more memory than is available in RAM. This temporary hard disk memory area is called virtual memory or swap file. The actual file name for this memory in Windows 9.x is called Pagefile.sys.

FIGURE 11.6 Graphics Adapter Properties window.

To view or change your virtual memory settings in Windows 9.x select Start>Settings>Control Panel>System>Performance>Virtual Memory. You will be presented with a window similar to Figure 11.7. As stated in the virtual memory window, you should be very cautious when changing your systems virtual memory settings. If you are not sure of what these settings should be, you should obviously let Windows manage your settings for you. If Windows is managing your virtual memory settings for you, it allocates around 12MB above the amount of physical RAM installed in your system. For example, if you have 64MB of RAM installed in your system, Windows will create and manage a Swap File of around 76MB of hard drive space.

FIGURE 11.7 Windows 9.x Virtual Memory Settings.

THE RECYCLE BIN

The Windows 9.x Recycle Bin is a desktop icon that represents a directory in which files are stored on a temporary basis. When you delete a file from a computer system's hard drive, it is moved to the Recycle Bin. To restore a file that has been deleted to its original location on the hard drive, right-click on the file in the Recycle Bin and select Restore or select File from the menu bar and then select Restore. If you want to remove a file from the Recycle Bin to free up hard drive space, select File from the menu bar, and select Empty Recycle Bin. You can also delete entries in the Recycle Bin by selecting File from the menu bar and selecting Delete. When you delete a file from the Recycle Bin, its associated entry in the hard drive's FAT is re-

moved. It is still possible to recover the deleted file with many available third-party utility programs.

DISK CLEANUP UTILITIES AND MORE

Your hard drive can get bogged down after a while with unnecessary files. Applications and programs can leave temporary files scattered on your hard drive, temporary Internet files and cookies are left behind when you surf the Internet, and all those downloaded "shareware" programs that you haven't used in ages can take up precious hard drive space.

Windows 98 has an excellent tool known as Disk Cleanup. This built-in utility allows you to get rid of those unnecessary files and free up space. To access the Disk Cleanup in Windows 98, click Start>Programs>Accessories>System Tools>Disk Cleanup. A window appears that asks you to select the drive you want to clean up. The default is (C:). Select the OK radio button, and the window shown in Figure 11.8 is displayed. You can select the options you wish to have removed from your drive by inserting a check mark next to the appropriate selections. Always check your downloaded program files as well as files located in the Recycle Bin to verify that you no

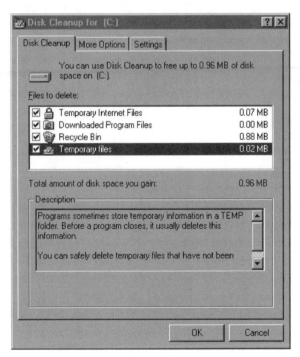

FIGURE 11.8 The Disk Cleanup window.

longer have a use for them before removing. You can do this by selecting the View Files radio button on the Disk Cleanup window.

If you select the More Options tab in the Disk Cleanup window, you will have the options of removing optional Windows components and other programs that you do not often use. If you choose to remove Windows components from within this window, you will automatically be directed to the Add/Remove Programs Properties/Windows Setup Window shown in Figure 11.9. This window lets you add or remove a Windows component. Notice the Install/Uninstall tab. The Install/Uninstall window lets you install applications and programs from a floppy or CD or uninstall registered software that you do not use. The Add/Remove Programs Properties window can also be accessed by clicking Start>Settings>Control Panel>Add/Remove Programs.

You should also take note of the Startup Disk tab in Figure 11.9. With the Startup Disk window, you can create a Windows 9.x bootable troubleshooting floppy disk that you can use later for diagnostic purposes.

Windows 9.x allows you to schedule routine maintenance jobs easily through the use of Maintenance Wizard. This utility is a handy tool that

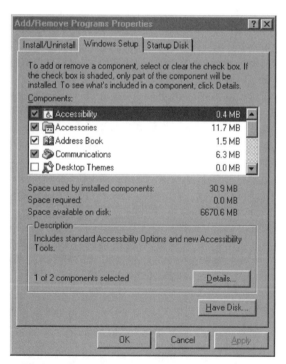

FIGURE 11.9 Add/Remove Programs Properties window.

can be used to automatically run utilities such as Defrag, Scandisk, or Disk Cleanup at times that are convenient for the computer user. In Windows 9.x, the Maintenance Wizard utility can be run by selecting Start>Programs>Accessories>System Tools>Maintenance Wizard.

BACKUP UTILITY

Windows operating systems come with a Backup utility program, which is used to backup information to a tape storage device for future restoration. It is of utmost importance that you back up your critical information in the event of an operating system failure or accidental deletion of files.

A good backup program consists of a backup schedule that can be created using the Backup utility or a third-party backup utility program. In Windows 9.x, the Backup utility can be accessed by selecting Start>Programs>Accessories>System Tools>Backup. If the Backup utility is not installed, you can install it through the Add/Remove programs applet located in Control Panel.

There are several backup types and strategies that you can implement. The backup type and strategy that you use depends on the amount of storage capacity you have, the time it takes to back up files, and the time it takes to restore files. The following types of backups can be used to build your own personalized backup strategy.

- *Copy.* Backs up only selected files. The Copy backup turns the Backup archive bit off or resets it.
- *Full backup.* Backs up everything on your hard drive. If you have to restore an entire system, it is the best backup to have. During this backup, the backup archive bit is turned off. This simply means that every file will be backed up again whether or not its contents have changed. The disadvantages of this type of backup are that it takes longer to run and it is often redundant because most system files do not change.
- *Incremental backup.* Backs up all the files that have changed or been created since the last backup job and have their archive bits set to on. This backup type uses less tape storage space and spreads the storage of files across several tapes. With an incremental backup, files are backed up much faster than with a differential backup, but they take much longer to restore. To do a proper incremental restore, you will need the last full backup tape and multiple incremental tapes.
- *Differential backup.* Backs up all files that have been created or changed since the last backup and does not reset the archive bit. The

archive bit is left on. Differential backup takes much longer to do but is much faster to restore. To do a proper restore, you will need the last full backup tape and the last differential backup tape.

A Zip drive is a popular information storage device. The average Zip drive can hold about 100MB of data, which can be very useful for the daily storage and backup of important files. Users of Windows can use a third-party utility, such as WinZip™, to store files in compressed form and then back them up. Windows stores compressed files in .ZIP format.

PRINTERS

The current A+ Operating Systems Technologies exam is likely to make sure that you are familiar with file and printer sharing, as well as methods used to create and rename printer shares and change printer properties.

In Windows 9.x, if you want to add a printer, rename a printer, share a printer, connect to or disconnect an already shared network printer, or change a currently installed printer's properties, you can select Start>Settings>Printers or My Computer>Printers or Control Panel>Printers. Once you have navigated to the printer's applet, you can right-click an already installed printer and rename it, change its shared name, cancel current print jobs, or select Properties to change advanced features and settings for a printer. If you want to add a local or networked printer, simply select the Add Printer Icon, select Next, and choose Local Printer or Network Printer. If you select Local Printer, you will be required to choose a printer manufacturer and printer or choose the Have Disk option and insert your local printer's driver disk or CD. If you select Network Printer, you will need to specify the UNC name for the location of the shared Network Printer or browse to the printer on the network with the Browse radio button. Remember for the exam that the proper UNC syntax to browse to a shared network printer is `"\\Computername\Printername"`.

A shared printer can utilize spooling techniques. When spooling is implemented, print jobs are stored on a networked computer system's hard drive. The print jobs are sent to a printer when it is available to print. If you want to print directly to a printer without print jobs being spooled, you can change a printer's spool settings to "Print directly to the printer." This can be accomplished by right-clicking a currently installed printer, selecting

Properties>Advanced, and choosing the "Print directly to the printer" option.

So that others can access your locally installed printers and files, you must enable File and Print Sharing on your local system in the Network applet in Control Panel. The same is true if others in a Windows 9.x workgroup or network wish to share their printers and files. Besides printers and files, you can also share CD devices and modems in Windows 9.x.

WINDOWS 9.X NETWORKING

Windows 9.x clients can be part of a workgroup or a domain. A workgroup is typically implemented when a network consists of 10 or fewer computers. A workgroup, otherwise known as a peer-to-peer network, utilizes share-level security (password-protected shares) and does not require the use of high-end server computers. Three components that must be present and properly configured for a computer to operate successfully in a peer-to-peer network are a NIC, a protocol, and the ability to share resources. A *domain* is implemented when the number of computers exceeds 10. A domain utilizes high-end server computers that hand out or serve resources to users who are authenticated through the use of user-level security.

Computers must have a common language or protocol in order to communicate with one another over a network. Windows 9.x provides built-in support for several commonly used protocols. These protocols and their descriptions follow.

- TCP/IP is the most widely used protocol on the planet. Every computer using the Internet has a unique TCP/IP numeric address. This protocol can be used in a Windows 9.x network to share information. If you are currently connected to a network, you can view your own TCP/IP address information in Windows 9.x by selecting Start>Run, entering "WINIPCFG" on the Open line, and clicking OK. Your computer's IP configuration will appear, including the NIC's MAC address, IP address, Subnet Mask, and Default Gateway.

 To display your IP address information in Windows NT, enter "IPCONFIG" in place of "WINIPCFG".

- IPX/SPX is a Novell protocol that allows Windows clients to communicate with resources on a Novell network. IPX/SPX and its Windows counterpart NWLink can be used to share information in a Windows 9.x network.
- NetBIOS—don't be fooled on the exam—NetBIOS is not a protocol used to share printers and files on a network. It is actually an API program that allows computers within a LAN to communicate.
- NetBEUI is a small, fast, efficient transport protocol that is well suited for small networks. NetBEUI can be utilized to share information in a Windows 9.x network.

Connecting a Windows 9.x system to a network is a fairly basic task. The first thing to do is navigate to the Network applet located in Control Panel or right-click the Network Neighborhood icon on the desktop and select Properties. A network configuration window appears similar to that shown in Figure 11.10.

The second step is to install Client for Microsoft Networks. You do this by clicking on the Add radio button and selecting Client from the type of network components you want to install. Click the Add button again, and select Microsoft and Client for Microsoft Networks from the list of manufacturers and network clients. Once the client for Microsoft Networks is installed, highlight it in the network components configuration window, and click Properties. The Client for Microsoft Networks Properties General tab appears, from which you can choose to log on to a Windows NT domain.

Next, you must install any special protocols necessary to communicate and share information with other computers on the network. Remember, if you want to communicate with Novell systems, install IPX/SPX. TCP/IP and NetBEUI are installed by default if you chose to install networking during the Windows Install and Setup routine. These two protocols can be used to communicate with other Windows systems on a network. If you did not install networking when you installed the OS, select the Add button on the Network Configuration window. Highlight Protocol and click the Add button. Select a manufacturer and protocol, and then click OK.

Finally, if you want to share your resources with others, you will need to install the file and print sharing service and make sure you give access to your resources by selecting the File and Print Sharing button in the Network Configuration window.

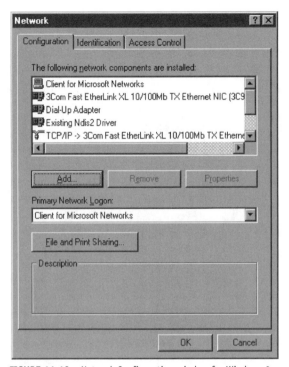

FIGURE 11.10 Network Configuration window for Windows 9.x.

DIAGNOSING AND TROUBLESHOOTING TEST TIPS

The information provided in this section is intended to serve as a quick reference to assist you with diagnosing and troubleshooting many Windows 9.x-related issues. Many tips and shortcuts are presented in this section that are likely to show up on the exam. It is a good idea to read over the following information in final preparation for the Windows 9.x section of the test.

- If you install a hard drive larger than 2GB and your operating system doesn't see beyond the 2GB, your drive is not partitioned as FAT32. You may also need to get a BIOS upgrade from the manufacturer of your motherboard.

- The smallest unit of measure that Windows 9.x can work with on a hard drive is called a *cluster*.
- To create a folder in Windows Explorer, select File>New>Folder or right-click the window and select New>Folder.
- To create a shortcut on your Windows desktop, right-click the desktop and select New>Shortcut.
- In Windows 9.x, the file MSDOS.SYS should be at least 1K.
- Installation files in Windows 95 are called cabinet or .CAB files. The proper name syntax used for Windows 95 .cab files is `Win95_xx.cab` (xx = a numeric value, such as 13).
- In order for a mapped network drive to retain its mapping on reboot, you must check the "Reconnect at Logon" box when establishing the mapping.
- The End key is used to access the interactive startup menu during the Windows 98 boot sequence.
- The Alt+Tab key sequence allows you to toggle between applications that are currently running on your system.
- The <Shift>+<F8> keystroke sequence can be used to refresh your desktop in Windows.
- Menus within Windows programs, such as Word or Windows Explorer, designate hot keys with an underscore (for example, Files, Edit, and View).
- You can get a system configuration printout from a Windows 9.x command prompt by entering `"MSDN"` and pressing the Print Screen key.
- If you want to access a printer by its UNC name, the proper syntax is `//computername/printername`.
- If you have installed a new modem and your previous dial-up networking configuration does not work, go to the dial-up networking properties of your original entry and configure them for the new modem.
- The DOSSTART.BAT file is automatically executed when you restart your system in MS-DOS mode.
- SCANREG can be used to restore a Registry from DOS. If you want to replace the Registry with an older Registry, use SCANREG/RESTORE. If you want to fix the current loaded Registry, use SCANREG/FIX.
- If you have recently installed Client for Microsoft networks, IPX/SPX, and File and Print Sharing and are still unable to browse

your network, verify that "File and print sharing" is checked. Without this setting enabled, you will not be able to see other workstations in Windows 9.x.

- If you want to configure a dial-up connection to the Internet, you must have the network protocol TCP/IP bound to a dial-up adapter.

- If you are using a laptop computer with a NIC and the NetBEUI protocol, "File and print sharing" must be enabled on the NIC if you want to share information.

- If you are having difficulty moving a window between two monitors connected to the same computer system, you may already have the window maximized.

- To remove unneeded items from the Windows 98 Start menu, right-click the item in the Start menu and choose Delete or right-click on the taskbar, select Properties, navigate to the Customize Start Menu Options, and use the Remove button to eliminate unwanted Start menu items.

- Client, Adapter, Protocol, and Service are network components that can be added through the Windows 9.x Network applet.

- If you are having trouble detecting USB devices, you are most likely running the original version of Windows 95, which doesn't support USB without an update. Alternatively, you may not have USB support enabled in your BIOS settings.

- If your system hangs at the Windows 9.x splash screen on bootup, hold down the Shift key on startup to stop possible corrupt startup folder programs from loading.

- If items on your desktop look different from usual or are unidentifiable, the first step for resolving this problem is to refresh the desktop by right-clicking the desktop and selecting Refresh.

- If you need to restore an OS file that has been deleted from your system, you can use the EXTRACT command to restore a file from the Windows 9.x Installation CD.

CHAPTER SUMMARY

This chapter introduces many of the Windows 9.x concepts, utilities, shortcuts, and file systems that you will be required to know for the A+ exam. It is impossible to identify every detail that the current exam will cover;

therefore, it is very important that you practice with the tools mentioned in this chapter in order to back up your knowledge with hands-on experience and give you the best chance of passing the exam. There are many details of Windows 9.x that are beyond the scope of this book. Use all the resources you can get your hands on to pass this exam. It is suggested that you scan the Microsoft White Pages at http://www.Microsoft.com; they refer to all the Windows operating systems mentioned in this book. The following review questions are a great preparation tool. If you do not understand the concepts behind one of the review questions, use your operating system's Help utility or the Internet to give you more detail on the topics you do not completely understand.

REVIEW QUESTIONS

1. You are interested in using the Windows 98 Drive Converter to convert your FAT16 partition to FAT32. What can you gain from this conversion? (Choose 3)

 ☐ A. Your applications will load more quickly.

 ☐ B. You will utilize fewer resources.

 ☐ C. You will gain file level security.

 ☐ D. You will lose valuable storage space based on smaller 4K clusters.

 ☐ E. Your storage space overall will become more efficient.

 Answers: A, B, and E

 A, B, and E are all benefits that can be achieved when you convert to FAT32. File level security is a feature of NTFS (New Technology File System), which is only available with Windows NT and Windows 2000. Choice D is incorrect because smaller 4K clusters let you gain more storage space.

2. You plan on using only the OEM Windows 95 CD to install Windows on a blank hard drive. Why won't this work?

 ○ A. The Windows 95 OEM Installation CD is not bootable.

 ○ B. You do not have enough hard drive space.

 ○ C. You are using an unregistered OEM version.

 ○ D. You must partition the drive as NTFS5 first.

 Answer: A

The Windows 95 OEM installation CD is not bootable. If you plan on using this CD with a hard drive that is not bootable (in this case blank), you will need a bootable floppy disk with supporting CD device drivers installed to install this Windows version successfully.

3. What doesn't Windows 95A support?
 - ○ A. COMMAND.COM
 - ○ B. Defragmenter
 - ○ C. FAT32
 - ○ D. FAT16

 Answer: C

 Windows 95 release A does not support FAT32. It does utilize COMMAND.COM, include a Defragmenter utility, and provide support for FAT16.

4. Which is considered the easiest upgrade path?
 - ○ A. Windows NT to Windows 98
 - ○ B. Windows 95 to Windows 98
 - ○ C. Windows NT to Windows 2000 Professional
 - ○ D. Windows 2000 Professional to Windows 3.x

 Answer: B

 Windows NT cannot be upgraded to Windows 98. Choice D is out of the question. Although the transition from Windows NT to Windows 2000 Professional is fairly straightforward, upgrading from Windows 95 to Windows 98 is considered the easiest upgrade path.

5. Which are considered the safest ways for common users to edit or make changes to the Registry in Windows 95? (Choose 2)
 - ☐ A. REGEDT32
 - ☐ B. REGEDIT
 - ☐ C. Device Manager
 - ☐ D. Control Panel
 - ☐ E. REGEDT34

 Answers: C and D

 Using the Windows 9.x Device Manager and Control Panel options to change settings and devices are considered the safest ways for

common users to make edits to the Registry. Common users should not have the ability to make direct edits to the Registry using REGEDT32 or REGEDIT.

6. The Windows 9.x Registry is considered what?

○ A. A big spreadsheet

○ B. A hierarchical database made up of keys

○ C. A multi-tiered tree text file

○ D. A national database

Answer: B

The Windows 9.x Registry, as well as the Registries implemented in Windows NT and Windows 2000, are hierarchical databases made up of special Registry Keys that hold most of the operating system's software, hardware, and application settings.

7. When you press the F5 key right before the Windows 9.x splash screen appears, and enter Safe Mode, which of the following are not loaded? (Choose 4)

☐ A. NIC driver

☐ B. Modem driver

☐ C. AUTOEXEC.BAT

☐ D. CONFIG.SYS

☐ E. HIMEM.SYS

☐ F. Keyboard driver

Answers: A, B, C, and D

Safe Mode loads a generic VGA driver for basic video, a keyboard driver, and the extended memory manager HIMEM.SYS.

8. You are currently running Windows 95A on a 2GB hard drive. You install a new 10GB drive and configure it as a slave drive. You can only see 2.0GB of the new drive when running FDISK. What is the problem?

○ A. Windows 95A has a 2GB limit.

○ B. Windows 95A is only good for a one-hard drive system.

○ C. Windows 98 was previously installed.

○ D. Hard drive manufactures have been cutting costs and are keeping the other 8GB.

Answer: A

Windows 95A only provides support for up to 2GB partitions on a hard drive. If you wish to utilize partitions greater than 2GB, you should install Windows 95B or Windows 98.

9. You want to empty all the files in your Recycle Bin but you are not quite sure what will happen to them. What happens to files located in the Recycle Bin when it is emptied?

○ A. They are converted from FAT to NTFS.

○ B. They are bound to the IPX/SPX protocol.

○ C. Only the entries in the FAT are removed.

○ D. The hard drive sector is wiped out and marked bad.

Answer: C

When you empty the Recycle Bin, only the entries in the file allocation table (FAT) are removed. This gives you the ability to recover these files using third-party recovery tools.

10. You are interested in renaming a printer in Windows 9.x. What paths could you take? (Choose 2)

□ A. Start>Settings>Printers

□ B. Start>Run>Printers>Rename

□ C. My Computer>Printers

□ D. Start>Control Panel>Label Printer

Answers: A and C

A and C are valid paths to renaming a printer in Windows 9.x. B and D are invalid options.

WINDOWS NT

IN THIS CHAPTER

- Overview of Windows NT
- NT Server versus NT Workstation
- Installation and Upgrading
- The Windows NT Startup Process
- The Windows NT Registry
- Windows NT Networking and Administration
- Resource Sharing and Drive Mapping
- Utilities and Settings
- Printers
- Diagnosing and Troubleshooting Test Tips
- Chapter Summary
- Review Questions

OVERVIEW OF WINDOWS NT

In 1993, Microsoft introduced Windows NT to the world in order to meet the great demand for a true network operating system business solution. The original implementation of NT came in the form of Windows NT Server 3.1.

After several modifications, Windows NT Server 3.51 was released. In 1996, Windows NT Server 4.0 and NT Workstation 4.0 were released.

Windows NT was originally designed with the following concepts and features in mind.

- *Compatibility.* It was imperative that Windows NT be able to support and communicate with other file systems, such as FAT, HPFS (OS/2 High Performance File System), Mac OS, CDFS (Compact Disc File System), Unix, Novell Netware, and other NTFS (NT File System)operating systems. To be compatible with such file systems, NT was designed to provide support for networking protocols such as TCP/IP, IPX/SPX, NWLink, AppleTalk, DLC, and NetBEUI.
- *Reliability and stability.* Windows NT was designed to protect the major components of the operating system from other programs and applications that might fail. It was also designed to protect each program and application from all others by allowing each to run in its own virtual machine (VM). Windows NT is also considered the first truly fault-tolerant operating system. It was designed to provide built-in support for redundant storage through the use of Redundant Array of Inexpensive Disks (RAID).
- *Security.* Unlike a peer-to-peer network that uses password-protected shares, Windows NT was designed to centralize the control of user access to network resources through the use of special domain controller computers that authenticate users. These controller computers are known as *primary* and *backup domain controllers.*
- *Performance.* NT was designed to provide support for the use of multiple processors and true multitasking abilities. It can support true 32-bit preemptive multitasking while maintaining backward support for 16-bit cooperative programs.
- *Internet Explorer and Web Services support.* Windows has built-in support for Internet Explorer and a personal Web server.

The current A+ Operating Systems Technologies exam will most likely focus on your ability to troubleshoot Windows NT boot operations, emergency repair operations, and file system compatibility issues. To give you the best possible chance of passing the exam, it is highly recommended that you support the knowledge you will gain in this chapter with hands-on experience. In other words, follow along with the examples provided in this

chapter on a real computer system running Windows NT Server or Workstation 4.0.

NT SERVER VERSUS NT WORKSTATION

The current A+ exam is likely to refer to Windows NT Server 4.0 and Windows NT Workstation 4.0 simply as Windows NT or Windows NT 4.0. Many of the procedures for carrying out specific tasks are similar in both operating systems.

For example, a Windows NT question relating to the creation of an Emergency Repair Disk (ERD) may come in the following form.

> You want to create an Emergency Repair Disk in Windows NT 4.0. What command would you use to do this?
>
> ○ A. FDISK/ERD
> ○ B. ERD/MAKE
> ○ C. RDISK.EXE
> ○ D. ERD/RDISK
>
> Answer: C
>
> Notice that the question does not focus specifically on Windows NT Server or Workstation—an ERD can be created using either operating system. Although you should know the difference between a server computer and a client workstation, focus your studies on the capabilities of the operating system technology as a whole.

WINDOWS NT SERVER

Windows NT was designed for client/server-based network environments. In a client/server environment, the client computer or workstation requests information from the server computer. For our purposes, the client computer can be Windows 9.x, Windows NT Workstation, or Windows 2000 Professional. The server computer can be Windows NT Server or Windows 2000 Server. This chapter focuses on Windows NT Server.

A Windows NT Server computer is used to provide access to network resources and provide print and file sharing, database, e-mail, and fax services. Windows NT Server can also act as a gateway to mainframe computing systems or act as an Internet gateway server for client computers.

Before a user can log on to a Windows NT domain, the user must be assigned a user ID, which allows him or her to be authenticated on the Windows NT domain. The user ID is assigned specific rights to resources such as directories, files, and printers. This method of assignment provides centralized control of network access and serves as way to control and secure network file and printer sharing. A *domain* is defined as a group of networked computer systems that share a common security accounts manager (SAM) database that is used as a reference to grant users network access. When a new user is added to a Windows NT domain through the User Manager for Domains administrative tool, the user ID is stored in the primary domain controller's (PDC's) SAM database. This database is replicated to all backup domain controllers (BDCs) that exist in the same domain as the PDC. The purpose of a BDC is to improve network performance by load balancing the network authentication process and provide backup to the PDC in case of failure. In other words, users or clients can be granted access to the network through a BDC or a PDC. The BDC stores an identical copy of the SAM database in case the PDC suffers a crash. There can only be one Windows NT PDC server in a single Windows NT domain. There can be several BDC servers in a single Windows NT domain. The amount of BDCs needed in a domain is directly tied to the amount of users requiring authentication. Microsoft recommends having one BDC for every 2000 user accounts.

A well-trained network administrator or technician is usually assigned the duties of managing a Windows NT Server domain. The typical duties of a Windows NT network administrator include the following.

- *Managing network access and user permissions.* This includes adding and removing user accounts from the SAM database, managing groups of users, and assigning permission for users or groups of users to access network resources.

- *Installing and upgrading software.* The administrator is usually responsible for installing and fine-tuning operating system software, such as Windows NT Server or Workstation. This may also require software service pack installations, patches, and upgrades. Depending on the business needs of a company, the administrator may also be required to support and integrate many forms of third-party software.

- *Backups and virus protection.* It is the responsibility of the network administrator to provide backup and fault-tolerant systems in the

event of an emergency or system failure. In some cases, federal law and business contracts require proof that regular backups and backup procedures are in place in order for business to be conducted or contracts to be maintained. The recent onslaught of damaging computer viruses has instilled the need for enterprise-wide antivirus business solutions and skilled administrators that can maintain them properly. If you do not have a good backup plan and virus protection implemented, your entire business is at serious risk.

- *Network monitoring and utilization.* It is important that a network be properly monitored for maximum utilization and possible problem areas that may decrease overall network performance. Several tools included with Window NT are used for network monitoring; these will be discussed later in this chapter.

WINDOWS NT WORKSTATION

The majority of clients or computer users never actually see server computers or domain controllers. They access resources on server computers from desktop workstations or laptops that are running client operating systems, such as Windows 9.x, Windows NT Workstation, or Windows 2000 Professional.

Windows NT Workstation was developed to be the client-side workhorse of the Windows NT domain. It is designed to handle multitasking operations and support processor-intensive applications and programs. A Windows NT Workstation computer can act as a standalone operating system in a peer-to-peer network or be joined to a Windows NT domain. Many of the administrative functions available in Windows NT Server are also available in Windows NT Workstation. Workstations are thought to have less functionality and are only useful at the local operating system level.

INSTALLATION AND UPGRADING

Many factors must be considered as you prepare for a successful installation or upgrade of Windows NT. The installation processes for Windows NT Workstation and Windows NT Server are quite similar. Shortly, you will be guided through a full installation of Windows NT Server. Before the installation process is explained, there are several factors you need to consider; these important factors are explained next.

BEFORE YOU START

Microsoft provides strict minimum hardware requirements for the installation of Windows NT Workstation and Server. You should verify that your system meets or exceeds the minimum recommendations before installation. The minimum hardware requirements for a typical Windows NT Workstation installation are a 486 processor, 12MB of RAM, a VGA display adapter, 110MB of available hard drive space, a CD-ROM device, and 3.3-inch floppy drive. The recommended requirements for an NT workstation installation are a Pentium processor, 16MB of RAM, SVGA support, 300MB of available hard drive space, a CD-ROM device, a 3.5-inch drive, and a NIC.

As mentioned in Chapter 11, you should always consult the manufacturer's specifications before installing any software. Minimum and recommended hardware requirements for Windows NT Server as well as other Microsoft operating systems can be found at the Microsoft Web site (http://www.microsoft.com). It is also important to verify that your installed hardware is supported by the operating system you are installing. If you are installing a Windows operating system, you should check your installed hardware against the hardware compatibility list at http://www .microsoft.com/hcl.

Before installing Windows NT on a hard drive, you must also consider which type of file system the operating system will use. Windows NT works with FAT16 and NTFS. It is not compatible with FAT32 partitions unless you utilize special third-party programs. If you are planning a clean install of Windows NT on a hard drive, you should use NTFS in order to take full advantage of its many benefits. The benefits of NTFS include its overall ability to recover from system failure; support for RAID mirroring, which enables data to be written to two hard drives simultaneously, resulting in a complete hard disk backup; smaller cluster size than FAT16, which enables NTFS to support larger partitioned drive volumes and make better overall use of disk space; and the ability to provide file-level security and auditing.

If you are installing Windows NT on the same hard drive as Windows 9.x or DOS, you will want to use FAT16. FAT16 gives you the ability to see files across operating systems and partitions located on the same hard drive. You can always convert a FAT16 partition to NTFS later from a command prompt by entering the following command.

```
CONVERT C:/FS:NTFS
```

The Windows NT command prompt can be accessed by selecting Start>Run and entering CMD at the Open line. CMD.EXE is the actual command prompt in Windows NT and Windows 2000. You can also navigate to the Windows NT command prompt by selecting Start>Programs>Command Prompt.

If you want to create a dual boot scenario, which will allow you to boot into either the Windows 9.x or Windows NT operating systems (assuming they are installed on the same hard drive), you must have a bootable FAT system partition.

If you have Windows NT installed on the same hard drive as Windows 9.x and you cannot view files between the operating system's partitions, you most likely have Windows 9.x installed on a FAT32 partition.

Another important fact about NTFS and FAT32 partitions is that if you copy files from an NTFS partition or "volume" to a FAT32 partition or "volume," the files will retain their file attributes and long file names. They will also retain any information stored in the file. However, they will lose their compression status, file permissions assigned from within NT, and any encryption status.

This may seem like an awful lot to consider before installation, but it is important to consider all these items in order to achieve your operating system goals.

THE INSTALLATION PROCESS

The Windows NT Server installation process can be started in one of two ways.

To initiate an *over-the-network installation,* do the following.

1. Share a networked CD-ROM device and place the Windows NT Server CD in the shared device. Alternatively, copy the I386 directory and its contents to a local or shared network drive.

2. If you are using Windows or DOS, use the WINNT.EXE command from the client computer to execute the startup process. If you are upgrading from an older Windows NT version use the WINNT32.EXE command from the client computer. You will be presented with the Windows NT Setup screen. From this point on, follow the instructions in the next section after the appearance of the Windows NT Setup screen.

To initiate the installation process *using the three Windows NT installation floppy disks and the Windows NT Server CD,* do the following.

1. Assuming that your system is configured to boot first to a floppy drive, insert the installation floppy disk labeled "Setup Boot Disk" into the floppy drive, place the Windows NT Server installation CD into the CD-ROM device, and restart the system.

2. The Windows NT Setup screen appears. The installation will continue until you are prompted for the second installation floppy disk. While the information on the second disk is processed, you will see the Windows NT kernel loading the version and associated build number. The Welcome to Setup screen appears, which gives you the options to continue, repair, or exit the installation process. In this case, you want to choose the continue option and proceed with installation. Next, the license agreement appears. Page down to the end and press the F8 key to acknowledge your acceptance.

3. You will be asked to insert the third installation floppy disk. The installation process continues searching your system for installed hardware devices. At this point, the installation process has gathered enough information to determine if an older NT operating system has been installed on the hard drive. If the process finds evidence of an earlier version, you will be prompted with the following options:

 - To upgrade, press Enter.
 - To cancel upgrade and install a fresh copy, press N.

 Since we are doing a clean install, the second option is appropriate. The installation process continues, displaying the system type, video card, keyboard, and mouse information. The installation process continues until a list appears of the available partitions the program has found on your hard drive. If you have multiple partitions, you must select one on which to install NT. Be careful not to install NT onto a partition that currently contains a file system with information you want to keep. If you have one partition, select it and press Enter.

4. Next, you are given several options, including a choice of file system to format the partition with.

 - Format the partition using the FAT file system
 - Format the partition using the NTFS file system

 As explained above, format with FAT if you wish to maintain compatibility or dual boot with a DOS or Windows 9.x partition. Use NTFS if

you are interested in performance, program protection, file-level security, and support for file names of up to 254 characters in length. Choose the file system you want to format with and press Enter.

5. After the partition has been formatted, you are asked for the location in which to install the Windows NT files. The default location provided for you is \WINNT. Accept the default by pressing Enter. You will then be prompted for permission to scan the hard drive for corruption. Press Enter to continue. The setup program will continue to copy files to the hard drive and you will eventually be asked to press Enter again to restart the system. As the system starts back up you will notice the "Last Known Good Menu" pass by. This feature will be available every time you restart the operating system in the future. It is used to assist you with restoring the last good known system configuration stored on your drive if you make operating system configuration mistakes.

6. You are asked for type of installation you would like, including Typical, Portable, Compact, or Custom. It is best at this point to choose Typical installation and click Next. You will then be asked to supply a name and company name. Enter the appropriate information and continue. Next, you are asked to provide a CD key, which is provided with the installation CD kit. Enter it and continue. Then you must enter the type of licensing you would like to use. The two licensing options are per seat and per server.

 - *Per Seat means per device.* If you have a 300 per-seat licenses, 300 users can sign on to and legally use any of the Windows NT servers in your business.
 - *Per Server.* If you purchase 50 per-server licenses, or CALS, as Microsoft calls them, any 50 devices can connect to the specific server simultaneously.

If you need more help determining which license type to use, go to the Microsoft Piracy Web site (http://www.microsoft.com/PIRACY/samguide/tools/cal_guide/default.asp#server).

Enter the appropriate license type, select the number of licenses you have purchased, and continue. Next, you will be asked to specify a computer name for your server of 15 characters or less and to choose whether it will be a PDC, BDC, or standalone server. If this is the first server on your network, you should choose the PDC option. If it is the second domain controller installed, choose the BDC option. If the server is going to be used for exchange (e-mail), SQL (database),

fax, or file and print server, you should choose the standalone server option. After you have chosen the type of server that will be created, the installation process will ask you to configure a password of 14 characters or less for the administrator account. Confirm the password by entering it a second time, and click Next.

7. You are now prompted to create an ERD. If you choose the Yes option, setup will ask you to insert a blank floppy disk into the floppy drive and the ERD is created. You can select the No option and create an ERD later by entering RDISK/S at the Start>Run>Open line in the Windows NT GUI. The ERD disk contains valuable system configuration information that can be used to restore your system if it fails. The /S switch used with the RDISK command is used to back up the SAM database.

8. After you have created an ERD, setup offers you the opportunity to install additional components, such as accessories, communications options, games, multimedia, and Windows messaging. Select the components you wish to add and click Next.

9. Windows NT setup then informs you that you are entering the Windows NT Networking portion of setup. You are asked to choose how to connect the server from the following choices:

 - Do not connect this computer to a network at this time
 - This computer will participate on a network:
 - Wired to the network
 - Remote access to the network

 To connect to a network and allow the installation process to continue, select "This computer will participate on a network:" and choose "Wired to the network." Setup then asks if you would like Internet Information Server (IIS) installed. Do not select this option unless you want the server to provide Web services.

10. Next, you are prompted to allow setup to automatically detect your network interface card (NIC).

11. Assuming that setup has found the NIC and it has been configured properly, you are then asked which network protocols you would like to install. By default, Windows NT setup chooses TCP/IP, NetBEUI, and IPX/SPX for you. Accept the defaults, unless you require additional protocols. Setup then asks if you require special services. Accept the default unless you have special needs and continue. Next,

you will be asked if the system will be part of a work group or a domain. If this is the first server in a new domain, you will not be presented with this option. If you are joining this server to an existing domain, you can add it with a domain administrator's user ID and password.

12. Finally, you will need to set your system's time zone and adjust video display options. After this, the system will restart at least once, and you boot directly into the Windows NT GUI.

INSTALLATION NOTES

Windows NT can use a uniqueness database file and an answer file to automate the setup of multiple Windows NT installations. If you use these two files to automate your installation, you will be required to include most of the responses to the installation questions described above within these two files.

There are several important switches that you can use in combination with the Windows NT setup commands. Some of these important switches and useful installation notes are described here.

- Windows NT can be installed on the same hard drive as Windows 9.x, but Windows 9.x cannot be upgraded to Windows NT. Windows NT uses a different registry and operating system structure. If you are installing Windows NT on the same hard drive as Windows 9.x, you must specify a different location for setup to install the necessary files to; otherwise, setup will overwrite your previous Windows 9.x installation.

- If you want to create the three Windows NT installation floppy disks after setup has completed, you can use the command WINNT32.EXE/OX switch from a Windows NT command prompt. You can install Windows NT without being prompted for the three installation floppy diskettes by entering the command WINNT/B2 from a command prompt. This assumes that you have the Windows NT CD-ROM inserted in a CD device.

- The /I:inf_file switch is used with the WINNT command to identify the name of the setup information file to be used for an automated installation. The default file name is DOSNET.INF. The /udf switch is used during an unattended installation to specify unique settings for specific computers in the uniqueness database file.

THE WINDOWS NT STARTUP PROCESS

In order to support and troubleshoot the Windows NT operating system, it is very important to understand the Windows NT boot sequence and what really happens behind the scenes before the Windows NT GUI appears.

The following steps detail the Windows NT startup process.

1. When you push the power button on your system unit or select "Restart the computer?" from the Shut Down Windows menu, the system BIOS executes the POST (power-on self-test).

2. The BIOS then looks to load the MBR (master boot record), which is located on the hard disk. The MBR, which is actually a small program, is used to locate the active partition on the hard drive, which holds the operating system's boot sector.

3. The MBR runs the operating system program boot instructions, which are located in the boot sector.

4. The file Ntldr (NT Loader) that is stored in the root directory of the system partition (C:\) is executed. Ntldr is the first Windows NT operating system file loaded during the startup process. It is the main file used to see that the OS boot process is carried out properly. It can be compared to the IO.SYS file that is utilized with Windows 9.x.

5. Ntldr changes the operating system processor mode from Real Mode to 32-bit mode. This allows a 32-bit file system to be loaded. Keep in mind that Windows NT is a 32-bit operating system. In order for Ntldr to read both FAT and NTFS, the processor mode must be altered to run in 32-bit mode.

6. Ntldr reads the BOOT.INI file, which displays a choice of operating system boot-up options to the screen. By default, the choices are

 "Windows NT Workstation Version 4.00" (Or Windows NT Server if installed)

 "Windows NT Workstation Version 4.00 [VGA mode]"

 These options display for a default of 25 seconds. If you do not choose an option, the system will boot to the option that is selected in the System Startup section of System Properties in the Windows NT Control Panel (Figure 12.1). As shown in Figure 12.1, you can change the amount of time that the System Startup menu list is displayed. You can also change the location of where the

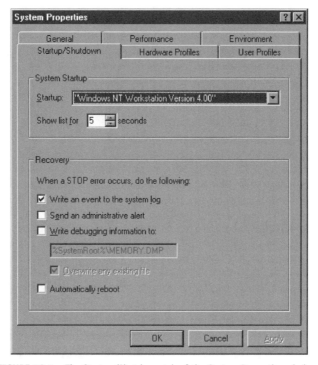

FIGURE 12.1 The Startup/Shutdown tab of the System Properties window.

MEMORY.DMP file stored if a "STOP" error occurs during system startup. Please note that the MEMORY.DMP file is stored in the System Root by default.

7. If the option to boot into "Windows NT Workstation (or Server) Version 4.00" was chosen in the previous step, Ntldr will call on the program Ntdetect.com to gather information on hardware that is connected to the OS. This information will later be loaded into the Windows NT registry. If another option was chosen in step 6, such as an option to boot into DOS or Windows 9.x (assuming that a dual boot scenario was created), Ntldr will call on the file Bootsect.dos to handle the responsibility of loading alternative operating systems.

8. In this step, Ntldr reads the system archive that is located in the Windows NT registry for all hardware devices and associated drivers. Ntldr also loads the files NTOSKRNL.EXE and HAL.DLL. Ntoskrnl is known as the Windows NT kernel. It resides in main memory at all

times after it is loaded. It is the core or central module of the Windows NT operating system and is responsible for memory management and all tasks associated with the OS. The Windows NT Hardware Abstraction Layer (HAL) is a device-level layer of code that allows programs for the operating system to be utilized without the overhead of APIs. The HAL is a required operating system component that provides a seamless connection from the Windows NT Kernel to hardware devices.

9. Ntldr hands complete control of the operating system over to Ntoskrln. This completes the startup process.

RESOLVING NT BOOT ISSUES

Many things can cause Windows NT Server or Workstation to boot up improperly, including incorrectly configured IRQ and I/O settings, problems with NTLDR, and important system files being deleted or overwritten. Following are some of the most common booting issues and the proper methods of troubleshooting or resolving them.

- If you can't boot into your NT operating system, you should always first attempt to use the "Last Known Good Configuration" option on startup. You can initiate this option by pressing the space bar when you see the "Last Known Good Configuration" option displayed at startup. As stated earlier, when you choose this option on startup, the system attempts to restore the last good operating system configuration load. This option is not useful if you have already booted into a configuration that is corrupt.
- If you receive the error message "Boot could not find NTLDR. Please insert another disk" on startup, it is advisable to run the ERD process. The ERD process restores important system files. In order for NT to boot properly, the files NTLDR, BOOT.INI, and NT DETECT.COM must be located in the root directory of the system partition.

 NTLDR, BOOT.INI, and NT DETECT.COM are the same three files that must be on an NT boot disk in order for it to be bootable.

NOTE

- If you receive an error message stating that Windows NT could not start because the file NTOSKRNL.EXE could not be found, it will be necessary to install a backup copy of this file from the ERD.

THE WINDOWS NT REGISTRY

The Windows NT Registry is very similar to the Registry used with Windows 9.x. The main difference is that the Windows NT Registry is a 32-bit program. The Windows 9.x Registry is a 16-bit program. Windows NT stores registry information in a file called REG.DAT. To maintain the ability to modify and communicate with older 16-bit programs, Windows NT supports the 16-bit registration database program editor REGEDIT.EXE that is used with Windows 9.x. REGEDT32.EXE is the Windows NT Registry editor that displays the Registry keys in the right pane of the display and the registry values in the left pane (Figure 12.2).

You can use either REGEDIT.EXE or REGEDT32.EXE to make changes to the registry in Windows NT. Make sure that you update your ERD disk using RDISK /S from a Windows NT Command Prompt before making any changes to the Registry.

If you would like more information about the differences between REGEDIT.EXE and REGEDT32.EXE, visit the Microsoft Product Support Web site at http://support.microsoft.com/support/kb/articles/Q141/3/77.ASP.

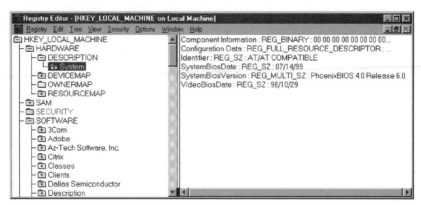

FIGURE 12.2 Windows NT Registry Editor displaying subkeys and values.

WINDOWS NT NETWORKING AND ADMINISTRATION

As mentioned earlier in this chapter, a Windows NT Workstation can participate in a workgroup or a domain environment. In a workgroup, each computer system houses its own SAM database. In a domain environment,

the SAM database is located in a more central location, such as a PDC or BDC. This allows administrators to control user access to the network and provide for the sharing of network resources from a centralized location. A workgroup model mirrors a peer-to-peer network in which security and the sharing of resources is controlled at every machine. Imagine organizing a workgroup of 200 users—you would have to control user access to the workgroup and password-protected shares at every single system!

USER ACCOUNT CREATION AND MANAGEMENT

Windows NT comes with an administrator account that is used to manage and maintain the operating system. You were asked to create a password for this account during the Windows NT installation process. Keep in mind that a Windows NT administrator account can be renamed, but it cannot be deleted. Once you are logged on as the administrator, you can create user accounts (or user IDs), which grant users access to a Windows NT network.

User accounts are created in User Manager on a Windows NT Workstation. User Manager can be accessed by selecting Start>Programs>Administrative Tools [Common]>User Manager. Selecting User Manager brings up the window shown in Figure 12.3. If you are using Windows NT Server, you will administer user accounts with User Manager for domains. User Manager for Windows NT Workstation is a scaled-down version of the more complex User Manager for Domains.

Following are guidelines for creating Windows NT User IDs and passwords.

- User IDs can be up to 20 characters long and are not case sensitive.
- User IDs can be made up of numbers, letters, and allowable characters.
- Passwords can be up to 14 characters long and are case sensitive.
- Passwords can be made up of numbers, letters, and allowable characters. The following characters can be used to make up a password: ` ~ ! @ # $ % ^ & * () _ + - = { } | [] \ : " ; ' < > ? , . /
- As shown in Figure 12.3, User Manager has several built-in groups. These groups are designed for ease of administration. A Windows NT built-in group has preassigned user rights. Windows NT user rights allow users or groups of users to carry out specific tasks, including the right to back up the system, shut down the system, or change the system time. After a user ID has been created in User

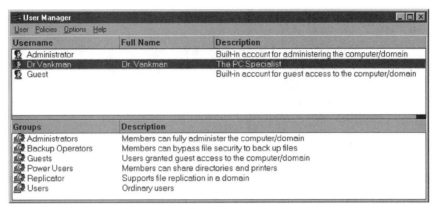

FIGURE 12.3 The Windows NT User Manager.

Manager, it can be placed in a group. When the user ID is placed in a group, the ID inherits all the rights associated with that group. For example, if the user ID BSAWYER were created and added to the Administrator Group, the user BSAWYER would inherit all the user rights associated with the Administrator Group.

Every Windows NT Workstation or Server has a set of built-in local groups. If a user has been placed into a local group, it is possible for the user to access resources and be granted rights on the local system. To ease domain-level administration efforts, Windows NT Server also makes use of global groups. Many users can be placed in a global group, and the Global group can then be added to local group located on a workstation or server. The end result is that it is possible for all users in the global group to access resources assigned to the local group on a particular workstation or server.

In addition to creating user IDs and the assignment of user rights, User Manager also has the ability to audit the success and failure of events that occur on the system. An administrator can audit access to files and objects, users who have logged on or logged off the system, and security policy changes, just to name a few. The results of the events that have been audited are displayed in the Windows NT Event Viewer. Event Viewer is described under "Utilities and Settings," later in this chapter.

LOGON

When Windows NT first boots up, a user ID and password are required to sign on to the local computer system or the network (domain) the system is connected to.

Once a user ID and password have been created for a user, the user can proceed to sign on. Once a user is signed on to the operating system, the Windows NT Security and Logon Information box can be displayed by pressing the Ctrl+Alt+Del keys all at once. The Logon Information box displays the following information and provides the following options to the currently signed-on user.

- The computer name and currently signed-on user.
- The logon date and time.
- Lock Workstation. This is a great built-in security feature that lets the user secure the computer while away. To unlock the workstation, the user presses Ctrl+Alt+Del again and enters the proper credentials to sign back on to the system.
- Logoff. The option to end the current Windows NT session is available. Simply select the Logoff radio button. The message "This will end your Windows NT session" appears. Select the OK button and you will be logged off the system.
- Shut Down. If you select the Shut Down option, you are presented with the option to shut down the system or shut down and restart. These options are the same as the options offered by selecting Start>Shut Down from the Windows NT desktop display. The only exception is that you are also offered the ability to close all programs and log on as a different user if you use Start>Shut Down.
- Change Password. If you have been granted the right to change your own password by a network administrator or network security person, you can select the Change Password radio button to change your sign-on password (user rights are discussed shortly).
- Task Manager. Similar to Windows 9.x, Windows NT comes with a built-in Task Manager (Task Manager is discussed in more detail later). You can enter the Task Manager by selecting the Task Manager radio button.
- Cancel. The last option is the Cancel radio button. If Cancel is selected, you are directed back to the Windows NT desktop.

It is important to note that the same Windows Security and Information display can be accessed in Windows 2000 Professional and Server by following the same procedures. The information and options available are identical.

LSA, SID, AND ACL

Security access to resources and the entire security sign-on process that takes place when a user logs on to Windows NT is very complicated and beyond the scope of this book. However, a basic explanation of the process is in order.

When a user logs on to NT Workstation, the local security authority (LSA) generates what is called a security access token (SAT). This SAT is assigned a SID (security ID for the user). The unique user SID contains access rights and privileges that have been assigned to the user's ID that was created in User Manager or User Manager for Domains (explained in the next section). Windows NT maintains an *access control list* (ACL) for all objects on the Windows NT domain. An object can be a file, a folder, or a printer share, just to name a few. In order for a user be granted access to an object on the domain, the user's SAT must be accepted by the ACL. It is improbable that the A+ Operating System Technologies exam will address detailed questions on this subject.

USER PROFILES AND SYSTEM POLICIES

A Windows NT local user profile is created when a user first logs on to a Windows NT system. The local user profile is a configuration of the environmental settings and preferences that have been established by the user. In simple terms, a user profile is a combination of desktop configuration settings the user sees every time he or she logs on. An administrator may implement a roaming user profile for an individual if he or she wishes to use the particular configuration settings assigned to the user at any other computer.

With a roaming user profile, the user's profile information is stored on a server computer and is presented to the user wherever he or she logs on to the network.

Windows NT has a useful tool for controlling user environments called the System Policy Editor. With the System Policy Editor tool, an administrator can configure system policies for computers, users, or groups of users. For example, lets say you wanted all users who signed on to the network as the user ID GUEST to be restricted from changing the screen saver and wallpaper and editing the registry. You can use the built-in settings within System Policy Editor to create a policy for the user ID Guest and apply the restrictions above. You would then need to copy the file NT-CONFIG.POL (which is the policy you have saved in System Policy Editor) to the NETLOGON share on the authentication server. When the user GUEST logs on to the network, the policy takes effect.

Profiles and system policies are basically tools used by administrators to control a Windows NT network.

DIAL-UP NETWORKING

Dial-up networking allows you to connect to remote networks using a modem or ISDN connection from within Windows NT. If you did not choose the Remote Access to the Network option during the Windows NT installation process, dial-up networking is not installed on your system. If this is the case, you can add dial-up networking by accessing the Network Applet located in the Control Panel, select the Services tab, and click the Add radio button. A list of network services opens. Choose Remote Access Service and click OK. Remote Access Service must be installed to utilize dial-up networking. You will be asked for the location of the I386 folder, which contains Windows NT installation .CAB files. Insert the Windows NT installation CD if you have not copied the I386 directory to the C:\ drive (which, by the way, is common practice among NT administrators). This avoids the need to use the installation CD to install services and drivers. Select Continue, and the Remote Access Service will attempt to find a modem connected to your system. Simply follow the instructions for the modem identification and associated COM port and reboot the system when prompted. This process also installs a network dial-up adapter, which can be seen in the Network Applet of Control Panel once you have rebooted.

After you have rebooted your system, navigate to My Computer>Dial-Up Networking. You will be required to set up a phone book entry and configure the proper protocols and authentication methods used to communicate with the Dial-up Server. From here it's as simple as clicking the phone book entry you have created to access a server remotely.

If you are using dial-up networking in Windows 9.x or Windows NT and cannot connect to a dial-up server—or an ISP, for that matter—you should first try to establish a new connection within dial-up networking. For Windows 9.x, select the New Modem option from the Dialup Networking Connection Properties. For Windows NT, attempt to create and configure a new phone book entry from within the Dial-up Networking applet in My Computer.

 In order to establish a dial-up connection with the Internet, you must have TCP/IP and a network dial-up adapter.

NOTE

RESOURCE SHARING AND DRIVE MAPPING

The procedures for sharing folders, printers, and other resources in Windows 9.x, Windows NT, and Windows 2000 are all relatively similar.

To share a folder within the Windows NT operating system, navigate to Windows NT Explorer by clicking Start>Programs>Windows NT Explorer, or right-click the Start button and select Explore. Once in Explorer, right-click on a folder to be shared with other users, then select the Sharing tab. If the folder has been previously shared, the Share As button will be selected, and a Share Name will appear, as shown in Figure 12.4. You will also notice that, in Windows Explorer, a previously shared folder is displayed with a hand holding it so as to share its contents. If a folder is not shared, the Not Shared button will be selected. Simply select the Share As button and enter a Share Name. Select Apply, then OK, and the folder will be shared.

Notice the Permissions button shown in Figure 12.4. If you click Permissions from within the OS, you will see the users who have access to the newly created share. By default, the Everyone Group in Windows NT has access and full control of newly created folder shares and printer shares. You can choose the Add or Remove options in the Access Through Share

FIGURE 12.4 Sharing a folder in Windows NT.

Permissions box to grant or disallow specific users access to your share. You can also change the type of access a particular user or group of users has to your share. The types of access rights that can be assigned to folder-level shares in Windows NT are No Access, Read, Change, and Full Control.

So far we have discussed folder sharing and permissions. If you look at Figure 12.4 once again, you will notice the Security tab. The presence of this Security tab indicates that the system has been configured with NTFS. We can use the Security tab to apply file-level permissions, implement auditing, or take ownership of selected items (Figure 12.5). These features are available only with Windows NT and Windows 2000. File-level permissions and auditing are not available in Windows 9.x.

Establishing drive mappings in an operating system allows you to connect to other computers, printers, and network resources. Having static drive mappings comes in very handy for displaying, moving, and copying information from one location to another.

To map a network drive in Windows NT, follow these instructions:

1. Right-click on the Network Neighborhood icon on the desktop.
2. Select Map Network Drive. The Map Network Drive dialog box will appear.

FIGURE 12.5 Windows NT Security tab.

3. From the Drive list, select the drive letter you wish to map.

4. Enter a path for your mapping. You need to enter the UNC name for the location of the server and share you wish to map to; for example, \\Servername\Sharename.

5. Select Reconnect at login to retain your mappings when you reboot the system.

6. Click OK.

Another way to access the Map Network Drive dialog box is to navigate to Windows NT Explorer and select Tools from the menu bar. You will have the option to Map Network Drive or Disconnect Network Drive.

After you have mapped to a resource on the network, your drive mappings can be located in Windows NT Explorer or My Computer.

UTILITIES AND SETTINGS

Windows NT offers utilities and tools for such tasks as formatting hard drives and assigning drive letters to volumes; monitoring and logging the performance of workstation or server computers; viewing system, security, and application event logs; and backing critical information. Some of the more commonly used tools and their functions are described next. All the following tools are located in the Administrative Tools [Common] area, which can be accessed by selecting Start>Programs>Administrative Tools [Common].

BACKUP

Windows NT comes with a built-in backup tool known as Backup. Backup provides the ability to back up and restore important system files and data. When Backup is first run, it attempts to find a tape drive unit attached to the system. If Backup does not find a tape drive unit attached to the system, a Tape Drive Error Detected window appears that suggests you check to see that the proper cables are connected, power to an attached tape unit is turned on, and that you have properly configured a tape unit using the Tape Devices option in Control Panel.

Once you enter the Backup main window, you can use the Operations drop-down menu to back up, restore, and perform general backup tape maintenance functions.

Most organizations today utilize third-party backup software that offers more functionality than the Windows NT backup tool.

DISK ADMINISTRATOR

The Windows NT Disk Administrator is a very useful administrative tool that lets you format drive space, assign and change drive labels, and implement fault-tolerance systems by establishing disk mirror sets and disk stripe sets.

Disk Administrator is located in the Administrative Tools [Common] area. Once you open the Disk Administrator, the window shown in Figure 12.6 appears.

From the Partition drop-down menu you can delete, create, or extend partitions and create volume sets or strip sets. From the Tools drop-down menu, you can format a displayed drive or volume, assign a drive letter to a disk or volume, or display the properties of a drive.

Explaining every function of the Windows NT Disk Administrator is beyond the scope of this book; however, it is important for you to understand the terms mentioned here for the A+ Operating Systems Technologies test.

FAULT TOLERANCE AND RAID

Fault tolerance is the ability of a computer system to recover from a hardware or software failure or crash. There are several types of fault-tolerant hard disk configurations and specifications known as RAID levels.

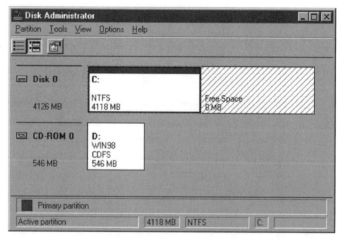

FIGURE 12.6 Windows NT Disk Administrator.

Several levels of RAID are available today that provide fault-tolerant systems. It is important that you have a basic understanding of the following three levels of RAID.

- RAID level 0, or *disk striping without parity*. With this level of RAID, data is spread or written over multiple hard disks. This technique provides better performance of read-and-write operations than other levels of RAID, but it is not considered fault tolerant.
- RAID level 1, *disk mirroring,* or *disk duplexing*. To use RAID level 1 and establish what is called a disk mirror with the NT Disk Administrator, you need two installed hard drives. After you have established a mirror within NT Disk Administrator, all data written to your first hard drive is also written to the second hard drive. This provides true fault tolerance. If one of your hard drives fails, the other drive can be used to recover data. With disk mirroring, only one hard drive controller card is used to support both hard drives. *Disk duplexing* is the same as disk mirroring, with one exception: a second hard drive controller card is used; therefore disk duplexing is more fault tolerant than disk mirroring.
- RAID level 5, otherwise known as *disk striping with parity*. RAID level 5 is one of the most widely used fault-tolerant implementations. This RAID level requires a minimum of three hard drives installed in a single system and can support up to 32 hard drives. With RAID level 5, all information and parity data are spread across the disks. If one disk crashes, the information needed to implement a complete recovery by the system can be gathered from the other two disks.

If you encounter a question on the OS exam that asks which Windows NT built-in administrative tool can be used to format a drive, change a drive letter assignment, or establish a fault-tolerant recovery implementation, *Disk Administrator* should be your answer.

VOLUME SETS

A combination of hard disk space from different partitions that is used to form a single logical area is known as a *volume set*. A volume set can combine the free drive space from up to 32 separate partitions to form one logical drive. For example, if you have three hard drives with a combined free space of 4GB, you can select each area of free space from each of the three drives displayed in the Windows NT Disk Administrator utility and combine the three areas to form one logical drive.

EVENT VIEWER

The Windows NT Event Viewer, also located in the Administrative Tools [Common] area, is used to monitor and evaluate significant events that occur within the operating system. Event Viewer maintains three separate event logs, each of which has its own unique purpose for monitoring and troubleshooting important events.

The three main event logs that can be viewed with Event Viewer are the System Log, the Security Log, and the Application Log.

- The *System Log* maintains information pertaining to important system events, such as services that have been stopped or started within the operating system. Some of these services may include the Event Log service, the computer browser service, DHCP service, or any other service run by the system. The System Log also maintains useful startup information, which can used to troubleshoot components that are attached to the system.
- *Security Log.* As mentioned earlier in the User Manager sections, enabled events in the Audit Policy are displayed in the Security Log. The Security Log can keep a record of successful and unsuccessful logon attempts to the domain or network. It can also track file and object access, as well as system restarts and shutdowns.
- *Application Log.* The application log keeps track of important information about system-related applications. These applications may include Microsoft Office, antivirus software, and Windows Update.

Over time, the event logs that are maintained within the Event Viewer can use up important hard drive space and cause your system to run slowly or crash. A good practice is to change the default settings from "Overwrite events older than 7 days" to "Overwrite events as needed."

PERFORMANCE MONITOR

Windows NT includes an important add-on utility that can be used to track and monitor the performance of system components and the overall performance of a workstation or server computer. This tool is called the Windows NT Performance Monitor. Some of the most useful information that can be gathered and logged by performance monitor includes processor utilization, memory utilization, memory page faults per second, percentage of free disk space, and real-time server counters to keep track of important server utilization.

WINDOWS NT DIAGNOSTICS

Yet another very useful tool included with Windows NT is the Windows NT Diagnostics utility. This utility can be used to view and troubleshoot system resources, such as IRQs, I/O ports, DMA channels, memory, and devices. All system services as well as environmental variables can also be viewed through Windows NT Diagnostics.

The Windows NT Diagnostics utility can be accessed through the Administrative Tools [Common] area or by selecting Start>Run and entering "WINMSD" on the Open line. The Windows NT Diagnostics utility is not meant to be used for updating or changing system or environmental settings; it is simply a representation of settings and information stored in the Registry used for diagnostics and troubleshooting.

TCP/IP UTILITIES

Several important utilities are part of the TCP/IP package and are installed with Windows NT Workstation and Windows NT Server by default. These utilities are used to troubleshoot and test network connectivity issues. Following are descriptions of the most commonly used TCP/IP utilities and their functions. Note that all these utilities work in a similar manner in Windows 2000.

PING

Short for Packet Internet Groper, PING is a utility used to test the connection between two computers. The following syntax is used to PING a computer by IP address or by name.

```
PING 209.15.176.206
PING CHARLESRIVER.COM
```

The PING utility works by sending a TCP/IP packet to a destination IP address and waiting for a reply. If the destination host receives the packet of information, four echo replies are received at the computer that initiated the PING command. PING is most commonly used to test connections to the Internet and ISPs.

IPCONFIG

You should recall from Chapter 11 that the WINIPCFG command is used at a Windows 9.x command prompt to display TCP/IP information, such as a system's IP address, subnet mask, and default gateway. Windows NT

and Windows 2000 utilize the TCP/IP utility IPCONFIG to display the same information. You can display a system's IP address and additional information by navigating to a Windows NT or 2000 command prompt and entering "IPCONFIG".

TRACERT

The TCP/IP TRACERT utility is used to troubleshoot connections between routes that a packet will take before reaching its destination address. In other words, TRACERT measures the time it takes for a packet of information to move between routers in hops until it reaches its destination. You can view the results of TRACERT and the time it takes for the packet to move between routers to see where the slow response is located.

NSLOOKUP

NSLOOKUP is used to query a DNS for a host name to IP address resolution. In simple terms, when the NSLOOKUP command is given, a request is issued to resolve a fully qualified domain name, such as CompTIA.com, to IP address.

From a command prompt, enter "NSLOOKUP CompTIA.COM". The results of this command would be

```
Name: Comptia.com
Address: 216.219.103.72
```

PRINTERS

The current A+ Operating System Technologies exam will most likely make sure that you can resolve basic Windows NT or Windows 2000 printing problems. Troubleshooting printing-related issues from within either of these two operating systems is basically the same.

There are several questions that you should ask yourself or a customer who is having difficulty printing.

- *Is the printer you are sending a document to set as the default printer in the Printers applet of My Computer or Control Panel?* If the desired printer it is not set as the default printer, you can rectify this situation by right-clicking the installed printer icon located in the Printers applet and selecting "Set as Default Printer." Print the document again. Another way to direct a print job to a specific printer is to select the File menu option from within the document

you wish to print. Next, select the Print option, and from the Printer Name drop-down menu option, select the installed printer to which you would like to direct the print job.

- *Is there enough memory installed on the Print Server or users workstation to handle the print job or jobs that have been submitted to print?* It is very common to experience "out of memory" errors when attempting to print to a locally installed or networked printer. More often than not, there is simply not enough physical memory installed on the system to handle the transition of the print job from the system to the printer. This can be resolved by installing more memory in the system itself.

- *Is the printer spooler service stalled on the shared network printer?* The printer spooler service is a service that manages print jobs sent to a Windows NT or Windows 2000 shared network printer. If a print job or multiple print jobs are stalled on a network print server running the spooler service, the simple solution is to stop and start the printer spooler service. In Windows NT, the Services applet is located in the Control Panel. In Windows 2000, the Services applet is located within the Control Panel/Administrative Tools applet.

- *Do you or the customer have rights to print to the shared printer?* As discussed earlier in this chapter under "Resource Sharing and Drive Mapping," file, folder, and printer shares can all be assigned access rights within Windows NT and Windows 2000. If you or a customer cannot access a certain printer share on a network, you may not have been granted the proper rights.

DIAGNOSING AND TROUBLESHOOTING TEST TIPS

The following information is designed to assist you with last-minute study preparation for the current CompTIA A+ Operating Systems Adaptive exam. You should review these important Windows NT Diagnosing and Troubleshooting Test Tips before taking the test.

- Windows NT is a multitasking, multithreaded operating system that can run applications in their own NTVDMs or virtual memory spaces. NTVDMs (NT Virtual DOS Machines) are part of a built-in Windows NT subsystem that allows 16-bit applications to act as if they are running in their own memory-protected DOS environment.

If you are running an application or program that interferes with another application or program, you should attempt to run the offending program in its own protected memory space.

- It is not possible to upgrade to Windows NT 4.0 from Windows 9.x. You can install Windows NT on the same hard drive but not in the same directory as Windows 9.x. However, you can upgrade to Windows 4.0 from Windows NT 3.1 or Windows NT 3.51 operating systems.
- The Windows NT workstation Dr. Watson log files are stored in C:\WINNT.
- Programs and files with the extensions .EXE, .COM, and .BAT can be run from the Windows NT command prompt.
- Windows NT supports port replication through the use of hardware profiles. If you want to ensure that the port replicator works on your laptop while at the office but is ignored while out of the office, you will need to enable Hardware Profiles in the System applet of Control Panel.
- Windows NT supports FAT16 and NTFS partitions. It does not include support for FAT32.
- Windows NT does not have a native Defragmenter utility.
- Windows NT does not have the Device Manager utility that was implemented with Windows 9.x.
- Windows NT does not support Plug and Play very well.

CHAPTER SUMMARY

By reading this chapter, you should have gained enough understanding to install, upgrade, and troubleshoot the Windows NT operating system. At this point, you should also have a basic understanding of the following.

- How to create an ERD from within Windows NT
- How the Windows NT domain model is structured
- How the Windows NT authentication process works
- How security and access rights are implemented and supported in Windows NT
- How to access and use some of the many important utilities associated with Windows NT, including User Manager, Task Manager, and Event Viewer, to name a few

- Sharing network resources and establishing drive mapping
- Diagnosing basic printing problems from within Windows NT and Windows 2000

Although it is beyond the scope of this book to cover every detail of this complex operating system, you should now have enough knowledge to answer the following review questions, which are designed to fine-tune your skills in preparation for the real CompTIA exam. As always, if you do not understand a topic or require more information, the Microsoft Web site is an invaluable resource.

REVIEW QUESTIONS

1. You have installed Windows NT Workstation on a computer that is already running Windows 9.x. You cannot see Windows 9.x files from within Windows NT Workstation. What is most likely the problem?

 ○ A. The Windows NT Workstation partition is FAT32.
 ○ B. The Windows NT Workstation partition is FAT16.
 ○ C. You need to Select View and Show All Files in Explorer.
 ○ D. The Windows 9.x partition is FAT32.

 Answer: D

 NTFS and FAT32 are incompatible file systems. You cannot see across these two partitions when they are installed on the same hard drive. The problem here is that you cannot see the Windows 9.x files from within Windows NT Workstation, so the obvious choice is that the Windows 9.x partition is FAT32.

2. You have just installed Windows NT. You attempt to boot into the operating system and receive the message "Boot could not find NTLDR. Please insert another disk." What should you do?

 ○ A. Make a copy of NTLDR from another NT computer and use it in yours.
 ○ B. Run the ERD.
 ○ C. Restart and use the Last Known Good Configuration.
 ○ D. Insert a blank floppy and type "RDISK/S".

 Answer: B

If you receive the error message "Boot could not find NTLDR. Please insert another disk" on startup, it is advised that you run the emergency repair process using the ERF. The ERD will restore your important system files.

3. Which important files must be located in the root directory of the system partition for Windows NT to boot properly? (Choose 3)

 ☐ A. COMMAND.COM
 ☐ B. NTLDR
 ☐ C. MSDOS.SYS
 ☐ D. BOOT.INI
 ☐ E. NTDETECT.COM
 ☐ F. IO.SYS

 Answers: B, D, and E

 In order for NT to boot properly, the files NTLDR, BOOT.INI, and NTDETECT.COM must be located in the root directory of the system partition.

4. You should always try this first if you can't boot into your Windows NT operating system.

 ○ A. Reformat the boot partition with FAT16.
 ○ B. Press F8 on startup to enter Safe Mode.
 ○ C. Reinstall from three setup floppies and installation CD.
 ○ D. Use the Last Known Good Configuration.

 Answer: D

 If you can't boot into your NT operating system, you should always first attempt to use the "Last Known Good Configuration" option on startup. You can initiate this option by pressing the space bar when you see the "Last Known Good Configuration" option displayed on the screen at startup.

5. You are currently running Windows NT and would like to convert your FAT16 partition to NTFS in order to provide for a more secure OS. What command would you enter at a DOS prompt to do this?

 ○ A. FDISK/MBR
 ○ B. CONVERT C:/FS>NTFS
 ○ C. CONVERT C:/FS:NTFS
 ○ D. FORMAT C:/ FAT16>NTFS

Answer: C

You can always convert a FAT16 partition to NTFS from a command prompt by entering the command "CONVERT C:/FS:NTFS". FDISK/MBR will format your master boot record. Choices B and D are invalid.

6. What command can you use to bring up the command prompt in Windows NT?

 ○ A. CMD.EXE
 ○ B. COMMAND.COM
 ○ C. Ctrl+Alt+Del
 ○ D. SYSPOL.EXE

 Answer: A

 The Windows NT command prompt can be accessed by selecting Start>Run and entering CMD at the Open line. CMD.EXE is the actual command prompt in Windows NT and Windows 2000.

7. You want to transfer files from within a Windows NT Workstation volume that is formatted with NTFS to a Windows 9.x volume that is formatted with FAT32. Which of the following will happen to your files? (Choose 3)

 □ A. They will retain any information stored in the file.
 □ B. They will retain their long file names.
 □ C. They will retain their file attributes.
 □ D. They will retain their compression status.
 □ E. They will retain their encryption status.
 □ F. They will retain file-level permissions.

 Answers: A, B, and D

 If you transfer files from an NTFS volume to a FAT32 volume, you will retain information saved within the file, the file's LFN (long file name), and the file attributes. However, the files will not remain compressed or encrypted, and you will lose file-level permissions.

8. This service must be installed in order to utilize dial-up networking with Windows NT. What is the service?

 ○ A. Dial-up Networking Service
 ○ B. Dial-up Networking Monitor Service

○ C. Remote Access Service

○ D. Windows Installer Service

Answer: C

Remote Access Service must be installed to utilize dial-up networking with Windows NT. All other choices are incorrect.

9. You have a 20GB hard drive with Windows NT installed. You are interested in formatting the free space available on the drive, labeling the newly formatted space with a drive letter, and exploring opportunities for a fault-tolerant implementation. Which Windows NT tool would you use?

○ A. Drive converter

○ B. Backup

○ C. Disk Administrator

○ D. Partition Administrator

Answer: C

The Windows NT Disk Administrator is a very useful administrative tool that allows you to format drive space, assign and change drive labels, and implement fault-tolerance systems by establishing disk mirror sets and disk stripe sets.

10. You believe that your customer is unable to print documents because the wrong printer is set as the default printer in the Printer applet of Control Panel. What would you suggest to resolve the customer's printing problem? (Choose 2)

□ A. Ask the customer to print to a different networked printer.

□ B. Navigate to the proper printer and "Set as Default Printer."

□ C. Tell the customer that a reboot should take care of the problem.

□ D. Reinstall the printer drivers.

□ E. Have the customer use the Print option from the document file menu and choose a specific printer.

Answers: B and E

If the wrong printer is set as the default printer, you will not be able to print documents. The simple solution is to set the desired printer as the default printer. Answers B and E are the proper procedures for setting a default printer or directing a print job to a specific printer.

WINDOWS 2000

IN THIS CHAPTER

- Overview of Windows 2000
- Windows 2000 Installation Process
- Windows 2000 Upgrade Procedures
- Windows 2000 Startup Process
- Windows 2000 Tools and Utilities
- Profiles
- Printers
- Windows 2000 Networking and the Internet
- Diagnosing and Troubleshooting Test Tips
- Chapter Summary
- Review Questions

OVERVIEW OF WINDOWS 2000

In case you haven't heard, Windows 2000 was built on Windows NT technology.

If you have used Windows 2000 Professional or Windows 2000 Server to any extent, you may have noticed that the Windows 2000 family of operating systems was built with a combination of the best Microsoft operating system technologies available, including Windows 9.x and Windows NT.

As you may recall, Windows 9.x is suitable for client workstation use and supports only FAT16 and FAT32 partitions. Unlike Windows NT, it does not support file-level security. Windows 9.x offers built-in Defragmenter and Device Manager utilities, which are very useful tools for maintaining hard drives and troubleshooting hardware devices and drivers, respectively.

Windows NT was developed for a domain structure environment and offers better security and administration capabilities than Windows 9.x, but it only provides support for FAT16 and NTFS partitions. Windows NT does not have a native Defragmenter utility and does not offer the Device Manager that was available in Windows 9.x.

Windows 2000 combines the functionality of Windows 9.x and Windows NT by including the following features.

- Support for FAT16, FAT32, NTFS, and CDFS file systems (Windows 2000 does not support HPFS)
- A built-in Defragmenter utility
- A built-in Device Manager utility
- Safe Mode support similar to Windows 9.x
- File-level and folder-level security
- Full administrative support for a client/server environment

In addition to the combined features included from the previous operating systems, Windows 2000 offers many new technologies and improvements. We discuss many important Windows 2000 advances in this chapter. Here are some of the most notable:

- *Improved security.* Windows 2000 offers file- and folder-level encryption with Encrypting File System (EFS). EFS makes use of public and private encryption keys. In order to decrypt a file or folder, you must be the one who originally encrypted it or be a recovery agent.
- *Better support for hardware.* Windows 2000 offers better overall support for Plug and Play, USB, and infrared.

NOTE Windows 2000 provides built-in drivers for USB support. To install a USB device, simply shut down the system, plug in the USB device to a USB port, power the system on, and run the Add/Remove Hardware Wizard located in Windows 2000 Control Panel. Choose the proper driver and restart the system. You can also use the Add/Remove Hardware applet to troubleshoot existing devices or uninstall device drivers.

- *Better support for laptops.* Windows 2000 assists with the overall performance of laptop computers by providing Advanced Configuration and Power Interface (ACPI) and smart battery.
- *Active Directory.* Windows 2000 Server provides Active Directory, which gives administrators a single point to manage network objects and resources.
- *Better disk management capabilities.* Windows 2000 makes use of disk quotas, which allow administrators to restrict the amount of hard drive space a particular user can use. Disk quotas can be applied to volumes or users.
- *Better support for the Internet.* Windows 2000 supports Dynamic HTML (DHTML) as well as Extensible Markup Language (XML), which helps Web developers create better solutions for business.
- *Windows 2000 file system protection.* Windows 2000 has a built-in backup feature called Windows file protection that keeps a backup of important system files. If you write over important system files with programs or applications, Windows file protection prompts you that it needs to restore the important system files you just replaced.

WINDOWS 2000 INSTALLATION PROCESS

Before installing Windows 2000, or any other Windows operating system, you must verify that your computer meets the minimum hardware requirements. The minimum hardware requirements for Windows 2000 Professional are as follows.

- 133MHz Pentium processor
- 2GB hard drive with 650MB of free drive space
- 64 MB of RAM
- VGA monitor
- Keyboard
- Mouse
- 12x CD-ROM (not required for over-the-network installation)

The second preinstallation step is to verify that your hardware is in compliance with the hardware compatibility list (HCL) located at www.microsoft.com/hcl.

 The Windows 2000 Professional installation CD-ROM contains a copy of the HCL, but this HCL is outdated. Your best bet is to visit the Web site to ensure the most recent hardware compatibility updates.

Next, you need to choose one of three Windows 2000 Professional installation methods. The three installation methods and their general descriptions are as follows.

CD-ROM INSTALLATION

Installing Windows 2000 Professional by CD-ROM is by far the easiest method. If your system BIOS supports the ability to boot to CD-ROM, all you have to do is place the installation CD in your CD drive and reboot. The installation process will begin by copying the installation files to your hard drive. Your system is then rebooted, and the GUI phase of the installation process begins.

FOUR SETUP DISKS

The Windows 2000 Professional CD-ROM can create four installation floppy disks to be used for installation if your system cannot boot to a CD-ROM.

If you are currently running DOS or Windows 3.x, open the Bootdisk folder located on the Windows 2000 Professional Installation CD and run the makeboot.exe program. If you are currently running Windows 9.x, Windows NT, or Windows 2000, run the makebt32.exe program, also located in the Bootdisk folder on the installation CD. After you have created all four floppy diskettes, place the first diskettes in the floppy drive and restart the system.

NETWORK INSTALLATION

To implement an over-the-network installation of Windows 2000 Professional, you need to copy the entire contents of the Windows 2000 professional CD to a shared network folder. It is advisable to have this shared location be on a server computer. In Windows 2000 lingo, this server is called a *distribution server*.

To begin an over-the-network installation from a Windows 9.x client or Windows NT Workstation, connect to the shared folder and execute the winnt32.exe program. To perform an over-the-network installation from a blank hard drive, boot the system from a bootable network floppy disk and execute the winnt.exe program from the distribution server.

No matter which installation method you choose, the Windows 2000 installation process will progress through the following modes and steps.

- Text mode setup
 - A partition for Windows 2000 is created.
 - A file system is chosen.
 - The partition on which the file system will be installed may need to be formatted.
 - The installation files are copied to the hard drive.
 - Setup Wizard (GUI mode of setup)
 - Choose regional settings.
 - Enter name and organization.
 - Enter the product key.
 - Enter a 15-character computer name.
 - Select and enter a local administrator account password.
 - Enter the date and time.
 - Network configuration
 - Setup attempts to autodetect installed NICs and proceeds to install Windows networking protocols and services, including TCP/IP, file and print sharing, and Client for Microsoft Networks.
 - You are prompted to join the computer to a workgroup or a domain.
- Final phase of installation
 - Startup menu shortcuts are created.
 - Installation configurations are saved to the hard drive.
 - Temporary installation files are removed.
 - System restarts.

AUTOMATED INSTALLATION

Although you will not be tested on the fine details of carrying out an automated installation of Windows 2000, it is important that you have a basic understanding of the tools used to carry out this type of installation. Passing the A+ exam is an important step toward a career in the computer industry. Understanding and implementing the newest operating system tools is just as important.

Like Windows NT, Windows 2000 offers the ability to carry out automated, unattended installations. In order to configure and carry out these

types of Windows 2000 Professional installations, you need to understand the following three important installation tools—Setup Manager, SYSPREP, and RIS—and you must do some planning.

SETUP MANAGER

The Windows 2000 installation CD comes with a utility called Setup Manager. Setup Manager can be used to create an unattended installation file called UNATTEND.TXT. UNATTEND.TXT is a file that Setup Manager uses to store and automate answers to installation questions that would normally have to be answered by a person sitting at a computer.

To install Setup Manager and implement the UNATTEND.TXT file, you must first extract Setup Manager from the Windows 2000 installation CD. To do this, navigate to the Support\Tools folder located on the CD and double-click the file DEPLOY.CAB. Next, you extract the file's SETUP-MGR.EXE and SETUPMGR.DLL to a common folder located on the hard drive. To do this, right-click each file (separately) and select the extract option. After this process is complete, executing the SETUPMGR.EXE file on the hard drive starts a wizard program that allows you to create the UNAT-TEND.TXT file and asks you which options you would like UNAT-TEND.TXT to perform. You can also use UNATTEND.TXT to create an automated installation of SYSPREP or RIS.

Here are some of the installation questions that can be answered by using UNATTEND.TXT.

- Confirmation (agreement) to the end user license (EULA)
- Name and organization
- Computer name
- Password for the local administrator account
- Display settings, such as monitor refresh rate and number of colors
- Network settings, such as protocols, services, and IP address settings
- Whether to join a workgroup or a domain
- Time zone settings

If you recall the installation process mentioned earlier in the chapter, the bullets above should look familiar to you.

SYSTEM PREPARATION TOOL (SYSPREP)

The System Preparation Tool (SYSPREP) is a Windows 2000 utility that allows you to prepare for the creation of a Windows 2000 disk image by

making sure that the security identifiers (SIDs) are unique for all target systems that will have an image copied to them.

With the use of third-party disk imaging software, such as Symantec Ghost, an exact duplicate or mirror image of a system can be made and distributed to multiple systems on a network. SYSPREP prepares a system for this image. Besides generating a unique computer SID, SYSPREP contains a mini-setup wizard that is used to specify settings such as computer name, regional settings, network settings, time zone, and workgroup or domain membership.

SYSPREP is a very useful tool for configuring many computers with the same operating system, configuration settings, and software. The process for installing SYSPREP as well as RIS is described under "Setup Manager," earlier in this chapter.

REMOTE INSTALLATION SERVICE (RIS)

RIS is a Windows 2000 Server utility service that is used to deploy Windows 2000 Professional to connected client computers over a network. You can use RIS to deploy the images you have created with third-party software to connected systems or to repair bad or corrupted installations you have already deployed.

WINDOWS 2000 UPGRADE PROCEDURES

Windows 2000 offers several upgrade paths. The following operating systems can be upgraded to Windows 2000:

- Windows 95 (All Versions)
- Windows 98 (All Versions)
- Windows NT 3.51
- Windows NT 4.0

Before upgrading to a new operating system, your first consideration should always be to make a complete backup of current operating system and data. This is crucial if you wish to have a path back to your current operating system and information. Next, you should scan your current operating system with updated antivirus software so that any viruses are not transferred during the upgrade process. Finally, you should uncompress any compressed drives.

Upgrading from a previously installed operating system to Windows 2000 is a fairly simple task. The most important thing to keep in mind for a successful upgrade is that the Windows 2000 setup program must be run from within the operating system you want to upgrade in order for your settings and information to be transferred to the Windows 2000. To upgrade from Windows 9.x or Windows NT using the Windows 2000 installation CD, do the following.

1. Boot your system into Windows 9.x or Windows NT.

2. Insert the Windows 2000 installation CD.

3. If your system autodetects the installation CD, your current operating system is detected and you are asked if you want to upgrade to Windows 2000. Select Yes if you want to upgrade and continue with the upgrade process. If the installation CD is not autodetected, select Start>Run; type in the CD-ROM drive letter, followed by `"\I386\WINNT32.EXE"`, and click OK.

To upgrade from Windows 9.x or Windows NT to Windows 2000 over a network, do the following.

1. From within the operating system you want to upgrade, connect to a network share that contains the Windows 2000 installation or setup files.

2. Navigate to and run \I386\WINNT32.EXE from the shared network location.

3. Answer yes to perform the upgrade, and follow the installation instructions provided.

 If you have trouble running a previously installed application after you have upgraded to a new operating system, you are advised to reinstall the application on the upgraded operating system.

If you would like more information on upgrading to Windows 2000 from Windows 9.x or Windows NT, visit www.microsoft.com/windows2000/professional/howtobuy/upgrading/path/win9x.asp.

WINDOWS 2000 STARTUP PROCESS

The current A+ exam will most likely focus on your ability to utilize the Windows 2000 tools that are available during the startup process, or boot sequence, to complete or troubleshoot a system that will not completely boot into the operating system. Pay special attention to such tools as the Last Known Good Configuration option in the Advanced Options menu (described immediately after the startup process). It is more likely that the exam will target your ability to utilize these tools than expect you to memorize the fine details of the Windows 2000 startup process.

The steps in the Windows 2000 startup process are as follows.

1. The POST (power-on self-test) is run.
2. The startup process begins, and Plug and Play devices are recognized.
3. The MBR (master boot record) is located and processed.
4. NTLDR.COM (bootstrap loader) is loaded. The hardware detection phase begins.
5. The BOOT.INI is loaded and the operating systems are detected. If multiple operating systems are located in the BOOT.INI, BOOTSECT.DOS is processed, allowing a system to boot with Windows 9.x or DOS. Remember for the exam that multiple boot options are specified in the BOOT.INI file at system startup.
6. NTDECTECT.COM runs. Hardware and hardware profiles are detected.
7. The Windows 2000 kernel (NTOSKRNL.EXE) is loaded.
8. HAL.DLL is loaded, which creates the hardware abstraction layer.
9. The system reads the Registry and loads all necessary device drivers.
10. The logon process begins with the execution of WINLOGON.EXE.

ADVANCED OPTIONS MENU

You should recall from Chapter 11 that Windows 9.x offers a startup menu that provides several boot configuration options to be used for troubleshooting purposes. Windows 2000 offers a similar feature called the Advanced Options menu. When the Windows 2000 boot sequence is in its final phase, the Starting Windows screen appears. At this point, the option

to press the F8 key and enter the Advanced Options Menu is presented. If you press the F8 key, you will be offered the following options.

- Safe Mode
- Safe Mode with Networking
- Safe Mode with Command Prompt
- Enable Boot Logging
- Enable VGA Mode
- Last Known Good Configuration
- Directory Services Restore Mode (Windows 2000 domain controllers only)
- Debugging Mode
- Boot Normally

You should already be familiar with the functions of several of these options from our previous discussions of the Windows 9.x startup menu. The most important point that can be made here is that you should not completely advance into the Windows 2000 operating system if you have experienced trouble at startup. Instead, press the F8 key and choose the Last Known Good Configuration option. This loads the last known good Registry settings and allows you to boot into the operating system successfully if you have not already logged into the system with a bad configuration.

RECOVERY CONSOLE

The Windows 2000 installation CD comes with a utility called the Windows 2000 Recovery Console. The Recovery Console can be used to assist with the recovery of a computer system that is having problems starting or will not boot into an operating system at all.

The Windows 2000 recovery console can be installed so that it is available at system startup by navigating to the i386 folder located on the installation CD and entering the command WINNT32 /CMDCONS. This makes the Recovery Console option available when Windows 2000 boots up. The Recovery Console can also be used to copy system files to a hard drive and configure services that will be available when the system boots into the operating system.

DUAL BOOTING

With Windows 2000, you can set up your computer for several different dual booting scenarios. Windows 2000 can be dual booted with DOS, Windows 3.x, Windows 9.x, and Windows NT. However, some very strict rules

apply to dual booting with Windows 2000, depending on the booting scenario you want to create.

Here are some general rules to consider before installing multiple operating systems in a dual boot scenario with Windows 2000.

- Each operating system you install must be installed and configured on a separate volume. Microsoft does not support multiple operating systems installed on the same volume with Windows 2000. This is mainly to ensure that each operating system can maintain separate configuration settings and file structure. Each operating system is considered separate. All programs and drivers installed on one particular operating system are considered separate from any other installed operating systems.
- The volume that the system is booted from must be formatted with the proper file system to support the dual boot configuration. For example, if you are going to dual boot between Windows 2000 or Windows NT and Windows 9.x, the volume that the system boots to must be formatted as FAT.
- Windows 2000 should be installed after DOS or Windows 95. If you install Windows 2000 first and then attempt to install DOS or Windows 95, you will write over important system and boot files.

The following section describes the proper order of operating system installations necessary to achieve specific dual booting goals.

- To dual boot between DOS, Windows 95 or Windows 98, and Windows 2000, install MS-DOS, followed by Windows 95 or Windows 98, and finally Windows 2000.
- To dual boot between Windows NT 4.0 and Windows 2000, install Windows NT 4.0 followed by Windows 2000. If you are using an NTFS partition with Windows NT 4.0, make sure that you have installed Service Pack 4 so that your Windows NT 4.0 NTFS partition can access files on the Windows 2000 NTFS 5 partition.

After you have installed multiple operating systems on your hard drive, you can navigate to the Startup and Recovery Window and choose a default operating system. The default operating system displayed in Figure 13.1 is Windows 2000 Professional. The default operating system is the one that will be booted into when your system boots up. You can change the default operating system by selecting the drop-down menu under "Default operating system:" and selecting the installed operating system to be used as the default. You can also change the time limit for which the list

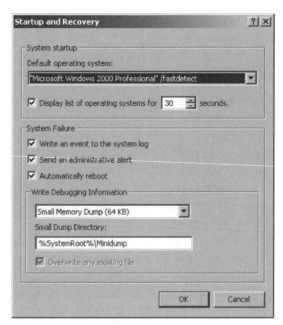

FIGURE 13.1 Choosing a default OS in the Startup and Recovery window.

of operating systems is displayed at system startup. To access the system Startup and Recovery window, navigate to Control Panel>System>Advanced>Startup and Recovery.

WINDOWS 2000 TOOLS AND UTILITIES

Although Windows 2000 is similar to Windows NT and offers many of the same tools and utilities, such as Task Manager and Event Viewer, Windows 2000 is a much more robust operating system that offers many new useful utilities, tools, and newly designed wizards. In this section, we focus on the Windows 2000 tools and utilities you are most likely to be tested on in the current A+ Operating Systems Technologies exam.

DEVICE MANAGER

Device Manager is discussed in detail in Chapter 11. As you may recall, Device Manager is available in Windows 9.x, but not with Windows NT. It is a useful utility that is a welcome feature with Windows 2000.

Device manager lists all the hardware devices that are attached to a system and ensures that the devices are operating properly. You can troubleshoot devices, view device resources, and update drivers for specific devices by double-clicking on a device listed in the Device Manager utility and selecting the appropriate option.

To access Device Manager in Windows 2000 professional, navigate to Control Panel>System>Hardware>Device Manager or Control Panel>Administrative Tools>Computer Management>Device Manager.

DRIVER SIGNING

Windows 2000 offers Driver Signing options that allow you to prevent or block users from installing software and device drivers that are not digitally signed or approved by Microsoft. This is a very useful feature that can save administrators and technicians from having to reconfigure systems that have been corrupted by unsigned or unapproved software or driver installations. To navigate to and block the installation of unassigned drivers, select Start>Settings>Control Panel>System>Hardware>Driver Signing. The Driver Signing Options window appears (Figure 13.2). By default, the option to warn users when an unsigned driver or file is installed is selected. Choose the option to block the installation of unsigned files and select OK.

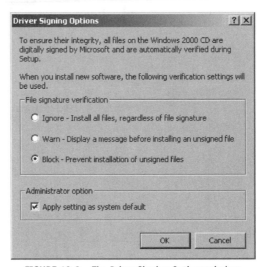

FIGURE 13.2 The Driver Signing Options window.

ADMINISTRATIVE TOOLS AND COMPUTER MANAGEMENT

There are many ways to access administrative programs and carry out administrative tasks in Windows 2000. You can use individual utilities and programs, create your own administrative console with Microsoft Management Console and snap-in programs, or use preconfigured tools, such as Computer Management, to carry out many administrative duties from one central location. The Microsoft Management Console will be discussed in more detail later in the chapter.

On the Windows 2000 Control Panel is the Administrative Tools folder. This folder contains many useful tools that were present with Windows NT 4.0, such as Performance Monitor, Event Viewer, Services, and Local Security Policy. This folder also contains an icon for a very useful administrative tool known as Computer Management. Computer Management is a prepackaged group of administrative programs, otherwise known as *snap-ins*, which can be administered from one central location. As shown in Figure 13.3, Computer Management provides quick access to system resources and tools such as Device Manager, Event Viewer, system information, and local users and groups. You can also manage disks and logical drives and run Disk Defragmenter from the Storage section of the Computer Management tree.

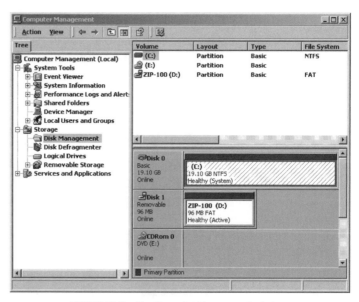

FIGURE 13.3 The Computer Management window.

LOCAL USERS AND GROUPS

The Local Users and Groups snap-in (see Figure 13.3) is the Windows 2000 Professional replacement for the User Manager, which was available with Windows NT 4.0 Workstation. Using this tool, you can add and remove users, make new local groups, add users to groups, assign user profiles (profiles are discussed later in the chapter), set passwords, and disable or unlock user accounts.

Windows 2000 Professional comes with built-in accounts for administrator and guest. The built-in groups available with Windows 2000 professional are Administrator, Power Users, Backup Operators, Replicator, Users, and Guests. Each of these groups has built-in preassigned permissions that allow user accounts assigned to a particular group to have special rights. The most powerful group is the Administrator group. Administrators have the privileges to carry out all tasks. Power Users have some administrative privileges and can install legacy applications. Backup Operators can back up and restore files and folders. The Replicator group is used for replicating directories. The Users group has very basic privileges. All users of the system are automatically added to the Users group.

The Guest group is similar to the Users group and has very limited rights to the system.

BACKUP UTILITY

The Backup utility has been revamped and included with Windows 2000. The newly designed backup utility provides useful Backup and Restore Wizards that can be used to design a backup or restoration job for files on a local machine or over the network.

As displayed in Figure 13.4, the Backup utility also offers the ability to create an ERD (Emergency Repair Disk).

Windows 2000 does not offer the ability to create an ERD using the Windows NT 4.0 utility RDISK.EXE.

You can use the Windows 2000 Backup utility to back up information from one file system type and restore the information to another file system type. For example, you can back up files located on an NTFS partition and restore the files to a FAT32 partition, but you must keep in mind that NTFS and FAT32 are not compatible file systems. If you restore to FAT32 from NTFS, you will retain long file names and file attributes, but you will lose file properties such as compression, encryption, and permission values.

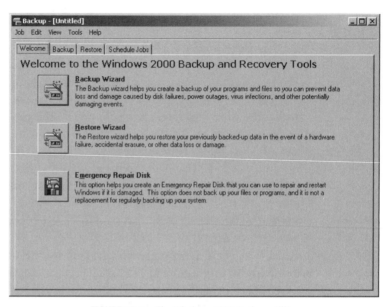

FIGURE 13.4 The Windows 2000 Backup utility.

DISK MANAGEMENT AND VOLUME TYPES

As discussed in Chapter 12, Windows NT 4.0 uses the Disk Administrator tool to manage hard disks and logical drives. Windows 2000 has a similar tool called Disk Management, which offers the ability to manage hard disks, logical drives, and dynamic disks (discussed in the next section).

To access the Windows 2000 Disk Management tool, open Control Panel>Administrative Tools>Computer Management>Storage>Disk Management. The Disk Management tool gathers information about local physical and logical drives and displays information similar to that shown in Figure 13.3.

With the Disk Management tool, you can change the drive letter and path for a disk or logical drive, format a drive, delete a logical drive, delete a partition, or mark a partition as active.

Similar to Disk Administrator in Windows NT 4.0, Windows 2000 Disk Management provides support for RAID levels 0, 1, and 5, which include striped volumes, mirrored volumes, and disk striping with parity. You should note that RAID levels 1 and 5 are only available in the Server versions of Windows NT 4.0 and Windows 2000. As you may recall, RAID levels were described in detail in Chapter 12.

The Disk Manager tool also supports simple and spanned volumes. Simple volumes are constructed from space on one physical disk drive. Spanned volumes are made up of areas of disk space located on different physical disks combined to form one logical drive space.

Basic and Dynamic Disks

Windows 2000 supports two disk storage types known as basic and dynamic disks. A *basic disk* is one that has been configured or "partitioned" with the traditional techniques we are familiar with from our previous studies of DOS, Windows 9.x, and Windows NT. A basic disk can be configured to have four primary partitions or three primary partitions and an extended partition. By default, a basic disk is created when Windows 2000 is installed. After installation, you can convert a basic disk to a dynamic disk using Disk Manager by right-clicking the basic disk displayed in Disk Manager and selecting Upgrade to Dynamic Disk. To convert a dynamic disk back to a basic disk, remove all volumes from the dynamic disk, right-click on the dynamic disk in Disk Manager, and select Revert to Basic Disk.

You should leave a hard disk configured as basic if you wish to access its data from DOS or Windows 9.x.

Dynamic disks are areas of space on a single disk or areas combined from multiple disks created and organized using volume techniques to organize areas instead of traditional partitioning techniques. Disks that have been configured with DOS or Windows 9.x cannot access dynamic disks. Dynamic disks can be created and managed using Disk Manager. You can create five types of dynamic disks: simple, mirrored, spanned, stripped, and RAID level 5 volumes.

Disk Quotas

Disk quotas can be implemented in Windows 2000 to track and control the amount of disk space used by a particular user or disk volume. To enable quota management, right-click on disk from Windows Explorer or My Computer, select Properties, choose the Quota tab, and choose the appropriate options to suit your administrative needs. Disk quotas can be used only for volumes configured with NTFS.

With disk quotas, an administrator can do the following.

- Limit the amount of disk space used by a user and create an event log message if this limit has been met.
- Create an event log message if a user or volume has met a warning level set for the amount of disk space specified.

Compression and Encryption

If your Windows 2000 system is configured with the NTFS file system, you can take advantage of compression and encryption. Compression allows the size of files and folders to be reduced so they do not use as much disk space as they would if they were uncompressed. To compress or uncompress a file or folder in Windows 2000, simply right-click on a file or folder from within Windows Explorer and select Properties. From the General tab, click the Advanced button. The Advanced Attributes window appears (Figure 13.5). From this window you can compress a file or a folder in the Compress or Encrypt attributes section.

NOTE

If files are compressed, they will be displayed in a different color in Windows Explorer. The default color for compressed files and folders is blue.

Files and folders created on NTFS partitions can be encrypted. *Encryption* is a feature of EFS that allows you to secure volumes, files, and folders. You can set the encryption attribute for a file or folder to secure its contents from the Compress or Encrypt attributes section (see Figure 13.5). To decrypt a file or folder, you must be the creator of the file or folder or be an Encrypted Data Recovery Agent (EDRA). EDRAs are discussed in the following section.

FIGURE 13.5 Setting compression and encryption attributes.

LOCAL SECURITY POLICY

As mentioned at the beginning of this section, the Local Security Policy icon can be accessed from the Administrative Tools folder located in the Windows 2000 Control Panel. Policies are used in Windows 2000 to enforce certain rules and restrictions on user accounts in order to protect the integrity of the operating system and to provide administrators with the ability to audit important events.

If you open the Local Security Policy icon, you will see that you can make policy and settings changes for the following policies.

- *Account Policies.* You can use the Account Policies section to create and apply a Password Policy and an Account Lockout Policy. This allows you to apply policies that force the implementation of such items as minimum or maximum password age, password length, and account lockout after so many failed password attempts.
- *Local Policies.* These policies include an Audit Policy, User Rights Assignment, and Security Options. This is where you enable the auditing of events such as File and Object Access and System events in Windows 2000. You can also make changes to the rights that users and groups have on the local machine from this area.
- *Public Key Policies.* This policy is part of the Windows 2000 EFS, which allows the recovery of lost data by designated Recovery Agents. In this area, administrators can create and add EDRAs, who can be used to unlock or decrypt encrypted files and folders that have been encrypted by other users.

MICROSOFT MANAGEMENT CONSOLE

Windows 2000 offers a new feature called Microsoft Management Console (MMC). The MMC is used to provide a personalized central location for administration through the installation of snap-ins. *Snap-ins* are applications that represent the various utilities and tools available in Windows 2000, such as the Disk Defragmenter, Device Manager, Computer Policies, Event Viewer, Services, and Certificates, just to name a few. To navigate to and personalize your own Management Console, select Start>Run and enter "MMC" in the Open line. Click OK. A somewhat empty-looking Management Console appears. To add or remove snap-in programs, select Console from the menu options bar. Next, select Add/Remove Snap-in, and from the Stand Alone tab, select Add. A list of available standalone

snap-in programs is presented. Simply choose the programs you wish to design your own console.

REGISTRY EDITORS

Like Windows NT 4.0, the Windows 2000 Registry holds system configuration and environmental settings that can be directly edited with utilities such as REGEDIT.EXE and REGEDT32.EXE. To edit the Windows 2000 Registry directly using either of these utilities, select Start>Run and enter either "REGEDIT" or "REGEDT32" on the Open line and select OK. The REGEDIT utility is an easy tool to use if you need to locate a specific registry key. The REGEDT32 utility is more useful for editing specific registry keys.

 Normal users should never have the ability to directly edit the Registry.

SYSTEM CONFIGURATION UTILITY

The System Configuration utility, known as MSCONFIG.EXE in Windows 9.x, is also available in Windows 2000. It provides a graphical display of important system information such as hardware resources, components, software, and Internet Explorer settings and information. One of the most useful features of the System Configuration utility is the System Summary. The System Summary gives detailed information about the system, including the installed operating system, system name, BIOS version, time zone, total physical memory, physical memory available, and many other important system values.

The System Configuration utility also gives you the ability to quickly launch programs such as Disk Cleanup, Dr. Watson, Hardware Wizard, and the Windows Backup utility.

To access the System Configuration Utility in Windows 2000, select Start>Programs>Accessories>System Tools>System Information or select Start>Run, enter "WINMSD" at the Open line, and press Enter. The System Summary appears by default. If you wish to launch any of the other tools, such as Disk Cleanup, from the menu bar, select Tools>Windows>Disk Cleanup or any of the other programs listed.

POWER MANAGEMENT AND OPTIONS

In the Windows 2000 Control Panel, you will notice an icon for Power Options. From within Power Options you can configure power schemes that

are designed to help reduce the amount of power consumed by devices attached to your system. The built-in power schemes available from the drop-down menu in the Power Options Properties/Power Schemes window are these.

- Home/Office Desk
- Portable Laptop
- Presentation
- Always On
- Minimal Power Management
- Max Battery

You can change the default power settings for each of the power schemes displayed by selecting the appropriate power scheme and changing the settings listed in the "Settings for" section, below the Power Schemes section. The three built-in options that can be changed are Turn off monitor, Turn off hard disks, and System standby.

ACTIVE DIRECTORY

Windows 2000 Server offers a directory service known as Active Directory. Active Directory provides a hierarchal view of network objects and provides a central location from which all resources on a network can be managed. With Active Directory, administrators can easily view and make changes to user IDs, permissions, rights, computer systems, printers, and any other objects listed in Active Directory. It is not likely that you will encounter many questions about Active Directory on the exam.

PROFILES

Windows NT and Windows 2000 utilize user profiles to customize and provide desktop environments for computers and users. Specific settings for the network, printers, modems, and display options as well as many other settings can be configured to provide special desktop atmospheres for users. Three types of user profiles can be implemented in Windows 2000: local profiles, roaming profiles, and mandatory profiles.

- *Local profiles.* When a user first logs on to a Windows 2000 system, a local user profile is automatically created for that specific user. This

profile is stored on the local machine on the system partition in the ROOT\Documents and Settings folder. For example, if Windows 2000 were installed on the "C" drive and a user named BrianSawyer logged on to the system, a local profile for BrianSawyer would be created. The profile and its settings would be stored in C:\Documents and Settings\BrianSawyer. A local user profile is created for any other user who logs on to the same system. Their profile will also be stored in the C:\Documents and Settings folder.

■ *Roaming profiles.* Roaming user profiles are created and stored on network servers in order to provide identical environments for users wherever they may log on to the network. For example, an administrator could create a profile for a user named SteveBleile. The administrator would then copy the profile for SteveBleile to a profile server. The profile would then be automatically copied to any system that the user SteveBleile logs on to. Any settings or changes that have been made by the user SteveBleile will be copied back to the profile server and presented the next time the user logs on to the network.

■ *Mandatory profiles.* A mandatory profile is similar to a roaming user profile. The main difference is that changes to settings made by the user are not copied back to the profile server when the user logs off the system. Administrators provide a controlled environment for users by implementing mandatory user profiles. A user gets the same desktop (which was created by the administrator) wherever he or she logs on to the network.

HARDWARE PROFILES

When you install Windows 2000, a hardware profile named Profile 1 is automatically created. This profile is used to tell your operating system what hardware devices (and their settings) are to be used when your system is started.

Hardware Profiles are commonly implemented with the use of laptop or portable computer systems. Laptops are often used with docking stations, which are typically configured with devices such as printers, modems, NICs, or CD-ROMs. A *docked hardware profile* can be created on a laptop system to recognize all devices attached to a docking station automatically when the laptop is inserted into the docking station. Docking stations are typically used at home or at the office. A more suitable hardware profile, called *undocked,* can be created for a laptop when the laptop is not being used with a docking station. This hardware profile loads only the devices,

drivers, and settings needed when you are not connected to the docking station. Hardware profiles can be managed by selecting Control Panel> System>Hardware >Hardware>Hardware Profiles.

PRINTERS

Installing and managing printers in Windows 2000 is not difficult if you have already carried out similar tasks in Windows 9.x and Windows NT.

Windows 2000 utilizes an Add Printer Wizard to assist with the installation of local or network printers. To add a new printer using the Add Printer Wizard, select Start>Settings>Printers or open Control Panel>Printers. Next, double-click Add Printer. The add Printer Wizard will start. After clicking Next, you will be asked if the printer is connected locally or on the network.

If the printer you wish to install is connected directly to your system, select Local Printer and click the radio button to automatically detect and install a Plug and Play printer. If the printer and associated printer driver are detected, continue with the instructions to finish the installation. If the printer and associated printer driver are not detected, a message like the one in Figure 13.6 appears, and you will be asked to click Next to configure your printer manually. You will need to configure a printer port and provide the printer drivers from the printer manufacturer so that the operating system can recognize your printer.

If the printer you wish to connect to is located on a network, select Network Printer from the Local or Network Printer window and click Next. Then you will need to locate the network printer by entering the proper UNC name for the system to which the network printer is connected and the share name of the printer. Alternatively, you can click Next to browse for the printer on the network. The proper UNC for locating a printer share on a network is `\\Servername\Printer_name`.

If the printer you wish to connect to is located on the Internet or your Intranet, select the "Connect to a printer on the Internet or your Intranet" radio button and enter the appropriate URL address to connect to the printer.

If you want to change the printer properties for installed printers in Windows 2000, simply right-click on a printer, and select Properties. You will be able to change printer port settings, sharing options, security, and color management settings, just to name a few options.

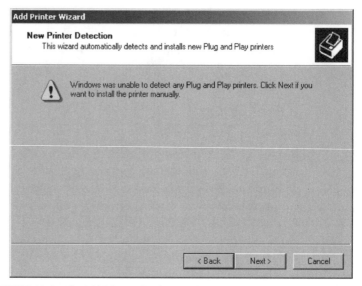

FIGURE 13.6 The Add Printer Wizard suggesting a Manual Mode printer installation.

WINDOWS 2000 NETWORKING AND THE INTERNET

The current A+ Operating Systems Technologies exam will most likely focus on your ability to configure network settings and protocols from within the Windows 2000 Professional operating system. The configurations of Windows 2000 Server and Advanced Server operating systems for network support are beyond the scope of this book. However, the exam will expect you to have a general understanding of network services such as WINS (Windows Internet Naming Service), DNS (Domain Name Service), DHCP (Dynamic Host Configuration Protocol), and FTP (File Transfer Protocol). In this section, we focus on Windows 2000 Professional network connectivity and define some of the important protocols and services used in networks, including the largest network of all, the Internet.

IMPORTANT NETWORK AND INTERNET PROTOCOLS AND SERVICES

In the previous operating system chapters, we have discussed protocols in some detail. In Chapter 12, you learned how to install protocols and service from within the network applet of Control Panel. In Windows 2000 Pro-

fessional, protocols and services are installed in much the same way, with the exception that they are installed from a different location. To install protocols and services, simply right-click on My Network Places, right-click on Local Area Connection, and select Properties. You will be presented with the General tab from which you can configure NICs, protocols, and services.

Following are the most important protocols and services that you may have to identify on the operating exam.

- *Windows Internet Naming Service (WINS).* WINS is used to determine the NetBIOS computer name associated with a particular IP address on a network. This process is known as *name resolution.* The WINS database resides on a server or servers on a network.

- *Domain Name Service (DNS).* DNS is a name resolution service that resolves Internet or fully qualified network domain names to an IP address. You can change what is known as the DNS server search order on client computers by adding DNS server IP address entries on the client systems. To navigate to this section, right-click on My Network Places and select Properties, right-click on Local Area Connection and Properties. Select Internet Protocol (TCP/IP) and click the Properties button, click the Advanced button, select the DNS tab, and select Add under the DNS Server addresses in the order of use section. Enter the IP addresses of the DNS servers you wish to use to resolve domain names. It's that simple! This tells the client computer in which order DNS servers should be used to resolve domain names. On another DNS note, domain names have extensions that identify an associated affiliation. .EDU is used for schools and colleges, .COM is for commercial use, .ORG is reserved for nonprofit groups, .GOV is reservered for the United States government, and .NET is used for networking systems or as a replacement for .COM.

- *Dynamic Host Configuration Protocol (DHCP).* DHCP is a protocol used to assign IP addresses automatically on a TCP/IP network. The DHCP Server hands out IP addresses to client computers configured to use DHCP. The alternative to DHCP is configuring your system to use a static IP address. To use a static IP address, you will need an IP address, a default gateway, and a subnet mask.

- *Internet Connection Sharing (ICS).* A feature of dial-up networking that allows all the computers in a home or small business to share one connection to the Internet. In Windows 2000 Professional, ICS

can be configured by selecting Start>Settings>Network and Dial-up Connections, right-clicking on a icon configured for an Internet connection, selecting Properties, selecting the Sharing tab, and clicking Enable Internet Connection Sharing for This Connection. You will then be presented with settings that you can customize for your connection.

- *Automatic Private IP Addressing (APIPA).* APIPA is a service used with Windows 98 and Windows 2000 Professional that allows client computers to configure themselves automatically with the IP address and subnet mask for network connectivity if a DHCP server fails or is not found. If a DHCP server fails, APIPA uses an IP address in the range of 169.254.0.0 through 169.254.255.254.

- *File Transfer Protocol (FTP).* FTP is a protocol used to transfer data between computers on a TCP/IP network. Special file servers known as FTP servers are used to handle FTP functions. Users are typically authenticated anonymously on FTP file servers, which means that users can read and update information stored on the FTP server without being authenticated or authorized to access the server. The FTP server does care who the user is.

- *Hypertext Transfer Protocol (HTTP).* HTTP is an Internet protocol used to define consistent connections.

- *Hypertext Transfer Protocol Secure (HTTPS).* HTTPS is a secure protocol used to transmit information on the World Wide Web. To access a secured Internet site, such as ChristopherCrayton.com, you would need a URL entry of HTTPS://ChristopherCrayton.com.

- *Simple Mail Transport Protocol (SMTP).* SMTP is a protocol used for transferring e-mail between client computers and e-mail severs. For a client to send e-mail messages using SMTP successfully, a client computer should be configured with an IMAP or POP server address. POP (Post Office Protocol) and IMAP (Internet Message Access Protocol) accounts use SMTP to allow a person using a dial-up or Internet connection to gain access to mail on a mail server computer.

WORKGROUP OR DOMAIN?

If you have installed Windows 2000 Professional and are not currently attached to a workgroup or domain, you can join your system to a workgroup or domain or change your system's name by right-clicking on the My Computer icon, selecting the Network Identification tab, and choosing

the Properties button. You will then have the options of changing your computer name or becoming a member of a workgroup or a domain. In order to join your system to a workgroup or domain, you must have administrative privileges.

INTERNET CONNECTIVITY

Configuring your system to connect to the Internet is not difficult. You need a Local Area Connection, TCP/IP, an Internet browser (such as Internet Explorer or Netscape Navigator), a modem, and an ISP.

You can use the Internet Connection Wizard to connect your system to the Internet. To do this, right-click on the Internet Explorer icon located on the desktop, select Properties, select the Connections tab, and click the Setup button. You will be offered several options for configuring and finally making your connection. Follow the instructions presented by the wizard.

VIRUSES

Computer viruses are becoming more and more of a threat to the integrity of computer systems and computer data. If a virus has wiped out your important personal information or destroyed your businesses data, then you are probably already aware of how critical it is to have a good antivirus package, updated antivirus DAT files, and a good backup plan.

Viruses are easily spread via the Internet, through e-mail attachments, infected floppy disks, and network shares. The most common types of viruses are the following.

- *Trojan.* A virus that comes disguised as a useful file or program. The file or program is used to deliver the Trojan virus to the system.
- *Macro.* Often spread through e-mail, a macro virus is one that infects programs, files, and templates associated with applications such as Microsoft Word or Excel. Macro viruses usually insert undesired objects or words into documents. They are usually programmed to be triggered by a specific action or event.
- *Boot sector.* These viruses infect the MBR on hard disks. They can easily make the hard disk unbootable. Thus, it is always good practice to have a bootable floppy virus-scanning disk available to assist with recovery from this type of virus.
- *Polymorphic.* A very popular type of virus that mutates so that it is virtually undetectable by antivirus software.

- *File infectors.* These types of viruses typically attach to executable programs, such as files with a .COM or .EXE extension.
- *Worm.* A worm virus resides in computer memory and duplicates itself until it finally consumes enough system resources to render the system inoperative.
- *Stealth.* A virus that can infect partition tables, boot sectors, and executable programs and that hide from antivirus detection software.

The recommended way to clean a virus from an infected computer is to boot the system to a virus-scanned boot disk that includes an updated DAT (Virus Definition file) and clean the virus from the infected system by running the antivirus cleaning software program from the boot disk.

DIAGNOSING AND TROUBLESHOOTING TEST TIPS

Windows 2000 is the newest and most complex operating system that you will face questions on when you take the current A+ Adaptive Operating Systems Technologies exam. This chapter is designed to prepare you with as many diagnosing and troubleshooting test tips as possible to prepare you for the test. Please use the following items, as well as the review questions and A+ Operating Systems Technologies Cumulative Practice Exam, to sharpen your skills in final preparation for the Windows 2000 portion of the exam.

- Windows 2000 components can be added to the operating system from the Windows 2000 Installation CD by using the Add/Remove Programs Applet in the Control Panel.
- If you are trying to connect to an ISP through a dial-up connection and receive the error message "Server cannot negotiate an appropriate protocol," this is most likely the result of an improperly configured or corrupt TCP/IP configuration.
- By default, files with the extensions .INI, .INF, and .DLL are displayed in Windows 2000 Explorer. If you want hidden files and folders to be displayed, choose Tools>Folder Options>View and select the Show Hidden Files and Folders in the Advanced Settings box of the View section.

- To assign or "map" a drive letter to a network folder in Windows 2000, simply right-click My Network Places or My Computer and select Map Network Drive.
- Windows 2000 provides network protocols for communication with other networked systems. Remember for the exam that Windows 2000 supports TCP/IP, NWLINK, NetBEUI, and Apple Talk. TCP/IP is used for most networks, including the Internet. NWLINK is used for communication with Novell Networks. NetBEUI is a fast, efficient Microsoft network protocol. AppleTalk is used for communicating with Apple Macintosh systems.
- If you have the ability to send e-mail and attachments over the Internet but cannot receive e-mail and attachments from others, you should verify that your SMTP settings and mail server settings are accurate.
- If you want to connect to a specific news group on the Internet via an ISP, you will need to acquire the IP Address associated with the Network News Transfer Protocol (NNTP) server for that ISP.
- You can create a shortcut for a program from within Windows Explorer by right-clicking the program and selecting Create Shortcut. To create a shortcut that will be placed on the Windows Desktop, right-click the program from within Windows Explorer, select Send to, and select Desktop (create shortcut).
- You can use the Alt+Tab keyboard sequence to switch between applications running in Windows 2000.

CHAPTER SUMMARY

Congratulations! You have completed the study of Windows 2000 and the A+ Operating Systems Technologies section of this book.

On completion of this chapter, you should have gained the information and skills necessary to carry out the following tasks and understand the following concepts.

- Install Windows 2000 Professional
- Upgrade to Windows 2000 Professional from Windows 9.x and Windows NT 4.0
- Prepare for dual boot scenarios with Windows 2000, Windows 9.x, and Windows NT 4.0

- Understand the steps and progression of the Windows 2000 startup process
- Implement Windows 2000 tools and utilities to carry out specific task and maintain operating system integrity
- Understand the different user profiles that can be implemented with Windows 2000
- Configure general file and folder options
- Install and configure printers in Windows 2000
- Diagnose and troubleshoot basic operating system problems
- Have a general understanding of networking protocols and Internet connectivity

REVIEW QUESTIONS

1. Windows 2000 provides support for which of the following file systems? (Choose 3)

 □ A. FAT32

 □ B. OS/2

 □ C. CDFS

 □ D. CFDS

 □ E. NTFS

 □ F. HPFS

 Answers: A, C, and E

 Windows 2000 provides support for FAT32, CDFS, and NTFS. The OS/2 operating system uses HPFS (High-Performance File System), which Windows 2000 does not support.

2. Which operating systems can you upgrade to Windows 2000 Professional? (Choose 3)

 □ A. Windows 95

 □ B. Windows 98

 □ C. OS/2

 □ D. Windows 3.x

 □ E. Windows NT 4.0

 Answers: A, B, and E

Of the choices listed, only Windows 95, Windows 98, and Windows NT can be upgraded to Windows 2000 Professional.

3. You just wrote over important Windows 2000 system files after installing a third-party application. Windows 2000 prompts you with the message "Files that are required for Windows to run properly have been replaced by unrecognized versions. To maintain system stability Windows must restore the original versions of these files." Where did this message come from?

 ○ A. System Protector 2000
 ○ B. Windows 2000 File Protection
 ○ C. Windows 2000 File Authentication
 ○ D. Windows 2000 File and Object Auditor

 Answer: B

 Windows 2000 has a built-in backup feature called Windows File Protection that keeps a backup of important system files. If you write over important system files with programs or applications, Windows File Protection will prompt you that it needs to restore the important system files you just replaced.

4. What should you always consider before upgrading to a new operating system?

 ○ A. Verify that you have the most current service pack.
 ○ B. Back up the system partition.
 ○ C. Back up your current operating system and data.
 ○ D. Back up only critical information.

 Answer: C

 Before upgrading to a new operating system, your first consideration should always be to make a complete backup of your current operating system and data. This is crucial if you wish to have a path back to your current operating system and information.

5. If you want to upgrade Windows 9.x or Windows NT to Windows 2000 Professional, what must you do?

 ○ A. Insert the Windows 2000 installation CD and reboot.
 ○ B. Insert the first Windows 2000 installation floppy diskette and reboot.

○ C. Run the Windows 2000 setup program from within Windows 9.x or Windows NT.

○ D. Connect to a network share that has the Windows 2000 setup program and reboot.

Answer: C

To perform an upgrade to Windows 2000 Professional, you must run the setup program from within an existing operating system. Choices A and B are valid options for a full Windows 2000 installation. D will not perform an upgrade or a full installation.

6. You want to install the Windows 2000 Recovery Console so that it is available at system startup. Assuming that your CD-ROM has a drive letter of D, what command would you use?

○ A. D:i386/INSTALL/CMDCONS

○ B. D:i386/WINNT32 /CMDCONS

○ C. D:i386/WINN/EXECMDCONS

○ D. D:i386/WINDOWS/EXECMDCONS

Answer: B

The Windows 2000 Recovery Console is a useful tool for troubleshooting a system that will not boot, copying system files to a hard drive, and configuring services. To install the Recovery Console so that it is available at system startup, insert the Windows 2000 installation CD and enter the command WINNT32 /CMDCONS from the i386 folder. You can then select the Recovery Console option when the system restarts.

7. Windows 2000 provides support for dynamic volumes. Which of the following dynamic volume types does Windows 2000 support? (Choose 4)

□ A. Duplicated volumes

□ B. Multihomed volumes

□ C. Spanned volumes

□ D. RAID level 5 volumes

□ E. Mirrored volumes

□ F. Striped volumes

Answers: C, D, E, and F

Windows 2000 provides support for five types of dynamic volumes: spanned, RAID-5, mirrored, striped, and simple.

8. Which are valid paths to creating a network drive mapping in Windows 2000? (Choose 2)

 □ A. Open My Computer, right-click System, and select Map Network Drive.
 □ B. Open My Computer, right-click C:, and select Map Network Drive.
 □ C. Right-click My Computer and select Map Network Drive.
 □ D. Explorer>Tools>Folder Options>Map Network Drive.
 □ E. Right-click My Network Places and select Map Network Drive.

 Answers: C and E

 Only choices C and E enable you to establish a drive mapping.

9. Where in Windows 2000 can you verify that a recently installed device is functioning properly?

 ○ A. Control Panel>Add/Remove Hardware
 ○ B. The Windows 2000 HCL
 ○ C. Hardware Profiles
 ○ D. Device Manager

 Answer: D

 Similar to Windows 9.x, Windows 2000 provides the Device Manager utility. The Device Manager places a yellow field containing a black exclamation point on devices that are having a problem or a red X on devices that are disabled. To troubleshoot a device, double-click the device and use the Troubleshooter utility.

10. Where in Windows 2000 are settings for local user profiles located?

 ○ A. C:\Documents and Settings
 ○ B. C:\Winnt\System32\Repl\Import
 ○ C. C:\Windows\Profiles\Settings
 ○ D. C:\Documents and Settings\Profiles

 Answer: A

 By default, local user profiles are stored in the C:\Documents and Settings folder in Windows 2000.

11. Several Windows 2000 and Windows 98 computers on your network are configured with DHCP and TCP/IP. What will happen to these computers if they are unable to acquire IP addresses from a DHCP server?

 ○ A. The computers will not be able to communicate on the network.

 ○ B. Automatic Private IP Addressing will assign IP addresses to the computers from the 169.254.0.0 range.

 ○ C. The computers will acquire valid IP addresses from a local WINS server.

 ○ D. The computers will acquire valid IP addresses from a remote DNS server.

Answer: B

A built-in feature of the Windows 98 and Windows 2000 DHCP client is Automatic Private IP Addressing (APIPA). This feature automatically assigns an IP address from the Class B IP range 169.254.0.0.

A+ OPERATING SYSTEMS TECHNOLOGIES TESTTAKER'S CUMULATIVE PRACTICE EXAMINATION

The questions in this practice exam are based on topics that have been presented in Chapters 10 through 13 of this book. The answers to the following questions as well as the chapter headers they are taken from are provided at the end of the test.

If you can answer all the questions in this practice exam correctly, and if you understand the theory behind each of the topics mentioned, there is a good possibility that you may pass the CompTIA A+ Operating Systems Technologies examination.

1. What is the overall system starting order?
 - A. POST, BIOS, Boot Sector, GUI
 - B. Boot Sector, POST, BIOS, GUI
 - C. POST, GUI, MBR, BIOS
 - D. Push the button, hope the magic happens

2. What is the command used to make a bootable floppy system disk?
 - A. FORMAT A: /S
 - B. FORMAT /S A:
 - C. SYS A: /FORMAT
 - D. MAKEFLOPPYBOOTABLE.BAT

3. How can you start the Disk Defragmenter utility in Windows 9.x? (Choose 3)

 □ A. Start, Programs, Accessories, System Tools, Disk Defragmenter
 □ B. Control Panel, System, Performance, Virtual Memory
 □ C. My Computer, right-click drive, Properties, Tools, Defragment Now . . .
 □ D. Start, Run, type in "defrag", click OK, click OK again
 □ E. Start, Programs, Accessories, System, Device Manager

4. Scandisk is a utility that scans and fixes problems with which? (Choose 2)

 □ A. Hard drives
 □ B. Tape drives
 □ C. CD-ROM drives
 □ D. Floppy drives

5. In Windows 9.x, what files can you edit by using the text editor SYSEDIT? (Choose 2)

 □ A. MSDOS.SYS
 □ B. WIN.INI
 □ C. IO.SYS
 □ D. AUTOEXEC.BAT

6. You want to make changes to the AUTOEXEC.BAT and WIN.INI files. What Windows text editors can be used? (Choose 2)

 □ A. SYSEDIT
 □ B. REGEDIT
 □ C. EDITPAD
 □ D. NOTEPAD

7. You attempt to run a 16-bit DOS program in Windows 95 and receive the error "This program cannot be run in Windows." What action should you take?

 ○ A. Reformat the drive and install DOS 5.5.
 ○ B. Reboot in MS-DOS mode and rerun the program.
 ○ C. Increase the virtual memory settings.
 ○ D. Change the Advanced Properties for the program to "Prevent MS-DOS-based programs from detecting Windows."

8. If you use the command XCOPY /S from a DOS prompt in Windows 9.x, what will happen?
 - ○ A. All the directories and subdirectories will be copied.
 - ○ B. Only hidden and archived files will be copied.
 - ○ C. Only the system files will be copied.
 - ○ D. Nothing. The /S switch is invalid with XCOPY.

9. If the Memory Manager in Windows 9.x cannot provide memory to an application, what will occur?
 - ○ A. A Book Fault
 - ○ B. A hard drive crash
 - ○ C. A Page Fault
 - ○ D. A Blue Screen of Death

10. In Device Manager, your NIC has a yellow circle with a black exclamation point on it. Why?
 - ○ A. It is not working properly and is in a problem state.
 - ○ B. It has been disabled.
 - ○ C. It is not recognized by the system at all.
 - ○ D. Windows doesn't support cards from NIC anymore.

11. You are running Windows 9.x. How can you direct a print job straight to the printer instead of the print spooler?
 - ○ A. Select Start>Settings>Control Panel>Disable Spooler.
 - ○ B. In the Spool Settings dialog box, select "Print directly to the printer."
 - ○ C. In the Spool Settings dialog box, select "Disable printer spooling."
 - ○ D. Specify full-duplex printing.

12. What command can you use to get an important system file of executable file from the Windows 9.x installation CD?
 - ○ A. EXTRACT
 - ○ B. COPY D:\FILENAME C:\WINDOWS\SYSTEM
 - ○ C. RESTORE
 - ○ D. IMPORT

13. You are experiencing strange things in Windows 9.x: the task bar is missing and you cannot load certain programs. What is most likely the cause?

 ○ A. The AUTOEXEC.BAT file is corrupt.
 ○ B. You have experienced a total hard drive crash.
 ○ C. The Windows 9.x Registry is corrupt.
 ○ D. The WIN.INI and SYSTEM.INI files are corrupt.

14. Which file executes when you restart your computer in MS-DOS mode?

 ○ A. DOSSTART.BAT
 ○ B. DEFRAG.EXE
 ○ C. WINSTART.BAT
 ○ D. DOSBOOT.EXE

15. System Monitor in Windows 9.x can be used to monitor which information? (Choose 3)

 □ A. RAID configurations
 □ B. Virtual memory
 □ C. Network client resources (on local computer)
 □ D. Network server memory (on local computer)
 □ E. Differential backup scenarios
 □ F. Windows NT audit trails

16. You are having trouble displaying entire Web pages in the Web browser. You want to view entire pages without having to use the left-to-right scroll bars. What should you modify?

 ○ A. Use the screen size buttons on your monitor.
 ○ B. Select the Advanced tab under Display Properties Settings and change the font size.
 ○ C. With the mouse, move the Screen Area Bar from 640 × 480 to 800 × 600 or more.
 ○ D. Select the Advanced tab under Display Properties Settings and select Big Screen.

17. How should you prepare a hard drive before a Windows 9.x installation?

 ○ A. FDISK, FORMAT, reboot the system.
 ○ B. Reboot the system, FDISK, FORMAT.
 ○ C. FORMAT, FDISK, reboot the system.
 ○ D. Simply run the DOS program PREPARE.BAT before installation.

18. The Dr. Watson utility offers two ways to view information that it has logged. What are they?
 - ○ A. Diagnostic View and Report View
 - ○ B. Standard View and Advanced View
 - ○ C. Standard View and Graphics View
 - ○ D. Text View and GUI View

19. You need more hard drive space to install a really big game in Windows 9.x. You notice a large number of unnecessary temporary Internet files. How do you get rid of them? (Choose 3)
 - □ A. C:\DELTREE.
 - □ B. The Disk Cleanup Tool.
 - □ C. Internet Explorer Tools>Internet Options>Delete Files . . .
 - □ D. Control Panel>Internet Options>Delete Files . . .
 - □ E. Internet Explorer Tools>Advanced>Restore Defaults.
 - □ F. Drag the Internet Explorer icon to the Recycle Bin.

20. Which backup type is the fastest and requires the least amount of tape storage space?
 - ○ A. FULL Backup
 - ○ B. Incremental Backup
 - ○ C. Differential Backup
 - ○ D. Full/Copy Backup

21. What is characteristic of an incremental backup?
 - ○ A. Will only back files up to a Zip drive
 - ○ B. Backs up all files no matter what
 - ○ C. Backs up all files with the archive bit set to off
 - ○ D. Backs up all files with the archive bit set to on

22. Which devices can be shared on a network using Windows 98? (Choose 3)
 - □ A. Monitor
 - □ B. Printer
 - □ C. Modem
 - □ D. CD-ROM
 - □ E. Mouse
 - □ F. Keyboard

23. Which protocols can be used to share printers in Windows 9.x? (Choose 3)

 □ A. NETBEUI
 □ B. TCP/IP
 □ C. IPX/SPX
 □ D. NETBIOS
 □ E. TCP/IPRINT
 □ F. PTPTPC

24. What action should you try first if print jobs are hung up or stalled in Windows NT or Windows 2000?

 ○ A. Change the parallel printer cable.
 ○ B. Stop and start the spooler service.
 ○ C. Restart the file and print server.
 ○ D. Reinstall the printer driver.

25. Which TCP/IP utility command would you use from a Windows NT command prompt to see your workstation's IP address, subnet mask, and default gateway?

 ○ A. IPCONFIG
 ○ B. WINIPCFG
 ○ C. PING
 ○ D. TRACERT

26. Which TCP/IP utility command would you use from a Windows NT command prompt to test a connection that includes several computers and routers between you and a destination computer?

 ○ A. NETSTAT
 ○ B. WINIPCFG
 ○ C. PING
 ○ D. TRACERT

27. Where in Windows 2000 can you block the ability of users to install unsigned files and device drivers?

 ○ A. Control Panel, System, Hardware, Driver Signing
 ○ B. Control Panel, System, Device Manager
 ○ C. System, Hardware, Certificates
 ○ D. Administrative Tools, Hardware Profiles, Digital Signing

28. What does WINS resolve on a network?

 ○ A. Broadcast traffic
 ○ B. Fully qualified domain names to IP addresses
 ○ C. NetBIOS computer names to IP addresses
 ○ D. MAC addresses to NetBIOS computer names

29. What does DNS resolve on a network?

 ○ A. Broadcast traffic
 ○ B. Fully qualified domain names to IP addresses
 ○ C. NetBIOS computer names to IP addresses
 ○ D. MAC addresses to NetBIOS computer names

30. Which of the following can easily be infected by computer viruses? (Choose 3)

 □ A. Operating system files
 □ B. Files located on a network server computer
 □ C. A boot sector
 □ D. A write-protected floppy disk
 □ E. A CD-R

31. You would like to implement profiles for your Windows 2000 Professional users. Which of the following type of profiles can you implement? (Choose 3)

 □ A. Roaming profiles
 □ B. Universal profiles
 □ C. Local profiles
 □ D. Remote profiles
 □ E. Mandatory profiles

32. You have instructions to change your system name and join your system to a domain. Where can both of these tasks be accomplished in Windows 2000 Professional?

 ○ A. Control Panel, Network, Client for Microsoft Networks
 ○ B. Administrative Tools, Computer Management
 ○ C. Control Panel, Network, and Dial-up Connections
 ○ D. Control Panel, System, Network Identification, Properties

33. Where in Windows 2000 Professional is the Disk Management tool located?

 ○ A. Administrative Tools, Disk Drives, Disk Management
 ○ B. Administrative Tools, Computer Management, Storage
 ○ C. Control Panel, Disk Management
 ○ D. Control Panel, System, Disk Management

34. What are the two disk types that are supported by Windows 2000 Professional? (Choose 2)

 □ A. Generic
 □ B. Monolithic
 □ C. Basic
 □ D. Simplistic
 □ E. Dynamic

35. You are attempting to install a printer in Window 2000 using the Add Printer Wizard. Unfortunately, the wizard does not detect your attached printer. What mode of installation will the wizard suggest if it cannot detect your printer?

 ○ A. Troubleshooting Mode
 ○ B. Automatic Mode
 ○ C. Manual Mode
 ○ D. Retry Mode

36. Which of the following are examples of Power Option settings in Windows 2000? (Choose 3)

 □ A. Portable Laptop
 □ B. Presentation
 □ C. Home/Office Desk
 □ D. Docking Station/Undocked
 □ E. Laptop/Presentation

37. What path can you take to connect to a Networked printer in Windows 2000 Professional?

 ○ A. Start>Settings>Printers
 ○ B. Start>Settings>Control Panel>Add/Remove Printers
 ○ C. Control Panel>System>Network>Connections
 ○ D. My Network Places>Network Printers

38. What kind of mail user accounts use SMTP to connect to mail servers through dial-up or Internet connections?

 ○ A. HTTP and HTTPS
 ○ B. POP and IMAP
 ○ C. FTP and HTTP
 ○ D. MAPI and PAMI

39. To transfer e-mail, what protocol would you use?

 ○ A. HTTP
 ○ B. SMTP
 ○ C. FTP
 ○ D. SNTP

40. What is the recommended way to remove a detected virus from a system?

 ○ A. Run an antivirus cleaning software program from within the operating system.
 ○ B. Run an antivirus cleaning program after running Scandisk and the Defragmenter.
 ○ C. Boot the system to a scanned boot disk and run the antivirus cleaning software program.
 ○ D. Send e-mail to your coworkers informing them that you have a virus. Then clean your system with an antivirus cleaning software.

41. To access a secure site named ChristopherCrayton.com, what URL entry would use?

 ○ A. HTTP://ChristopherCrayton.com /Secure
 ○ B. HTTP://ChristopherCrayton.com
 ○ C. PPTP://ChristopherCrayton.sec /8080
 ○ D. HTTPS://ChristopherCrayton.com

42. You attend a major university. You are interested in accessing information on your school's Web site. What domain name extension is your school likely to use?

 ○ A. .ORG
 ○ B. .COM
 ○ C. .EDU
 ○ D. .GOV

43. What does a DNS search order do?

 ○ A. Resolves multiple computer names to multiple IP addresses.

 ○ B. Locates a DNS server that will resolve domain names for a client computer.

 ○ C. It is an acronym used to block the sending of e-mail (Do Not Send).

 ○ D. Offers a user the ability to use multiple search engines.

ANSWERS

Answer Key	Question Taken From (Chapter and Section)
1. A	Chapter 10 "DOS System and Configuration Files"
2. A	Chapter 10 "DOS Windows Utilities"
3. A, C, and D	Chapter 10 "DOS Windows Utilities"
4. A and D	Chapter 10 "DOS Windows Utilities"
5. B and D	Chapter 10 "Windows Initialization Files"
6. A and D	Chapter 10 "Windows Initialization Files"
7. D	Chapter 10 "Memory Management Utilities"
8. A	Chapter 10 "DOS Commands, Switches, and Wildcards"
9. C	Chapter 10 "Memory Management Utilities"
10. A	Chapter 11 "Utilities and Settings"
11. B	Chapter 11 "Printers"
12. A	Chapter 11 "Diagnosing and Troubleshooting Test Tips"
13. C	Chapter 11 "The Windows 9.x Registry"
14. A	Chapter 11 "Diagnosing and Troubleshooting Test Tips"
15. B, C, and D	Chapter 11 "Utilities and Settings"
16. C	Chapter 11 "Utilities and Settings"
17. A	Chapter 11 "Installation and Upgrading"
18. B	Chapter 11 "Utilities and Settings"
19. B, C, and D	Chapter 11 "Utilities and Settings"
20. B	Chapter 11 "Utilities and Settings"
21. D	Chapter 11 "Utilities and Settings"
22. B, C, and D	Chapter 11 "Printers"
23. A, B, and C	Chapter 11 "Windows 9.x Networking"
24. B	Chapter 12 "Printers"
25. A	Chapter 12 "Utilities and Settings"
26. D	Chapter 12 "Utilities and Settings"
27. A	Chapter 13 "Windows 2000 Tools and Utilities"
28. C	Chapter 13 "Windows 2000 Networking and the Internet"
29. B	Chapter 13 "Windows 2000 Networking and the Internet"
30. A, B, and C	Chapter 13 "Internet Connectivity"

Answer Key	*Question Taken From (Chapter and Section)*
31. A, C, and E	Chapter 13 "Profiles"
32. D	Chapter 13 "Windows 2000 Networking and the Internet"
33. B	Chapter 13 "Windows 2000 Tools and Utilities"
34. C and E	Chapter 13 "Windows 2000 Tools and Utilities"
35. C	Chapter 13 "Printers"
36. A, B, and C	Chapter 13 "Windows 2000 Tools and Utilities"
37. A	Chapter 13 "Printers"
38. B	Chapter 13 "Windows 2000 Networking and the Internet"
39. B	Chapter 13 "Windows 2000 Networking and the Internet"
40. C	Chapter 13 "Windows 2000 Networking and the Internet"
41. D	Chapter 13 "Windows 2000 Networking and the Internet"
42. C	Chapter 13 "Windows 2000 Networking and the Internet"
43. B	Chapter 13 "Windows 2000 Networking and the Internet"

ABOUT THE CD-ROM

The CD-ROM included with this book contains A+ practice exams that will prepare you well for the CompTIA A+ Hardware Service Technician and Operating Systems Technologies examinations. The CD-ROM also contains demo versions of third-party software, featuring additional practice questions, simulated exams, instructional video demos, interactive training modules, and other learning tools to assist you in your A+ study.

A+ TESTTAKER'S GUIDE PRACTICE EXAMS

The practice exams in this folder were created by the author specifically and exclusively for this book. Each practice exam is an interactive, timed test that features a review to identify incorrect answers and areas of weakness.

There are two practice exams. The first exam contains practice questions for the Hardware Service Technician test (Chapters 1 through 9). The second exam contains practice questions for Operating Systems Technologies test (Chapters 10 through 13). Each exam has four separate tests that each include a total of 30 questions. It is recommended that you take these tests until you score 100% every time. This will ensure your best chance to score well on the real CompTIA A+ examinations.

SYSTEM REQUIREMENTS

- 486 DX2/66 or higher CPU
- 16MB RAM or higher
- CD-ROM drive
- Windows 95/98/NT/2000/ME/XP
- SVGA or better video adapter
- Mouse or compatible pointing device

- Internet Explorer 5.0 or greater with JavaScript enabled. To download IE 6.0, go to http://www.microsoft.com/windows/ie/downloads/ie6/default.asp.

ON THE CD

INSTALLATION

No installation is required. Simply insert the CD, navigate to your CD-ROM drive letter, and double-click "A+ Practice Exam" to start the program. You can copy the program to your hard drive by copying the program file and "Include" folder to a local drive.

GENERAL OPERATION

Each exam contains 30 questions and must be completed within 30 minutes. You will receive a score at the end of the exam or at any point you elect to end the exam.

At the end of each exam, a review option is available to check your answers.

Exam scores are displayed on the startup page for the last practice of each exam.

KEYBOARD SHORTCUTS

There are two keyboard shortcuts available once a practice exam has been started.

To navigate to the next question after starting a practice exam, use Alt+N for Next.

To go back to the previous question, use Alt+B for Back.

SOFTWARE CONTRIBUTORS

CYBER PASS, INC.

Exam Essentials 6.0
Multimedia Extensions 6.0

Cyber Pass, Inc.
Minto Place
P.O. Box 56060
Ottawa, ON K1R 7Z1
CANADA
613-237-4991
http://www.certify.com

Exam Essentials includes A+ Core Hardware Service Technician (220-221) and A+ OS Technologies (220-222) practice exams and every other test Cyber Pass offers. Multimedia Extensions is a free add-on module that enhances Exam Essentials by adding graphics and ScreenCam tutorials to Exam Essentials questions.

SELF TEST SOFTWARE, INC.

A+ Bundle—2001 Objectives, 220-20x

Self Test Software, Inc.
4651 Sandy Plains Rd., Suite 104
Roswell, Georgia 30075-5737
800-244-7330
http://www.selftestsoftware.com

Self Test's A+ Core Hardware practice test and A+ OS Technologies practice test, both included in this "bundle," help you prepare for the A+ certification exams by providing hundreds of exam-like questions to test your knowledge.

SPECIALIZED SOLUTIONS, INC.

A+ Boot Camp

Specialized Solutions, Inc.
3910 Riga Boulevard
Tampa, FL 33619
800-942-1660
http://www.specializedsolutions.com

This demo version of Specialized Solutions' A+ Boot Camp features video instruction, interactive training modules, simulated exams, and a variety of learning tools. This demo version has fewer features and components than the full version of the product. A link to Specialized Solution's Web site is provided on the demo if you decide to purchase the full version.

TRANSCENDER LLC

A+ CoreCert 2.0, A+ OS-Cert 2.0

Transcender LLC
565 Marriott Drive, Suite 300
Nashville, TN 37214
615-726-8779
http://www.transcender.com

These demo versions of the A+ CoreCert 2.0 and A+ OS-CERT 2.0 practice exams have most of the features of the full versions but fewer questions. These files are demos only and cannot be activated to the full version. If you decide to purchase the product, you will have the opportunity to download the full version.

ACRONYM GLOSSARY

AC (alternating current) Current that changes from a positive voltage to a negative voltage during one cycle. An example is household electricity in the United States, which is 110 volts at 60 hertz.

ACPI (Advanced Configuration and Power Interface) A power management specification that makes better use of power by letting the operating system control the power provided to peripheral devices.

ADC or A/D (analog-to-digital converter) A component on a sound card that converts analog sound to a digital bit stream.

AGP (Accelerated Graphics Port) A 32/64-bit expansion interface available on newer PCs that supports fast three-dimensional graphics and provides the video controller card with a dedicated path to the CPU.

ANSI (American National Standards Institute) A nonprofit organization whose primary purpose is to develop standards for the information technology industry.

API (application program interface) A set of uniform routines or rules that allow programmers and developers to write applications that can be used to interact with various operating system platforms. APIs define system calls for service.

ARP (Address Resolution Protocol) A TCP/IP protocol used to determine the hardware MAC address for a network interface card.

ASCII (American Standard Code for Information Interchange) Specifies a 7-bit pattern that assigns numeric values to letters, numbers, punctuation marks, and certain other characters by standardizing the values used. ASCII enables communication between computers and peripherals by using numbers in place of characters.

AT (Advanced Technology) IBM's name for its 80286 PC that was introduced in 1984. The AT Form Factor refers to the layout of the components on a motherboard.

ATA (Advanced Technology Attachment) The American National Standards Institute standard for IDE drives.

ATAPI (Advanced Technology Attachment Packet Interface) Interface standards that allow devices such as CD-ROM drives, Iomega Zip drives, and tape backup drives to utilize IDE/ATA controllers.

ATX (Advanced Technology Extensions) A more recent motherboard form factor that has replaced the AT form factor.

BIOS (basic input/output system) The BIOS is software built in to a ROM BIOS or flash BIOS chip that is used to control hardware devices such as hard drives, keyboards, monitors, and other low-level devices before a computer system boots into an operating system.

BNC (bayonet nut connector, bayonet Neil-Concelman, or British Naval Connector) A connector used to connect a computer to a coaxial cable in a 10Base2 Ethernet network.

bps (bits per second) A standard measurement of the speed at which data is transmitted; for example, a 56K modem has the ability to transmit at a rate of 56,000 bps.

CCD (charge-coupled device) A light-sensitive circuit in a device, such as a digital camera or optical scanner, that stores and displays the color representation of a pixel in electronic format. CCD arrays are made up of CCDs whose semiconductors connect.

CD (compact disk) A round metallic disk that stores information such as text, video, and audio in digital format.

CD-R (compact disk-recordable) A type of compact disk that can be written or recorded to once but read many times.

CD-RW (compact disk read/write) A type of compact disk that can be written to several times.

CGA (Color Graphics Adapter) The first color graphics adapter for IBM PCs. CGA can only produce a resolution of 640 × 480 and two colors. CGA has been replaced by VGA for the most part.

CMOS (complementary metal-oxide semiconductor) Nonvolatile RAM that is used to hold hard drive, DRAM, and other necessary startup information to boot a computer system. Modern CMOS is typically stored in flash RAM.

CPU (central processing unit) Also referred to as the processor, the CPU is the brain or central element of a computing system. It is where all main calculations occur.

CRT (cathode ray tube) A vacuum tube located inside a monitor that houses beams of electrons used to illuminate phosphors and produce graphic images.

CSMA/CD (carrier sense multiple access with collision detection) A contention-based protocol used to detect collisions of packets in Ethernet networks. If a collision occurs, the information is retransmitted.

DAC (digital-to-analog converter) A device used to convert digital information to analog signals. A DAC is typically used by a modem to prepare information for analog phone line transmission.

DC (direct current) DC is the unidirectional movement or flow of electrons. DC is necessary for most electronic computer components.

DHCP (Dynamic Host Configuration Protocol) A protocol used to dynamically assign IP addresses to computer systems in a TCP/IP network. DCHP eases administrative overhead by reducing the need to assign individual static IP addresses.

DHTML (Dynamic Hypertext Markup Language) A new form of HTML programming code that allows developers to create more interactive or responsive Web pages for users.

DIMM (dual inline memory module) A 64-bit data path memory module. In Pentium computers, one DIMM can be installed in a memory bank.

DMA (Direct Memory Access) A technique used by computer devices to access and move data in and out of memory without interrupting the CPU.

DNS (domain name system) An Internet service that translates fully qualified domain names to computer IP addresses.

DOS (disk operating system) A 16-bit operating system developed by Microsoft that does not support true multitasking capabilities.

dpi (dots per inch) A measurement of image resolution. The number of dots per horizontal inch is used to calculate the dpi that a device such as a printer is able to produce.

DRAM (dynamic random access memory) A popular type of memory used to store information in a computer system. DRAM chips must be electronically refreshed continuously to hold their data.

DSL (Digital Subscriber Line) A popular high-speed technology that uses phone lines for Internet connectivity. The two most widely used forms of DSL are ADSL (Asymmetric Digital Subscriber Line) and SDSL (Symmetric Digital Subscriber Line).

DVD (Digital Versatile Disk, or Digital Video Disk) A type of CD technology developed for full-length motion pictures that can hold 4.7GB to 17GB of information.

ECC (error correction code or Error Checking and Correction) A technique used to test data for errors as it passes out of memory. If errors are found, ECC attempts to make the necessary corrections.

ECP (extended capabilities port) An IEEE 1284 bi-directional parallel port standard that offers faster transfer rates than traditional parallel port standards. ECP is most often used for communication between computer systems and printers or scanners.

EDO (Extended Data Output) A type of DRAM that has the ability to read more information before needing to be refreshed. EDO is much faster than its predecessor FPM DRAM.

EEPROM (Electrical Erasable Programmable Read-Only Memory) A type of PROM chip whose information can be changed or erased with an electronic charge. EEPROM chips were very popular before the introduction of flash ROM chips.

EGA (Enhanced Graphics Adapter) IBM introduced EGA in 1984. The EGA standard for video adapters offers a resolution of up to 640×350 and supports up to 16 colors. EGA has been replaced by VGA and is for the most part obsolete.

EIDE (Enhanced IDE) An enhancement to the IDE hard drive standard that offers access to hard drives larger than 528MB through the use of

LBA support. The EIDE standard also offers support for DMA; for up to four attached devices, including tape drives and CD devices; and for faster hard drive access time.

EMI (electromagnetic interference) An electronic phenomenon that occurs when the signal from two or more electronic devices interferes with each other. EMI can occur when one data cable is placed too close to a second cable. If the electrical signals cross, the integrity of the information passing along the data cable may be affected.

EMS (Expanded Memory Specification) A memory management tool used to gain access to memory above the 640K memory limitation in an MS-DOS-based environment. Advances in the ways that Windows manages access to memory has for the most part eliminated the need for EMS.

EPP (enhanced parallel port) An IEEE parallel port interface standard; also known as IEEE 1284. EPP supports bi-directional or half-duplex data transmission methods.

EPROM (erasable programmable read-only memory) A ROM chip whose contents can be erased by shining an ultraviolet light through a hole in the top of the chip.

ESD (electrostatic discharge) The movement or transfer of electrons from one location to another. Static electricity can be transferred from the human body to an electronic component, causing damage to the components. ESD can be avoided by wearing an ESD-protective wrist strap when working with components.

FAT (file allocation table) A table consisting of clusters that are logical units of information located on a hard drive and used by the operating system to identify the location of stored entries or files.

FIFO (first-in, first-out) A data storage method in which the oldest information is read or used first.

FPM (Fast Page Mode) A DRAM memory type that makes use of memory paging, which increases overall memory performance. Most DRAM memory types are FPM.

FPU (floating-point unit) A math coprocessor that is built into the CPU. An FPU is designed to handle higher-end mathematical equations that assist with today's complex formulas and graphical calculations.

FRU (field-replaceable unit) An interchangeable or replaceable computer part or component that can be installed at a customer site or remote business location by a computer technician.

FTP (File Transport Protocol) A transfer protocol primarily used on the Internet to transfer files from one location to another.

GB (gigabyte) A measurement of computer system data storage space; 1GB is equal to 1024MB, or approximately 1 million kilobytes.

GUI (graphical user interface) A graphical means by which a person communicates with a computer system. In the early days of computing, operating systems such as DOS used text-based interfaces. Today, operating systems such as Windows allow the user to interact with the system by means of icons, pictures, and graphical tool bars.

HMA (high memory area) The memory location consisting of the first 64K of the extended memory area. The HMA is controlled by the software driver HIMEM.SYS.

HTML (Hypertext Markup Language) A programming language that is used to create pages or hypertext documents on the World Wide Web. HTML is a scripting language that uses tags to define the way Web pages are displayed.

HTTP (Hypertext Transport Protocol) A fast Internet application protocol used for transferring data.

IDE (Intelligent or Integrated Drive Electronics) A specification for hard disk and CD-ROM drive interfaces whose drive controllers are integrated onto the drive itself. IDE provides support up to two drives per system, whereas EIDE supports up to four drives per system. Today, the more common reference used for this technology is ATA.

IEEE (Institute of Electrical and Electronics Engineers) The world's leading international standards organization whose primary purposes are the development of information technology standards and the welfare of its members.

I/O (input/output) A term used to describe devices and programs that transfer information into and out of a computer system. Input devices can include keyboards, mice, and touch screens. Output devices can include printers, monitors, and plotters.

IP (Internet Protocol) A TCP/IP protocol used primarily to allow computers to be connected in a local area network or to the Internet.

IPX/SPX (Internetwork Packet Exchange/Sequence Packet Exchange)
A Novell networking protocol used primarily with Novell Netware.

IRQ (interrupt request) A communication link to a CPU that a device
uses to notify the CPU that the device needs its attention. If two
devices attempt to use the same IRQ to communicate with the CPU,
an IRQ conflict will most likely occur.

ISA (Industry Standard Architecture) An industry standard that
describes the expansion bus architecture for the IBM AT and XT PCs.
ISA expansion slots can still be found in most systems today, although
they are steadily being replaced by PCI and AGP technology.

ISDN (Integrated Services Digital Network) A digital
communications standard that allows data and voice to be used on the
same phone line connection. ISDN provides support for up to 128Kbps
transfer rates and is intended to replace traditional analog technology.

ISP (Internet service provider) A company whose primary business is
to provide access to the Internet for other companies and individuals.

Kbps (kilobits per second) A measurement of data transfer rate. One
Kbps is equivalent to 1000 bits per second.

KB (kilobyte) 1024 bytes.

LAN (local area network) A network of computers that are typically
connected in a central location, such as a building. In a LAN,
computers are connected by wires or other media and share common
resources such as printers, files, and modems.

LBA (Logical Block Addressing) An enhanced BIOS translation
method used for IDE and SCSI disk drives that allows accessibility
beyond the 504MB limit imposed by traditional IDE.

LCD (liquid crystal display) A technology for flat screen displays that
uses polarized sheets and liquid crystals to produce images. LCD
technology was originally used for laptop computers and watches but
is becoming very popular for desktop computers.

LED (light-emitting diode) A highly efficient, long-lasting light that
illuminates when electrical current passes through it.

MAN (metropolitan area network) A network that is smaller than a
WAN but larger than a LAN. It is usually confined to a city block or a
college campus.

MAPI (Messaging Application Programming Interface) A Microsoft application programming interface that provides the ability to send e-mail and attachments from within programs such as Word, Excel, PowerPoint, and Access.

MAU (Multistation Access Unit) A special hub used in a token ring network that is used to connect computers for a star topology network while maintaining token ring capabilities. Also known as MSAU.

MB (megabyte) 1024 kilobytes or 1,048,576 bytes.

MBR (master boot record) A small program that is executed when a system first boots up. The MBR is located on the first sector of a hard drive.

MCA (Micro Channel Architecture) A proprietary 32-bit expansion bus developed by IBM for its PS/2 computers.

MDA (Monochrome Display Adapter) A standard for monochrome adapters introduced by IBM. Monochrome is only capable of displaying text.

MIDI (Musical Instrument Digital Interface) A standard or protocol used for the interface between a musical instrument or device and a computer system. Used for digital synthesizers for playing and manipulating sound.

MMX (multimedia extensions) A multimedia technology developed by Intel to improve the performance of its Pentium microprocessor. MMX technology included 57 new processor instructions and is said to improve multimedia application performance up to 60%.

modem (modulator-demodulator) A communication device used to convert signals so they can be transmitted over conventional telephone lines. A modem converts incoming analog signals to digital format and outgoing digital signals to analog format.

MPEG (Motion Picture Experts Group) A standards group that works with the ISO to establish rules and standards for audio and video compression. MPEG technology is used to make high-quality compressed files.

MSCDEX (Microsoft CD-ROM Extensions) A software driver used in Windows 3.x and DOS to allow the operating systems to communicate with CD-ROM devices. The actual file that contains the driver is called

MSCDEX.EXE. More efficient 32-bit CD-ROM drivers, such as CDFS, have replaced MSCDEX.EXE.

NIC (network interface card) An electronic circuit board that attaches a computer to a network. A NIC is installed inside a computer system. It connects to a wire that typically leads to a networked hub, router, or bridge.

NLX (InteLex Form Factor) A computer motherboard form factor designed to provide more room for components than the LPX form factor.

NTFS (NT File System) A Windows NT hard drive file system that offers file- and object-level security features, file compression, encryption, and long file name support. A new version of the NTFS file system called NTFS5 is offered with the Windows 2000 operating system.

OEM (original equipment manufacturer) An OEM version of software, such as Windows 95, that is designed to be packaged and distributed by a specific manufacturer on specific computers.

OLE (object linking and embedding) A specification created by Microsoft that allows objects created in one program or application to be embedded or linked to other applications. With OLE, if a change is made to an application, the change is also made to the second application.

OSI (Open Systems Interconnect) The OSI reference model is a networking model developed to provide network designers and developers with a model that describes how network communication takes place.

PCI (Peripheral Component Interconnect) A 32- to 64-bit expansion bus created by Intel and used in most modern computers. Today, most NICs, sound cards, and modems are connected to a motherboard through a PCI expansion bus.

PCMCIA (Personal Computer Memory Card Industry Association) A group of companies that are responsible for the specifications that apply to small expansion cards used in laptop computers. There are three main types of PCMCIA cards. Type I is used mainly for RAM, type II is used for modems, and type III is used for hard disks.

PDA (personal data assistant) A small handheld mobile computing device that provides functions similar to a desktop or laptop

computer. Most PDAs today use a pen or stylus in place of a keyboard to input data.

PIF (Program Information File) A file that is used to provide settings for 16-bit DOS applications. A PIF file has a .PIF extension and stores information such as window size and memory that should be allocated to an application or program.

PnP (Plug and Play) A technology introduced in Windows 95 that has the ability to auto-detect devices that are attached to a computer system. In order for a system to be fully PnP compliant, there must be a PnP operating system, a PnP BIOS, and PnP devices.

POST (power-on self-test) A program that tests computer components, such as RAM, disk drives, and peripherals at system startup. If the POST finds a problem during its diagnostic testing, it usually reports a numeric error to the screen or sounds a series of beep error codes.

PROM (programmable read-only memory) A ROM chip that can be written to once.

RAID (Redundant Array of Inexpensive Disks) Using multiple hard disks to provide data redundancy. RAID spreads data across several hard drives to provide fault tolerance in case of a disk crash. There are several levels of RAID. The most common are levels 0, 1, and 5.

RAM (random access memory) A computer system's main memory storage location. Information held in RAM can be quickly accessed by the computer's CPU without the need to read the data preceding the required information.

RAMDAC (random access memory digital-to-analog converter) A chip on a video card that converts binary digital data into analog information that can be output to a computer monitor.

RDRAM (Rambus dynamic random access memory) A type of fast DRAM memory developed for today's Pentium computers by Rambus, Inc.

RGB (red, green, and blue) The three primary colors of light that are used in PC monitors. A color monitor has three electron guns. Each of the electron guns represents one of the three primary colors of light to produce a final color image to computer screen.

ROM (read-only memory) A computer chip whose information cannot be deleted or erased but can be read by the system many times. ROM is nonvolatile memory that holds the system BIOS.

SAM (security accounts manager) A built-in Windows NT and 2000 component that is used to manage the security of user accounts.

SAT (security access token) A security token that allows users access to resources in a Windows environment. A token carries access rights that are associated with a user's account.

SCSI (Small Computer System Interface) A standard that applies to fast electronic hardware interfaces in computer systems. SCSI technology can be used to allow up to 15 devices to be daisy-chained together. SCSI is most commonly used to connect hard drives, CD-ROM devices, scanners, and printers to computer systems.

SDRAM (synchronous dynamic random access memory) A type of DRAM that synchronizes itself with the internal clock speed of the computer's processor.

SEC (single edge connector) Intel's chip package design that uses a circuit board with a single edge connector. A processor and memory cache are integrated onto the circuit board and inserted into the computer system's motherboard.

SEP (single edge processor) A processor chip package design similar to SEC.

SGRAM (synchronous graphic random access memory) A single-ported type of video RAM that is synchronized with the CPU's clock to achieve high speeds.

SID (security identifier) A unique security number that is associated with users, groups, and accounts in Windows NT or 2000 Network. Access to processes that run in Windows NT or 2000 require this unique SID and a token.

SIMM (single inline memory module) A type of circuit board on which DRAM chips are mounted. The circuit board is inserted into the motherboard. A SIMM module has a 32-bit-wide data bus.

SQL (Structured Query Language) A programming language used to gather or query information from various computer databases. IBM developed SQL in 1974.

SRAM (synchronous random access memory) A fast type of memory that does not have to be refreshed over and over to maintain its contents. SRAM is faster than DRAM and is used mostly for cache memory in computer systems. Also referred to as *static RAM*.

STP (shielded twisted pair) A type of copper cabling used in networks in which pairs of wires are twisted around one another to extend the length that a signal can travel on the cable and reduce the interference of signals traveling on the cable.

SVGA (Super Video Graphics Array) A video display standard that applies to any resolution or color depth higher than the VGA standard of 640 × 480 and 16 colors.

TB (terabyte) 1024 gigabytes, approximately 1 million megabytes, or 1,099,551,627,776 bytes.

TCP/IP (Transmission Control Protocol/Internet Protocol) The primary set of protocols used by the Internet and most networks. TCP/IP allows different networks and computers to communicate with one another.

TSR (terminate-and-stay-resident program) A program that remains resident in computer memory and can be run repeatedly without having to be reloaded into memory. Most TSR programs are loaded into memory by the DOS file AUTOEXEC.BAT. DOSKEY is a TSR program.

UART (Universal Asynchronous Receiver/Transmitter) A chip that converts data from serial information to parallel information and vice versa. UARTs are used for equipment or devices that are attached to serial ports.

UMA (upper memory area) The first 640K to 1024K of memory addresses reserved for device drivers and system use.

UMB (upper memory block) A reserved memory block in the UMA used to load device drivers and TSR programs.

UPS (uninterruptible power supply) Provides a continuous supply of power to a computer system when a primary power source fails. A UPS can also protect a system from power sags.

URL (uniform resource locator) A URL is an address that points to a resource or another URL located on the World Wide Web. An example of a URL is http://www.charlesriver.com.

USB (Universal Serial Bus) An interface standard that supports up to 127 devices using one system resource (IRQ). With USB, PnP peripheral devices can be attached to a computer system while the power is on and the operating system is up and running.

UTP (unshielded twisted pair) A common type of twisted-pair cable used in most networks. There are five categories of UTP that support different data transmission speeds. Unlike STP, UTP does not have a protective shielding.

VGA (Video Graphics Array) A display standard for video adapters developed by IBM. VGA replaced CGA and EGA standards and supports a resolution of 640 × 480 at 16 colors.

VL-Bus (VESA local bus) A 32-bit expansion bus that has been replaced by PCI expansion bus technology.

VRAM (video random access memory) A special type of dual ported memory that is used in video adapters to produce graphic images to a computer monitor.

VxD (Virtual Device Driver) A 32-bit device driver used in Windows. Virtual device drivers have a .VXD extension.

WAN (wide area network) A WAN is typically made up of two or more LANs linked together to form a larger network. WANs are usually spread over large areas. The Internet is a WAN.

WINS (Windows Internet Naming Service) A Windows Networking service that provides a computer NetBIOS name to IP address resolution.

WRAM (window random access memory) A very fast type of dual ported video memory that has the ability to read and write larger sections of memory than VRAM.

WWW (World Wide Web) A system of servers on the Internet that provide support for pages and documents created with HTML and other scripting languages. You can access the WWW by using such tools and Web browsers as Internet Explorer, FTP, Telnet, HTTP, and Netscape Navigator.

XGA (eXtended Graphics Array) A video display standard developed by IBM that has the ability to support a resolution of 1024 × 768. XGA can also support up to 65,536 colors.

XMS (eXtended Memory Specification) The first 64K of memory located above 1MB.

ZIF (zero-insertion force) A lever-socket combination used to pull a CPU away or up from the motherboard's data bus. ZIF sockets were used for the early Pentium processors.

INDEX

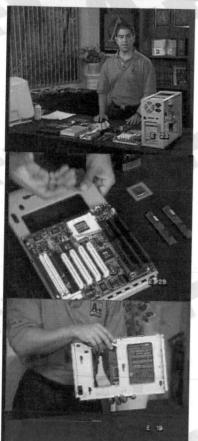